BLACKNESS
IN
MOROCCO

BLACKNESS IN MOROCCO

Gnawa Identity through
Music and Visual Culture

CYNTHIA J. BECKER

UNIVERSITY OF MINNESOTA PRESS

MINNEAPOLIS

LONDON

The University of Minnesota Press gratefully acknowledges the
financial assistance provided for the publication of this book by the
Boston University Center for the Humanities.

Portions of chapters 1, 3, and 6 were previously published in a
different form in "Gnawa Material Culture: Innovations across the Sahara," in *Caravans
of Gold, Fragments in Time: Art, Culture, and Exchange across Medieval Saharan Africa*,
edited by Kathleen Bickford Berzock (Princeton, N.J.: Princeton University Press, 2019),
91–105, and in "Hunters, Sufis, Soldiers, and Minstrels: Trans-Saharan Derivations
of the Moroccan Gnawa," *RES: Anthropology and Aesthetics* 59/60
(Spring/Autumn 2011): 124–44.

Published by the University of Minnesota Press
111 Third Avenue South, Suite 290
Minneapolis, MN 55401-2520
http://www.upress.umn.edu

ISBN 978-1-5179-0938-3 (hc)
ISBN 978-1-5179-0939-0 (pb)

Library of Congress record available at https://lccn.loc.gov/2020020415

Printed in the United States of America on acid-free paper

The University of Minnesota is an equal-opportunity educator and employer.

27 26 25 24 23 22 21 20 10 9 8 7 6 5 4 3 2 1

To my parents,
who always supported my love of learning and travel

CONTENTS

PREFACE AND ACKNOWLEDGMENTS

My interest in the topic of Gnawa art and performance began in a moment of intense and intimate encounter while I was conducting my dissertation research on Amazigh art in southeastern Morocco in the late 1990s. I attended a ceremony that involved healing and possession in the remote desert town of Khamlia—a cluster of adobe houses largely inhabited by the descendants of enslaved people who, after emancipation, aligned with the local Amazigh group, the Ait Khabbash. I was shocked to discover that people there still referred to themselves as Ismkhan, a word that means "slaves" in the local Amazigh language. As a native of New Orleans with a deep awareness of that city's complex history of racial classification, I questioned why people would adopt as their self-descriptor what seemed to be a demeaning and pejorative term.

As I tried to make sense of this, local people explained to me that identifying as a "slave" was not merely pejorative, because the term signified a link to sub-Saharan Africa and special access to the spiritual realm. They equated Blackness and a historical connection to slavery with healing powers, a dimension of empowerment absent from the racial categories that I was accustomed to in America. One man suggested that if I wanted to learn more, I should visit the city of Essaouira and ask for Mahmoud Gania, "the best Gnawa musician in Morocco," since, he explained, "Gnawa were also slaves and heal through spirit possession." Several days later I drove my rickety, secondhand Renault 4 across the High Atlas Mountains from the desert, heading west to the coastal town of Essaouira accompanied by a few friends. The cool breezes and seagulls flying over the city's eighteenth-century walls were an abrupt change from the desert where I had spent the past few years. Essaouira was a quiet, sleepy town in 1997, and asking around, we easily found Mahmoud Gania's house, knocked on his door, and were warmly greeted. We were honored by his welcome, and he played Gnawa music for us that very evening.

When Gania began to play the *guinbri* and sing, I saw a very different Morocco from that of the Amazigh culture I had been studying. I was hooked. I knew that I had found the topic of my next research project. As an Africanist art historian who worked in Morocco, the topic of Gnawa visual culture and performance allowed me to address one of the most timely and compelling issues in African and Middle Eastern studies: the geographic and conceptual divide between North and sub-Saharan Africa and the separation of the continent into an Arab north and a Black south. For years, Africanists had been telling me that the topic of my dissertation, Amazigh art, was "not African enough" for the simple reason that Imazighen were not Black. Since Gnawa were the descendants of enslaved Sahelian Africans, they were certainly Black—or were they?

The ambiguity and fluidity surrounding Blackness and its relationship to Gnawa initially eluded me. It was only after I acquired more familiarity and became deeply immersed in the local community in Essaouira that I became privy to local intrigues concerning issues of authenticity that disclosed the slippery meaning of "Blackness." I gradually gained entry into the spirit-possession ceremonies for which Gnawa are renowned. After attending many such ceremonies I began to see how spirit possession constitutes a unique construction of Black identity. Many people chose to confide in me, perhaps hoping to influence my research or simply seeing me as a neutral party. Some in the community maintained that "real" Gnawa were phenotypically Black—and I should learn about Gnawa only from them. At the same time, many light-skinned people attended ceremonies regularly and even performed as musicians and ritual specialists. I found that the term "Gnawa" can be used in a multitude of ways to indicate a profession, to refer to a type of spiritual therapy, to describe a spectator at a ceremony, as well as to refer to one's ancestral connection to sub-Saharan Africa.

Since 1997, I have spent considerable time in Essaouira, but after 2006 I began to spend every summer there, eventually living in the city long term with the support of a Fulbright-Hays grant. In 2006, the end of August coincided with the Islamic month of Sha`ban, a time when Gnawa practitioners hold spirit-possession ceremonies, as during the following month of Ramadan the spirits are said to sleep. It was also during the summer when the popular Gnawa and World Music Festival was held in Essaouira. When some of my Moroccan friends felt intimidated by the swelling crowds, I felt at home and could push my way through mobs of concertgoers. In fact, I always felt that growing up in New Orleans prepared me for this project, especially Gnawa all-night spirit-possession ceremonies (*lila*). Having spent a great deal of time doing research on Black Indian traditions in New Orleans, I regularly marched with them during Mardi Gras. I felt that a Gnawa ceremony had the same energy as Mardi Gras, which I loved. In Morocco, I did not find it difficult or strange to stay up all night listening to music. I appreciated hearing a person's bare feet rhythmically slap the floor while possessed, and I loved feeling the repetitive sound of metal cymbals deep in my chest. I began to

crave the smell of *jawi*, a type of incense used to induce possession. I became such a regular figure at ceremonies that I started to memorize the spirit-possession repertoire simply from the sheer number of ceremonies that I attended. I will never forget the day that I walked by a group of Gnawa musicians sitting in a small shop with a *guinbri*. They called me over and had me listen as one of them plucked a rhythm on the instrument. He asked me to identify the spirit associated with it, and everyone laughed when I kept answering correctly. After that experience, I felt that I was finally ready to write this book. In Essaouira, two lineages are considered to be the most authentic Gnawa, the Gania and the Sudani families, and they both greatly helped me with this project.

While Gnawa ceremonies were thrilling, I also began to see a more sober side of Essaouira. After Sha`ban, the city felt like a quiet backwater, and many musicians and diviners struggled to survive. Gnawa musicians hustled to get gigs at local hotels and restaurants; many young men played multiple performances in the same night, pushing themselves to energetically dance and do acrobatic jumps in order to put on a good show. Female diviners tried to build up their client base to ensure that a constant stream of women visited them for healing. Life as a Gnawa musician and healer could be glamorous, but it also had its dark side. I saw people suffering from drug and alcohol abuse. I lost friends to serious illnesses, such as the artist Regreguia Benhila, who invited me into her home outside Essaouira shortly before her death. M`allem Abdellah Gania passed away in 2013, and his absence was sorely felt at the Zawiya of Sidna Bilal where his *guinbri* playing carried everyone through Essaouira's biggest spirit-possession ceremony each year. His brother Mahmoud Gania passed away shortly afterward from cancer, which also took the life of Halima Meses.

This book is dedicated to them and to my Moroccan family who always took such good care of me. First, my adopted family in Essaouira, Yassin and Eliza Azzi, their mother Fatima, and sister Ahlam, who invited me to eat more meals than I can count in their home. Mokhtar Gania and his daughter Sana spent countless hours with me, transcribing songs from the Gnawa spirit pantheon. I loved watching his daughters Hasna, Meryem, and Cherifa grow up to become beautiful young women. Zaida Gania was also very patient, telling me stories about her family, answering my numerous questions, and organizing an all-women's Gnawa ceremony at her home for me. My sister-in-law Khira Ouadderrou came to spend time with me in Essaouira, traveling all the way from the Tafilalet oasis, a twelve-hour bus ride across mountains and desert. My family in southeastern Morocco allowed me to host a spirit-possession ceremony in their home, and a sorrowful note of gratitude goes out to my mother-in-law, Mama Lahacen, who sadly passed away while I was working on this book.

It is impossible for me to list all of the people who helped me with this project. Many invited me to Gnawa ceremonies, took me to visit a friend who happened to be a Gnawa healer, or simply agreed to talk with me about Gnawa-related topics. My

PREFACE AND ACKNOWLEDGMENTS

appreciation goes out to Gnawa practitioners both inside and outside Essaouira, including Abdeslam Alikane, Adil Amimi, Abdelkarim `Asiri, Said Boulhimas, Hajja Brika, Abdellah El Gourd, Abdenbi El Meknassi, Abdellah Gambori, Khadija Hadidi, Asmae Hamzaoui, Omar Hayat, Ahmed Labnoua, Hajja Latifa, Abderrahmane Naciri, Hajja Naima, and Hamza Sudani. Najib Sudani was always friendly and helpful, inviting me to many Gnawa ceremonies. All the women who supported the Zawiya of Sidna Bilal, especially Fatima and Mbarka, deserve a special thanks. Said Moufli and Mohammed Sabar showed me around Tamanar, and Ismkhan in Khamlia always welcomed me, especially Hamad Mahjoubi who became a close friend after our road trip in Niger with Brian Nowak, who talked about spirit possession with me for hours. Nowak provided me with an incredible entry into Niger's spirit-possession scene, going to many ceremonies with me; Sue Rosenfeld allowed me to stay in her home during my numerous visits to Niamey. Seydou Diakité and Sekouba Traoré gave me insight into the role of hunters and their griots when I visited Mali.

André Azoulay, Hassan Hakmoun, Torben Holleufer, Amazigh Kateb, and Neila Tazi discussed various aspects of Gnawa visual and performing arts with me. Marjorie Olster, Victoria Giambrone, and Tammy Kady visited me in Morocco, and we shared some great adventures. I worked with editors Joanna Rutter and Grete Viddal, who read and commented on multiple chapter drafts. Viddal also arranged for me to speak about Gnawa possession at the Joel James Colloquium in Santiago de Cuba, which provided invaluable insight into similarities and differences between Gnawa trance, Santería, and Vodou. My colleagues and friends Christa Clarke, Henry Drewal, Christraud Geary, Kim Sichel, and Diana Wylie read drafts of various chapters. My writing group "NAWLA," which includes Amanda Carlson, Andrea Frohne, Shannen Hill, and Carol Magee, also read chapter drafts, especially at their beginning stages. My Boston University colleagues in the History of Art and Architecture Department, the African Studies Center, and African American Studies served as a great source of inspiration. Thanks to Hassan Hajjaj, Lamia Naji, and Mohamed Tabal for allowing me to reproduce their artwork in this book. `Abid El Gaouzi took me to meet several artists and provided insight into the art scene in Essaouira. Nordine Benhaga patiently helped with transcription and interpretation of Gnawa song lyrics. Thanks to the numerous institutions that allowed me to reproduce images from their collections, including the Melville J. Herskovits Library of African Studies and the Newark Museum, Philippe Jacquier at the Collection Gabriel Veyre, the Gnawa and World Music Festival in Essaouira, and the Maison de la Photographie in Marrakech.

Aomar Boum, Katarzyna Pieprzak, and Prita Meier served as excellent outside readers and offered thoughtful comments that improved this book. The research and writing for this book were conducted with the support of a Fulbright-Hays grant and a fellowship from the Radcliffe Institute for Advanced Study, where I met Seema Alavi, who quickly became not only a colleague but a good friend. Boston University supported a

research leave in 2018, and the Boston University Center for the Humanities provided a publication production award. I thank Pieter Martin, senior editor at the University of Minnesota Press, and Anne Carter, who helped with the publication process.

Finally, I thank my entire family in New Orleans, especially my parents Kathleen and George who taught me to be persistent and determined. Scott, Jessica, Zachary, and Meredith kept me smiling and laughing. I profoundly thank Addi Ouadderrou, who took that initial trip with me to Essaouira, for his many years of love and support. We spent uncountable hours discussing Gnawa ceremonial practices and discussing the intricacies of Tamazight and Arabic. Most important, he gave me the encouragement and words of advice I needed to finish this book.

NOTE ON TRANSCRIPTION
AND TRANSLITERATION

This book includes many Arabic words, but they are primarily from the Moroccan dialect of Arabic. Moroccan Arabic is largely a nonwritten vernacular that has been heavily influenced by Tamazight, the local language of the Imazighen (Berbers). This gives the Moroccan dialect many unique features, such as shortened vowels (Kapchan 2007, xi). I have tried to remain faithful to the Moroccan pronunciation of Arabic and Sudani words, the latter a name given to words carried by enslaved people to Morocco. In order to make the transliteration of Arabic legible for most readers, I followed a simplified version of the transliteration guidelines recommended by the *International Journal of Middle Eastern Studies*. With the exception of ` to signify the Arabic letter `*ayn* (as in `*abid*) and the ' to represent *hamza* (as in Qur'an), diacritics are not used in this book. The *hamza* is used only when it occurs within the word Qur'an and not elsewhere. I indicate a plural by adding an s to the word, such as *lilas*. Proper names and names of cities are spelled according to conventional usage.

Introduction

Becoming Gnawa

It is probably true to say that for every gallon of ink that has been spilt on the trans-Atlantic slave trade and its consequences, only one very small drop has been spilt on the study of the forced migration of black Africans into the Mediterranean world of Islam and the broader question of slavery within Muslim societies.

—JOHN HUNWICK, *The African Diaspora in the Mediterranean Lands of Islam*

What interests me the most is the culture of silence—the refusal to engage in discussions about slavery, racial attitudes, and gender issues—and my goal is to recover the silenced histories of slavery in "Islamic" North Africa.

—CHOUKI EL HAMEL, *Black Morocco*

They brought us from the Sudan. They brought us in sacks. They separated me from my mother. They sold us, the nonbelievers.

—Excerpt from a Gnawa ceremonial song

IN 2005, THE MOROCCAN PHOTOGRAPHER and videographer Lamia Naji photographed Gnawa spirit possession for use in a multimedia project called *couleurs primaires*. Gnawa spirit possession is associated with the descendants of enslaved West Africans, who are believed to have carried the practice with them to Morocco. In a series of grainy, high-contrast, black-and-white photographs, Naji focuses on segments of people's bodies, dark interior spaces, and shadowy figures of musicians and dancers (Figure I.1). The title of the series, which translates into English as "primary colors," seems at odds with the black-and-white photographs. It refers to the attribution of specific colors to different spirits in a Gnawa spirit pantheon and, at the same time, suggests the association of race with visual markers. Naji's unconventional angles and points of view give the photographs a sense of ambiguity; they provoke a desire to see beyond what the photograph permits us to see, creating tension between the seen and unseen.

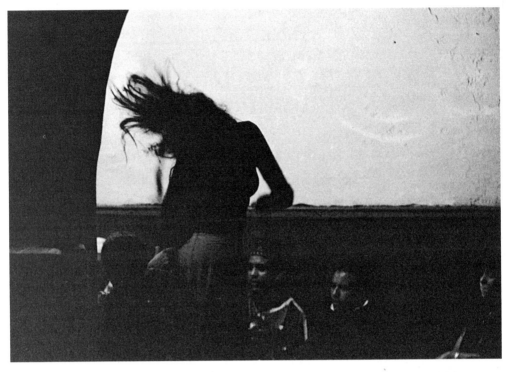

Figure I.1. Lamia Naji, photographer, *Untitled*, from the series *couleurs primaires*, 2005.

The act of capturing spirit possession with photography is inherently paradoxical since it attempts to render what is theoretically immaterial, material. Naji endeavors to capture the deeply personal and sensual dimension of the experience that lies outside of the photograph. In doing so, she works in a style that acknowledges the performative nature of possession. For example, she often photographs dark figures against stark white backgrounds, giving the sense of a staged performance (Figure I.1). She includes spectators who watch those engaged in possession, implicating spirit possession as a highly visual form of public display (Figure I.2). A woman collapsed in the center of the photograph in Figure I.2 pushes us to consider why the people looking at her remain motionless and appear unable or unwilling to help her. But those familiar with Gnawa ceremonies realize that the photograph was taken after a possessed woman satisfied her spirits. Released from their grip, she fell to the ground in exhaustion. Ultimately, the power of the image lies in its failure to record as much as it relies on what is captured by the photograph itself (Suhr 2015, 110).

This elusiveness that Naji seeks to capture in her photographs suggests, on a broader level, the ambiguity that surrounds the very term "Gnawa." It appears that some variation of the term "Gnawa" has existed in Arabic literature since the twelfth century, but how and why "Gnawa" developed as an identity linked to Blackness and enslavement remains shrouded in a great deal of myth and historical vagueness.[1] While Arabic

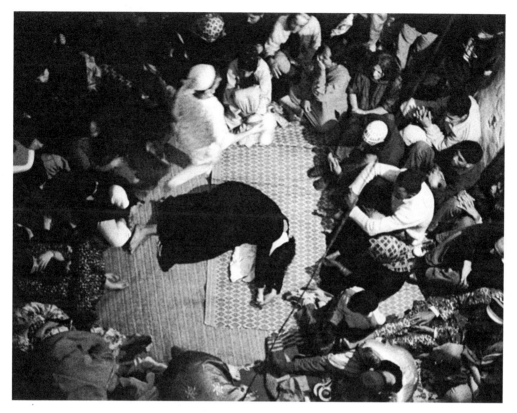

Figure I.2. Lamia Naji, photographer, *Untitled*, from the series *couleurs primaires*, 2005.

sources concerned themselves with rules and regulations concerning the slave trade and the treatment of the enslaved, no known documentation of Gnawa spirit possession exists before the nineteenth century.[2] Further complicating the issue is that "Gnawa" can be used in a multitude of ways to indicate a musical profession, to designate a type of spiritual therapy, to describe a spectator at a spirit-possession ceremony, to comment on one's dark-skinned phenotype, as well as to refer to one's ancestral connection to West Africa.[3] As a history that has remained largely invisible, one must turn to sources of information found beneath the surface that embody cultural history, allowing for a reconstruction of the past and an understanding of the present condition of Blackness in Morocco. *Blackness in Morocco* looks at how "Gnawa" became an identity that united people based on cultural and political understandings of Blackness.

Given that Gnawa is intimately connected to the history of enslavement, it is crucial to start with the history of trans-Saharan trade. For more than thirteen centuries, caravans transported enslaved people from Africa south of the Sahara into what is now the Kingdom of Morocco. Millions were displaced from south of the Sahara to the north. Enslaved men served as soldiers, and enslaved women were concubines for the elite; they worked for rural families herding camels and fetching water; enslaved women

served as wet nurses, and men farmed the land. And yet, there are no museums dedicated to slavery in Morocco; there are no plaques or monuments that recognize this history. In their place, silence. This is not to say, however, that the history of enslavement has been completely erased from memory. Gnawa performances have become a means through which the largely suppressed history of enslavement has been conserved and remembered.

This book considers how "Gnawa" emerged as a performative practice associated with Blackness and enslavement, concentrating on the postslavery period (from the late nineteenth century to the present). As an art historian whose work crosses into the field of ethnography and lived experiences, I address in this study the historical consciousness of subaltern groups and how they give Blackness material form through certain modes of dress and particular musical instruments, which are used in a performative context. *Blackness in Morocco* identifies some of the historical processes that enabled "Gnawa" to become a recognizable identity during the decline of slavery. This book asserts that "Gnawa" united people who came from many regions of Africa south of the Sahara, as well as from within Morocco itself. Ultimately, what has resulted in a Gnawa identity was not a common origin from a specific region or ethnic group in West Africa but a connection to Blackness, which took on a mythological and symbolic quality. The idea that Black people could heal through spirit possession developed due to the historical claim that sub-Saharan Africans practiced a form of religiosity associated with pre-Islamic and so-called pagan beliefs, a claim used to justify the trans-Saharan slave trade. The result is a somewhat paradoxical situation where the agency of Black Moroccans is linked to the history of enslavement. Therefore, in addition to healing, Blackness as embodied during Gnawa performances expresses an intimate association with the experience of injustice associated with enslavement.

Due to the silence surrounding the history of slavery in Morocco, such a study requires that one not only investigate the visible legacy of the slave trade but also be aware of the constructed nature of Blackness itself. This book consists of various case studies that consider the different visual and performative aspects of Gnawa identity, drawing from archival material as well as long-term, multi-sited research in both urban and rural Morocco. This study begins with a consideration of images of dark-skinned male musicians taken by European photographers in the late nineteenth century. These contributed to public conceptions of what it meant to be Gnawa, reinforcing a stereotype between Blackness and male public performance. In Morocco, the stereotyped and exaggerated vision of the Black male entertainer developed into a commodity to be sold and an identity to be marketed, but the experience of enslavement and actual condition of Black men and women were largely disregarded. Rather, tropes circulated portraying slavery in Morocco as gentle or discussing how Black women could use their sexuality to strategically manipulate their "masters" and better their lives. When Black women were made visible, rather than be empowering, it was disempowering. Dark-skinned

women in Morocco were portrayed in the visual realm as concubines and in positions of servitude. Given the constructed nature of visibility and the invisibility of Black subjectivities, in order to understand the meaning of Blackness, one must look for alternative sources of information beyond official representations.

The bulk of this book relies on immersive and experiential research conducted principally in the town of Essaouira due to its historical role as a center for trade and exchange, both cultural and commercial. Located on Morocco's Atlantic Coast, Essaouira was developed by Sultan Muhammed bin `Abd Allah (ruled 1757–90) in the eighteenth century to serve as a trading port. Due to the presence of North Atlantic trade winds, goods could easily be carried from Essaouira by sail between Europe, West Africa, and the Americas. Due to its strategic importance, the sultan sent people enslaved from West Africa, as both laborers and soldiers, to construct and guard this burgeoning port city. He also installed a large number of Jewish merchant families to take advantage of their long-term business connections across Europe. Finally, eight European consulates were built there to enhance trading relations (Lakhdar 2010; Ottmani 1997, 211–33; Ross et al. 2002, 25–26).

Essaouira's importance as a trading center declined during the period of the French Protectorate (1912–56) due to new emphasis on trade by railroad to which Essaouira was not connected. As a response to its economic decline, much of the city's elite left for the new political and commercial center of Casablanca, as well as Europe and Israel. Essaouira remained neglected for most of the twentieth century until the founding of the Essaouira-Mogador Association in 1992 by members of Morocco's economic and intellectual elite whose families had historical ties to Essaouira. Their promotion of Essaouira as a multicultural center led to increased national and international attention and contributed to the founding of the first Gnawa and World Music Festival in 1998. After the first festival attracted around twenty thousand people, it was made into an annual event contracted to A3 Groupe, an event-organizing company located in Casablanca (Ross et al. 2002, 40).[4] Today it attracts more than four hundred thousand visitors each year, most of them Moroccans. Investors began buying and restoring decrepit houses in the city's historic section to turn into tourist accommodations and building beachfront hotels. The city became recognized as a UNESCO World Heritage Site in 2001 due to its historic architecture and role as an eighteenth-century international trading seaport.

Essaouira has become a city intimately connected to the term "Gnawa," which is used across the city to market such goods as paintings, clothing, hotels, and spices; numerous shops sell Gnawa recordings and musical instruments. So renowned are Gnawa in contemporary Essaouira that the artist Lamia Naji, whose photographs were discussed at the beginning of this Introduction, traveled there to produce her series *couleurs primaires*. Gnawa as a cultural and musical form has gone from being a marginal religious practice associated with the enslaved to becoming a crucial part of Essaouira's

identity and a major contributor to the city's tourist industry (Ross et al. 2002, 44). Furthermore, the popularity of Gnawa music has spread across Morocco and led to the transition of Gnawa musicians from those hired at a modest fee to perform private spirit-possession ceremonies to professional recording artists playing on the global music circuit.

Despite the visibility and subsequent popularity of Gnawa music locally and abroad, issues of race and slavery in Morocco have only recently become a focus of scholarly examination and public debate. Historian John Hunwick wrote that the failure of the Black minority to press for an internal investigation of its past history was one of the many reasons why basic questions about trans-Saharan slavery remain unanswered (2002, xi). Hunwick noted that some of the impediment was due to well-entrenched boundaries in the academy between African and Middle Eastern studies; a specialist would need to be trained in both fields of study and know multiple languages (2002, xiii). Therefore, he identified the many questions that endure, including: "How many slaves crossed the Sahara into North Africa?" and "What kinds of occupations did slaves undertake and what skills may they have acquired that prepared them for economic viability as free persons?" (2002, xii). As we will see, the latter question is particularly relevant to this study.

Writing more than ten years later, the Moroccan-American historian Chouki El Hamel largely agrees with Hunwick's assessment; he particularly laments the fact that North African scholars continue to ignore the topic of slavery, largely due to their denial that racial prejudice exists in Morocco. El Hamel accuses them of presenting a false vision of North Africa free from the social problems and racism despite North Africa's involvement in the trans-Saharan slave trade (2013, 2). In a 2016 article from *Jeune Afrique*, the Algerian writer Kamel Daoud writes about a disingenuous duplicity that exists in the Maghreb where people see racism and the history of slavery as a Western problem. He recounts that "arguments worthy of the Ku Klux Klan on the threat posed by Blacks" are readily heard in the Maghreb, a region where slavery remains a taboo topic despite the fact that some descendants of the enslaved have lived in servitude for generations.

Donald Carter, in his book *Navigating the African Diaspora* (2010), provides useful insights into the discursive silence that exists in the Maghreb. Building upon the work of Ralph Ellison and Franz Fanon, Carter posits that invisibility—the politics of who gets to be seen—qualifies as the central aspect of the diasporic experience. Carter asserts that state power erases diasporic communities from national discourse in order to manage and marginalize them. At the same time that he critiques the state of the field, Chouki El Hamel also recognizes how little is known about when Gnawa emerged as a collective identity. He describes Gnawa as a designation "generally referring to blacks from West Africa transplanted by forced migration into Morocco, lumped together in one category, a fictional 'ethnic black' group that had no differentiated ethnic or linguistic reality" (El Hamel 2013, 276).

This current book builds on El Hamel's assertion that "Gnawa" is a constructed collective identity that gradually emerged in Morocco. It asserts that another factor behind the absence of "the Gnawa" from historical archives is due to the fact that the codification of "Gnawa" as a recognizable identity coincided with the decline of slavery, a topic discussed in more detail in chapter 1. While spirit possession and its related music certainly existed in Morocco prior to this point, "Gnawa" as a homogenized cultural identity complete with a specific spirit pantheon and a systematic possession ritual came together gradually, and as we will see in this book, the spirit pantheon continues to evolve and change.

In recognizing the constructed nature of the category of "Gnawa," this book interrogates the popular assumption that "Gnawa" refers to a biologically determined ethnic identity. My practice throughout this book of using the term "Gnawa" without the definite article speaks to the constructed nature of identity. Using the term "the Gnawa" suggests they are a distinct people or ethnic group and is a remnant of colonial-era writings, where ethnicity was viewed "as a primordial form of identity by colonial administrators. Ethnic boundaries which had once been fuzzy and mutable became rigid and bounded" (Tilley 2006, 12). As noted by John and Jean Comaroff, an addition of a "the" in front of a group name reinforces the homogenizing process of ethnic incorporation, ignoring internal divisions and withdrawing a group from time or history (2009, 12). Their research on the "identity industry" in the book *Ethnicity, Inc.* (2009) proved useful to this study, as it analyzes why and how people chose to market and brand their otherness in order to profit from what makes them different.

Further complicating this study is the fact that in the last several decades, the marketing of "Gnawa" as an identity label resulted in the change of "Gnawa" from a term linked to Blackness and spirit possession into a label tapped by everyone from unemployed youth to descendants of enslavers without any genetic linkage to sub-Saharan Africa. "Gnawa" has developed into a subculture associated with social protest and rebellion against conservative social norms and, as such, has permeated the international art scene. Some visual artists have begun to address Gnawa-centric topics in order to emphasize Morocco's historical and cultural connection to the African continent, emphasizing the nation's multicultural heritage and rejecting claims that Morocco is essentially a Middle Eastern or Arab nation. Others view Gnawa spirit-possession practices as offering an alternative form of religiosity to people, acting as a counterweight to a growing Islamist movement (Aidi 2014, 152). For example, in the exhibition catalog for her series *couleurs primaries*, artist Lamia Naji described her spirit-possession photographs:

> This work represents the loneliness of an individual in search of an answer that would justify one's existence, a belief that would grant one a place in society, the right to express one's joys, one's pains or even to deliver one's body in complete freedom to a spiritual entity. (2005, 22)

Naji understands Gnawa possession as a poetic, universalist expression of spirituality and yet realizes that the trance state is experienced differently by each individual. For many, Gnawa spirit possession represents liberation from conservative values and allows people to express their frustration with perceived gender and social inequalities.

The elusiveness of "Gnawa" as a category opens it up to being used in multiple ways. Gnawa spirit possession can evoke a connection to sub-Saharan Africa and/or the wider African diaspora. As an identity connected to marginality, to the history of enslavement, and, ultimately, to Blackness, "Gnawa" in contemporary Morocco serves as a foil against those who wish to suppress the nation's historical connection to the larger African continent.

BLACKNESS AND DIASPORA

The history of enslavement and the construction of race is typically the purview of African diaspora studies in the Americas. Very few scholarly writings in this field consider North African Muslim nations, such as Morocco, or even diaspora communities within the continent more broadly.[5] Numerous discussions centering on race and representation in diaspora and performance studies have proven useful to this book's inquiry, both conceptually and methodologically. At the same time, this study adheres to the caution suggested by Moroccan historian Fatima Harrak, who asserts that characteristics of slavery elsewhere should not be imposed blindly onto Morocco (2018, 280).

Extremely useful to this study are those that consider the slave trade and its racial legacy on the African continent, especially those that look at Muslim Africa. Edward Alpers, for example, recognized that the experiences of enslaved Africans in the Indian Ocean world have largely been silenced and suggested that scholars could learn a great deal from studies of spirit possession and healing on the Swahili coast (2000, 85). Of particular relevance to this study are spirit-possession practices on the Swahili coast of Kenya where socially marginalized groups appropriate Islam and Arabic as a source of mystical potency (McIntosh 2009). In her book *The Edge of Islam*, author Janet McIntosh uses spirit possession to discuss the power dynamics between two groups, one underclass and marginalized and the other dominant politically and socially. She discusses how social and economic disparities shape religious practice and attitudes toward spirit possession and its compatibility with Islam. *Blackness in Morocco* demonstrates how the study of Islam and Muslim societies is central to understanding the global diaspora experience.

Furthermore, a comparison between the Swahili coast and Morocco reveals that Blackness cannot be understood without examining the process of colonization and how it impacted local categories of belonging. This study begins with the late nineteenth century in Morocco, a period that coincides with increased European incursions.

Europeans had difficulty grasping the nuanced categories of race in both East and North Africa where they did not understand how intermarriage between elite men and enslaved women resulted in a dark-skinned elite that was "socially Arab." For most Europeans, dark skin was a racial marker associated with inferiority and low social status, and such attitudes impacted local self-conceptions. The result was that subaltern groups in Africa often came to understand themselves in relation to global forms of historical and racial consciousness, which influenced local notions of Blackness and racialization.

While the relationship of enslaved communities to hegemonic systems of power varies throughout different periods of history, what remains consistent is the association of Blackness with marginality and otherness. This was the case across the Maghreb where the enslaved and their descendants formed unique communities that engaged in spirit possession and healing in Tunisia, Libya, and Algeria. In his recent study of music performed at Tunisian spirit-possession ceremonies known as *stambeli*, Richard Jankowsky recounted that the history of sub-Saharans north of the Sahara has been largely obscured. He writes that the narrative of *stambeli* "is a history *of* others and about healing *by* others, both visible and invisible" (2010, 5–6). While Jankowsky recognizes that dark-skinned people in Tunisian society often experience racism, he states that Black people are believed to have a particularly powerful efficacy in manipulating the world of spirits and healing spirit-induced illnesses, which makes their rituals appealing to the larger Tunisian society (2010, 18). Therefore, he describes a somewhat paradoxical situation where one's agency is linked to the history of oppression. In a Moroccan context, Blackness is also a source of agency and self-respect due to its connection to healing. At the same time, Blackness is associated with marginality and otherness, and it is this very association with alterity that makes the appropriation of Gnawa identity attractive to someone without dark skin and without enslaved ancestors. In the last several decades, the act of appropriating a Gnawa identity is less about harnessing spiritual power and more about using Blackness as means of social protest.

In his book *Appropriating Blackness*, E. Patrick Johnson makes the compelling argument that Blackness is not based solely on phenotype but is dependent on the performance of certain racialized signifiers. He explains, "individuals or groups *appropriate* this complex and nuanced racial signifier in order to circumscribe its boundaries or to exclude other individuals or groups" (2003, 2). Johnson argues that when Blackness is appropriated, it becomes political. People construct notions of Blackness and perform it for the purposes of cultural capital, allowing marginalized people to counter oppressive circumstances and put forth a particular political or cultural worldview (2003, 3–4). While Johnson's definition of Black culture is essentially performative, Hortense J. Spillers, in her essay "The Idea of Black Culture," defines Black culture as one of emancipation and struggle due to its linkage to slavery and colonization that struggled to "unmake the conditions of alienation" (2006, 25). As a culture that arose due to violence, coercive labor, and the struggle to survive, Black culture can serve as

a source of inspiration for those seeking liberation. Both scholars share the idea that Blackness is not based on phenotype but can be appropriated as a culture of resistance.

The appropriation of Gnawa identity will be discussed throughout this book, and as we will see, Blackness and its connection to alterity represent protest and an expression of freedom and resistance. As a form of music and culture associated with Blackness, "Gnawa" has taken on many of the attributes of Black Atlantic aesthetics, such as hip-hop and rap, indicating the impact of global marketing and its hypercommodification of Blackness as an "emotive force that resonates with others in the diaspora" (Perry 2008, 639). Visual symbols associated with Gnawa have been adopted by Moroccan artists and photographers, such as Lamia Naji, who display their work in both local and international galleries and museums. "Gnawa" has become an icon that appeals to many due to its association with the African continent, rather than the Middle East and the Arab world. Therefore, this book concludes that the increased visibility of Gnawa performances has contributed to a desire to connect Morocco to the larger African continent. But within this expanded popularity of Gnawa music exists a desire by some to return to the Black origins of the tradition, a desire that is often expressed during the occasion of spirit-possession ceremonies.

MARGINALITY, BLACKNESS, AND SPIRIT POSSESSION

Blackness and its link to marginalization is embodied during Gnawa spirit-possession ceremonies, referred to as *lila*, meaning "night" in Arabic, which is the topic of two chapters in this book. It is important to recognize that "spirit possession" is a very broad term that has been subject to a great deal of scholarly interest and critique. Among anthropologists and historians of religion, there is little consensus as to what the term "spirit possession" means, when to use it, and how. Some prefer to use the terms "trance," "shamanism," "dissociation," or "ecstatic religious practice," and a great deal has been written about the pros and cons of each.[6] Deborah Kapchan reminds us that "analytical categories tend to tell us more about the historical moment of their enunciation and its preoccupations than about the 'truth' or 'meaning' of the enactments themselves" (2009, 104).

Moroccans themselves use the dialectical Arabic word *jadba* to describe trance, which derives from the classical Arabic word *ja-dha-ba*, meaning "to attract," which is realized through communication with spirits who enter the body, inducing an altered state of being that satisfies the spirits and results in healing (Kapchan 2007, 33–34). In Sufi lexicon, the term *jadba* refers to a divinely inspired attraction to higher states of consciousness and a feeling of ecstasy that results in the desire to achieve a oneness with God, which is the general goal of Sufism (Fuson 2009, 24; Kapchan 2007, 42).[7] Gnawa spirits, however, do not evoke a spiritual connection with God but permanently inhabit

a person. A person possessed by a Gnawa spirit is referred to as *meskoun*, meaning "inhabited" in Arabic. People also refer to the possessed state as a *hal*, meaning a heightened state of emotion and transcendence (Chlyeh 1998; Kapchan 2007, 42).

Recognizing the constructed nature of knowledge and how it impacts systems of categorization, this study uses the terms "spirit possession" and "possession trance" to describe an embodied phenomenon where an individual's body and actions can be influenced and controlled by supernatural entities, following the lead of other scholars who have discussed similar practices in the Maghreb (Hell 2002; Jankowsky 2010; Kapchan 2007). As noted by Paul Stoller (1995), anthropological scholarship on spirit possession is probably among the most theoretically sophisticated in the field, and this inherently interdisciplinary study does not seek to grapple with the multiple theatrical, functionalist, psychoanalytical, and biological approaches that attempt to explain it. Rather, it takes what Victor Igreja refers to as a holistic approach, focusing on the cultural logic of spirit possession and the links between possession and religion, healing, gender relations, and politics. A holistic approach, Igreja writes, "considers spirits and spirit possession as complex symbolic platforms which provide ways of understanding, trying out, coming to terms with, and contesting modernity, colonialism, capitalism, and religious and other hegemonies" (2018, 2). This study places local acts of possession in a wider cultural and historical context, looking at how people's personal experiences of possession allow them to act upon the world, articulate their everyday life experiences, and engage with larger issues of identity and memory, including historical constructions of race in Morocco that are based on unequal hierarchies of power.

During a Gnawa spirit-possession ceremony, human mediums are possessed by spirits with different personalities and names with the goal of healing spirit-inflicted illnesses. Spirits are divided into distinct groups organized by colors and personality and are evoked into possession with particular musical rhythms, songs, incense, and animal sacrifice (see Appendix). A variety of spirit families exists, including blue spirits who are associated with the water or the sky, red who are linked to the slaughterhouse, and white spirits who are given Muslim identities. Black spirits are said to originate in West Africa and are the most ferocious and efficacious; their qualities and personalities are thoroughly discussed in chapter 4.

Rather than replicate the work of previous scholars, this study's discussion of Gnawa spirit possession does not address the phenomenology of trance as an altered state of consciousness or consider physical or psychological healing (Benachir 2001; Kapchan 2007). It does not address each aspect of a Gnawa *lila* and does not outline how a ceremony unfolds from beginning to end. It does not include detailed descriptions of the attributes associated with each spirit (Chlyeh 1998; Claisse 2003; Diouri 1994; Lapassade 1990; Majdouli 2007). Nor does it look for West African retentions (Bravmann 1995; Pâques 1964) or use music to understand the meaning of Gnawa practices (Fuson

2009; Goodman-Singh 2002; Witulski 2018). It is not a study of the most famous Gnawa musicians and the entire Gnawa music scene in Morocco. It is very much focused on the city of Essaouira. Bertrand Hell's book *Le tourbillon des génies* (2002) offers a valuable approach and inspired this study. He takes a case-study approach that relies on his personal involvement in ceremonies and close engagement with the participants in them. Hell conveys his personal reactions to experiencing "the atmosphere saturated with rhythms and dances, laughter and tears, smells and colors that makes the world of Gnawa unique" (2002, 14). In other words, many aspects of Gnawa spirit possession do not have a visual aspect, and, as this study asserts, it is the manner in which Blackness is seen, heard, and experienced through the senses that can tell us about the relationship of race to power.

Paul Stoller's book *Sensuous Scholarship* (1997) provides another theoretical touchstone for this book. Stoller asserts that Songhai spirit possession in Niger can be interpreted as embodying memories of dispossession—a collective and personal "deep" history that is rarely recorded by scholars or written in books. He defines embodiment as a human body "consumed by a world filled with smells, textures, sights, sounds, and tastes, all of which spark cultural memories" (1997, 85). Spirit possession tells alternative histories, engaging all of the bodily senses to recount the pain, abuse, and struggle experienced by the marginalized. According to Stoller, the sensual experiences that occur during spirit possession guard cultural memory in societies where textual history is limited or nonexistent and can serve as expressions of subversive discourse and political struggle (1997, 47, 56).

Blackness in Morocco considers what the embodiment of Blackness during a Gnawa *lila* reveals about political and social resistance. It looks specifically at the manifestation of black spirits believed to originate in West Africa, relating them to the larger Gnawa spirit pantheon. It presents spirit possession as a dynamic subaltern performance that responds to current hegemonic power structures. As we will see, black spirits exist within larger networks of power relations, and they address Morocco's historical and contemporary relationship to Africa south of the Sahara. Furthermore, when black spirits appear, the possessed may hold flames over their bodies, beat their chests, and even eat raw meat, activating all of the senses. The manifestation of black spirits also functions as a signifier of spiritual potency and authenticity within a practice that has become increasingly porous in recent years; Gnawa ceremonies have come to include many without a historical connection to enslavement.

This book recognizes and analyzes the simultaneous expressions of belonging that occur during Gnawa ceremonial occasions, especially where it concerns the relationship of spirit possession to Islam. Some in Morocco devalue Gnawa spirit possession as anti-Islamic and a remnant of sub-Saharan animism. Gnawa practitioners, on the other hand, do not see a conflict with Islam, and many take breaks during a *lila* to perform their daily prayers, revealing a great deal about the historical relationship between

northern and western Africa. During the period of the trans-Saharan slave trade, sub-Saharan Africans were perceived to be non-Muslims. Since Islamic law did not allow for the enslavement of fellow Muslims, classifying Black West Africans as nonbelievers allowed for their enslavement (Lydon 2015). However, it is this very connection to Africa south of the Sahara and a pre-Islamic identity that gives Gnawa spirit possession its potency. Possession by spirits is understood as a practice carried by the enslaved from West Africa to the north, an animistic practice with the extraordinary ability to heal unexplainable and incurable illnesses. While the association of Blackness with pre-Islamic and so-called pagan practices may be viewed negatively, it is this very connection to Blackness that gives a Gnawa *lila* its special healing power and attracts practitioners.

BLACKNESS IN A TRANS-SAHARAN CONTEXT

During Gnawa ceremonial songs, performers typically refer to their origin as "the Sudan," a term used in North Africa to refer to the people from West Africa (Sudani). The word "Sudan" is linked to the history of trans-Saharan trade, as it draws from a term popularized by medieval Muslim writers who imagined the area south of the Sahara as the "land of the Blacks" (*bilad al-Sudan*).[8] Arabo-centric medieval writers from the Maghreb classified Black people as non-Muslim and unbelievers, conflating the color line with a religious one, so that the "land of the Blacks" was conceived of as lying outside the *umma* (worldwide community of Muslims) (Lydon 2015, 6). According to a mythology long shared by Judaism, Islam, and Christianity, Black Africans were descendants of Ham, the son of Noah who, as punishment for having seen his father naked, was cursed with dark skin and whose descendants were condemned to enslavement. This mythology undergirded racist attitudes based on skin color that in turn served to justify racially demarcated hierarchical power relations (El Hamel 2013, 62–71).

Enslaved people in Morocco were referred to by a variety of terms depending on the circumstances of enslavement: `abid (literally meaning "slaves" in Arabic, `abd, singular) or khadim(a), meaning "worker" in Arabic, or in rural Amazigh areas, Ismkhan/Ismgan ("slaves" in the Tamazight language, Ismkh or Ismg: singular). The Arabic word for slave, `abd, can both refer to an enslaved person and be used in reference to one of God's worshippers or servants—that is, those who obey God rather than a human master. Many Moroccans claim that this religious meaning proves the term "slave" is not derogatory since every Muslim is, in a sense, "a slave" to God. At the same time, there is no denying that the word `abd was commonly used to refer to an enslaved person from Sahelian Africa and that the term was racialized.

In Morocco, there are many local words that denote slight variations in phenotype and physical appearance that carry racialized meanings.[9] At the beginning of my field research, a group of young girls from a family of hereditary Gnawa musicians and diviners informed me of the local discourse and revealed themselves as hyperaware of these

distinctions because of their own dark skin. In an effort to help me with my research, they contributed these terms to my Moroccan Arabic vocabulary for skin tones: z`ar for very fair skin with blond hair, *beid* for "white" skin, *soumar* to refer to tan or light-brown tones, *hamrani* for brown/reddish skin, *kabdi*, meaning "the color of liver," for dark brown, and `*azzi* meaning "very dark black."[10] Moroccan racial hierarchies associate the first three categories with beauty and desirability while the terms *hamrani*, *kabdi*, and `*azzi* are interpreted locally as insults and racial slurs.

In Morocco, the process of racialization that went hand in hand with trans-Saharan slavery resulted in the association of dark skin with subservience; hence the words used to distinguish nuances in dark skin tone reflect this historical stigma. Since the names given to dark-skinned people in Morocco carry pejorative connotations, throughout this book I made the decision to use "Black" and "Blackness" as umbrella terms to describe people who share an identity and a sense of community. The act of capitalizing the letter B is meant to signal that racialized identities are historically constructed social categories and are often claimed for political or cultural reasons.[11]

Black people who are born in Morocco or move there from elsewhere are often racialized as "others," and such divisions are often attributed to colonial-era conceptions of the African continent. Western historiography constructed the Sahara as a buffer zone that separated two racially distinct Africas; French colonialists who occupied Algeria in 1830 categorized North African Berbers and Tuareg as part of "white Africa" (*Afrique blanche*), which lent currency to the notion that North Africa was an extension of Europe and Imazighen (whom they called Berbers) descendants of the Romans. Arabs were seen as an "other" distinct from so-called Berbers, but relative to those from south of the Sahara, they were still classified as racially "white." The politics of race and religion, both European and North African, during the colonial period conspired to cement the notion of a Saharan divide between "white" and "black Africa" (*Afrique noire*) (Lydon 2015, 8–9).

Despite this apparently rigid color consciousness that presumably divided the African continent, racial categories are not always linked to phenotypic differences, and some people with dark skin would not consider themselves Black or Gnawa, since class and patrilineal descent can trump race. Bruce Hall's *A History of Race in Muslim West Africa, 1600–1960* explains the complexity of racial identities and argues that racial classifications were not simply the result of colonialism but were closely intertwined with local notions of lineage and descent rather than with observable differences of skin color. Categories such as "Arab," "Imazighen/Berber," and "Muslim" are historical and racialized constructions that have taken on different meanings over time. People may define themselves as Arabs based on Arab Muslim genealogies that connect them to religious figures, particularly Muslim Sufi saints (Hall 2011, 30, 61). But such genealogical ties tend to be more mythical than genetic, and people commonly used Islam to bolster a claim to being "Arab."

Despite the constructed nature of such labels as "Black" and "Gnawa," it is clear that many aspects of Gnawa material culture are a product of the trans-Saharan slave trade. At the same time, as noted by historian Allan Meyers, the precise origins of Gnawa practices are impossible to reconstruct:

> We will probably never know when specific Sudanese [Sahelian African] traits were introduced into Morocco, who introduced them, or whence they came. Furthermore, our lack of knowledge is not especially important; the origin of traits and the dates of their introduction are less significant than the fact that they exist at all. The more noteworthy problem is sociological rather than historical; black people in Morocco have been sufficiently distinct from the population at large to have maintained a characteristic music, dance style, and religious idiom, all of a Sudanese character, even though they have had little direct contact with the Sudan. (1977, 438)

While it is not the goal of this study to identify West African retentions, it is worth stating that the act of luring spirits into possession through rhythmic music, sacrificial blood, and incense exists in many areas of Sahelian Africa, the region from where many people were enslaved. Similar possession-trance phenomena occur during the *holey-hoore* of the Songhai in northeastern Mali, the *tumbura* in the Nile Valley, the *zar* of the Sudan, Hausa *bori* in Nigeria and Niger, and Bamana practices in central Mali including hunters' dances, ceremonies, and Komo rituals.[12] As asserted by scholar Bertrand Hell, Gnawa practices are clearly a mix of diverse cultural and religious influences that arose from the most disadvantaged in the society (2002, 83).

Throughout Sahelian Africa, people hold possession-trance ceremonies similar to those of Gnawa to heal illnesses caused by spirits, and the relationship between Gnawa ceremonies and those held in the Sahel became evident to me when I attended spirit-possession rituals in Niger.[13] During both Gnawa *lila* and Hausa *bori* ceremonies in Niger, for example, musicians combine the performance of a stringed instrument with repetitive percussive rhythms, spirit praise-poetry, the blood of animal sacrifices, and perfumes and incense intended to lure supernatural spirits to inhabit and take over the bodies of their mediums. A Gnawa musician plays the *guinbri* (a plucked lute), and a Hausa musician plays the *goge* (a single-string fiddle).[14] Other musicians accompany these stringed instruments with repeating rhythmic accompaniments in order to induce trance. An ensemble of typically five or more Gnawa men play metal cymbals (called *qraqsh* or *qraqeb*), while one to three Hausa men play large calabash gourds turned upside down (*kwarya*). In Niger, people wear clothing and embody behaviors that give visual form to the personality of their possessing spirit. During Gnawa ceremonies, people do not dress in such elaborate costumes as in Niger, but they wear tunics or drape cloths that indicate the spirit's personality, with red cloth for fiery spirits and blue for cool and calm ones.

Many scholars have drawn connections between Gnawa practices and sub-Saharan spirit possession, especially the French scholar Viviana Pâques. She traced Gnawa ceremonial practices to West African beliefs in her book *La Religion des esclaves* (1991). Trained by the renowned ethnologist Marcel Griaule, she began her career by identifying the pre-Islamic "African essence" of the entire region of northwestern Africa in her book *L'arbre cosmique* (1964). While various scholars have discredited her evidence as contrived and implausible, Pâques provided readers with rigorous and valuable descriptions in her later book focusing on Gnawa.[15] In *La Religion des esclaves*, she carefully analyzed each element of Gnawa ceremonial practices, finding evidence of a highly complex and unified cosmological system in each gesture, movement, and action seen at a Gnawa *lila*.

This study asserts that Gnawa ceremonial practices are not part of a unified religious system but, like the process of identity construction, are constantly evolving to adapt to changing environments. A clear example of this is the incorporation of elements perceived as prestigious from the dominant Arab-Muslim culture of Morocco. For example, those who self-identify as Gnawa claim to be descendants of Bilal, an enslaved Abyssinian man (i.e., Black) who became one of the first followers and a close companion of the Prophet Muhammed. Establishing an ancestral link to Bilal, a relationship not historically feasible, constitutes a piece of the patchwork of their identity and demonstrates how people understand a Gnawa identity as coexisting with Islam, using symbols derived from Islamic history. The performance of music also figures into Gnawa origin stories, as Bilal danced and sang to cheer the sorrowful Fatima, favorite daughter of the Prophet Muhammed. In different versions told to me, Bilal made a drum or a lute from a palm tree and a hat with tassels that he swung around in jest—details that connect Bilal's performance with that of contemporary Gnawa musicians. As a reward, Muhammed offered Fatima in marriage to Bilal who declined on the grounds that he did not deserve to marry the Prophet's daughter. This story reinforces a claim that Gnawa healers and musicians have *baraka* ("divine blessing") and to a special status within Islam, even as it reinforces a connection to enslavement and Blackness.[16] However, it is important to remember that Islam is not a monolithic religion with clearly defined boundaries and rigidly codified practices. As Janet McIntosh reminds us in her book *The Edge of Islam* (2009), like race, Islam is subject to local imaginaries and, despite its conception of itself as a universal religion, is appropriated in a multitude of ways to express belonging and difference.

The relationship of Gnawa practices to Islam has been historically contentious. In the early twentieth century, the Moroccan elite reinforced a dichotomy between Islam and animism as they sought to connect elite religious practices in Morocco to the larger Muslim and Arab world. They characterized Gnawa spirit possession as based on sub-Saharan animism under a superficial Muslim facade and considered it in relation to

Sufism, a form of Islamic mysticism. Over time, gradations of acceptability had developed between Sufi groups in Morocco where some carried elite status and were tolerated as religiously acceptable by the ruling elite. Others, notably the Hamadsha, `Aissawa, and Heddawa, were considered low-status forms of "popular" Sufism due to the fact that they attracted and accepted impoverished people; they also engaged in behaviors seen as marginal to Islam, such as ecstatic dancing to music and self-mutilation. Gnawa lay at the very bottom of this hierarchy, positioned in an ambiguous relation to both Islam and Sufism—sometimes granted a quasi-Muslim status as a distinctly marginal Sufi sect, while other times regarded as lying outside of Sufism altogether (Spadola 2014). During the first half of the twentieth century, the Moroccan ruling elite sought to cleanse the nation of the superstitious heterodoxy found in Gnawa spirit possession and other "low-status" Sufi orders. Their aspiration was to affiliate Morocco with the larger Arab world and the global community of Muslims (*umma*), promoting an ideal of Arab modernity and progress (Ait Mous 2013, 738, 749).

Most scholarship on Gnawa practices concurs with the classification of them as existing on the margins of Sufism. Deborah Kapchan, for example, states that Gnawa "do not consider themselves Sufis, nor are they considered Sufis by others" (2007, 26). The historian Chouki El Hamel writes that among Muslim intellectuals, Gnawa practices "are considered an inferior form of Sufism—a cult influenced by pagan black traditions and embraced mostly by lower-class people with little or no literacy and learning" (2013, 282). While Kapchan and El Hamel are simply reporting how people understand Gnawa practices, I contend that local perceptions of them as existing on the margins of Sufism and Islam are historically rooted in conceptions concerning the inferiority of Black religious practices.

As previously discussed, Janet McIntosh's work on Giriama spirit possession in Kenya serves as a useful model for understanding the relationship of Gnawa practitioners to Islam. Giriama are viewed as economically, socially, and religiously inferior by their wealthier Swahili and Arab neighbors. Giriama spirit-possession practices, McIntosh explains, simultaneously seek to tap into Islam's perceived power as a prestigious religious system and to repudiate that system through an attitude of resentment and resistance (2009, 15). For instance, during possession, many Giriama respond negatively when Muslim spirits possess them; they vomit and show evidence of suffering from other illnesses, which McIntosh interprets as a form of rebellion against Muslim power and resentment about Giriama marginalization (2009, 160–69).

The fact that Muslim law allowed those deemed non-Muslim to be enslaved (Hall 2011) gives rise to the ambivalent and sometimes tenuous historical relationship between enslaved West Africans and their Muslim enslavers that plays out in Gnawa spirit-possession ceremonies. As this book will demonstrate, Gnawa ceremonial practices give primacy to Islam and conform to the status quo in hegemonic terms, but as noted by

James C. Scott in his book *Domination and the Arts of Resistance*, subordinate groups do
not engage in complete hegemonic compliance. Nor do they overtly defy powerhold-
ers. Rather their performative expressions occupy "the vast territory between these two
polar opposites" (Scott 1990, 136), simultaneously conforming to and reacting against
dominant forms of hegemony. As previously mentioned, this book interrogates how
conceptions of Blackness engage with dominant religious, political, and social para-
digms, while always being mindful that Gnawa practitioners themselves do not see their
spirit-possession practices as in conflict with Islam.

BECOMING GNAWA IN POSTSLAVERY MOROCCO

In contemporary Morocco, Gnawa music is associated with the tourist industry and
world music scene, with musicians performing in public squares or onstage at the Gnawa
and World Music Festival in Essaouira. This study asserts that the self-marketing of a
Gnawa identity began in the late nineteenth century with dark-skinned male musicians
drawing the attention of a foreign audience. It argues that "Gnawa" as an identity uni-
fied a disparate group of dark-skinned people during a period of intense global contact
(1870s to 1910s), when the Moroccan economy began to collapse and its social structure
transformed. This period coincided with increased European imperialism and incur-
sions into Morocco, and the elite experienced great financial hardships. Expensive repa-
rations and disadvantageous trade agreements resulting from conflicts with European
powers dramatically drained the kingdom's financial resources, which contributed to the
depreciation of Moroccan currency, a sharp rise in domestic prices, and general eco-
nomic instability (Burke 1976, 20–22). It was also during this period that the Moroccan
monarchical state (the *makhzen*) suffered severe economic hardship and lost several key
military battles with Spain and France. By the time the Kingdom of Morocco became
a French Protectorate in 1912, slave markets had been closed and many of the enslaved
manumitted, but the institution of slavery endured. The protectorate government was
afraid that an abrupt end to slavery would be massively unpopular and result in a revolt
against French occupation. The pervasive colonial attitude was that economic and social
changes would eventually lead to the total demise of slavery.

Indeed this was the case, and the practice of enslavement continued to decline.
Manumitted slaves faced the immediate problem of how to survive economically; they
typically had no money, no education, no land, and no network of family support. The
historian Madia Thomson (2011) specifically noted the migration of those manumitted
from rural southwestern Morocco into the northern cities, such as Tangier, where they
naturally affiliated with those of similar cultural backgrounds. One of the avenues of
economic survival available for former slaves was the performance of music on the
streets in exchange for money, wherein lies the inception of the self-definition and self-
commodification of "Gnawa" as an identity. Members of the underclass who were set

adrift in an environment of economic decline turned this identity into a marketable commodity.

The visibility of Gnawa performers on the streets of Morocco did not go hand in hand with increased attention to the history of trans-Saharan slavery, as previously discussed. North African scholars and the larger public have avoided confronting the legacies of the slave trade, accounting for the conspicuous absence of historical research on trans-Saharan connectivities (Hunwick 2002, ix; Lydon 2015, 13). In discussing how Blackness is portrayed in contemporary Moroccan rap music, for example, Christina Almeida writes that "issues of race, racism, or slavery have been absent from the public sphere. The official discourse is denial and silence on racial attitudes and racism on the basis of skin color" (2016, 85). She draws upon historian Chouki El Hamel's observation, in his groundbreaking book *Black Morocco*, that Morocco has traditionally been described as "a racially and ethnically homogenous nation, defined religiously by Islamic doctrine and linguistically and politically by Arabic nationalism" (2013, 2). Furthermore, he argues that most scholars from the Maghreb refuse either to admit the injustices of slavery or to recognize the process of racialization that has led to the association of Blackness with enslavement.

Since the publication of El Hamel's book, popular magazines in Morocco began to pay attention to racial issues, including *Jeune Afrique* and *Zamane*, which address the history of the slave trade, the prevalence of racism, and the problems experienced by recent sub-Saharan migrants into Morocco. The widely available journal *Zamane*, in particular, contemplated whether Morocco's history of trans-Saharan slavery has contributed to racism against Black Moroccans as well as West African migrants (Chmirou 2013). Its cover featured a fictionalized Orientalist-style sketch of two "Arab" men with turbans and beards, contemplating the purchase of two frightened-looking dark-skinned women. In bold letters, the cover carried the title "WHY ARE WE RACISTS?," directing this question to the Moroccan public. Most important, this Moroccan magazine took the complex and uncomfortable topic of trans-Saharan slavery into the public realm in an eye-catching fashion with the intention of making a massive public impact. It suggested that racism was deeply embedded in Moroccan society and reinforced the idea that Blackness was intimately associated with enslavement.

MODES OF ENCOUNTERING GNAWA
VISUAL AND PERFORMING ARTS

Years of research and travel on both sides of the Sahara and the African diaspora form the foundation of the present book.[17] I traveled to Mali to interview Bamana hunters, attended Songhai and Hausa spirit-possession ceremonies in Niger, interviewed Santería practitioners in Santiago de Cuba, and marched with Black Indians during carnival in my hometown of New Orleans. Each of these experiences features in my book. But the

vital core of my research was my attendance at, and, at times, participation in, more than fifty Gnawa spirit-possession ceremonies in Essaouira over the course of eight years. These ceremonies (*lila*) form a central unit of my analysis. The prominence of Gnawa musicians in the city and its relatively small size enabled me to establish friendships with people quickly.

I stood out as a foreigner who spoke Moroccan Arabic and explained that I was in Essaouira to do research and write a book about Gnawa practices. The fact that I visited Essaouira repeatedly and for extended periods of time was rewarded with numerous invitations to Gnawa *lilas* in private homes, a rarity for many researchers. Recognizing the troubled and complex history photography has played as an ethnographic tool, any photographs that I took during a ceremonial context were taken with consent. Some musicians, such as M'allem Abdeslam Alikane, generously introduced me to female diviners with whom they worked. While attending an all-night Gnawa spirit-possession ceremony, I offered some dates and nuts to a local woman, and this was the beginning of my friendship with Hajja Naima, who took me and my project very seriously, introducing me to many Gnawa musicians, practitioners, and diviners. When I met with people only once or twice, I typically conducted more formal interviews, which I note in the book's footnotes. However, much of my knowledge came from informal conversations with people who became my friends. I casually stopped in their homes to drink afternoon tea and sometimes eat meals with their families. When speaking with them, I relied on what anthropologists Henk Driessen and Willy Jansen refer to as "small talk" (2013). They write that as long as potential interlocutors are informed of a fieldworker's goals, it is not necessary from an ethical point of view to constantly repeat one's research intentions during daily communications, and this is the approach that I took. Driessen and Jansen (2013) recognize that not having to use an interpreter to engage in small talk means that researchers have the cultural context necessary to unravel social complexities and interpret local intrigues. "Small talk" was a big part of my approach and allowed me to develop the friendships that were not only necessary to my project but also very gratifying and rewarding in their own right.

This interdisciplinary project relies on anthropological methods, but it also aims to contribute to scholarship in my own discipline of African art history. In particular, the question of whether North Africa is part of the Middle East where it has been traditionally placed by scholars. This was the topic of the 2009 edition of the journal *Critical Interventions: Journal of African Art History and Visual Culture*, entitled "Africanity and North African Visual Culture."[18] More scholars in my field are including North Africa into the African art canon, breaking down traditional disciplinary boundaries that divided Africa at the Sahara (see, for example, Berzock 2019; Clarke 2017). While the articles in these books and journals, mine among them, consider transnational artistic and cultural connections across the Saharan divide, Jessica Winegar and Katarzyna

Pieprzak noted that scholarship had yet "to pay special attention to the thorny, but important, issues of racism and stereotyping in the construction of Africa in visual culture, especially that emerging from North Africa" (2009, 11). Studies on racial constructions north of the Sahara remain sparse.

While some publications are beginning to address the trans-Saharan slave trade, as previously discussed, constructions of Blackness and its relationship to racism are rarely discussed either inside or outside of Morocco. Forced migration and mobility across the Sahara by enslaved people resulted in lives relegated to servitude on the margins of power. This book aims to redress that omission by considering how Blackness as an identity category impacted cultural production and how racialized constructions have influenced Morocco's relationship with the rest of the African continent.

The modes of material culture that are the focus of this book—items such as musical instruments, cowrie-adorned hats, and gowns—are linked to alterity. While some museums inside and outside of Morocco collected North African material, such as Amazigh silver jewelry and textiles, those objects associated with enslaved people were not typically included. One exception is the Musée du quai Branly-Jacques Chirac in Paris, which, by virtue of France's colonial history in North Africa, houses a large collection of Moroccan material culture, including hats, musical instruments, and amulets that they identify as "Gnawa." Therefore, this history involves material objects typically left out of the art historical canon, as they involve the largely suppressed and invisible history of trans-Saharan movements.

Chapters 1 and 2 concentrate on the representation of Blackness in popular media, including postcards. These chapters draw heavily on analyses of early twentieth-century postcards that were largely responsible for disseminating information about Africa to the Western public around the turn of the twentieth century (see, for example, Edwards 2001, 2013; Geary 1998, 2002, 2008; Geary and Webb 1998; Vokes 2012). In the 1980s, postcards emerged as a subject of academic inquiry, and now many scholars consider them as objects of encounter (Geary 2018, 9). As these studies demonstrate, photographs taken in Africa by non-Africans are open to multiple interpretations. First, they can be seen as representative of "the gaze," that is, both an act of looking and an ideological discursive position that is often linked with the representation of African people as "objects of control, desire, and appropriation" (Edwards 2013, 48). Such an analysis is particularly pertinent to our reading of colonial-era images, which are indisputably visual evidence of unequal power relations between Europe and Africa, as reflected in the many studies on photography in North Africa that interpret photographs of "the other" as a reflection of European imperial ideology (see, for example, Alloula 1986). Postcards played a peculiarly influential role in shaping Western visions of "the other" as they circulated prolifically across geographic boundaries, simultaneously determining and revealing how "the West" imagined an Orientalized North Africa.

Accordingly, in chapters 1 and 2, this book shifts the analytical focus from what colonial-era imagery reveals about the Western gaze to a consideration of how this imagery impacted local self-representations. This reorientation means listening to the voices of those whose expressive culture has been omitted from official histories, as enslaved and other marginalized populations typically are (Sheller 2012; Smith 2013). Gnawa material culture represents what V. F. Mudimbe would refer to as a "discourse of otherness and ideology of alterity" (1988, xi). Looking at the "hidden transcripts" present in Gnawa self-representations can reveal a great deal about the agency of those who operate in a web of asymmetrical power relations (Scott 1990). While chapter 1 looks at the trope of the Black male musician and its development, chapter 2 considers how women responded to historical imagery that largely depicted them as concubines and servants by strictly limiting photography in the spirit-possession ceremonies that they control.

Chapters 3 and 4 address the hallmark of Gnawa identity: the performance of spirit-possession ceremonies called *lila*. During a Gnawa *lila*, music, incense, animal sacrifice, and special foods are used to evoke spirits into possession on behalf of an individual afflicted with some illness or adversity who has sought out a diviner as the only cure. In concentrating on the material expression of spirits and the experience of possession, I deliberately leave aside the psychological meanings and functions of possession as an extrinsic interpretation imposed on the proceedings by outside observers. Instead, I take peoples' accounts of their experience at face value. As Paul Christopher Johnson noted, to properly study possession, one must take its premise seriously, namely, the material manifestation of spirits: "'Possession' points relentlessly toward the material, the world of things, bodies and earth" (2014, 2). Johnson insists that possession "directs, grounds, and localizes the sensations, experience, and interpretations named as 'spirits'" (2014, 2). Thus, chapters 3 and 4 examine material expressions of Gnawa spirits, analyzing and describing the songs, styles of dress, and dances performed during a *lila*.

A *lila* consists of two portions, first, the *fraja* performances led by the male musicians followed after midnight by the spirit-possession and healing portion led by a (usually) female diviner. One enters into the most intense spirit-possession portion of the *lila* with its sensory immersion in sights, smells, and sounds already slightly dazed. Since any *lila* is a test of endurance, for both the audience and the performers, I would normally prepare myself by napping during the preceding day, knowing that I would get little or no sleep at night. During the *lila* itself, I was sometimes lucky enough to be able to lean against a wall, but I usually found myself in between other women, sitting cross-legged, unable to spread our legs out straight, and leaning on each for support. I often spent hours with someone's child on my lap. At some point during the night, I would hunt for a spot in the host's home and place a scarf over my head to take a quick nap, sleeping in a row next to other women. Making it through a *lila* was a feat

of physical stamina as well as a sensory onslaught of burning incense, food offerings for the spirits, exuberant dances, and intense colors.

The work of many Africanist art historians inspired the methodology for this book, which takes a multisensory and interdisciplinary approach that acknowledges the living, dynamic, and kinetic character of African expressive culture, which is embodied in Gnawa visual and performing arts. Art historians Robert Farris Thompson, Joanne Eicher, Frederick Lamp, and Henry Drewal have advocated a sensorial and experiential approach to African aesthetics as key to understanding the cultural fabric of a society (Drewal 2005; Eicher 1995; Lamp 2004; Thompson 1983).[19] Henry Drewal's research, in particular, demonstrates how African and African diaspora "artists and audiences use the senses (sight, taste, hearing, speaking, touch, motion, and extra-sensory perception) to create and respond to the affective and aesthetic qualities of art" (Drewal 2005, 4). Such an approach is also advocated in the discipline of performance studies where scholars such as Dwight Conquergood embraced an embodied approach to research, which he referred to as "dialogic performance." Conquergood called for researchers to embody the smells, sounds, sights, and emotional feel of a culture in order to understand the dynamic of life and negate the distance between researcher and researched, bringing them together as coactors in a performance (2013, 21). Thus, the sounds, odors, and tastes that I experienced during Gnawa performances served as a crucial unit of analysis for me and allowed me to understand the dynamic relationship that existed between spirits and the human vessels they inhabited.

There are several different groupings of Gnawa spirits, each with different characteristics and colors (see Appendix). Gnawa songs remain largely unwritten, passed down orally from generation to generation, and no individual holds ownership over them. When I began the project of recording the names of spirits and their associated songs, I worked with Mokhtar Gania who, along with some other musicians, performed songs from a *lila* for me in his home. I recorded it, and then we began the long process of transcription, with the assistance of Gania's daughter Sana. Most of the words were in Arabic, and I later translated the lyrics into English. I asked Mokhtar and other members of the local Gnawa community to explain the meaning of phrases, especially the subset of words that were not Arabic and that Gnawa themselves classify as "Sudani" (West African) words. Despite the intensity of this process, I only included a small portion of these songs in this book. This exercise was helpful because it allowed me to understand the structure of a *lila* and also identify some of the various languages that contributed Gnawa ceremonial lyrics, including Tamazight, Zarma, Bamanankan, and Hausa. Talking to various musicians, diviners, and those in attendance about the spirits' attributes, I gradually built up a conceptual model for what was happening in front of me. I eventually came to recognize individual spirits within each family by their dance gestures, their clothing, and the songs performed for them. I also spent time attending lectures, art

exhibitions, and musical concerts at Dar Souiri, a historic building in Essaouira that was reopened as a cultural center in the 1990s.

Chapters 5 and 6 of this book address the increasingly porous boundaries of Gnawa identity—as well as the backlash from members of the Gnawa community who wish to preserve a more exclusive version of Gnawa identity linked to "Sudani" ancestry. As noted by Christopher Tilley, when members of a group perceive threats of change to group identity, they often redouble efforts to preserve a pure, authentic group identity and continuity with the past (2006, 13–14). E. Patrick Johnson also asserts that it is during times of social, cultural, or political crisis when identity politics are acted out and authentic Blackness is called into question (2003, 2). He then asks a provocative question pertinent to this study: "How are the stakes changed when a 'white' body performs blackness?" (2003, 2). I found that anxiety concerning increased commodification and market forces have pushed some Gnawa practitioners, especially those from hereditary families of diviners and musicians, to reassert their Blackness and their claims to an ancestral history of enslavement in order to brand themselves "authentic," beginning a re-Africanization movement that seeks to "purify" Gnawa identity. In response to the permeation of Gnawa music and ceremonies into the larger Moroccan culture, they stress their connection to West Africa and Blackness in an attempt to recoup power from outsiders whom they see as profiting from their culture.

Thus, while Gnawa identity is complex and inexact, the term "Gnawa" can be taken most usefully and accurately to refer to a category of practice linked to Blackness as a signifier of marginality and otherness. Historically, it has allowed those who identified with the experience of suffering and oppression associated with enslavement to band together and create communities based on their ability to heal and to contact the spiritual realm, complicating our notion of the word "slave" from one of exploitation into one compatible with dignity and self-respect. Furthermore, documenting and understanding the history of marginalized groups, such as enslaved people in Morocco, requires scholars to look at what is often left out of the archive and outside of official histories. A study of how and when objects, and the people who used them, went from obscurity to visibility illustrates how Moroccans have reconfigured their relationship to the history of trans-Saharan slavery. In conjunction, the increasing visibility of Gnawa music and performance within Morocco has opened up the possibility for people to self-identify as African.

1

From Enslavement to Gnawa

Historical Postcards and the
Construction of Gnawa Identity

I N MARRAKECH'S VIBRANT SQUARE, Djemma el-Fna, musicians, storytellers, snake charmers, and dancers gather to perform for local and foreign tourists. Veiled women sit on crates, applying henna to their female customers' hands and feet, while others read tarot cards. Orange juice vendors, perched high on their wooden carts, attract passersby with samples of freshly squeezed juice. As I strolled through the square on a warm summer's night in 2010, a group of male musicians noticed me watching them and began to walk toward me. Immediately recognizable as Gnawa musicians due to their cowrie-adorned headdresses, iron castanets, and large barrel drums, the men began to perform in front of me until a small crowd formed a circle around them. One did some acrobatic jumps while everyone—including me—snapped photographs (Figure 1.1).

After their three-minute performance, they removed their hats, turned them over, and presented them to the crowd in solicitation of monetary donations. In doing so, Gnawa musicians are participating in a local Moroccan tradition of busking called the *halqa*, or "circle," in which traveling public poets, storytellers, acrobats, singers, and musicians perform at the center of a circle of onlookers who offer them money to keep the performances going. At its conclusion, many of the spectators without cameras quickly moved away, presumably viewing these men as mere panhandlers, while others expressed their pleasure in the performance by dropping coins in their upturned hats. The camera introduces an additional dimension of exchange into this already commodified transaction, since the performers expect those holding cameras to pay more, given the fact that they have captured, frozen in time and carried away, a permanent memento of the performance. This photographic encounter exemplifies the commodified role men play in contemporary Morocco as roaming Gnawa musicians, panhandlers, and tourist attractions.

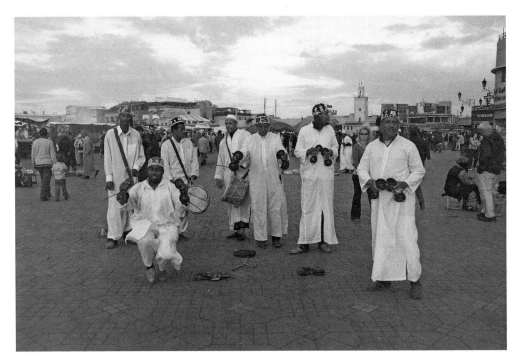

Figure 1.1. A group of Gnawa musicians in Djemma el-Fna perform for the camera, Marrakech, Morocco, 2010. Photograph by the author.

It was with the arrival of the camera on the Moroccan scene that men began to market themselves as Gnawa for a global audience, and they have continued to do so— a fact that is evident when one compares the photograph that I took in 2010 with a postcard from more than a century earlier (Figure 1.2). There is remarkable similarity between the late nineteenth-century image and my own twenty-first-century one: both groups of men face the camera wearing white tunics and cowrie-adorned hats while holding similar musical instruments. However, much more significant than similar dress styles is the fact that in both images the men are clearly aware of and engaging with the photographer. In the postcard, they hold up their instruments as if about to play, as the camera's technology at the time would not have been fast enough to capture the motion of an actual performance, clearing posing for the image. This comparison reveals that since the introduction of photography in Morocco, Gnawa musicians have configured their performances for the camera, collaborating with the photographic enterprise to produce images that have remained surprisingly consistent for more than one hundred years.

Complicating this scenario is the fact that the date and circumstances surrounding the photograph in Figure 1.2 are impossible to determine. First, the effect of silhouetting the musicians indicates that the postcard was a composite image, the backdrop and musicians having been photographed on separate occasions: a photograph of the musicians

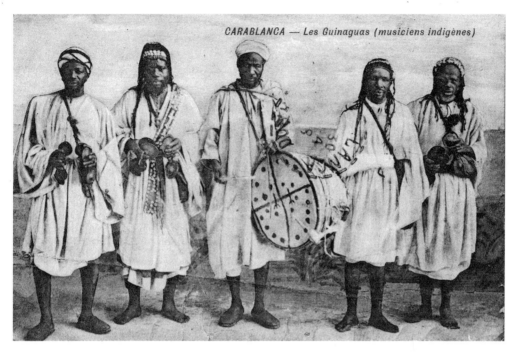

Figure 1.2. Photographer unknown, *Casablanca – Les Guinaguas (musiciens indigènes)*. Postcard published by J. Gonzales & Cie, Casablanca, circa 1910. Collection of the author.

was placed on top of the backdrop photograph and retaken to make a new negative. It was not unusual in the early twentieth century to combine two (or more) photographic images in this manner. In this instance, it illustrates the role that photography played in codifying a "type" of Black musician in Morocco.

This chapter examines how photography contributed to the formation and visual fixation of Gnawa as a racialized identity associated with Blackness and the public performance of music at the turn of the twentieth century. The gradual disintegration of slavery was one of the effects of the overall destabilization of Morocco's hierarchical economic and social structure that led to the establishment of French Protectorate in 1912. Many of the formerly enslaved—newly manumitted but also landless and impoverished—migrated to cities where they found playing on the streets for Europeans in exchange for money one of the few options open to them. Marketing themselves as musicians and dancers, at an early date, these men performed for Euro-American tourists and visitors who associated their skin color with the exotic. Dark-skinned Moroccans captured their imagination, and Black men performed for the camera. Their images proliferated on postcards that were widely disseminated across Europe and the United States. These artifacts gave rise to the visual trope that came to emblematize this population and ultimately consolidated a somewhat disparate, disenfranchised minority group into "Gnawa."

POSTCARDS, SELF-MARKETING, AND AGENCY

By the early twentieth century, Europeans in Morocco had taken hundreds of photographs of phenotypically Black male musicians that were published in travel guides and popular magazines and also turned into photographic postcards, such as the one in Figure 1.2. In the images, Black men consistently hold musical instruments, dance, wear cowrie and beaded headdresses, and often smile directly at the camera. The visibility of dark-skinned men in photographs geared to a European and American audience made Black subjects more susceptible to commodification, but as noted by John and Jean Comaroff, the process of self-marketing typically develops in response to other global factors (2009, 147). More specifically, images of the performing Black male body in Morocco likely responded to the caricaturing and dehumanizing images of blackface minstrels that became popular during the nineteenth century. Images of blackface minstrels traveled globally, and photographs of dark-skinned Moroccans no doubt fed into the market for Black performers.

Given the visibility of Black male performers on postcards produced in Morocco at the time, the questions arise: How much control did Black men have over their own images? Did photographic visibility offer Black men the opportunity for self-representation or were such images simply exploitative and exoticizing? Nicole Fleetwood addresses this issue in her book *Troubling Vision* where she asserts that the deliberate performance of visibility draws attention to the constructed nature of visuality. She defines visibility as "the state of being able to be seen," while visuality "refers to the mediation of the field of vision and the production of visual objects/beings" (2011, 16). Fleetwood elaborates on the relationship of visuality to Black cultural studies:

> Vision and visual technologies, in this context, are seen as hostile and violent forces that render blackness as aberration, given the long and brutal history of black subjugation through various technologies, visual apparatus among them. Yet it is a rendering that often totalizes the gaze so that black subjects have no recourse in which to challenge scopic regimes. (2011, 17)

Studies of visuality recognize that photographs remove an image from the wider world and focus on just one scene, event, action, or person, and in the process, something is left out of the account. This left-out-of-account leads to the desire to fill in the missing information, which can devolve into stereotypes and social caricatures, conveying racialized constructions and reinforcing power structures (Cowie 2007, 101; Rolling 2009, 97). John Berger writes, "Every time we look at a photograph, we are aware, however slightly, of the photographer selecting that sight from an infinity of other possible sights" (1972, 10). Studies of visual culture, therefore, emphasize the authorial voices of photographers and recognize that understandings of them are constructed both by them and by the audience viewing the image.

Thus, many scholars interpret imagery in terms of the photographer's gaze and see the subject as a victim, taking a Foucault-derived approach that concentrates on the relationship between visuality, surveillance, and power, interpreting imagery as a manifestation of asymmetrical power relations (Foucault 1995). Fleetwood (2011) looks at the intentionality of the Black subject and asserts that some knowingly perform stereotypical tropes of Blackness in order to draw attention to racialized constructions, troubling the visibility of Blackness. In the last several decades, similar agency has been granted to the subjects in historical photographs from Africa. This scholarship has been invaluable to acknowledging the agency of the African subject in the photographic transaction, showing that even when the photographer is in a position of power, photographs do not simply render African people "objects of control, desire, and appropriation" (Edwards 2013, 48). The work of Christraud Geary (2002, 2018), Elizabeth Edwards (2013), and Christopher Morton (2012) has been invaluable in establishing a model for colonial-era photographs that acknowledges the agency of the African subject in the photographic transaction. They assert that African subjects actively participated in crafting and asserting their own self-representation, through their choice of particular props, clothing, and poses. Through an analysis of comportment and display, one can discern local agency and subjectivities (Geary 2002, 20, 26; 2018).

Geary and others shift the analytical focus from what colonial-era imagery reveals about the West and unequal power relations to a consideration of how photography impacted local self-representations. While much of this work has focused on sub-Saharan Africa, scholarship on North African photography has lagged behind theoretically, with most scholars continuing to reflect an Orientalist perspective that fails to attribute agency to the photographic subjects. It is therefore part of my remit to extend these analyses to North Africa.

Of particular relevance to this chapter is scholarship that looks at the impact of tourism and market forces on photographic imagery. Krista Thompson (2006) and Mimi Sheller (2012) looked at counterhegemonic perspectives within tourist images from the Caribbean. In addition, art historian Sidney Kasfir's (2007) examination of the influence of market and commodity forces on African artistic production includes an exploration of the ways in which Western spectatorship influenced self-representation among young Samburu male warriors in Kenya. Kasfir shows how outsider interest resulted in Samburu men assuming an increasingly theatricalized identity that was then captured in postcards and Western-made commercial films. These scholars demonstrate that local artistic production and visual self-representation intersect with global markets through the tourist industry. The idea of performing one's self-image in response to market forces was also the topic of the book *Ethnicity, Inc.* where John and Jean Comaroff assert that since the beginning of the twentieth-first century, identity has been increasingly claimed as property to be branded and sold in self-consciously consumable forms, especially when it is enacted repeatedly for tourist-consumers (2009, 11, 29).

This chapter applies the idea of self-actualized ethnicity construction and self-marketing to the period that economists and historians refer to as the first wave of globalization, the second half of the nineteenth and the early part of the twentieth centuries (Haugerud, Stone, and Little 2000). Between the 1870s and the 1910s, increased trade due to technological innovations such as the steamship and trains led to the transport of goods across great distances. The international market in trade expanded, and many European countries vied to control the resources of Africa. As stated by J. Lorand Matory in his book *Black Atlantic Religion*, long-distance communication across nation-state borders impacted the construction of ethnic identities during the nineteenth century. According to Matory, this period is often disregarded by scholars who typically assert that more intense global interconnectedness began in the late twentieth century (2005, 8–9). Some of this can be understood as a remnant of nineteenth-century scholarship that presented ethnic groups as existing in isolated and neatly bounded categories, but the actual reality was much different as boundaries were much more fluid than typically recognized (Kasfir 1984; Matory 2005).

At the end of the nineteenth century, increased European incursions into the Kingdom of Morocco led to economic hardship among the wealthy, slave-holding elite, which profoundly impacted the lives of the enslaved. According to historian Edmund Burke III, "Morocco in the nineteenth century was undergoing very great social, economic, and political transformations and was in fact very far from the immutable country it was often romantically pictured to be" (1976, 19). Economic hardship meant that the elite found it difficult to maintain large numbers of enslaved people, and as predicted by the French Protectorate government in Morocco, economic and social changes eventually led to the gradual demise of slavery. Black men recognized that they had a commodity to sell and an identity to perform that was of interest to both the photographer and the burgeoning tourist industry, becoming "Gnawa."

"Gnawa" was not an identity that was quickly understood, which is illustrated by the fact that Black musicians were not easily categorized by postcard makers. The captions accompanying these postcard images applied such diverse labels as "Nègro soudanais," "Nègre du Soudan," "Danseurs Soudanais," "Musicien marocain," and "Les Guinaguas (musiciens indigenes)" to those who would become known as Gnawa. The majority of captions used terms associated with Blackness (*nègre* and *Soudan*), distinguishing the subjects in them from the larger Moroccan population, who were categorized racially as Arabs, Imazighen (Berbers), or Jews, and contributing to the categorization of Morocco's dark-skinned population as a distinct group. Furthermore, the awkward spelling of Gnawa (as "Les Guinaguas" in Figure 1.2) indicates that the word "Gnawa" was as yet unfamiliar to Europeans and not yet standardized (and indeed it does not commonly appear in written European records until the very end of the nineteenth century).[1]

Postcards, in particular, contribute to our understanding of the massive changes occurring in Africa during this, the first age of globalization (Geary 2018). In their book

Postcards: Ephemeral Histories of Modernity (2010), Jordan Mendelson and David Prochaska show how postcards played a role in art, commerce, and identity-formation, recognizing that postcards were geared to an international audience looking for images of the exotic. During the golden age of postcard production (1890 to 1910), the wider availability of mass-marked commodities, global circulation of print media, and intensification of colonialism resulted in postcards connecting people and spaces (Geary 2018, 16). Photographic studios were often owned by small-scale, independent businessmen, and in the absence of copyright restrictions, studios often purchased photographs from other ones (Geary 2008; Hickling 2014). Photographs taken in the colonies were shipped back to specialized firms in Europe that routinely reprinted, manipulated, and recaptioned them. (The photographer sometimes provided the original caption but these were also frequently added by the European publisher with an eye to marketing and then changed by others downstream.) The finished postcards were shipped back to the colonies to be sold as tourist souvenirs on which people typically inscribed messages to their friends and family to be sent back to Europe again (Geary and Webb 1998, 2–3). As noted in Patricia Goldsworthy's study of postcards in Morocco, they often functioned more as a "commodity designed to appeal to a broad consumer base than as a reflection of colonial ideology and government propaganda" (2010, 164). Since postcards were meant to appeal to a large range of consumers, best sellers were reproduced more frequently. This fact renders them useful to the present study as an index of the popularity of particular images or image genres.

During the heyday of postcard production, some of the most common motifs depicted were exotic vistas and landscapes, monumental architecture, the visits of European officials to their colonies, and, most pertinent to our subject, *scène et type* photographs that classified colonial inhabitants deemed to be colorful or exotic by ethnic or tribal categories. Postcards also served as a sort of news medium, as indicated by one (Figure 1.3) postmarked "Campagne du Maroc, Colonne de Mequinez" (Moroccan campaign, Column [Military Unit] of Meknes); on the back a soldier wrote a message to his family, reminding us that postcards were a means of recording Morocco's colonial history.

Indeed, photography cannot be understood apart from the history of colonialism, which contributed to the introduction of modern tourism in Morocco. Until 1901, Moroccan sultans outlawed photography, proclaiming it counter to Islamic restrictions on image making. An exception was made for the city of Tangier in northern Morocco, which was declared an international zone, and where Europeans took photographs of locals to sell to tourists and photographic publishing companies, with resident photographers such as Léon Davin, George Washington Wilson, and Antonio Cavilla setting up studios in the 1880s.[2]

At this early date, dark-skinned men dressed in shell-adorned headdresses, playing instruments associated with Gnawa, posing for the camera in the streets and studios of Tangier. When the ban was lifted and the French Protectorate was formed in 1912,

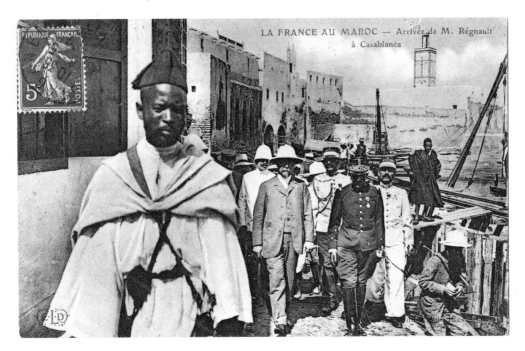

Figure 1.3. Photographer unknown, *La France au Maroc – Arrivée de M. Régnault à Casablanca*. Published by E. Le Delay, Paris, circa 1910. Collection of the author.

Black men capitalized on the burgeoning tourist industry, illustrating a central argument that I make in this book: that self-marketing for both a local and a foreign audience contributed to the construction of a Gnawa identity. "Gnawa" as a marketable identity gradually emerged in the late nineteenth and early twentieth century with the slow disintegration of Moroccan slavery. Authorities, colonial officials, and tourists used photography to define Blackness and classify phenotypically Black men into a distinct group, and at the same time, the Black male subjects were using photography to carve out a space for themselves as performers in postslavery Morocco, actively engaging in the process of self-fashioning. Such actions provided them with increased access to market and money, creating "a brand" that was theirs to sell as a means of empowerment (Comaroff and Comaroff 2009, 15).

My analysis draws upon photographs from various archives, which were reprinted in books and as postcards.[3] The proliferation of images of Black musicians among these reveals that they had early on become a type of image popular with tourists. The widespread dispersion of photographs taken by Europeans during the late nineteenth and early twentieth centuries across collections and continents inspired me to create my own archive of around three hundred postcards of Black musicians by buying inexpensive images from online sellers across the globe. I was sometimes able to locate an original photograph in an archive that allowed me to identify the photographer and

approximate date of the image, but most have been impossible to date since postcards were made from photographs typically taken several years before the postcard was printed. For this reason, I am unable to differentiate between photographs taken before and after the ban on photography was lifted, except to note that photography became more commonplace after 1901.

As noted by Christopher Morton and Darren Newbury in their book *The African Photographic Archive,* digital images have become such a valuable resource that "in the last twenty years the notion of the archive has expanded to include the vast global circulation of audio-visual media shared and stored via the internet" (2015, 4). At the same time, the authors warn that this proliferation of images and access to them has resulted in a narrow focus on the content of photographs without contextualizing the processes governing their collection, that is, how archival practices respond to a variety of political, cultural, and social agendas (2015, 4). Recognizing the challenges and limitations of relying on limited and diffuse archival sources, I spent years collecting and comparing photographs from the various databases found in France, Morocco, and the United States in order to accumulate a representative sample of images. The images that I rely on in this chapter are among the most commonly reproduced by postcard publishers during the early twentieth century.

Of the hundreds of postcards that show dark-skinned people, only 10 percent depict women, and among these, women were only shown in the roles of servants/slaves or concubines (the topic of chapter 2). Today, gender conventions limit the public performance of music by women, so we can assume that such restrictions also existed in the past, explaining why Black women did not perform music on Morocco's city streets. It is also notable that none of the photographs depicts men or women working in agricultural fields or performing the other types of labor that were common to enslaved people—an important exception being photographs of the sultan surrounded by his legions of Black soldiers, an image that became commonplace once Sultan ʿAbd al-Aziz lifted the ban on photography in 1901.

Prior to a discussion of photography, however, it is crucial to recognize that dark-skinned men also received considerable attention from European painters, who depicted them engaged in public performances, contributing to the visual trope of the Black male performer that developed even more with the production of the photographic postcard. Artists often wrote brief notes on their sketches, identifying the men they sketched as West African and reinforcing their status as Black "others." The point is that the Black musicians emerged as a popular image to be reproduced in postcard form, having been chosen according to the criteria of the observers/photographers in conjunction with the market. These images are not broadly representative of available reality; instead they record the fascination of Europeans in particular types of subjects deemed most picturesque, most exotic, or most entertaining. However, as we shall see, Black men used such imagery to their advantage, self-marketing their identity and becoming "Gnawa."

PAINTING A VISUAL STEREOTYPE

Among the most renowned artists to depict a Black male musician was Eugène Delacroix, who, in 1832, spent six months in Morocco with a French diplomat, Comte Mornay. During his visit, Delacroix sketched a Black man holding a musical instrument, recognizable as a *guinbri*, a type of plucked lute played by Gnawa musicians in Morocco today, on a single sheet of paper. Delacroix did two sketches (frontal and profile) of this barefoot man in tattered clothes, his hair and beard in mid-length tresses (Figure 1.4). This particular sketch, currently in the print collection of the Louvre, features a barely visible note that reads: "Foullah. There is a bridge on which the strings pass."[4] "Foullah" is the French spelling of a West African ethnic group, also called the Fulani, Peul, or Pular, who are widely dispersed among the savanna and Sahelian regions of West Africa from Senegal to Chad. The background behind the man is blank, providing no contextual

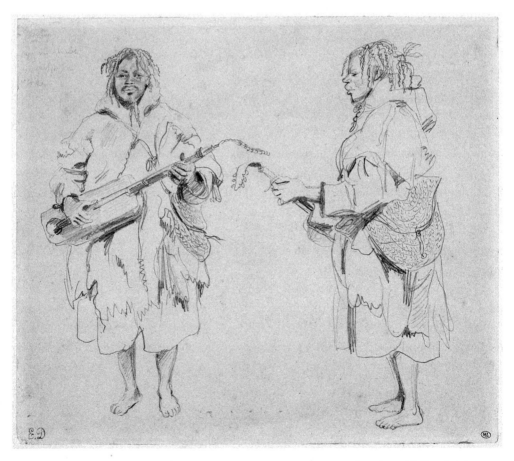

Figure 1.4. Eugène Delacroix, *Two Studies of a Moorish Musician*. Drawing, 23.5 × 24.4 cm. Inv: RF23324. Photograph by Michèle Bellot. Musée du Louvre. Copyright RMN–Grand Palais/ Art Resource, NY.

information; therefore, it is unknown whether Delacroix encountered the man on the streets of Morocco or during a concert arranged by the sultan for Delacroix and Comte Mornay's entertainment.

Delacroix's sketch was later replicated by Denis-Auguste-Marie Raffet, who also sketched a Black musician holding a *guinbri* and wearing ragged clothing in 1847 (Figure 1.5). As in Delacroix's sketch, this man is shown both frontally and in profile, giving the impression of capturing the movement of a musician during a performance. Studying the work in the Yale Art Gallery print room, I noticed several faint words written at the bottom right of the image, many of them indecipherable, but the word "fûla" can be made out, resembling the word "Foullah" found on Delacroix's sketch and apparently referring to the man's perceived ethnic origin as sub-Saharan Africa. Raffet visited Tangier the year this sketch was made, but whether he himself encountered such musicians on the streets of this northern Moroccan city remains unknown. However, the strong similarities between the sketches of Raffet and Delacroix suggest that the image of the Black male musician was becoming iconicized in the nineteenth century.[5]

Alfred Dehodencq was among several other nineteenth-century artists who painted images of dark-skinned men dancing on Moroccan streets, and it appears that his work was also impacted by Delacroix. Between 1854 and 1863, Dehodencq lived between Tangier and Spain and, during the Paris Salon of 1874, exhibited a painting titled *La danse des nègres à Tanger* (Figure 1.6) that strongly suggests the influence of Eugène Delacroix's painting *The Fanatics of Tangier* (1837–38). In a brochure advertising the salon of 1838, Delacroix had described *The Fanatics of Tangier* as depicting a group of Sufi men entering "a veritable state of intoxication" that enabled them to "walk on red-hot coals, eat scorpions, lick red-hot irons and walk on sword blades, all without noticing their injuries" (cited in Sharp 2009, 22). Dehodencq's painting of a public group dance captures the same sense of frantic energy, suggesting that Delacroix's painting had, in the intervening decades, come to serve as a type, influencing artistic representations of the exotic other.

The flat roofs and vivid blue sky, along with the square minaret and view of water in the distance, indicate that Dehodencq used visual tropes associated with the Mediterranean coastal city of Tangier. The viewer's eyes are drawn to the bright, white robes worn by the dark men in the center of his composition. Dehodencq painted their white garments as if they are flailing out around them, giving the impression that they are whirling in a circle. Furthermore, upon closer inspection, the men are holding iron castanets associated with Gnawa musicians today.

Public dances performed by Black men were a continuing source of fascination to European travelers to Morocco. A written description of them can be found in the travel memoir *Morocco and the Moors*, which was written by the English doctor Arthur Leared (1879). Leared describes the elaborate and somewhat controversial wedding in Tangier of an English woman to a member of the Moroccan elite (to whom he refers by the

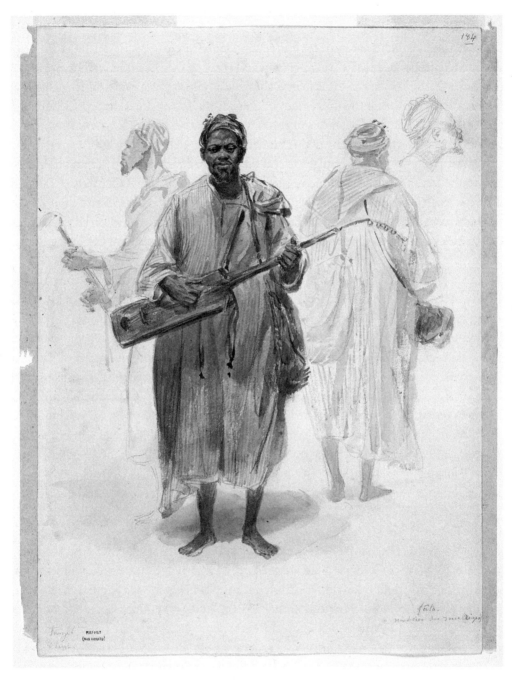

Figure 1.5. Denis-Auguste-Marie Raffet, *Un Maure musicien des rues à Tanger*, 1847. Watercolor with graphite underdrawing, 28.4 × 20.7 cm. Gift of Edith Malvina K. Wetmore. 1945.5. Courtesy of the Yale University Art Gallery.

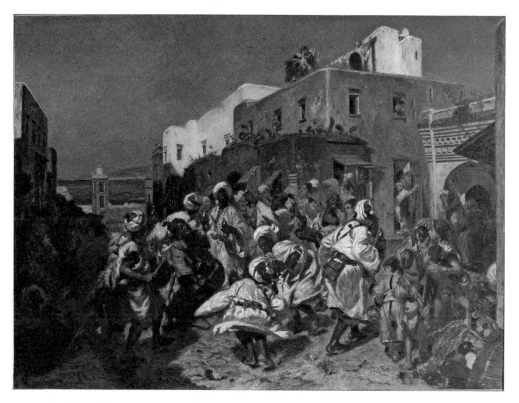

Figure 1.6. Alfred Dehodencq, *La danse des nègres à Tanger*. Exhibited during the Paris Salon of 1874. Oil on canvas, 152 × 202 cm. RF2587. Photograph by Hervé Lewandowski. Musée d'Orsay. Copyright RMN–Grand Palais/Art Resource, NY.

honorific title of *sharif*). On the sixth day of the seven-day wedding, "the fête of the black population" was held:

> A number of them [the black population] came to the sharif's house dressed in white, each negro holding in his hands a pair of metal castanets. The castanet men formed a ring, while each individual turned round and round, at first slowly, and then, at a gradually increasing rate to the accompaniment of the strains of their wild music; till after the manner of the dancing dervishes, an astonishing speed was attained. A couple of large drums added to the din. (Leared 1879, 362)

One can interpret the text by Leared in a variety of ways. First his reference to speed and acceleration could refer to pejorative stereotypes of savagery and wildness Europeans often associated with sub-Saharan Africans. Perhaps Leared also viewed the dance as a means for Black Moroccans to express their freedom from enslavement, causing him to emphasize that the men were spinning at an astonishing speed. Most important, this description by Leared, the painting by Dehodencq, and sketches by Delacroix and

Raffet all attest to Western fascination with dark-skinned performers in Morocco. The same conventions of visual representation typical of painting informed photography and, ultimately, postcards. Photography quickly became the dominant medium of the colonial period, coinciding with and, I contend, spurring the codification and formation of a recognizable and marketable Gnawa identity. The art historian Krista Thompson (2006) has shown how the tourist industry in Jamaica deployed photography as a means to promote the island's dreamlike tropical landscape. Photography was likewise used to promote tourism in Morocco, one of the last African countries to be colonized and to allow photography in the interior. Colonial administrators saw Morocco as a reformed colonial project in relationship to Algeria where many administrators had served prior to their work in Morocco. Having seen the effects of mass destruction of cultural heritage by the French army, colonial officials stressed that Morocco's indigenous life was particularly worthy of tourist interest. Unlike their neighbors in Algeria and Tunisia, Morocco had preserved its original and diverse cultural heritage intact due to the longer exclusion of European influence (Hunter 2007, 587; Irbouh 2005).

PHOTOGRAPHY, EUROPEAN ENCLAVES, AND THE RISE OF TOURISM

Unlike neighboring Algeria, where photography flourished at an early date, in Morocco photography was limited legally to the European enclave of Tangier until 1901, as Morocco attempted to insulate itself from European influence when France invaded neighboring Algiers in 1830. Europeans were restricted to specific port cities, among which Tangier was particularly popular due to its proximity to Europe across the Strait of Gibraltar (Burke 1976, 24). Schools in Tangier ran according to a European model, Western-trained doctors staffed hospitals, and Europeans built numerous apartment complexes, villas, and tourist hotels. A telephone system, dance halls and bars, theaters, and European-language newspapers flourished. By 1904, 20 percent of Tangier's population came from Europe; the city was home to a cosmopolitan mix of Jews, Muslims, and Christians.

As part and parcel of its development as a modern Western-style urban center, well ahead of cities of the interior, Tangier became an early adopter of photography, which quickly developed into a profitable business, catering to foreign diplomats and tourists. By 1885, the Spanish photographer Antonio Cavilla had opened a studio there (Goldsworthy 2009, 33, 151).[6] Cavilla often photographed market scenes and architectural views, but it is his portraits of individual Moroccans that are of particular interest to us here, especially his use of photography to create a taxonomy of Moroccan "types."

Europeans were obsessed with classifying Morocco's population into racial and ethnic categories. For example, Gustave Jeannot, a French lawyer and author of the 1907 book *Étude sociale, politique et économique sur le Maroc*, divided Moroccans into distinct

racial groups, estimating that the population of ten to twelve million consisted of seven to eight million Berbers, one million Arabs, and one and a half million "Maures," whom he defined in his text as Morocco's intellectual, ruling elite (1907, 13). Also among his population count were 110,000 Jews, 15,000 Europeans, 150,000 "Blacks" (Nègres), and an undisclosed number of Harratin, whom he described as dispossessed, "primitive" dark-skinned laborers who lived in the southern oases of Morocco (1907, 123). "Blacks," according to Jeannot, formed a distinct race and were "of Sudanese origin, directly imported as slaves or guards of sultans, descendants of slaves, or came themselves to settle in Morocco, on the Saharan side of the Atlas" (1907, 122). Despite recognizing that some "Blacks" migrated voluntarily to Morocco, he categorized the majority of them as slaves and, like many writers of the time, described the situation of slavery as gentle and mild, recommending that colonial authorities should not end slavery abruptly because this would be too disruptive to the privileged class. Rather, he suggested that the practice of slavery would eventually vanish, as trade routes closed and as many enslavers manumitted the enslaved after death (1907, 123). Jeannot's account also indicates the European obsession with classifying Morocco's complex and diverse population, placing people within distinct racial groups. As this demonstrates, outsiders typically linked Blackness to servitude, using pejorative terms such as "primitive" and "slaves" to describe dark-skinned people.

Photography was also used to categorize people according to racial categories, and sometime in the late 1800s, Cavilla took a photograph of a dark-skinned man in profile wearing a headdress with a pointed projection and braided tresses adorned with various shells and beads, which was later transformed into a postcard (Figure 1.7).[7] The photograph is not quite a profile shot since it shows the subject, a dark-skinned man, in three-quarter view, as Cavilla evidently positioned the camera from above to emphasize the series of marks cut into the man's cheeks and along the side of his face. Since this style of body modification has never been a common practice in the Maghreb, this man must have stood out to the photographer, whose positioning also emphasizes the subject's elaborate shell-adorned headdress. Posing the man in front of a blank backdrop, the photographer allows the viewer's eye to follow the angle made from the top of the man's headdress to the bottom of his beard for a clear view of his facial markings without any visual distractions.

Cavilla's photograph was published as a postcard with the caption "Musicien marocain" and was printed in a 1906 edition of National Geographic Magazine with the caption "A Soudan Minstrel."[8] The varying captions suggest that the term "Gnawa" was not regularly used in the public realm in the early twentieth century. Some of the earliest uses of the term Gnawa (Gnaoua in French) to refer to Black street performers appear in the journal published by the French "scientific mission to Morocco," the Archives marocaines. For example, in 1904 the ethnographer Georges Salmon pointedly embedded this "ethnic" group within the economics of foreign tourism:

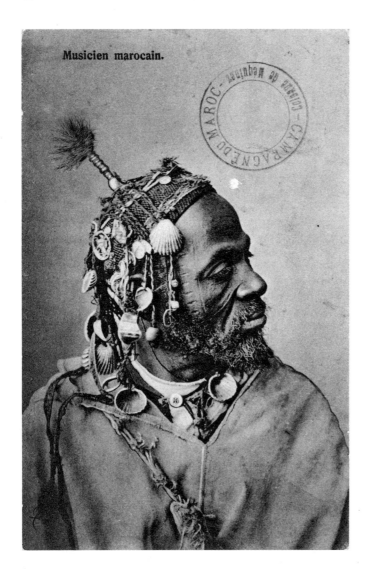

Musicien marocain.

Figure 1.7. Antonio Cavilla, photographer, *Musicien marocain*. Postcard published by M&M L., circa 1910. Collection of the author.

In Tangier, the *Gnaoua* are recognizable in their costume composed of a large number of rags of all colors, superimposed as best they can, to their cap adorned with shells and pearls of glass, and especially to their rhythmically monotonous dances, which are accompanied by small copper cymbals. The immediate purpose of these dances is to raise some money from foreign tourists. (1904, 264)

"The immediate purpose" of Gnawa performance apparent to foreign observers is economic transaction. As chapters 3 and 4 of this book will explore, there is also a spiritual dimension of Gnawa music, but it is invisible to these colonial observers and their cameras, as it is revealed only in the relative obscurity of spirit possession and other places largely unseen by Europeans. In the absence of that larger communal and spiritual

context, Gnawa musicians are, literally and figuratively, reduced to the status of buskers. The sacredness of the music to induce spirit possession in private ceremonial contexts goes unacknowledged and unconsidered by photographers. Rather their performances are restricted to the realm of folkloric performances for tourists. While women played a major role in spirit-possession rituals held by Black Moroccans, as we will see in chapter 2, Europeans were not interested in nor privy to such ceremonial practices.

Visual evidence suggests that over the years some Black men earned money through performing in Tangier in two ways: by playing music on the streets, and by sitting for photographers for the postcard industry. These two performance modes were linked, as illustrated by a series of twelve postcards that I collected with postmarks ranging from 1914 to 1943, depicting the same man wearing the same garb but in different poses and contexts. In most of the photographs he holds metal cymbals (*qraqeb*)—an instrument associated with Gnawa today (Figure 1.8). His oversized patchwork gown, thick

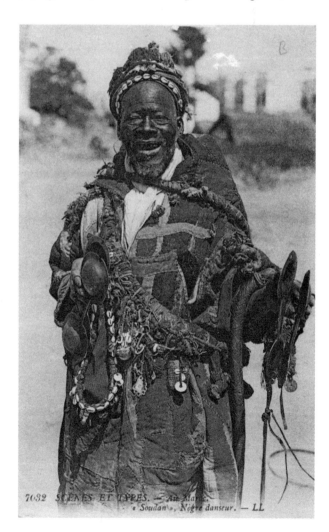

Figure 1.8. Photographer unknown, *Scenes et Types. – Au Maroc."Soudan," Nègre danseur*. Postcard published by Levy Fils & Cie, Paris, circa 1910. Collection of the author.

sash covered with leather packets, beads, and shells, single hoop earring, and cowrie-adorned headdress sometimes wrapped with a white turban indicate that he wore a specific "uniform" that identified him as a wandering musician. He gives the impression of happily playing for the camera, gazing directly at the photographer with a wide smile. Almost every card is labeled "Tanger, Maroc," and in Figure 1.9 he is given the moniker "The Friend of the Tourists."[9]

While we do not know the identity of this man, one postcard identified him as "head musician of the negros" (*le chef de musique des négros*). Although most postcards were sent to France, Figure 1.10 was sent to the United States, and the message written on the back of the garishly hand-painted photograph is particularly revealing of the tourist's perspective: "These are wild looking people. How would you like to meet this fellow in the dark?" The messages written by senders on the back of postcards often allude to the

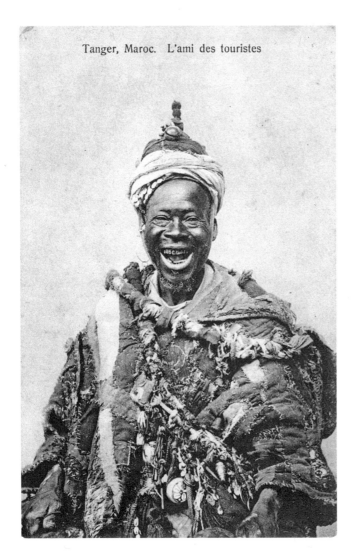

Tanger, Maroc. L'ami des touristes

Figure 1.9. Photographer unknown, *Tanger, Maroc. L'ami des touristes.* Postcard published by S. J. Nahon, Magasin de Nouveautés. Tangier, Morocco, circa 1910. Collection of the author.

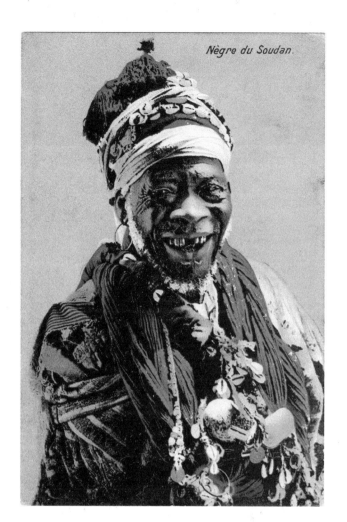

Nègre du Soudan.

Figure 1.10. Photographer unknown, *Nègre du Soudan*. Postcard publisher unknown, circa 1910. Collection of the author.

Imprimé - Illustré

Gibralta Spain
July 31, 1923.

Dear Paul
I have been across the strait of Gibralta to Tangier, Morocco, Africa and had the time of my life. Was even into the Sultan's Palace. These are wild looking people. How would you like to meet this in the dark?

Mr. Paul Oliver
25 Fairbanks St.
Brighton
Massachusetts
U.S.A.

postcard's subject and become part of the postcards' "social lives," inscribing new mean-
ings onto them as they cross cultural and geographic borders (Kopytoff 1986). This
unknown man's image continued to be reproduced in postcard form for at least four
decades, and while we do not know his specific identity and history, he came to stand
for the trope of the Black busker. His use of the same style of dress and musical instru-
ments in each photograph and his direct engagement with the camera indicate that he
was conscious of his social role.

Multiple publishers and printers produced the various postcards seen in this chap-
ter; the lack of copyright that existed at the time complicates our ability to date them.
While the postcards in Figures 1.8 and 1.9 were not postmarked, the postmark in Figure
1.10 is "1923," but a postmark does not indicate when the image was taken; it simply
indicates that an image sold well enough to be republished. An image similar to that
in Figure 1.8 was reproduced in postcard form on a card postmarked in 1943 and sent by
a U.S. Army lieutenant to Kansas City, Missouri (Figure 1.11). It includes an inscription
that reads: "Remember this old man? I sent you a picture of him last January. He is a
prominent 'man about town.' Beats the drums for a few francs." We do not know whether
the American lieutenant actually saw this same man performing or not, but the prolif-
eration of this image indicated how dark-skinned musicians became popular tropes that
widely circulated among postcard publishers.

While the name of the man whose image graced so many postcards remains unknown,
he clearly performed on the streets of Tangier for many years, wearing the same patch-
work tunic, pendant-covered sash, and cowrie-adorned headdress. In fact, the postcard
in Figure 1.12, labeled *Yaouleds et danseur* ("Sons and Dancer") shows the same man,
visibly aged and sitting on a chair in what appears to be a studio setting, wearing the
same outfit while surrounded by three young men.[10] One of the young men stands
with his hand on the elder man's right shoulder, a European photographic conven-
tion common to studio portraits of the time. A hand on the right shoulder is also a
tradition in early and later West African photography, where it may indicate that the
person who places his hand on the shoulder of the seated person is a son or heir.[11] The
photograph suggests that this street musician was part of a larger community. Although
the lack of copyright makes these photographs impossible to date and to fully contex-
tualize, the fact that he visibly aged in front of the camera indicates that he engaged in
the profitable enterprise of performing a particular identity for the camera over a pro-
longed period of time.[12]

PHOTOGRAPHY AND THE
BRITISH ANTISLAVERY MOVEMENT IN MOROCCO

The fact that photography of Black male performers was embedded in a marketplace
that traded in images and stereotypes of Black men cannot be disentangled either from

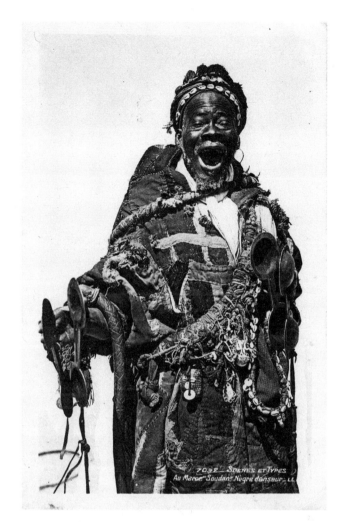

Figure 1.11. Photographer unknown, *Scenes et Types Au Maroc "Soudan" Nègre danseur*. Published by Lévy et Neurdein Réunis, Paris, circa 1910. Collection of the author.

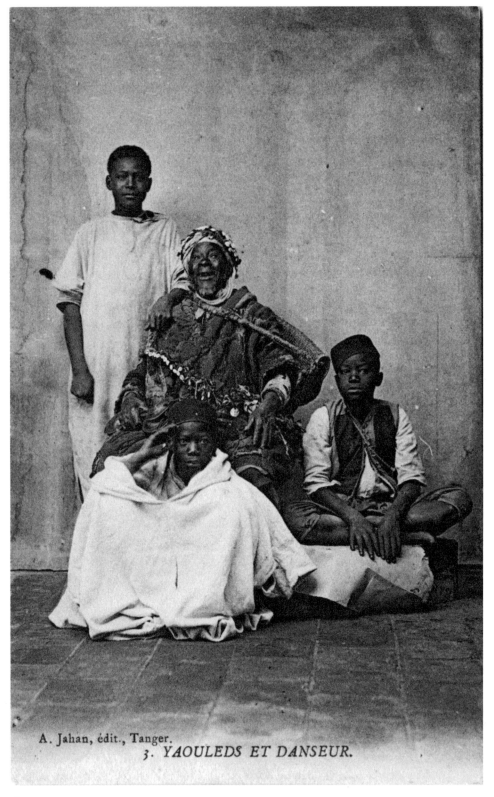

A. Jahan, édit., Tanger.
3. YAOULEDS ET DANSEUR.

Figure 1.12. Photographer unknown, *Yaouleds et danseur*. Published by A. Jahan, Tanger, circa 1910. Collection of the author.

the history of slavery or from European efforts to ensure its abolition in Morocco. During the latter half of the nineteenth century, involvement with European trade and the colonization of Algeria by France resulted in the increased presence of Europeans who used photography as a tool to draw public attention to the practice of slavery. The abolition of slavery by Great Britain in 1833 and by France in 1848 fueled the abolitionist movement's spread to Morocco.[13] In 1842, Sir John Drummond Hay, the British consul general to Morocco, wrote a letter to Sultan Moulay `Abd ar-Rahman (ruled 1822–59) recommending that he abolish slavery. The sultan refused, responding that slavery was accepted in Islamic law and the British demand was offensive to Islamic traditions (El Hamel 2013, 244).

During a trip to Essaouira in 1844, James Richardson requested a meeting with the sultan to present him with a petition written by the British and Foreign Anti-Slavery Society. The sultan, who was in Marrakech at the time, refused to grant him an audience and, according to *The British and Foreign Anti-Slavery Reporter*, the sultan ordered that Richardson "leave Morocco in the same vessel which brought him" (1844, 74). Richardson resisted until he was allowed to meet the governor of Essaouira, who also rejected Richardson's request that the sultan abolish slavery. The governor responded as follows:

> were the Emperor to agree with your Society, and abolish the traffic in slaves through his dominions, all the people would rise up against him in revolt, and the Emperor would be the first to have his head cut off. (1844, 74)

The sultan and other Moroccan elites adamantly opposed slavery's abolition as it was an integral part of the Moroccan social hierarchy. That social hierarchy consisted of regional leaders, *shurfa* (singular, *sharif*), who claimed descent from the Prophet Muhammed and were allies of the sultan when it served their interest. According to the governor, abolishing slavery would have angered them, and because the sultan relied on them for support, it would have been disruptive to his rule (Thomson 2011, 107–8). At the same time, drawing attention to Morocco's slavery system and claiming the desire to end it justified further colonial intrusions.

By 1880, Western pressure did succeed in forcing the closure of public slave markets of Morocco's urban centers (El Hamel 2013, 256). The only slave market that remained active was in the city of Marrakech, operating several times a week in the late afternoon when otherwise its stalls were used to sell yarn and thread (called Souk al-Ghazal). The historian Mohamed Ennaji estimated that between two and eight thousand enslaved people passed through Marrakech annually between 1876 and 1894, the fluctuating numbers reflecting Morocco's internal economic cycle, drought, and other factors (1999, 108).[14] In Marrakech, Fes, and other cities, slave markets were held at certain times and on particular days of the week, with an auctioneer leading the enslaved through the market and gathering bids. The auctioneer received a portion of the sale and brought the enslaved to the notary, who drew up a document of purchase for the buyer (Schroeter 1992, 193–94).

Bringing the issue of Moroccan slavery before the larger British public, a 1906 edition of the *Illustrated London News* featured a full-page spread composed of multiple photographs of the Marrakech slave market (Figure 1.13). Marketed as a middle-class sensationalist publication, the *Illustrated London News* often published full-page images from European colonies, using photographic collages to give the illusion of a cinematic narrative unfolding across the page as the reader's gaze moved from image to image (Collier 2012, 497–99). The story in question, entitled "The Moorish Slave Market and Its Pious Ceremonies," unfolds with a top left image depicting men praying before the market begins; the presence of the bottom half of a blurred leg in the left corner of the image and the low angle of the camera suggest the photographer was sitting on the ground, perhaps concealing his camera to make it less conspicuous to locals. In a different publication, a member of the British and Foreign Anti-Slavery Society noted that the European pressure to close slave markets and outlaw slavery had made locals tense, recounting that when he entered the slave market in Fes,

> everything stopped. The slaves who were being sold were hustled away before I could make any note of their appearance and manner, and presto! the slave dealers and the slave owners who had been so boisterously busy trafficing in human flesh, sat around in a circle in the most innocent manner possible, smoking *kief* [hashish]. (Bonsal 1893, 329)

Clearly, Moroccans during this period were aware of European criticism regarding slave markets and hid their activities. One may wonder why the enslaved did not approach Europeans asking for assistance, but as noted by Chouki El Hamel, "many women, men, and children sold into slavery did not know what was in store for them," and El Hamel asserts that if they were being resold, they might have realized from experience that the more pleasant and amicable they were, the better chance they might be purchased by a humane owner (2013, 257). The images from the *Illustrated London News* create an aesthetic of distance that implies objectivity, since it suggests the photographer is not interfering with the events unfolding before him or her and that the photograph presents a factual record of events. The poor quality of the images and the photographer's distance from his subjects thus underscore their authenticity.

The photograph on the top right shows men walking enslaved children through the market, and the center image of the page's layout shows the process involved in making a sale. In both images, various adults and children walk in a bare, open square surrounded by crumbling stalls that appear to be empty. The gray, hazy tone of these photographs, due to poor quality in this early period of half-tone photographic reproductions, coupled with the distance of the photographer from his subjects, renders captions essential to readers' understanding of the events taking place.

Three photographs at the page's bottom depict enslaved women. On the far left, a woman wearing white shades her face with her gown's sleeve, blocking her face from the camera's lens, indicating that the photographer's presence had been discovered by

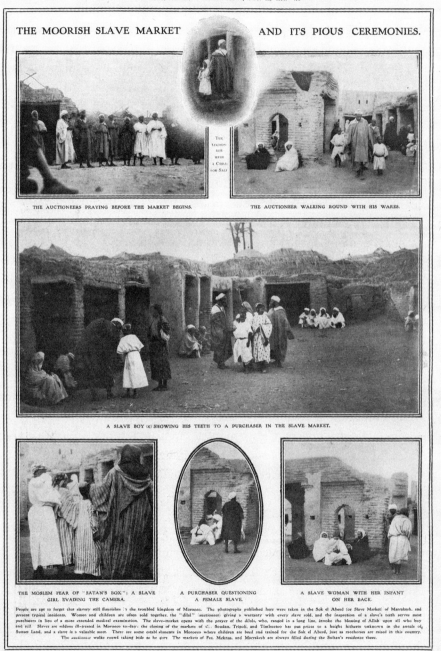

THE MOORISH SLAVE MARKET AND ITS PIOUS CEREMONIES.

THE
AUCTION-
EER
WITH
A CHILD
FOR SALE

THE AUCTIONEERS PRAYING BEFORE THE MARKET BEGINS.

THE AUCTIONEER WALKING ROUND WITH HIS WARES.

A SLAVE BOY (x) SHOWING HIS TEETH TO A PURCHASER IN THE SLAVE MARKET.

THE MOSLEM FEAR OF "SATAN'S BOX": A SLAVE
GIRL EVADING THE CAMERA.

A PURCHASER QUESTIONING
A FEMALE SLAVE.

A SLAVE WOMAN WITH HER INFANT
ON HER BACK.

People are apt to forget that slavery still flourishes in the troubled kingdom of Morocco. The photographs published here were taken in the Sok el Abeed (or Slave Market) of Marrakesh, and present typical incidents. Women and children are often sold together, the "dilal" (auctioneer) giving a warranty with every slave sold, and the inspection of a slave's teeth serves most purchasers in lieu of a more extended medical examination. The slave-market opens with the prayer of the dilals, who, ranged in a long line, invoke the blessing of Allah upon all who buy and sell. Slaves are seldom ill-treated in Morocco to-day: the closing of the markets of the Soudan, Tripoli, and Timbuctoo has put prices to a height hitherto unknown in the annals of Sunset Land, and a slave is a valuable asset. There are some establishments in Morocco where children are bred and trained for the Sok el Abeed, just as racehorses are raised in this country. The auctioneer walks round taking bids as he goes. The markets of Fez, Meknas, and Marrakesh are always filled during the Sultan's residence there.

Figure 1.13. "The Moorish Slave Market and Its Pious Ceremonies." *Illustrated London News*, September 22, 1906. Collection of the author.

locals, who prior to this image had failed to notice him. The caption reads, "The Moslem Fear of 'Satan's Box': A Slave Girl Evading the Camera." This caption suggests the woman's gesture is foolishly based on superstition, without considering that being photographed by a man might violate gender norms or that the demeaning nature of the transactions taking place might motivate the woman to avoid the camera. The art historian Zoe Strother critiqued the popular commentary in Europe at the time that explained the rejection and even fear of the camera in Africa as evidence of irrational religious beliefs and fear of "soul-stealing" magic. She asserts that a more common concern was the quite rational distrust of strangers with unknown agendas, which also seems to apply in this case (2013, 189, 201).

A caption at the bottom of the page describes Morocco as "a troubled Kingdom," where, nevertheless, "Slaves are seldom ill-treated," which undercuts the article's presumed intent to incite outrage among Europeans by exposing the persistence of slavery. But while antislavery sentiment coalesced among the general public and the press outside Morocco, the political reality inside Morocco remained more complex and ambiguous. For one thing, Europeans transacting business in Morocco were willing to ignore slavery in the interest of maintaining political and economic relations. For example, Sir John Drummond Hay, the British consul who urged the abolition of slavery in Morocco, wrote at the end of his career, which spanned from 1845 to 1886, that Moroccan slaves, unlike those in the Americas, were "not transported, like pigs, in vessels"; on the contrary, they were "the spoilt children of the house" (1896, 357). In truth, Hay succeeded in persuading the British government to take a lenient view of slavery so as not to jeopardize open trade between the two nations in order to prevent other European nations from gaining a foothold in Morocco (El Hamel 2013, 254; Wright 2002, 62).

At the same time that images of slave markets circulated through Europe, antislavery activists seem to have used images of dark-skinned musicians performing on Morocco's streets to draw attention to the plight of the enslaved. For example, in his book *Travels in Morocco*, the antislavery activist James Richardson gives an account of a performance by Black musicians in Tangier:

> At every Moorish feast of consequence (four of which are celebrated here in a year), the slaves of Tangier perambulate the streets with music and dancing, dressed in their holiday clothes, to beg alms from all classes of the population, especially Europeans. The money collected is deposited in the hands of their chief; to this is added the savings of the whole year. In the spring, all is spent in a feast, which lasts seven days. The slaves carry green ears of wheat, barley, and fresh dates about the town. The Moorish women kiss the new corn or fruit, and give the slaves a trifle of money. A slave, when he is dissatisfied with his master, sometimes will ask him to be allowed to go about begging until he gets money enough to buy his freedom. . . . All depends on his luck. It may be months, or even years, before he accumulates enough to purchase his ransom. (1860, 71)

Beyond illustrating local interest in Black male performers, Richardson's text makes clear that performing on the streets was a means of survival and even salvation for enslaved or newly manumitted Black Moroccans, being one of the few means available for them to earn money and, in some cases, buy their freedom. At the same time, Richardson's antislavery agenda is clear as his description paints enslaved people as beggars whose only hope for freedom was their ability to gather money through the performance of music.

BLACKNESS AND PERFORMING THE SULTAN'S POWER

Blackness was on display in early twentieth-century Morocco not only through performances on the streets by Black musicians but in the choreographed processions organized by the sultan featuring his large regiment of Black soldiers. Some of the earliest photographs to be taken by Europeans in Morocco were of the sultan's processions, but ironically enough, photography contributed to the downfall of the very sultan who first permitted it in Morocco. In 1894, the thirteen-year-old Moulay ʿAbd al-Aziz became sultan, having been chosen by the Grand Vizier Ahmed ben Moussa (better known as Ba-Hmed).[15] While this system of appointment was not in itself unusual, it is notable that Ba-Hmed was the grandson of a Black palace slave who, through intelligence and cunning, had risen through the ranks to become the most trusted advisor of Sultan Hassan I (ruled 1873–94). Ba-Hmed's rise to power was unusual, but it was not unique: since the sixteenth century, a number of enslaved men had played crucial roles in the sultan's palace, serving as advisors and personal assistants to the sultan, indicating that although there were correlations among Blackness, enslavement, and powerlessness, the lines were not impermeable, illustrating the complexity of racial categories in Morocco. Ba-Hmed exemplified an empowered Black man who, after Hassan I's death, took full executive power and manipulated the chain of succession. He ensured that the inexperienced and sheltered thirteen-year-old Moulay ʿAbd al-Aziz would serve as Morocco's next sultan, instead of Hassan I's elder sons, thereby preserving his own status within the palace where he continued to serve as the new sultan's regent. When Ba-Hmed died in 1900, and the sultan was finally free to rethink his regent's conservative policies, he welcomed European technology and modernity into his kingdom. Among the innovations he embraced with enthusiasm was photography when, in 1901, he hired the French photographer Gabriel Veyre as his private photography instructor.

Although the sultan controlled what and where Veyre could photograph, after a few months he granted Veyre permission to photograph his public processions, leading to the development of a photographic image that came to represent to the world the power and authority of the sultan: the sultan on horseback surrounded by an entourage of Black men (Figure 1.14). The Moroccan historian Mohammed Ennaji explained that "soldiers made power manifest, impressing it on the minds of commoners and notables

alike, surrounding it like a setting for a jewel, heightening its sparkle" (1999, 101). In his 1860 book *Le Maroc contemporain*, Narcisse Cotte, an attaché to the French consul, included a romanticized description of one particular member of the Black Guard as "a negro giant, whose face, surrounded by a white muslin with stripes of purple, resembled the fantastic sphinxes of old Egypt" (1860, 212). Comparing a member of the sultan's Black Guard to an ancient Egyptian sphinx served as an "othering" mechanism that illustrates Europeans' perception of "the Orient" as uniform and static (Said 1979). The tone of Cotte's comment—simultaneously impressed and ridiculing—evokes the fascinated superiority of the European gaze while also implying that slavery was seen as a deeply embedded, and colorful, characteristic of Moroccan society. The legions of Black men who walked with the sultan in procession became part of a conspicuous display of wealth and a distinct visual language of power and politics. Black men were not a sign of the sultan's popularity but of his prosperity, as he was responsible for clothing and housing his legions of soldiers and their families. Furthermore, the Black Guard was an example of the Black body being owned and displayed as an object.[16]

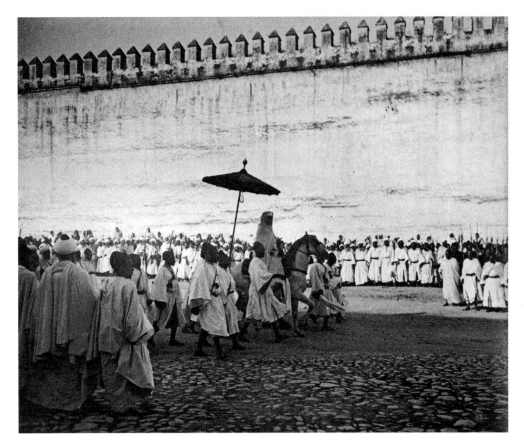

Figure 1.14. Gabriel Veyre, *Sortie du sultan*, March 28, 1901. Stereoscopic glass plate. Copyright Collection Gabriel Veyre.

In his 1905 book *Dans l'intimité du Sultan, au Maroc* Gabriel Veyre described the impressive sight of the sultan, seated on horseback, wearing white, and sheltered by a massive green parasol, processing during religious celebrations (such as *Mouloud*, the birth of the Prophet, and `*Aid el-Adha*)[17] surrounded by his Black Guard (*Garde Noire*) (2010, 179). These choreographed processions were accompanied by music, loud chanting crowds, animal sacrifices, and the firing of cannons. Celebrated outdoors in a large open space outside a mosque (*musalla*), much of the Moroccan public attended these ceremonies, which served as the most powerful ritual expressions of the monarch's power. Such processions gave "the population access to the experience of their nation as united, their ruler as powerful and legitimate, and their faith as unrivaled and victorious" (Combs-Shilling 1989, 187). Photographs of the Black Guard with the sultan in procession were clearly images of the monarch's wealth, prestige, and status.

At the same time, the processions, like the photographs of them taken by Veyre, obscure the tumultuous political and economic changes impacting Morocco. Despite the magnificence of these public spectacles, it was during the rule of Moulay `Abd al-Aziz (ruled 1894–1908) that the economic situation of the *makhzan* became increasingly precarious and impacted his ability to support a large number of slaves. Photographic equipment was one of many wasteful excesses that the sultan permitted himself. According to Veyre, the sultan owned an enormous quantity of cameras, "of all shapes and sizes," as well as darkroom equipment, all of which was left "in a pile, without [anyone] bothering to shelter it." It was "abandoned in the wind, in the sun, in the rain, in all the inclement weather, as playthings for the sheep that wandered around the palace" (2010, 11–12). Taking advantage of the sultan's weaknesses, in 1904, France signed treaties with Britain and Spain that allowed France to eventually occupy Morocco, which they justified on the grounds that Morocco's political stability had eroded under the ineffective leadership of the sultan. Rising anti-European sentiment at the time resulted in instances of Moroccan crowds violently attacking Europeans, including the beating of a French tourist who tried to photograph some locals (Miller 2013, 73; Porch 2005, 147).

On the fifth of August in 1907, a French battalion responded to anti-European aggression by bombarding Casablanca, and a fierce on-the-ground battle resulted in French occupation of the city and its surrounding countryside two days later. The French government used photography to document their colonial project, including one photograph that became a postcard depicting the arrival of the French minister Eugène Régnault to Casablanca in 1907 (Figure 1.3). The camera focused on Régnault and the French officials who accompanied him, but looming large in the foreground of the photograph is the slightly blurred image of a dark-skinned man, dressed in white and staring directly at the camera. This man's style of dress, a cape draped over his shoulders and felted wool hat perched at the top of his shaved head, identifies him as one of the sultan's Black soldiers. The sultan granted his Black Guard a new set of clothing each year made from the finest quality white cotton and sewn with silk thread, as their physical presentation

attested to the sultan's own prestige and status. As seen in this photograph, he wore a relatively short, collarless gown with wide bell-shaped sleeves, belted around the waist, and topped with a white cloak (*selham*). Visible in the photograph are the cords draped across his body to hold a leather satchel on one side and a dagger on the other side. The well-dressed Black Guard in this photograph was meant to reflect the power and authority of the sultan, but despite appearances, even before this photograph was taken, the power of the sultan was in decline, resulting in the decreased status of the Black Guard both within and outside the palace. The guard's blurred image in the photograph and the focus of the camera on the French officials behind him thus seems to predict the eventual demise of the Black Guard's political status, while the presence of the French soldiers signals the rise of a new military order. Moroccans, frustrated with the sultan's ineffectual leadership and perceived Europhilia, sought to replace him with a leader who would provide more resistance to European influence. Eventually, widespread public dissatisfaction, failed crops, and drought, as well as increased economic difficulties, led to Moulay 'Abd al-Aziz being usurped by his brother Moulay 'Abd al-Hafid in 1908 (ruled 1908–12).

Moulay 'Abd al-Hafid quickly found himself in immense financial debt, which led to increased reparations and taxes demanded by France. Debt left him in an economic and political stranglehold and led him to sign the Treaty of Fes in March of 1912, which resulted in the creation of the French Protectorate and his forced abdication of the throne that same year. Such political turmoil further diminished the status of the Black Guard, and according to historian Rita Aouad Badoual, at this point "slaves in the entourage of the sultan were still numerous but deprived of their military functions and isolated from the political scene" (2013, 144). The French official Dr. L. Arnaud wrote that after the formation of the protectorate, a number of soldiers deserted the army and others were deemed unfit for service, resulting in the reconfiguration of the Black Guard into a smaller army by the French and a decrease in their power (1940, 39).

When the French established the protectorate, they placed a new sultan, Moulay Yusuf (ruled 1912–27), on the throne and organized annual 'Aid el-Adha ceremonial processions in order to show their respect for Moroccan traditions and to maintain the facade that the sultan retained political authority under the protectorate government, even though he had been chosen and appointed by the French (Holden 2011). None of the tensions regarding the declining power of the Moroccan sultan is evident in photographs taken of him. The postcard in Figure 1.15 shows Moulay Yusuf on horseback surrounded by his palace guards who accompany him on foot; one mounted on a horse holds a massive parasol to shade the sultan.[18]

The uniformly white garments worn by the uniformly Black men in the postcard conveyed a notion of order, repeating an image of the sultan surrounded by his Black Guard that dated to 1901. Furthermore, it conveyed the colonial message that Moroccan society was safe for tourists. Once Morocco was under French control, the practice of

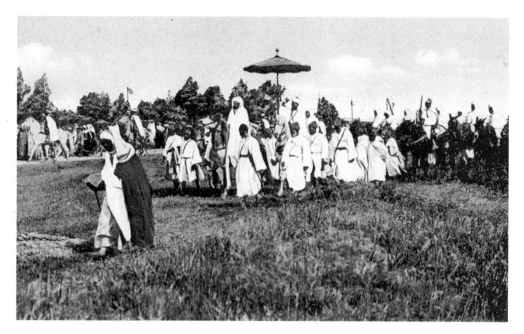

Figure 1.15. Photographer unknown, *Maroc. – Le Sultan Moulay Yussef se rend à la prière.* Published by Photo Flandrin, Casablanca, circa 1912. Collection of the author.

photography took off, and Morocco became a favored destination for both amateur and professional photographers (Goldsworthy 2009, 25, 27). One of the inadvertent consequences of this burgeoning photographic enterprise was the forging of a new identity for Black Moroccans as Gnawa.

MOROCCO, TOURISM, AND
BLACK SELF-REPRESENTATION

With the French Protectorate came the rapid rise of tourism in Morocco between 1919 and the mid-1930s. During this period, travel guides and ethnographic studies conducted by French colonial officers often mention Black street performers. In one article entitled "A Trip to Morocco," a traveler describes watching, with determined impassivity, the musical performance of Black men in Marrakech's Djemma el Fna square: "We were shown an old slave and a star turn, but a stamping crowd of oldish negroes with beaded headdresses failed to stir us to any wild enthusiasm even when bloodcurdling yells were thrown in to give the show a spice of excitement" (Williamson 1938, 205). In his book *Morocco the Piquant*, George Edmund Holt wrote about the diversity in Tangier, describing Black musicians thus: "[A] Sudanese dancer finds there some fellow-minstrel from the Sudan, and together they clash their cymbals and sing their songs and go through their old dances" (1914, 11). Jean Besancenot, who traveled widely

in Morocco in the 1930s, photographed and later sketched a dark-skinned musician whom he referred to as a person of the "humblest condition," along the lines of snake charmers, acrobats, and water carriers, who dressed in a simple patched tunic (1990, 141). Such comments reflect the low esteem in which many travelers held the performance of dark-skinned musicians, whom they viewed as inconsequential buskers of marginal status. And yet, despite being routinely dismissed and stigmatized, the record shows that these Black performers drew disproportionate attention from photographers as embodiments of Moroccan exoticism.

During the period of rising tourism and increased French military presence, photographs of Black musicians were reissued as postcards to be sent back to Europe by both tourists and colonial soldiers stationed in Morocco. Many of the photographs feature groups of men on the streets together performing music, suggesting that these men are profiting from the burgeoning tourist industry. For example, the postcard in Figure 1.16 was labeled "Danseurs Soudanais" and shows two drummers and a cymbal player walking down a public street. Two barefoot men wear cowrie-adorned hats while the man in the middle wears simple sandals and a cowrie-adorned sash. Their staggered pose indicates that their position in the photograph may have been purposefully arranged so that they were all visible to the camera. The multistoried building faintly visible in the background and the carefully ordered palm trees planted along a wide boulevard

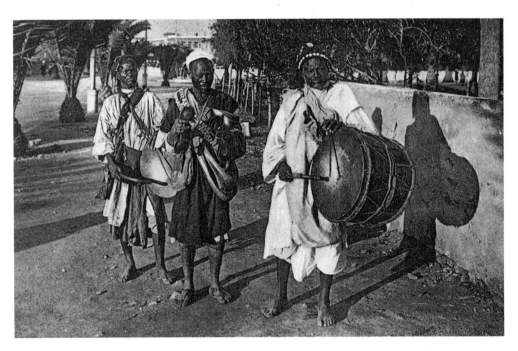

Figure 1.16. Photographer and publisher unknown, *Danseurs Soudanais*, circa 1910. Collection of the author.

suggest that this postcard was made from a photograph taken after the formation of the French Protectorate in 1912. French associationist policies in Morocco depended upon the building of new cities alongside ancient walled cities like Fes and Marrakech (referred to as the *medina*).

In 1914, Hubert Lyautey, the first French resident general in Morocco, had recruited French architect Henry Prost to design nine European quarters that included new retail outlets, hotels, and housing for Morocco's expanding European community and for the administrative offices needed to run the protectorate (Hunter 2007, 584). Apparently, the Black performers in Figure 1.16 had left the countryside or the section of the city reserved for locals in order to play for European tourists, who would have been staying in hotels located in the newly built European section (referred to as the Ville Nouvelle), further illustrating how Black performers capitalized on rising numbers of tourists. During this period, many slave-owning families were forced to emancipate large numbers of slaves they could no longer maintain (Ennaji 1999, 9). The resulting socioeconomic flux led to waves of people migrating from the south to urban centers in the north, confirmed by early twentieth-century French accounts, such as that of Georges Salmon who wrote in 1904 that "in Tangier, in effect, the blacks come from the Sous, the southern region of the Atlas" (1904, 262).[19] The work of historian Madia Thomson (2011) also confirms that Amazigh-speaking manumitted slaves from the Sous moved into Moroccan cities, especially the international zone of Tangier, where they created communities bound by a shared language and culture.

Some postcards suggest the gradual professionalization of Black performers, who may have migrated from the Sous during this period. In Figure 1.17, for example, a group of dark-skinned men of different ages surround a lighter-skinned seated man, who wears clothing associated with elite status, while the musicians wear mismatched, ragged outfits. Offsetting the haphazard outfits, the cowrie-adorned sashes and caps (some with fringe) unite the men in this photograph, giving them the appearance of a somewhat unified musical troupe. The caption of the postcard reads: "Messieurs Amar brought back a tribe of Chleuhs from the southern Atlas [mountains] from their African tour." This card's publisher and date of publication remain unknown and the caption difficult to interpret. It remains unknown whether there were two men who led the group but only one was shown in the photograph. Given the style of the picture, it appears that this troupe made a tour of France or elsewhere in Europe to perform, perhaps in one of the colonial expositions. The seated man is presumably one Mr. Amar and those around him the "Chleuhs," a common slang term for Imazighen from southwestern Morocco. However, it is also possible that the person who wrote the caption did not consider the dark-skinned men to be Moroccan, viewing them as a group from sub-Saharan Africa. The fact that the majority of the postcards in this chapter were labeled as "Nègre du Soudan," "Type de Soudanais," and "Danseurs Soudanais" reinforces the point that

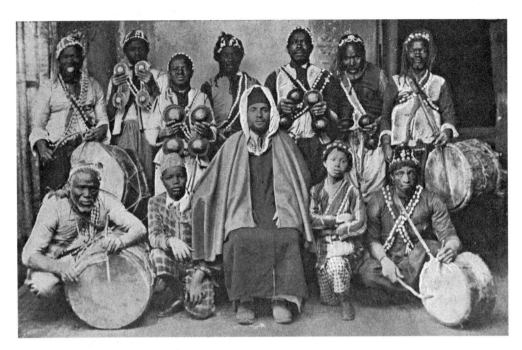

Figure 1.17. Photographer and publisher unknown, *Mm. Amar ont ramené de leur Tournée d'Afrique une tribu de Chleuhs du Sud Atlas*, circa 1910. Collection of the author.

Black men did not fit into European racial classifications that divided Moroccans into distinct categories as either Arab, Berber, or Jew. This process of othering impacted how Black Moroccans represented themselves to the camera and contributed to the codification of their identity as "Gnawa."

In her analysis of early twentieth-century tourist images of the Caribbean, art historian Krista Thompson has persuasively shown how the consumption of culture by outsiders feeds back into its production. She writes that Western "images created to project an image to the outside world also shaped how local communities learned to see themselves and their environments" (Thompson 2006, 12). This feedback process has resulted in Black men in Morocco adopting the identity of public performers, dating back to the early twentieth century. Notable in Figure 1.17 is the figure standing at the far left of the viewer, who is sticking out his tongue for the camera, seemingly embracing the descriptor "clown of the street" that was bestowed on Gnawa performers by early twentieth-century French ethnographer René Brunel (1955). The poses taken by the man in Figures 1.8, 1.9, 1.10, and 1.11 also suggest a man posing in an exaggeratedly cheerful manner. Hence, a body of images was built up into a European imaginary that ultimately redounded upon Black musicians as a set of expectations to meet, paradigms to fulfill, and models to replicate. Black men were shown as exotic and rhythmically gifted bearers of tradition who became part of a homogeneous community known as "Gnawa." Numerous postcards from Morocco depict Black men positioning themselves in front

of the camera and performing as clowns, which can be compared to similar images of blackface minstrels circulating globally at the time.

At the same time, in the photographs we see evidence of men consciously choosing to dress in a particular manner to create a unified appearance, a style of dress that came to be associated with "Gnawa." Contemporary Gnawa musicians commonly wear either red Fes-style caps with black tassels and cowries or bonnet-style caps with long strands of hair-like braids hanging from the top and sides of the hat's crown. The antiquity of this style of headdress is undeterminable due to the fact that the hats' core material, wool or other fabric, tends to disintegrate over time and people reuse older beads and pendants on new hats. However, we can, at minimum, date the appearance of this style of headdress to photographic images and written records from the early twentieth century, indicating that it became a symbol of group membership.[20]

Furthermore, a hat identified as "Gnawa" was given to the Musée de l'Homme in Paris in 1905. Currently in the collection of the Musée du quai Branly-Jacques Chirac in Paris, it was woven from palm fronds. Its maker decorated it with cowrie shells arranged in an apparently haphazard pattern and added a small amulet constructed from leather (Figure 1.18). Visual records reveal that one of the striking characteristics of early twentieth-century Gnawa headdresses is their lack of uniformity. Only two visual

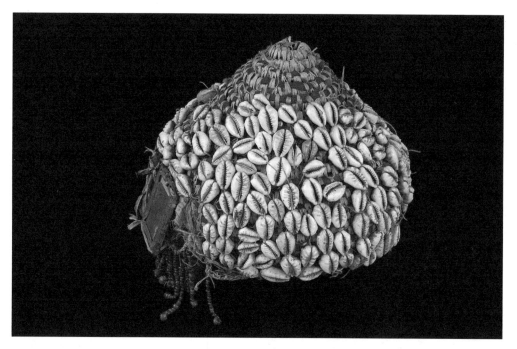

Figure 1.18. Man's hat, Morocco, before 1905. Plant fibers, weaving, cowrie shells, glass beads, 12.5 × 19.5 × 19.5 cm. Inv. 71.1905. Musée du quai Branly-Jacques Chirac, Paris, France. Copyright Musée du quai Branly-Jacques Chirac. Dist. RMN–Grand Palais/Art Resource, NY.

aspects link these headdresses across time: the presence of hanging tresses and cowrie shells. While it might be tempting to posit a connection between Gnawa headdresses and Rastafarian dreadlocks, the latter postdates the formation of Gnawa communities.[21]

One striking image of a dark-skinned musician was taken by Marcelin Flandrin (1889–1957), who traveled to Morocco for his military service where he became a photographer for the army. Flandrin's photograph, seen in Figure 1.19 and taken around 1920, shows a man wearing a headdress and cowrie-adorned sash similar to that seen in many postcards. A similar photograph of the same man appears to have been tightly cropped and reproduced in an advertising campaign by the renowned Swiss chocolatier Chocolat Suchard. Between 1930 and 1932, the company printed a series of three hundred cards showing French colonial scenes, referred to as the *Collection Coloniale*, that could be collected by consumers and arranged inside albums (Dale 2011, 33). Card number 103, seen in Figure 1.20a and 1.20b, features a caption identifying the subject as "Un noir marocain," and the brief text recounts that Black people were brought to Morocco by conquerors or slave merchants. The Colonial Collection included this Black performer, along with subjects from other French colonial interests, and transformed them into images of empire in order "to familiarize the public with the idea of *la plus grande France*" and encourage enthusiasm for the colonial project within the metropole (Dale 2011, 35). The transit of this image from photograph to collecting card reveals how photographs of Black Moroccans were part of the colonial currency and contributed to the colonial spectacle. Although the card did not employ the term "Gnawa," by the 1930s the link between enslavement, Blackness, and male street performers had been fixed in the European imagination.

Through the feedback process discussed above, photography contributed to the creation of a dress style and a unique brand associated with Gnawa musicians today. The sheer quantity and consistency of Black male performers wearing specialized clothing that involved such elements as cowries, long tresses, decorative caps, and patchwork gowns indicates that they were playing a part in their own image-construction, collaborating in some sense with photographers to frame and assert their cultural identity through dress and pose. Thus, at the end of the nineteenth century, the camera functioned to codify a public identity for an ethnically and historically complex hybrid community of phenotypically Black Moroccan men drawn from various regions of Morocco. Manumitted Sahelian Africans, members of the sultan's Black Guard, and rural Black laborers joined together to become Gnawa. While this process will be discussed further in chapter 3, it is worth noting that low-status dark-skinned laborers (referred to as Harratin) throughout history relocated from southern oases to urban centers during times of drought or in response to economic or social instability; some re-created an identity for themselves as "Gnawa."

Performing for the camera became a means for subaltern actors to fashion their cultural identity into a commodity for themselves. Sidney Kasfir argues that the Samburu

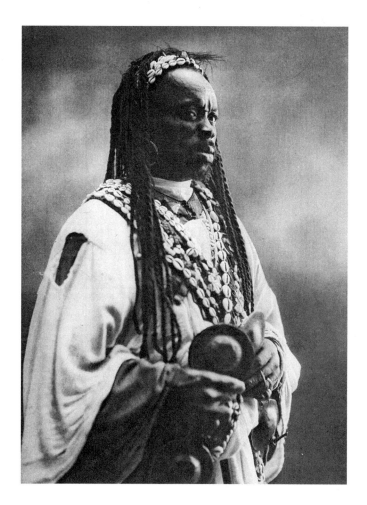

Figure 1.19. Photograph
by Marcelin Flandrin,
circa 1920. Archive
Maison de la Photographie
Marrakech, Morocco.

cattle-herders of northern Kenya took on a commodified identity by way of their rep-
resentation in foreign-produced films and on postcards. Since their livelihood had suf-
fered due to environmental disaster and political marginalization, their engagement
with the camera became a practical alternative mode of subsistence: "A crucial point,
however, is that it is the *representation* that is sold and consumed and not pastoralist
culture itself, as is sometimes claimed" (Kasfir 2007, 308). This is an important distinc-
tion to keep in mind for our purposes. Like Samburu men, Gnawa have been savvy
participants in the global market, presenting a theatricalized version of themselves to
the European camera that draws upon local conceptions of Blackness but, at the same
time, plays to European stereotypes. While people may exaggerate certain aspects of
their identity for the consumer market, this does not mean that the culture itself has
been "sold out." While little information exists as to the practices and beliefs of enslaved
people in precolonial Morocco, Black men performed music in private ceremonial occa-
sions to induce possession by spirits, but these were not photographed by outsiders,

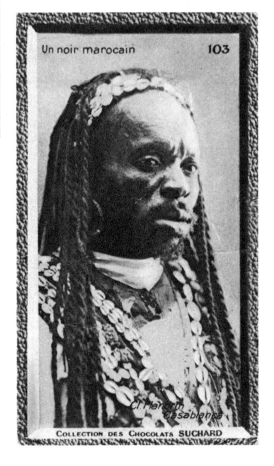

Figure 1.20. Photograph by Marcelin Flandrin, *Un noir marocain*, 1920. Collection des Chocolats Suchard. Card no. 103, circa 1930–32. Collection of the author.

suggesting that the community prevented European photographers entry into them or that the photographers snubbed them.

The hundreds of photographs of dark-skinned musicians taken by Europeans and transformed into postcards illustrate how marginalized communities engaged in the active commoditization of music for a European audience. As we have seen, the codification of "Gnawa" as a distinct identity intersects with increased European involvement in Morocco and the subsequent decline of Morocco's hierarchical social structure. United by their dark phenotypes and marginalized status, men of diverse origins borrowed, adapted, mixed, and blended aesthetic styles from various groups, crossing geographic, cultural, and religious borders to come together as Gnawa. Former enslaved people responded to the gradual disintegration of the institution of slavery and their resulting economic insecurity by creating communities that relied on the self-marketing of their music to a European audience—often by performing first and foremost for photographers. The repetition of the image of the Black male performer contributed to the creation of an identity as Gnawa.

2

Black Women, Photographic Representation, and Female Agency

SINCE THE LATE NINETEENTH CENTURY, Black men in Morocco have been savvy participants in the global market, using musical instruments and styles of dress to represent their identity as African, and specifically as Gnawa—recognizing the power of photography to construct and propagate that identity as a consumable image. Accordingly, photographs of Black men dominate the colonial-era archive, while photographs showing women as active agents are notably absent. Instead, what proliferated in nineteenth- and early twentieth-century European imagery—both painting and photography—were images of Black women as concubines and servants, imagery that inscribed racial identities onto the body, showing women as passive victims of Morocco's slavery system. Male musicians have been performing spirit-possession music for a largely female audience and under the auspices of female diviners. As shown in chapter 1, men took that repertoire of songs into the streets and performed as wandering minstrels. Meanwhile, there are no known photographs documenting Gnawa spirit-possession and healing ceremonies from the late nineteenth century and none showing women's role therein.

It was only in postcolonial Morocco that cameras began to record Gnawa ceremonies, and since then, films and photographs that feature women, albeit still rare, have become increasingly common. While an outsider might construe the presence of the camera as an opportunity for the invisible to become visible, for women's agency to finally be acknowledged, the reality is that most women forbid photography during the ceremonies that they themselves organize and attend. I witnessed the aversion to photography among women in 2010 at the home of Mokhtar Gania, a male musician from a renowned family of musicians living in the town of Essaouira. On the occasion I observed, a group of Moroccan women sat in a semicircle around Gania, who, sitting on the floor, was flanked by four male musicians. As I listened to the rhythmic sounds

of the music, breathing in the incense used to invoke spirits into possession, Sidi Hamu, a Gnawa spirit associated with slaughterhouses and the color red, suddenly possessed a woman who stood up to dance in front of the male musicians. As she swung her head back and forth, the woman's headscarf fell off and her thick, black hair cascaded down her back; then she bent forward and began swinging her hair from side to side. Zaida Gania, Mokhtar's sister and a diviner (*mqaddema*), stood up and covered the woman's face with a red cloth, the color preferred by the spirit, and held a smoking brazier filled with incense in front of her face.

As I picked up my camera to photograph this woman, having been granted permission by Mokhtar to take pictures before the beginning of the ceremony, Zaida signaled that I should put it away and later explained to me that while I could photograph the male musicians who sat facing the audience, I should refrain from pointing my camera in the direction of women. Over the years, this experience proved to be the rule. I attended dozens of ceremonies where Moroccan women reprimanded both locals and foreigners for taking photographs of them, stopping those who tried to film and photograph with their cell phones and cameras. They did not object if someone took photographs of male musicians at a ceremony.

Why did women react negatively to the camera? Early representations of Black women in the visual archive lie behind the rejection of the camera that I observed among women at Gnawa ceremonies. This chapter begins with late nineteenth- and early twentieth-century photographs by Europeans and ends with contemporary attempts by women to control self-representations. The historical relationship between women and photography is fraught in North Africa, and this is particularly amplified in the case of Black women in North Africa, who, when depicted, were historically shown in positions of servitude. Their long and complex history with the camera has led them to seek to control their own self-images. Given the fact that the technology of the camera has historically lain in male hands, this has meant choosing invisibility. While invisibility suggests the erasure of agency, it is paradoxically a choice that increases empowerment by allowing women to control if and when they are photographed and to decide who has the right to circulate their images.

Two studies on race and representation have proven useful, conceptually and methodologically, to this chapter's inquiry. In her book *At the Edge of Sight*, Shawn Michelle Smith invites readers to ask questions that also guide this chapter: "What resides at the literal and metaphoric edge of the photograph? . . . What cannot be seen because the photographer does not focus on it? What cannot be seen because cultural discourses and habits of thought obscure it? What simply does not register photographically?" (2013, 8). Similar issues are raised by Mimi Sheller in her book *Citizenship from Below*, which discusses slavery in the Caribbean. She poses a question pertinent to this study: "What dilemmas of representation face historians of slavery and emancipation—or of any field more generally in which the subjects of history cannot 'speak' or be represented

in official evidentiary terms?" (2012, 5). Sheller searches for alternative sources of representation to the colonial narratives—those found beneath the surface or outside the frame. In her chapter on tourist photography from the turn of the twentieth century, Sheller pays as much attention to what those photographs fail to describe and what the travel narratives do not say as she does to what they ostensibly describe and record. In order to discover the agency of the subaltern, she identifies points of "instability, disruption, and opposition to the colonial gaze" (2012, 216). Borrowing from these precedents, this chapter looks beyond the frame of the photograph to examine what we can learn from what is not seen as we seek to unravel the cultural forces that have made invisibility a desirable choice.

MISSING WOMEN, COLONIAL PHOTOGRAPHY, AND SPIRIT POSSESSION

In contemporary Morocco, women are the primary participants in all-night Gnawa spirit-possession ceremonies, the *lila*. Gnawa men play music to invoke spirits to possess their human hosts, who, in most cases, are women. As noted, photographs of female participation in Gnawa ceremonies from the colonial era are nonexistent. Compounding this ethnographic lacuna is the fact that detailed descriptions of Gnawa ceremonies and women's involvement are also rare. If Gnawa ceremonies are discussed at all in colonial accounts, it is in pejorative terms, signaling that Europeans had little interest in attending or recording such ceremonies. Legy, in his book *Folklore of Morocco*, for example, described Gnawa as a "devil-worshipping brotherhood organized on the lines of the religious societies," and wrote that orthodox Muslims referred to them as the "Brotherhood of Satan" (1935, 38).

Several articles that mention Gnawa practices appeared in the journal *Archives marocaines*, which was published between 1904 and 1934. One of the editors, Georges Salmon, wrote about religious practices in the northern city of Tangier in the 1904 edition of the journal. Salmon noted that Gnawa consisted of Black people from the Sous region of southwestern Morocco, who were often considered to be no more than street acrobats who primarily gathered money from foreign tourists. However, he noted that they also held a public "celebration of fava beans" (*fêtes de fève*) that consisted of wandering through the streets to collect money to buy a bull that they adorned with streamers. Led down the streets of Tangier, the bull, a goat, and chickens were preceded by people holding lit candles. The procession continued until it arrived at a group of rocks painted white by the edge of the sea. Salmon recounted that these rocks signaled the location of sea spirits, and Gnawa sacrificed the animals in front of a large crowd of locals, chanting prayers, playing music, and dancing; once they threw the fava beans into the water, the group returned to someone's home, "possibly that of a madman," recounted Salmon, to hold a ceremony (which he called a *laîla*) (1904, 264–65).

While Salmon and his companions also witnessed the public sacrifice of animals, he does not describe spirit possession in any detail, leading one to believe that he was not invited to witness it or not interested in attending a ceremony. He concluded his article by describing Gnawa as Black people who served as "intermediary forces between the djinn and people," noting that such beliefs were diminishing each day. He wrote, "that it can even be said that this belief no longer finds true adepts except in the female population, among the negroes and the weak-minded. Good Muslims and educated people judge them severely" (1904, 269). Salmon found Gnawa practices little more than curious manifestations of an inferior form of Islam that were repugnant to good Muslims, and, as he wrote, they "reveal the survivals of animism" (1904, 272).

Gnawa ceremonies were likewise accorded little respect by scholars of Moroccan Islam, such as Émile Dermenghem, who relegated Moroccan Gnawa to two paragraphs in his mid-twentieth-century book on North African Sufism, acknowledging that "we have rarely described their [Gnawa] proper festivals and studied their music and their songs" (1954, 285). He based his account on work done by Georges Salmon, repeating Salmon's description of the bean ceremony and revealing how writers often relied on secondary sources. However, like the previous descriptions, he does note the central role women play in Gnawa ceremonies.

In his account of a ceremony in the city of Salé, from a 1906 edition of *Archives marocains*, L. Mercier described a *Mousem des Guenâoua*, or "Gnawa ceremony," that was dominated by enslaved Black women, who, he noted, played an "active role as important as that of men" (1906, 110). Due to the short time that Mercier spent in the region, he did not see an actual Gnawa ceremony but based his description on that of a local informant. His article did contain some crucial information, noting that enslaved Black people held ceremonies for themselves as well as important clients across all classes of society, indicating that Gnawa musicians and female diviners (*mqaddemat*) were hired to provide a service for others (1906, 111). Attendance at a ceremony was not akin to declaring one's Gnawa identity, and the work that Black women and musicians did for clientele at a ceremony was a financial transaction. In other words, just because a woman attended a Gnawa *lila* does not mean that she self-identified as "Gnawa."

In the article "Negro Influence in Morocco" (1934), Edward Westermarck also wrote about the many women possessed at a Gnawa ceremony, "danc[ing] for hours, even the whole night" and dressed in clothing associated with particular spirits. His account emphasizes the sensational aspects of the spectacle: "Some of the women beat their necks with cords, which were among the clothes, or with sticks, or lacerate their thighs with a dagger, and many of them eat fire" (1934, 625). Unfortunately, it appears that Westermarck, like most foreigners who give accounts of Gnawa ceremonies, did not actually attend one. He wrote, "Unfortunately I did not arrive at the spot until the proceedings were just over, but I am speaking from credible hearsay" (1934, 626).

The sensational nature of Gnawa practices did not go unheeded by French officials who exploited the perceived exoticism of Gnawa music, holding public gatherings that featured male musicians to benefit a burgeoning tourism industry. The public performance of music by men purged of spirit possession and the participation of women was deemed "folkloric" and seen as a means to attract European tourists. Women, therefore, did not engage in public Gnawa performances. One may assume that societal strictures about Muslim women being seen publicly by men may have restricted them from public performance, but the reality was much more complex. Low-status women often worked outside of the home while elite women were the ones relegated to the private realm. For example, the Moroccan sociologist Fatima Mernissi addressed how class impacted physical mobility in her semiautobiographical book *Dreams of Trespass*. The book mixes fiction with fact to recount her experience growing up in 1940s urban Morocco as part of an elite extended family that Mernissi refers to as a *harem*. Class privilege resulted in wealthy women (i.e., the *harem*) being kept inside the extended family home, while male members supported them financially. Elite women had access to the outside world restricted by the male patriarchy, not being allowed to listen to the radio or leave the house without supervision. While Mernissi's mother, grandmothers, and female cousins had few experiences outside the family's urban home, the mobility of low-status women to leave the house was noted by Mernissi when the narrator's aunt, Lalla Radia, defends the structure of the *harem* as a privilege enjoyed by elite women:

> All respectable men provided for their womenfolk, so that they did not have to go out into dangerous, unsafe streets. They gave them lovely palaces with marble floors and fountains, good food, nice clothes and jewelry. What more did a woman need to be happy? It was only poor women like Luza, the wife of Ahmed the doorkeeper, who needed to go outside, to work and feed themselves. Privileged women were spared that trauma. (1994, 46)

In this passage, Mernissi reflects on how the status of elite women contributed to their invisibility in the public realm. On the other hand, low-status women visited the market, ran errands, and worked outside the home. So why did Gnawa ceremonial practices that involved spirit possession remain private?

In Mernissi's book, one chapter dedicated to a woman named Lalla Mina provides insight into why spirit possession was restricted to shrines and/or private homes of Gnawa clients. Mernissi described Mina as a woman whose "serene black face" contrasted with the yellow gown and headscarf that she wore to honor the Gnawa spirit named Lalla Mira, whose preferred color was yellow (1994, 157). Mina attended Gnawa ceremonies in the home of a man named Sidi Belal, who, like Mina, "had originally come from the Sudan and begun his life in Morocco as an uprooted slave" (1994, 159).

The spirits, she continued, "seemed to recruit more easily from the powerless and the poor," and when women from high-ranking families attended Gnawa gatherings, Mernissi wrote, they hid the fact from the male members of their families, who looked down upon them as breaking religious law (1994, 159).

Mernissi refers to a Gnawa *lila* as a "forbidden" and "subversive" ceremony that was an expression of "women's solidarity" that freed women "for once of all external pressures" (1994, 158–61). According to her, Moroccan men from the privileged class, who were more likely to be literate, dismissed Gnawa spirit possession as superstition derived from sub-Saharan animism, and elite women hid participation from their families. Several early twentieth-century documents reinforce Mernissi's account that both Moroccans and Europeans viewed Gnawa practices negatively, calling the elite women in Fes who attended *lila* with their slaves "ignorant" (Michaux-Bellaire 1907, 320). One article states that "the Gnawa population" in the city of Salé consists entirely of Black slaves, "but they have quite a large customer base from all classes of society" (Mercier 1906, 141). These clients, however, do not attend public Gnawa gatherings, which the author describes as barbarous and rude. Rather their clients prefer to be more discreet and seek their healing services in secret (Mercier 1906, 142). Another article states that men from elite families also attended Gnawa ceremonies, listing some of the men by name and noting that "they are men of little intelligence" (Michaux-Bellaire and Salmon 1905, 203). Such accounts illustrate the contempt held toward Gnawa practices during the early twentieth century and explain their invisibility. Such animosity may have contributed to the reason that Gnawa *lila* were held at night and in private homes away from the wider public, contributing to their invisibility.

Despite the public visibility of lower-status women in urban Morocco, the visual representation of women actively involved in Gnawa ceremonial practices would have contradicted and fallen outside of colonial constructions of Black womanhood as passive and servile. Rather when the participation of Black women in ceremonies was discussed, it was limited to one or two sentences, and they were typically presented as performing a service for elite women. Similarly, when Black women were photographed, they were presented as subservient, showing them as concubines and servants and producing the paradox underlying this chapter. Namely, the blindness of the colonial gaze to Black women's powerful role in spirit-possession ceremonies meant the only extant representations of Black women assigned them subservient status. Thus invisibility was thrust upon Black women that resulted in a segment of the Moroccan population almost completely absent from the photographic record.

MORE THAN CONCUBINES AND SERVANTS

Compared to other areas of Africa, few colonial-era photographers took or published images of Black women in Morocco despite the fact that historians estimate that the

largest numbers of enslaved people displaced from south of the Sahara were women (Ennaji 1999, 17–19). The monarchy as well as elites living in the cities of Fes, Salé, Safi, and Marrakech used enslaved women as domestic servants, wet nurses, entertainers, and concubines. Enslaved women also worked in rural areas for powerful families and religious shrines (*zawiya*), or for nomadic families who might own one or two enslaved women to perform domestic chores. According to historians, rural female slaves were little more than beasts of burden, harvesting crops, collecting water and firewood, caring for offspring, and performing a wide range of domestic chores (Ennaji 1999, 5; El Hamel 2008b, 84).

Colonial-era writers reduced Black women to servile status, portraying dark-skinned women in stereotypical guises as concubines or household servants in elite households. For example, a written account of Morocco dating to 1809 describes concubines as

> black women, purchased originally at Timbuctoo; they reside in the house with the wives, performing menial offices of the domestic establishment. The children of these concubines, when not the master's offspring, are born slaves, and inherited by him, who either keeps them for the purpose of marrying them to some black slave of his own, or sells them in the public market. (Jackson 1809, 162)

Such accounts are relatively rare and, when they do exist, deny Black women any sense of agency and portray them as subject to the whims of their so-called masters.

Photographers working in Morocco did not sexualize women to the same extent as those from Algeria and sub-Saharan Africa, where photographs of topless women became a common trope (Alloula 1986; Doy 1998; Geary 2002, 2008; Willis and Williams 2002). At the same early twentieth-century moment when European photographs were promulgating images of hypersexualized women from sub-Saharan Africa, both men and women in coastal West Africa were flocking to studios to have their photographs taken by African photographers, resulting in more complex and varied images, many of which show agency on the part of the Black female subject (Peffer and Cameron 2013). Similarly, men and women posed comfortably for the camera in East Africa, adorning themselves in ways that allowed them to suggest wealth and sophistication and, at the same time, engage with a form of technology associated with global connectivity (Meier 2013, 106). Unlike other areas of Africa, few Moroccans visited photographic studios to have their portraits taken.[1]

This phenomenon was largely due to the fact that the Moroccan sultan banned photography in the interior until 1901, which had the side effect of preventing locals from actively embracing photography. When the sultan lifted photographic restrictions, Morocco's Jewish population was the first to adopt photography and open studios, while Muslims typically clung to earlier proclamations that indicted photography in the proscription against mimetic imagery in the *Hadith* (Traditions of the Prophet).

Moreover, many Moroccans rejected photography on political grounds, seeing it as a destructive Western cultural incursion and an attack on the Muslim faith (Goldsworthy 2009, 24, 41–43, 151–53).[2]

Within this context 'Abd al-Aziz, the sultan who lifted the ban on photography and pursued his own avid interest in photography, aroused the contempt of the local population. According to one early twentieth-century French observer, photographs of the sultan made their way onto postcards that were sold in the shops of Tangier, causing a "scandal among his subjects, who, as faithful observers of the Coran, don't allow the representation of the human body" (Zeys 1908, 7). In his embrace of photography, the sultan went so far as to take photographs in his private residence, including in the female quarters of the imperial palace, where he photographed women. One such photograph, published in Gabriel Veyre's *Dans l'intimité du Sultan, au Maroc 1901–1905* (Figure 2.1), taken in 1902, is of two women whom Veyre identified as "black matrons charged with the surveillance of the sultan's wives" (2010, 144). According to Veyre, the sultan photographed women in his *harem*, instructing them to dress in their most beautiful attire and posing them for the camera (2010, 115).

In this photograph, sunlight bathes the skin of these two women whose exact identities remain unknown, although their style of dress indicates access to wealth: large-sleeved caftans (gowns), gold necklaces, jeweled tiaras, and flowing white headscarves that drape onto the ground making them appear to be floating on a cloud. The two women sit upright with their hands placed firmly on their thighs in European-style chairs (although the chairs are barely visible). Such chairs were not typical of Moroccan households of the time, where low sofa-like benches with cushions placed along the walls were the norm. This manner of sitting, in addition to the telephone and sign with electric lights captured in the background, signals the sultan's effort to embrace technology associated with European modernity. While the sultan did not depict these women in a sexualized manner, they serve a decidedly decorative and commodified role as representations of the wealth and status of the sultan. The photographs themselves as well as the imported goods featured in them demonstrate how the sultan was engaging with Western expressions of modernity and global connectivity. The similarity of the women's poses and facial expressions, age, and style of dress serves to obscure their individuality and suggests that their bodies were also seen as objects of conspicuous consumption that allowed the sultan to perform his wealth and status.[3]

Since their identity remains unknown, their identification by Veyre as "Black" coincides with the historical fact that women enslaved from Sahelian Africa were often part of a sultan's *harem* and served as status symbols associated with luxury and prestige. The decorated surface of the women's bodies reflected the status of the household of which they were a part. Furthermore, the use of the word "Black" by Veyre can be attributed to a racial discourse established by Europeans that associated Blackness with servitude and slavery in a North African context. However, the reality of racialized discourses

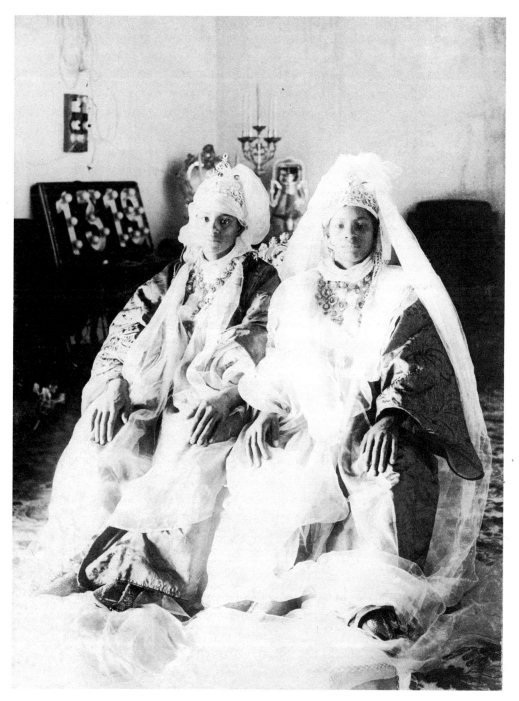

Figure 2.1. Photograph by Sultan `Abd al-Aziz, 1902. Silver print, 12 × 9 cm. Copyright Collection Gabriel Veyre.

in the Kingdom of Morocco was much more complex, and social identity was based on more than phenotype and place of origin. For example, enslaved West African women forced into concubinage could become powerful matriarchs if their sons rose through the ranks. Indeed, three Moroccan sultans, Moulay Ismail (ruled 1672–1727), Moulay `Abd ar-Rahman (ruled 1822–59), and Moulay al-Hasan I (ruled 1873–94), were reputed to be the sons of enslaved Black women who had become royal concubines (El Hamel 2013, 162; El Hamel 2008b, 75). Moroccans, therefore, practiced hyperdescent (the opposite of the "one drop," hypodescent rule that prevailed in the United States). In practice, this system reinforced the patriarchal nature of Moroccan culture that viewed male ancestry as more significant, allowing a child to identify as Arab if his or her father identified as such (El Hamel 2013, 305). According to European racial essentialism, such intermarriage between Arab men and Black women led to an unhealthy mixing of the races in Morocco, especially among the elite (Badoual 2004, 345). The fact that intermarriage was not viewed as taboo by all groups within Morocco points again to the comparative complexity of racial categories. Phenotype did not necessarily determine identity, and in some cases, patrilineal and class identity trumped racial constructions.

Jeremy Prestholdt, writing about a similar slavery system on the Swahili coast, observes that "the value of the domestic slave lay, in part, in their capacity to represent their owners, to draw attention to and accumulate social capital for an owner, as well as to perform their owner's will" (2008, 119). While Aziz's photographs are some of the earliest images of Moroccan elites consuming the world, similar imagery was emerging elsewhere in Africa. For example, during this period the sultan of Zanzibar also dressed women's bodies in decorative textiles and jewelry, displaying them surrounded by objects and architecture associated with worldliness and wealth (Meier 2016, 120).[4] Women in the Moroccan sultan's *harem* were also adorned to reflect the wealth and power of the monarch.

While doing research on early twentieth-century publications about Morocco, I found that the sultan's photograph of the so-called Black women in Figure 2.1 was also published in the 1905 edition of an illustrated London weekly titled *The Sketch: A Journal of Art and Actuality* (454–55). The article was titled "The Harem of the Sultan of Morocco," and the photograph of the two women was given an entire page in this arts and high society magazine. The caption did not mention the color of the women's skin but read, "Posing for Their Lord and Master, Harem Beauties Snapshotted by the Sultan of Morocco."

Both the photograph and its accompanying article played into the imagination of Europeans that the sultan kept a large *harem* of beautiful women. Certainly, the sultan understood the power of such images on the European imagination and allowed them to circulate. While we will never know the identity of these women and whether they were wives, concubines, or caretakers of the sultan's legal wives, their well-dressed and ornamented bodies signaled the wealth and status of their owner. Furthermore,

they illustrate how early twentieth-century European racial categorization and the sweeping association of Blackness with servitude did not necessarily apply in a Moroccan context.

While the sultan was experimenting with the camera, photographic studios run by Europeans became more common, and Moroccan women frequently posed, presumably for pay. Despite this, few postcards featured dark-skinned women; typically photographs showed women who fit Europeans' expectation that North Africans were light-skinned Arabs and Berbers, to whom Europeans assigned a racial classification similar to their own. As noted by historian Bruce Hall, nineteenth-century French officials described Arab, Berber, and so-called Moors as "white." They saw them as part of a pure race that was not Black, emphasizing that their features resembled those of Mediterranean people and describing them as having straight noses and soft hair (2011, 177). Since dark-skinned women did not fit into stereotypes that the European public held about North African women, I found that they were largely left out of photographic records that typically depicted North African women in a hypersexualized manner (Alloula 1986).

A rare exception can be seen in Figure 2.2, where a well-dressed, dark-skinned woman looks away from the camera with a blank expression on her face while reclining in the classic odalisque pose. This pose had developed into a common visual trope used by painters and photographers to suggest carnal pleasure associated with a *harem*. Identified in the postcard's caption as "Jeune négresse," the subject was dressed by the photographer in a kaftan and a white overgarment with massive sleeves, a style of dress associated with elite, urban women in Morocco at the time. The woman wears a wide brocaded-silk belt of the type made in the city of Fes, considered so valuable that they were passed down as part of a deceased woman's inheritance and were often cut in half to be shared in the event of two heirs. She also dons a black headscarf, which contrasts with the long white scarves worn by the two women photographed by the sultan. Furthermore, she wears neither jewelry nor the wide ankle-length trousers or silk leggings common to elite women of the time. Instead, one of the model's legs peeps from under her gown to reveal her knee and the top of her thigh, suggesting the sexual availability of this female subject.

This same woman was photographed wearing the same style of dress but sitting cross-legged with her bare legs exposed and her shirt unbuttoned to her waist (Figure 2.3). The captions reveal a great deal about how Europeans conceived of Blackness at the time. The caption on the reclining image in Figure 2.2 reads "Casablanca— Jeune négresse," while the caption in the postcard in Figure 2.3 reads "Tanger Esclava Marroqui." Clearly the word *négresse* in French was equated with "slave" (*esclava*) in Spanish. As noted by the French historian Rita Aouad Badoual, the *Dictionnaire Larousse* from 1928 defined the French word *nègre* as "a person belonging to the black race/a black slave/a person who lives in subjection" (2004, 344, n. 19).[5] Within the much more

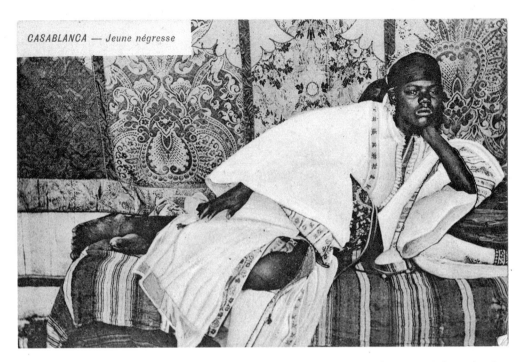

Figure 2.2. Photographer unknown, *Casablanca—Jeune négresse*. Published by J. Gonzalez & Cie, Casablanca, circa 1910. Collection of the author.

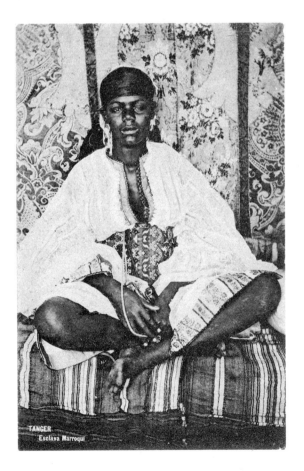

Figure 2.3. Photographer unknown, *Tanger Esclava Marroqui*. Published by A. Arévalo. Librería Española y Extranjera, Tangier, circa 1910. Collection of the author.

complex Moroccan milieu, as I have noted, skin color was not the infallible indicator of status that these images and their captions suggest.

European photographers also staged images of dark-skinned women playing subservient roles in relation to Arabs in Morocco. In Figure 2.4, for example, the photographer arranged two women so that the dark-skinned one sits cross-legged on the floor, slightly slouching with her profile to the camera, while a lighter-skinned woman lounges on a sofa, directly looking at the photographer. The fact that the dark-skinned woman sits lower than the other woman, whom viewers would identify as a Moor or an Arab, and does not look at the camera, was meant to suggest that the dark-skinned woman held servile status, perhaps working as a slave or servant to the reclining woman. This is reinforced by the caption, which identifies the women as a "Mauresque et sa Nègresse." The two women are dressed in very different styles of clothing, suggesting that they

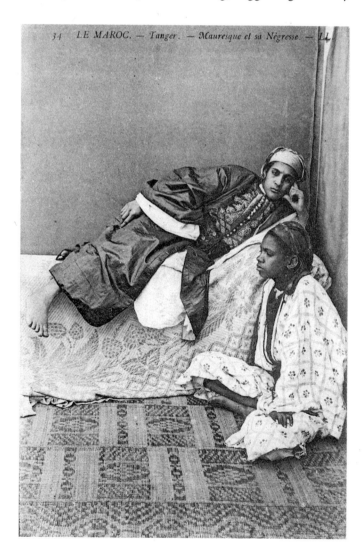

Figure 2.4. Photographer unknown, *Le Maroc – Tanger – Mauresque et sa Négresse*. Published by Lucien Levy, Paris, circa 1910. Collection of the author.

hold different social and economic statuses. The reclining Moorish woman wears a crisp, dark-colored garment adorned with embroidery over a white gown, and as fabric indicated wealth, her layered dress suggests high status. In contrast, the sitting woman is dressed in a patterned white fabric that appears thin, somewhat wrinkled, and covered with less elaborate embroidery. Such an image and its caption conveyed the idea that those who constructed the image associated servile status with dark skin color, an idea subscribed to by postcard consumers in Europe and the United States at the time.

In reality, a European photographer, who was almost always male, could not have entered the women's quarters of an elite household in urban Morocco. When such visitors were invited into the household of the Moroccan elite, they would likely have been served food and drink by women enslaved from western Africa (Ennaji 1999, 20). One postcard (Figure 2.5) depicts a dark-skinned woman dressed in a white garment, her

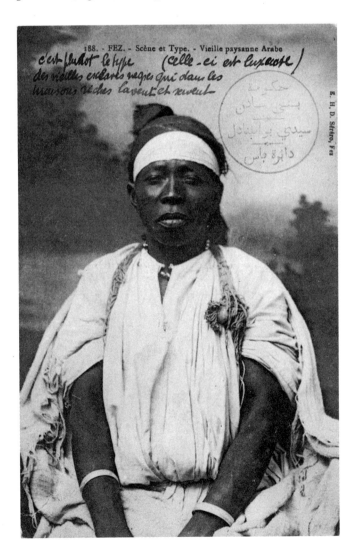

Figure 2.5. Photographer unknown, *Fez. – Scène et Type. - Vieille paysanne Arabe*. Published by E. H. D. Séréro, Fez, circa 1910. Collection of the author.

wide sleeves held up on her arms by ties around her shoulders—a style of attire that allowed women to literally roll up their sleeves when they were engaged in housework. Unlike the opulent jewels and long, flowing scarves worn by the sultan's concubines in Figure 2.1, this tired looking woman who stares expressionlessly at the camera has white and black scarves tied severely around her head and wears two simple, thin bracelets around each wrist. Although the caption describes her as "an old Arab peasant," the sender wrote the following message on the front of the postcard so that her identity would be clear: "This is rather the type (this one here is luxurious) of old black slaves, who cleaned and served in the houses of the rich." The figure's rigid frontal pose resembles anthropometric images that focused on the physiognomy of the other in order to classify them into types. Hence, this photograph not only records the Black female body as an object of social control but also reinforces the association between Blackness and enslavement.

These images are a slight glimpse into a largely invisible and silent world—a world that remains outside the frame of the photographic image, "what simply does not register photographically," as Shawn Michelle Smith has said.[6] As we have seen, photographers, wittingly or unwittingly, typically portrayed dark-skinned women in stereotypical guises as concubines or household servants in elite households. As noted by Christraud Geary, postcards that depict "the black female body are among the most painful legacies of colonial image-making" that constructed and reinforced racist ideologies (2008, 156). Provocatively, Geary asks whether republishing such photographs reexposes these women to the voyeuristic gaze, in essence revictimizing them. She suggests that one way to counter the perpetuation of negative stereotypes is to offer a context of agency and self-representation, as well as to juxtapose them with "images that show African and (African-descended) women as they represented themselves and as they wanted to be seen" (2008, 159).

Despite a few exceptions, Black women were largely omitted from the early twentieth-century photographic archive in Morocco. At the same time, the predominance of Black women in Gnawa ceremonies was downplayed in various written accounts. Noting that enslaved women attending such ceremonies were often accompanied by the women for whom they worked, Roger Le Tourneau suggests that women from the most respectable and pious families in Fes were drawn to the "exoticism" of Gnawa practices and their "mysterious and demonic character" (1949, 611–12). He is at pains to attribute the influence of Gnawa ceremonies over these "respectable" women to the "black blood" running in many of these elite families due to intermarriage (1949, 612).[7] In other words, from the European point of view, these elite women were not truly "white" and confused European racial dichotomies. However, the ground truth of Moroccan society was that racial distinctions among Moroccans themselves, due to intermarriage and miscegenation, were not as simplistic as those indicated in colonial-era postcards.

Europeans used the camera as a weapon in their campaign to distinguish Moroccans based on racial types, to impose order on what they perceived as racial chaos—in the process ignoring or misrepresenting the complexity surrounding racial identities in Morocco. For example, the postcard in Figure 2.6 depicts two women that the caption identifies as a "Moroccan Woman and Type of the South." Clearly the postcard producer who created the caption cannot conceive of a phenotypically dark-skinned woman as "Moroccan," distinguishing her as coming from the south (i.e., West Africa). How do we interpret such an image? Is the dark-skinned woman the mother of the child that she holds? Are the two women co-wives? Women who may have been perceived by Europeans as having distinct racial backgrounds could have been sisters, co-wives, or simply friends, demonstrating that seeing does not equate with knowing.

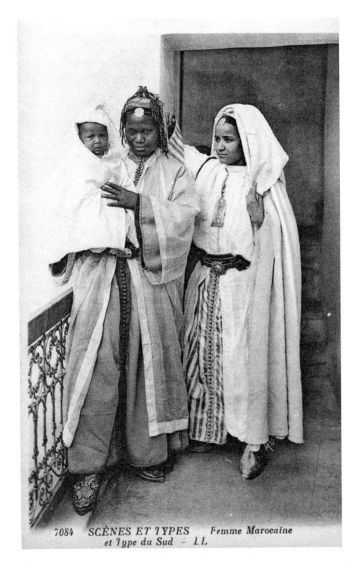

7084 SCÈNES ET TYPES *Femme Marocaine*
et Type du Sud – LL

Figure 2.6. Photographer unknown, *Scènes et Types Femme Marocaine et Type du Sud*. Published by Lucien Levy, Paris, circa 1910. Collection of the author.

Many of the photographs were taken during the decline of slavery in the early twentieth century. At this point, the educated elite began to reject the practice of concubinage and polygamy as a hindrance to societal advancement and a modern lifestyle. Yet, in the midst of these changes, enslaved women often remained in a situation of extreme dependency; they continued to be passed down like possessions from one generation to another and one household to another until their death. It was only as these enslaved women died that they were replaced by salaried domestic labor (Badoual 2004, 351).

FILMING GNAWA: VOICELESS WOMEN
DISRUPT THE VOYEURISTIC GAZE

Until the 1960s, most scholars, both European and Moroccan, avoided writing about Gnawa ceremonial practices, dismissing them as heretical rites replete with sub-Saharan animism or classifying them as inconsequential folkloric practices. This changed in the 1960s when the French anthropologist Viviana Pâques made Gnawa ceremonies her primary focus, which initiated interest in them by local Moroccan scholars as well. Pâques also made an important contribution to the archive of visual representations of women's roles in Gnawa ceremonial life by way of a 2012 DVD released under the name of *Gnawa: Au-delà de la musique* (Gnawa: Music and beyond) where Pâques served as scientific coordinator to the French filmmaker Jacques Willemont.[8] The film includes a montage of footage shot by Willemont in the Moroccan town of Tamesloht between 1969 and 2011. Pâques worked for decades in the small town of Tamesloht because it is the site of a massive gathering (*moussem*) of various Sufi groups, including Gnawa practitioners, who make a pilgrimage there each year.

Pâques worked closely with a single male informant, Al-ʿayachi, whom the film's narrator describes as "a great initiate" with exceptionally deep knowledge of a Gnawa cosmological system, which he explained to Pâques during their decades-long collaboration. The film grants only Al-ʿayachi, as the male patriarch, direct access to the camera and presents him as the authoritative and authentic voice of his people. However, at one point while explaining the structure of Gnawa ceremonies in Arabic, Al-ʿayachi acknowledges his indebtedness to women: "I was trained by a Gnawa woman, I was born here, in her house. She was called the Saharawiya [Saharan woman]. Our family hails from the Sahara, but my parents lived here (in Marrakech) as did their parents before them" (Figure 2.7).[9] Whether the Saharan (i.e., Black) woman from the distant south was Al-ʿayachi's great grandmother is not clarified in the film, but his statement reveals a paradox: a female anthropologist used a male informant to understand a world largely controlled, and a tradition largely transmitted, by women.

Around the same time Pâques initiated her research, male musicians performing as Gnawa were starting to become increasingly professionalized and commercialized.

I was trained by a gnawi woman,

Espaces

Figure 2.7. Film still from *Gnawa: Au-delà de la musique*, 2012. Directed by Jacques Willemont under the scientific direction of Viviana Pâques. Espaces.

For example, during this period, various all-male groups within Morocco, such as Nass El Ghiwane, began to incorporate rhythms, songs, and instruments traditionally played at Gnawa possession-trance ceremonies into their repertoire to create a new genre of protest songs addressing the daily struggles of Moroccan life (Hell 2002, 343). Nass El Ghiwane's incorporation of Gnawa musical influences represented a break from Middle Eastern music, reflecting a rising national consciousness among the youth as well as changing geopolitical realities, as young people began to question Morocco's position in the Arab world. Gnawa music became increasingly associated with social protest and reflected the reorientation of Moroccans toward the African continent rather than the Middle East (Bentahar 2010, 45).

Professional recordings featuring Gnawa music and ceremonies began to proliferate in the 1990s, a period that coincided with the creation of the Gnawa and World Music Festival in 1998, which gave Gnawa music greater international visibility. During the 1990s, various labels released recordings of male Gnawa musicians performing songs sung during the evocation of spirits, as well as recordings of fusion music recorded with jazz musicians from the United States, such as Randy Weston.[10]

Such recordings served to elevate the *guinbri* player (referred to by Gnawa as *m`allem*, a generic Arabic term used to refer to anyone who masters a particular craft) to the role of professional musician. Until the recent monetization of Gnawa music, most musicians had to have a day job, practicing a trade, such as carpentry or blacksmithing, to generate a livable income. The advent of commercial recordings, as well as the increased participation of Gnawa in the global music scene, has allowed some Gnawa male musicians to support themselves through the performance of music alone. Thus, the status of Gnawa male musicians was elevated to the public stage, while at the same time, the women who control ceremonial life have remained largely invisible.

Gnawa: Au-delà de la musique includes a recognition of the increased national and global popularity of Gnawa music, with the narrator noting, "Now that Gnawa music has become popular, some musicians are so demanding that many followers abandon the idea of a *derdeba* [possession ceremony]." In other words, the international popularity of Gnawa musicians has resulted in male musicians demanding higher prices to perform at the traditional ceremonies (a fact also noted by the scholar Deborah Kapchan in her recent book on Gnawa), further marginalizing women in Gnawa ritual life as many women can no longer afford to hire musicians to play at their *lila* (Kapchan 2007).

I found that increased international visibility has encouraged men to stage shorter versions of Gnawa possession-trance ceremonies in exchange for money. In recounting his efforts to film a ceremony in the 1990s, the German videographer Gerd Becker, for example, reported that male musicians were easy to find: "It would have been easy to organize a *lila* for money with Moroccans falling into a furious trance. Many made this type of offer to me" (2004, 393). But a genuine woman-led possession-trance ceremony is much harder to come by for foreigners. Since men were and are the ones to interact with the foreign filmmakers, they routinely cut women out of their traditional role as *lila* organizers, pocketing the profits themselves, and in the process distorting outsiders' perception of the ceremony, replacing it with a malecentric version of reality. Foreign filmmakers, therefore, typically film Gnawa ceremonies organized by male musicians specifically for them. The musicians will sometimes allow the filmmakers to record their wives, sisters, and other female relatives brought in for the occasion but only under their auspices. Women commonly work as Gnawa healers or diviners, and when they suggest that people should hold a Gnawa ceremony, they hire the musicians to play at a ceremony that she largely organizes.[11] Acting as agents, promoters, and organizers of the ceremonies, in addition to their conventional role as musicians, men thus appropriate women's roles.

While Pâques did not disclose her financial relationship with the people with whom she worked, we must assume that some such relationship enabled her and Willemont to make this film. Pâques explained that her motivation in making the film was to bring visibility to a largely invisible culture. She recounts in the film *Gnawa: Au-delà de la musique*, "As long as people haven't seen it, it doesn't exist. And they are right. Because

in the end, if we don't see something, it doesn't exist. It is only when we become aware of something that it exists. If I do not look at the moon, it doesn't exist" (Figure 2.8). This points us back to the question posed at the beginning of this chapter: What can we know about women's roles from what is seen and not seen? Pâques does not address the problem of selectivity, the fact that what is left out of the frame is consigned to invisibility. If something cannot be seen within a European frame of reference, such as a photograph or an ethnographic film, it does not exist, which in this case undermines women's sphere of influence and cultural potency. At the same time that Pâques desires to record, preserve, and teach outsiders about Gnawa ceremonial practices, her film inadvertently marginalizes women, rendering them almost voiceless and invisible.

While most of the film elides women by presenting only a male interpreter of tradition, at one point we witness a casual moment in the world of women as they prepare for the evening's ceremony. Although, significantly, the women never look at the camera, they are aware of its presence, as evidenced when the *mqaddema*, Al-ʿayachi's wife Mina, picks up a tray and starts to sort dried beans. She remarks in Moroccan Arabic (her words are subtitled in the English version of the film), "I am only good for

Figure 2.8. Film still from *Gnawa: Au-delà de la musique*, 2012. Directed by Jacques Willemont under the scientific direction of Viviana Pâques. Espaces.

separating seeds. Who are these? *Mluk* (spirits). Who are those? Genies (demons)"
(Figure 2.9).[12] As she continues to sort beans, interestingly, the translators failed to
include her final remarks in either the French or the English subtitles of the film, which
can be overheard in Moroccan Arabic: "May they [the spirits] come to them [the film-
makers]."[13] She is likely poking fun at the numerous questions that anthropologists
such as Pâques pepper informants with during the process of research, by playfully call-
ing upon the spirits to curse them. But there is also a subtext here of resistance to and
skepticism about the very process of filmmaking, that is, the gaze of the camera. Pâques
worked with translators who would have understood the woman's Arabic, but failing
to translate these comments suggests that the filmmakers either regarded these remarks
as inconsequential or omitted them self-protectively, thereby controlling what could be
seen and therefore known. In disregarding this particular woman's subtle attempt to dis-
rupt the camera's voyeuristic gaze, the filmmakers misrepresent the indirect and com-
plicated relationship women have with the camera. And while the film shows women
preparing for the ceremony and possessed by spirits, it does not allow women to speak
for themselves. Instead Al-ʿayachi, the Moroccan male narrator, and Pâques are the only

Figure 2.9. Film still from *Gnawa: Au-delà de la musique*, 2012. Directed by Jacques
Willemont under the scientific direction of Viviana Pâques. Espaces.

people to speak directly to the camera, appropriating to themselves the role of representing women's roles in Gnawa ceremonial practices.[14]

Pâques does not consider the issue of Blackness, but the commentary at the beginning of the film defines Gnawa as "brotherhoods of former black slaves." It is impossible to know whether the women in Pâques's film self-identified as Black or reacted negatively toward the camera as a reaction to historical representations of Black women as subservient. In recent years, I experienced an increasing desire among women that Gnawa authenticity should be linked explicitly to phenotypic dark skin. The diffusion of Gnawa practices and music among the general Moroccan population, some of whose families were enslavers rather than were enslaved, has served to increase debate about the meaning of "Gnawa authenticity." Despite the inherent connection that Moroccans make between Blackness and the history of slavery, the whitening of Gnawa practices paradoxically impels some women to emphasize dark skin as symbolic of their authenticity. Hence, women use their Blackness as an asset rather than a hindrance and transfigure Blackness from a legacy of marginality and enslavement into a source of agency and self-respect, which, as we will see, provides them with access to material wealth.

As Patricia de Santana Pinho has pointed out with respect to constructions of race in Brazil, discourses associated with racial categories "are responsible for more than visible morphological characteristics (color, hair, features), determining predispositions and tendencies as well" (2010, 151–52). This fact is instantiated by the association in Morocco between women categorized as Black and healing powers. For instance, in rural Morocco Black women are frequently asked to nurse sickly children because their breast milk is believed to contain *baraka*, "blessings," providing good nourishment to the child. A dark-skinned woman in her sixties recounted to me how people often brought their sick children to her for them to suckle, leaving them for several days. She told me that one grown man whom she breastfed as a child often visited her with gifts to show his appreciation. While the practice of using Black women as wet nurses holds positive associations as it recognizes a special healing power associated with Blackness, it simultaneously reinforces the negative link between Blackness and servitude, since it is, after all, simply another form of exploiting Black women's bodies.

It is in response to these negative connotations of Blackness that many women who self-identify as Black embrace the term "Sudania" to describe themselves, a term derived from the Arabic *bilad al-Sudan*, meaning "land of the Blacks," and used in Morocco to refer to the geographic region to the south of the Sahara. In addition, some of these women embrace the association made between Blackness and healing by declaring themselves powerful Gnawa healers. I devote the remaining portion of this chapter to the visibility of two women from the Gania family. Both Jmiaa and Zaida Gania are sisters from a hereditary Gnawa family who embraced a Sudani identity as a means of rejecting a hierarchical system based on racial classification. Aware of the power of the image, they used the camera in a very deliberate and controlled manner. Zaida, in

particular, controls photographs and does not allow viewers to see some of the most powerful and potent aspects of Gnawa ceremonies that occur within the feminine sphere and outside visual frames of reference.

CAN THE SPIRITS BE PHOTOGRAPHED?

I met the diviner Jmiaa Gania before I met her sister Zaida. Jmiaa lived in the town of Essaouira, and when I visited her home in 1997, she generously explained the divination process to me. She even took the unusual step of allowing me to photograph her divination tray, the collection of objects, inherited from her ancestors, that she used to conjure and placate spirits (see Figure 4.1). Jmiaa suffered a fatal stroke in 2005, but shortly before her death she allowed the Moroccan photographer Lamia Naji to photograph some of her ceremonies for use in Naji's video project called *couleurs primaires*, which was discussed in this book's Introduction.[15] During Naji's video, still photographs flash across the screen in time to an original score of electronic house music, created by Fernando Gullon. The music reinforces a connection between the sense of release one feels when dancing at an American or European nightclub and the sense of abandonment experienced by those possessed by spirits at a Gnawa ceremony. At the same time, the images in the video convey a sense of ethnographic authenticity, appearing in chronological order and taking the viewer through the progression of a *lila* from beginning to end. It starts with people purchasing animals at a market, followed by the preparation of food, animal sacrifice, images of the ritual space, a candlelit procession (`aada), and Gnawa male dances (*fraja*), and ends with arresting images of people engaged in the act of possession itself.

In one of the most memorable of Naji's photographs of Gnawa trance (Figure 2.10), we are brought into contact with two women, apparently possessed, while a third figure remains largely out of the frame, only partially visible. This image, like many others in this series, is taken from above, giving the sense that the photographer attempted to maintain a discreet distance from her subjects. Naji told me that it was only after much negotiation that she was given permission by Jmiaa Gania to photograph Gnawa ceremonies. We see a dark-skinned woman, possibly one of Jmiaa Gania's nieces, to the left, holding a scarf, apparently placed on her by a diviner who drapes a scarf of the color preferred by the spirit over a person's body. Since the image is in black and white, one cannot be certain as to the woman's possessing spirit. Her identity remains obscured because Naji focuses her camera on a light-skinned woman whose long black hair partially covers her face. Her open mouth and closed eyes indicate that a possessing spirit has overtaken her body, and she is completely unaware of the camera's presence. Her tousled hair and hands behind her back suggest a figure in motion, indicating the importance of music to induce the trance state—something that cannot be seen but only heard or perhaps felt within the body. Therefore, what is interesting about this image is

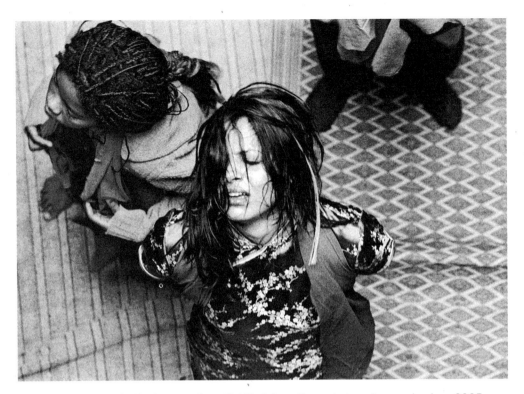

Figure 2.10. Lamia Naji, photographer, *Untitled*, from the series *couleurs primaires*, 2005.

not just what it succeeds in depicting but what is not shown. Photography cannot visually represent some of the key features of spirit possession, emphasizing the paradoxical nature of capturing something invisible (spirit possession) through a visual means.

Experienced either as still photographs or in succession on a video screen, Naji's images bring to mind observations made by Shawn Michelle Smith in her book *At the Edge of Sight* (2013). Smith writes that photography can make the invisible visible but, at the same time, reinforces how much ordinary seeing can be blind. Photography, in fact, reveals the limits of the visual in capturing the range of human experience and can also obscure racial and social inequalities (2013, 4). Smith probes these limitations, raising the provocative questions: "What resides at the literal and metaphorical edge of the photograph? What remains just outside the frame? What cannot be seen because the photographer does not focus on it? What cannot be seen because cultural discourses and habits of thought obscure it?" (2013, 8).

These edges—what lies beyond the frame—are as much a part of Naji's photographs as what the camera focuses on, as she intentionally exposes how much the experience of spirit possession lies outside of the visual realm. Naji deliberately cuts off people's bodies, includes blurred imagery, and limits our field of view (see also Figures I.1. and I.2). She works in a style that highlights the confines of photography, requiring a viewer

to imagine the events that occur and the people who exist outside of the visual frame itself. By doing so, she draws attention to the fact that Gnawa spirit possession exists at the threshold between subjective trance experience and public performance. Spectators can see possession occurring in the space of a Gnawa *lila*, but how much can they really understand about a person's intimate encounter with the spiritual realm?

As described by anthropologist and filmmaker Christian Suhr, photographs of spirit possession are "a test of one's willingness to surrender all scepticism to the fact that the invisible is invisible and therefore cannot be seen" (2015, 108). He describes such photographs as "failed images" because they do not capture the invisible, but they require us to take a leap of faith and surrender to the unknown. Photography, therefore, is almost antithetical to spirit possession, since it is nearly impossible to capture the possession experience visually and, at the same time, such photographs risk revealing too much about one's personal experience of possession. This tension between seeing and not-seeing is what causes most women to forbid cameras at the Gnawa ceremonies that they organize, including Jmiaa's sister Zaida Gania.

Although Zaida shared her family's history with me and even allowed me to observe consultations with clients at her home, I was never allowed to see her divination tray, much less to photograph her in possession. In fact, Zaida would not let anyone except for close family members see her divination tray, carefully covering it with a cloth during consultations with clients and storing it, along with those she inherited from her sister and her mother, in a small room that she called the "room of the spirits" (*beit el jawad*). Zaida let me witness several of her consultations with clients, and when I asked her about her tray's concealment, she told me, "If I show it [the tray] to someone, the *jawad* [spirits] will not work. Even my mother never showed anyone her *tbiga* [divination tray]. If someone comes into the room, the *mluk* run away and leave me, so I cannot work." Zaida's secrecy reinforces the idea that she holds arcane knowledge not available to the general public, solidifying her power; at the same time, secrecy protects her from harm. In fact at Zaida's annual *lila*, while possessed by a spirit named Serku Belayji, Zaida would scan the room and snatch objects from people the spirit deemed were behaving in a disrespectful manner. People looking at their cell phones might have their phones taken; men wearing baseball caps might have those confiscated; women talking to their friends might have a small article of clothing, such as a neck scarf, removed. At the end of the spirit's song, people had to give small donations of money in order for their things to be returned. Serku Belayji demands respect and one's full attention.[16]

If an onlooker doubts Zaida's possession and views her with contempt, the spirits can be vengeful; they might hold Zaida responsible for this disrespectful behavior. This was demonstrated in the case of Zaida's sister who some say suffered from a stroke induced by angry spirits. But the instinct toward concealment also manifests continuing antipathy to the disempowering effect of the camera and of the outsider's judgmental and disbelieving gaze.

But Zaida Gania is not opposed to being seen. Zaida allows cameras during the street processions that precede her ceremonies during which she takes control of the means of self-representation. Gnawa in the town of Essaouira begin their ceremonies with a street procession called the `aada, which means "tradition" or "custom" in Moroccan Arabic, that resembles wedding processions during which the gifts for the bride are carried through the streets. During the `aada, a female diviner, surrounded by male musicians whom she hires, walks through the streets accompanied by her closest friends and female assistants. While the male musicians play drums and iron cymbals, women carry milk, dates, and, if the procession occurs at night, lit candles. Most quickly parade through the streets near the house of the diviner, publicly announcing the beginning of the ceremony, and if the group passes any Sufi shrines, they might pause while women sprinkle offerings of incense-infused milk onto the shrine and the musicians perform by its door.

Such processions draw attention to the ceremony, especially those held by the Gania family. When I joined Zaida Gania's procession in 2010, she was joined by her younger brother and musician Mokhtar, who played the barrel drum along with other members of his musical troupe. Unlike the typical `aada, this one was held the afternoon before her ceremony when the streets were at their busiest. While a group of around fifteen male musicians and twenty women marched down the streets of Essaouira, stopping traffic en route, no one dared to complain for fear of angering Zaida and her retinue of spirits.

On these public occasions, Zaida does not object to photographs. In Plate 1, Zaida can be seen in the right of the photograph wearing a black tunic and cowrie-adorned hat and sashes. She is flanked by male musicians and is the center of a public spectacle, surrounded by Moroccans who photographed the occasion with their cell phones and filmed with video cameras. Given that this occurred during August, Essaouira was filled with tourists and Moroccans who live abroad returning home to visit the city during their summer vacations. As activity swirls around her, her brother Mokhtar (on the far left of the photograph) plays the barrel drum. Zaida clearly distinguishes herself as the leader by virtue of both her serious demeanor and her attire. She wears a man's long tunic, a cowrie-adorned hat, referred to as *shashea d Bambara*, meaning "hat of the Bambara" in colloquial Moroccan Arabic, two cowrie-adorned black sashes across her chest, and a thick black belt covered with cowries. Unlike other women in the procession who dress in long colorful hooded gowns typical of women in Morocco, Zaida dons the style of dress worn by those possessed by black Gnawa spirits, spirits who have a racialized identity as they are believed to originate south of the Sahara. But they typically wear this attire only in the midst of a ceremony rather than while walking down the street. By wearing the color black, Zaida emphasizes her connection with a family of spirits originating in Africa that she refers to as *Uled Sudan*, meaning "children of Sudan."[17]

Through her visual self-representation, Zaida asserts herself as the most powerful and renowned diviner in Essaouira and reinforces the idea that women play crucial roles

in Gnawa ceremonies—something in danger of being forgotten by those who are only exposed to secular, public, staged performances by male musicians. In this context, we can appreciate the impact of Zaida Gania's public display in displacing and subverting the historical stereotypes of Black women as enslaved house servants, concubines, or victims of derogatory racial concepts that categorize dark-skinned women as subservient. In a reversal of Moroccan hierarchies of race that typically value light skin for women as more attractive, Zaida asserts dark skin with powerful Gnawa-ness or *tagnawit*. As expressed by scholar Mimi Sheller, people of African descent in the Americas use various forms of bodily assertion to contest the power and gaze of those who may exoticize them (2012, 17). Likewise reversing the history of objectification and subjection of the Black female body, Zaida uses her own dark skin as a means of elevating self-esteem and restoring dignity. Rather than viewing her ancestors as passive victims of slavery, she emphasizes her family's extraordinary healing powers through a connection to the Sudan.

Zaida is representative of the women who participate in Gnawa ceremonies in not portraying herself as a victim of a hierarchical system of racial classification. While she processes through the streets of Essaouira, her composed demeanor is that of someone whose every word and gesture contains great power and arcane wisdom. As such, Zaida uses her body as a site of cultural production, representing a Sudani Black identity. Zaida illustrates that Black women can be active contributors to the construction of a Gnawa identity.

While Zaida does not allow photography in her ceremonies, it is completely within the prerogative of the diviner to allow photography if she wishes. At some ceremonies, a diviner allows people to photograph male musicians, but often does not allow photography during the possession portion of the *lila* itself. But if she does allow photographs, and many do, those who fall into possession have no choice but to accept the presence of the camera unless they leave the ceremony. In fact, at most public shrines, such as the Zawiya of Sidna Bilal, discussed in chapter 5, people often took photographs, and sometimes professional photographers were hired to record the shrine's annual *lila*. On a spiritual level, women who forbid photography recognize that spirit possession amplifies the lack of human agency, stresses the ambiguity of experience, and emphasizes the unknowable. Zaida Gania wants to stay in control of her spirits and protect herself and, by doing so, controls how they could be seen and who could see them, as will be discussed further in chapter 4.

When we finished the street procession previously described and entered Zaida's home to begin the spirit-possession portion of the ceremony, I put away my camera. Indeed, I gradually began to welcome Zaida's prohibition of cameras, which forced me to appreciate fully the multisensory nature of Gnawa ceremonies. Without the camera situated between me and the experience, I became immersed in the call-and-response singing while sitting among a crowd of women and felt myself being carried away in the

repetitive energy and rhythm of the music. I enjoyed breathing in the pungent smell of burning incense and tasting the sweet food passed around to signal the arrival of a particular spirit; I came to relish both the physical exhaustion and emotional giddiness that accompanies the end of an all-night possession-trance ceremony. In the end, Zaida's refusal to allow photography or video into her ceremonies bespeaks her awareness of the power of images to dilute, defuse, and desacralize the spirit-possession experience.

3

Fraja Performances

Geolocating Gnawa Ceremonies in the Sudan

A GNAWA *LILA* CONSISTS OF A SERIES of ritualized events typically occurring over a two-day period, commencing with an animal sacrifice on the first day. The second day starts with a public procession, followed by a performance known as *fraja*, which precedes the spirit-possession portion of the *lila*. Although the word *fraja* somewhat ironically means "amusement," the song lyrics deal with the personal and collective traumas experienced by the enslaved, such as being kidnapped from West Africa, separated from their mothers, placed in sacks, and forced to subsist on scraps of food. Most importantly, *fraja* performances serve to geolocate Gnawa ceremonies within a narrative that links them to a Sudani identity. As the music recounts historical struggles and hardships, the stage is set for the later possession portion of the Gnawa *lila*. Men wearing colorful tunics and cowrie-adorned headdresses perform *fraja* songs in front of the *guinbri* player, with the audience sitting in a semicircle around them, watching as Gnawa musicians perform acrobatic dance moves.

In addition to revisiting distressing scenes of the collective past, *fraja* songs incorporate the names of places and ethnic groups that function as touchstones of Blackness: Sudan, Timbuktu, Bambara, Fulani, and Hausa. *Fraja* performances seek to rectify the erasure of lineage, create a narrative of a homeland that existed before enslavement, and reinforce the sense of Gnawa as a unified group sharing a common heritage. Crucial to note is that this chapter does not use *fraja* performances to search for the presence of African retentions. In her book *Mama Africa: Reinventing Blackness in Bahia*, Patricia de Santana Pinho recognizes that enslaved people carried many African influences with them to Brazil, which are reified in their cuisine, their dances, and their music. While on occasion scholars can associate cultural practices to specific parts of Africa, she writes that "it is not possible to pin down the exact way in which Africanisms have been rearranged, reassembled, recycled and ultimately reinvented" (2010, 23). Likewise,

this chapter does not pretend to identify the specific origins of Gnawa practices or reconstruct the lives and experiences of the enslaved. Rather it seeks to illustrate what a connection to Africa south of the Sahara and an identity as Sudani means for those who participate in Gnawa *fraja* performances today. Crucial to doing so is the understanding that identifying as "Gnawa" was and remains a choice rather than one determined by biology or a common origin in sub-Saharan Africa.

Popular lore in Morocco asserts that Gnawa are descendants of captives from the Moroccan campaign of 1591 where they conquered the city of Timbuktu and enslaved thousands, forcing enslaved men to cross the Sahara and become soldiers of the sultan (Goodman-Singh 2002, 85). This book asserts that such a claim is entirely too simplistic, as it is improbable that current-day Gnawa are descended from a single trans-Saharan migration. Furthermore, such an explanation suggests that "the Gnawa" form a distinct ethnic group. Rather, this book asserts that Gnawa cultural identity is the product of a conscious self-fashioning by dark-skinned Moroccans that coincided with the gradual decline of slavery in the nineteenth century. But not everyone who self-identified as Black in nineteenth-century Morocco considered him- or herself "Gnawa," and this remains the case today.

Boundaries of identities are permeable, and scholar Patricia de Santana Pinho reminds us that people construct race-based identities "by choosing to share cultural values, myths of origin, a common past, and even certain 'biological' commonalities" (2010, 67). Turning to the example of Brazil, Pinho writes that in the case of Bahia the choice of embracing Blackness can be related to one's phenotype, but she also recognizes that physical attributes of "race" are "culturally, and not objectively, defined" (2010, 68). In other words, identities form and emerge in order to respond to historical and societal circumstances. Pinho writes that in early twentieth-century Brazil, Black Brazilians often looked to whiteness as a reference for dignity and self-esteem. However, in response to racism and racial inequality in Brazil, by the mid-twentieth century people transformed "the existing demeaning representations of blackness into new and dignified forms of identification" (Pinho 2010, 72). By doing so, the choice of identifying as Black in Bahia served as a strategy of social and political advancement and an expression of self-respect (Pinho 2010, 72).

In Morocco, categories of identity have also shifted due to historical and political circumstances. Categories such as Arab, African, Amazigh, Middle Eastern, and Sudani have been subject to local politics and social constructions and appropriated in a multitude of ways to express belonging and difference. As cultural theorist Stuart Hall reminds us, the process through which diaspora groups position themselves in relation to others is political. He asserted that cultural identity is not a fixed essence but is impacted by outside history and culture and has histories constructed through myth, memory, or narrative (1990). This chapter asserts that the performance of *fraja* during a Gnawa *lila* allows for an intentional identification as Sudani (i.e., West African)

through a specific racialized expression of Blackness connected to trans-Saharan slavery. During the period of trans-Saharan slavery, people from the Sudan were largely classified as nonbelievers, allowing for their enslavement (Lydon 2015). These ideas carried into Morocco where dark-skinned people were believed to have extraordinary supernatural abilities to heal through their contact with spirits. However, during *fraja* performance, songs counter this association of Blackness with animism and non-Muslim beliefs. They include praises addressed to Allah and the Prophet, accommodating the hierarchies of power and social order that privilege a Muslim identity within Morocco and express their adherence to what is deemed to be religiously appropriate behavior. Thus *fraja* performances have several functions and express various spheres of belonging simultaneously. First, they emphasize a historical connection to the Sudan by presenting the oppressive circumstances of the enslaved and their descendants, constructing a social identity distinct from that of their enslavers. At the same time, they affirm an affiliation with the majority culture of the enslaver and embrace numerous aspects of Islam, complicating simplistic categories used to divide Africa into North Africa versus sub-Saharan or Islamic versus non-Islamic.

This chapter asserts that *fraja* performances are part of the complex process of constructing and negotiating racial identities in a society where Blackness was historically equated with enslavement—a process that involves expanding and augmenting the narrative of slavery. It considers how Blackness and a connection to western Africa is conveyed, looking specifically at the dance movements performed, the clothing worn, and the visual imagery included in *fraja* songs. While recounting the suffering that occurred at the hands of the Muslims who enslaved them, *fraja* songs also portray a semihistorical, semi-imaginary version of the "Sudan" as a culturally and religiously prestigious homeland filled with proud gun-wielding hunters and boasting the legendary city of Timbuktu. However, that narrative is ultimately, inescapably, one of power lost. In the ubiquitous equation that posits spiritual power as inversely proportional to worldly power, it is the fact that a Gnawa/Sudani identity is inextricably linked to the history of suffering that opens the door to the spiritual realm. As discussed in this book's Introduction, the exaggeration of characteristics understood to be "other" can serve as a means to claim ritual power (Stoller 1995; Wirtz 2014). *Fraja* performances begin a Gnawa *lila* by evoking Blackness and a connection to the Sudan. This strategic positioning sets up the ceremony in preparation for the engagement of spirits in the possession portion that follows.

CHOOSING BLACKNESS IN HISTORICAL CONTEXT

While the process by which people chose to become Gnawa remains murky, various historical circumstances suggest that "Gnawa" as an identity united groups from different regions and backgrounds. The historical circumstances and economic hardships

that impacted the elite in the late nineteenth and early twentieth centuries contributed to the decline of slavery, and the formerly enslaved migrated to urban centers. Some embraced a self-identity as Gnawa, which was an identity linked to Blackness. For example, the historian Madia Thomson recounts that during this period large slave-owning Amazigh families in southwestern Morocco, an area known as the Sous, emancipated many of the enslaved, whom they referred to locally as Ismgan. This prompted many Ismgan to migrate from the south to urban centers farther north (2011, 249). Numerous French accounts corroborate Thomson's claims and state that most of the Gnawa living in early twentieth-century Tangier came from the Sous (Salmon 1904, 262; Dermenghem 1954, 285).

Certainly, many manumitted or runaway slaves intermarried Harratin, a low-status group of dark-skinned laborers who lived in the oases of rural, southern Morocco. The servile status and phenotype that they shared with manumitted slaves united the two groups (El Hamel 2002). Harratin were freeborn Muslims, but historically they occupied the lowest rung of the social and economic hierarchy and were allowed by the landowners for whom they worked to keep only a portion of their harvest. This compelled them to perform other types of labor to survive, and Harratin became specialized in activities such as metalsmithing, butchering, and construction.[1]

While little written scholarship exists on the history of Harratin in Morocco, Fatima Harrak notes that since the seventeenth century, Harratin have moved from the southern oases into northern cities, fleeing droughts, families, or political instability (2018, 290). Based on my discussions with Gnawa musicians today, when some Harratin relocated to urban centers, they intentionally adopted the identity of "Gnawa" and undoubtedly contributed to a Gnawa spiritual and musical repertoire. The origin story of the musician M'allem Abdenbi El Meknassi exemplifies this pattern: "I learned Gnawa music from my father. My family is not from the Sudan—my family is from the Tafilalet oasis—We are Harratin."[2] He recounted this to me with a satiric smile, acknowledging that the term Harratin is generally avoided in Morocco today as pejorative, before continuing, "I could tell you that we [Gnawa] came from Timbuktu but that is all a lie—we are Moroccan and Harratin."

Adding evidence to Meknassi's assertion is an account written by the scholar Bertrand Hell, who described one of his informants as a sixty-year-old Gnawa female diviner named Malika whom locals nicknamed *Khela* ("the Black"). Hell stated that she was known as one of the most powerful female practitioners in Casablanca, tracing her ancestry to the Draa valley, an oasis in the south of Morocco with a historically large Harratin population. Her family moved from the south to Casablanca at the beginning of the twentieth century, and Malika was among the third generation of Gnawa practitioners in her family. Her paternal grandmother was a diviner (*mqaddema*), her parents were Gnawa practitioners, and her uncle a master *guinbri* player (*m'allem*) (2002, 66–67). Her family history did not include a direct connection to a specific area of

western Africa, reinforcing this assertion that many who took on an identity as Gnawa likely moved to cities from Morocco's rural south rather than among those enslaved in the sixteenth century from Timbuktu.

Another implication of these ancestral stories is that many families who self-identify as Gnawa only began performing Gnawa music and acting as diviners in the late nineteenth and early twentieth centuries. Dark-skinned Arab-speaking Harratin could recreate an identity for themselves as Gnawa once they moved from the rural oases (such as the Draa valley and the Tafilalet oasis) into urban centers. Also thrown into the mix should be dark-skinned Ismgan/Ismkhan, a Tamazight name given to descendants of enslaved people in rural Amazigh regions of Morocco.[3] The low status and dark skin of these various groups united them regardless of whether their place of origin was Timbuktu, the Sous region of the southwest, or the desert oasis of the Tafilalet in the southeast. Phenotypically Black Moroccans could band together along with those enslaved from Sahelian Africa. Various low-status populations who had lived in Morocco for at least a generation, such as Ismkhan/Ismgan and Harratin, certainly contributed to the development of the Gnawa spiritual repertoire, further indicating the problem with attributing Gnawa practices as having a direct correlation to those in sub-Saharan Africa.

With the end of the twentieth century, Gnawa identity became more porous with the creation of the Gnawa and World Music Festival in 1998. This contributed to the increased popularity and exposure of Gnawa music to the larger Moroccan public. Waves of people who did not self-identify as phenotypically Black, had no enslaved ancestors, and had no ancestral connection to the Sudan also joined the ranks of Gnawa. Among these are rural families who migrated to cities to find economic opportunities and to escape rural poverty and lack of infrastructure (potable water, electricity, basic roads). Morocco's urban population made up 29.2 percent of its total population in 1960 and increased to 60 percent by 2015. The "Morocco Country Report" states that young people make up 30 percent of Morocco's population, yet the economic inactivity rate for those between fifteen and twenty-four years old is 70 percent (BTI 2016, 22). Urban development has not been able to provide for this population growth in terms of affordable housing, schools, sanitation, and employment, with only 27 percent of women engaged in the labor force (BTI 2016, 14). If women are employed, they are typically relegated to low-skilled jobs in urban Morocco with high levels of job turnover and low pay (Achy 2002, 2–4). Among women, the uneducated occupy the lowest rung of the economic ladder. Uneducated divorced women often suffer the most as they end up completely reliant for support on fathers or brothers who, given the high unemployment rate, are frequently unable to provide for them.

According to the 2009 Arab Development Report, health conditions, poverty, and unemployment were the most important sources of insecurity for Moroccans (cited in BTI 2016, 4). According to the "Labor Market and Growth Report" by Lahcen Achy,

the informal economy in Morocco provides more jobs for people than the formal sector (2002, 1). Essaouira, in particular, suffered when canneries, flour mills, and tanneries significantly declined in the 1970s, leaving the city with little industry. In 1982, commercial activities at its port were officially terminated, and while fishing continues to play a major role in the economy, fish stocks have declined in the last few decades. An economic backwater, in the mid-1990s the city began to rely on tourism (Ross et al. 2002, 28–31). Performing in a Gnawa musical troupe can provide a source of income for young men in Essaouira, who can play in local tourist restaurants and hotels.

Furthermore, participation in Gnawa healing ceremonies appeals to the urban poor, who often distrust the shoddy healthcare services provided by the government, and unemployed youth, who view the performance of Gnawa music as a means of employment. Unequal economic development has benefited the educated upper middle class and led to an increased sense of disenfranchisement among Moroccans, especially the youth (Lefèvre 2017). The expression of suffering, hardship, and injustice that is so central to Gnawa ceremonies appeals to the urban underclass who participate in their ceremonies, regardless of their phenotypes or any ancestral experience of enslavement.

It thus becomes clear that Blackness has become a signifier of marginality and oppression for the larger Moroccan public. "Gnawa" works as a constructed and ever-changing identity that in seeking to reify a connection to sub-Saharan Africa (i.e., Blackness), not only narrates the suffering of the historically enslaved but also addresses contemporary power dynamics. Regardless of phenotype, Gnawa-ness remains a viable and powerful identity for those who identify with the historic marginality experienced by the enslaved, especially the urban poor who find their own struggles with economic disenfranchisement reflected in Gnawa music. In other words, Blackness and a connection to Africa south of the Sahara is no longer an indication of skin color but has developed into a trope that allows people to express dissatisfaction with their socioeconomic status and confront hierarchical power structures.

CONTEXTUALIZING *FRAJA* PERFORMANCES

As stated at the outset, a *lila* typically takes place when an individual afflicted with some illness or adversity seeks out a diviner and is advised to host a private ceremony as the only cure. The host of the ceremony absorbs most of the cost. In cities like Essaouira and Marrakech, people spend what is equivalent to two weeks' income to buy sacrificial animals and food for the musicians and guests.[4] The ceremony itself expresses a spirit of humility, including the musicians' spatial arrangement sitting on the ground close to the audience and the physical venue of modest private homes (although some *lila* are held in Sufi shrines, as discussed in chapter 5) (Figure 3.1). Overall, the visual dimension of Gnawa performances conveys an aesthetic of humility, employing relatively inexpensive and easily available fabrics and other media, in keeping with the modest backgrounds

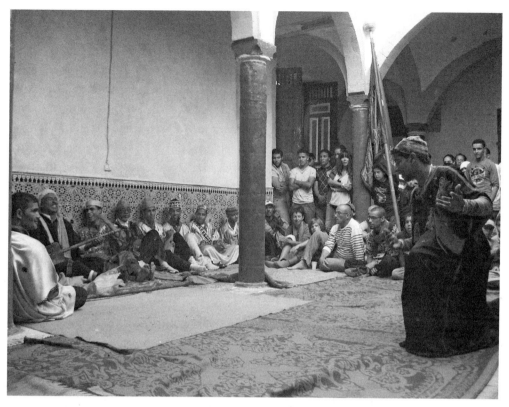

Figure 3.1. M'allem Omar Hayat performs *fraja* songs on the *guinbri* with men performing solo dances in front of him. Dar Dmana, Essaouira. Photograph by the author, 2009.

of both the musicians and their audience, who are not required to pay in order to enter a ceremony. However, guests often offer monetary donations to the musicians to offset the cost of a ceremony.

The belief system underlying the *lila* posits that attacks from a spirit can cause serious illness if a person does not take measures to placate the offended spirit. However, Gnawa ceremonies are not aimed at warding off or exorcising such attacking spirits. On the contrary, they seek to establish or restore a symbiotic relationship with the spirit, demonstrating that the possessed person submits him- or herself to be owned by the "master" spirit, for their mutual benefit.[5] The diviner, who is typically female, presides over the proceedings, hiring the musicians. She amasses the necessary incense, colored cloth, and other items needed to invoke the spirits. Most female diviners have established relationships of trust with a particular male *guinbri* player or *m`allem* who brings his ensemble of other (male) musicians who will accompany him on the iron cymbals, *qraqeb*. Therefore, this suggests that there is gender division that characterizes Gnawa ceremonies, with *fraja* performances the domain of men and the spirit-possession portion of the ceremony dominated by women. However, as we will see in chapter 4,

both men and women participate in possession by spirits and men can also serve as diviners, so the gender division is not always clear cut.

However, ceremonial music is provided by an all-male troupe of musicians. Typically the *m'allem* leads the songs that are performed while he plays the *guinbri*. *Qraqeb* players, also called *qraqebi* in Arabic, sing responses to the *m'allem*, so the style of music is clearly call-and-response. If the *guinbri* player does not have a good singing voice he will rely on a *qraqebi* to lead the ceremony; even for an accomplished singer, the length of the ceremony may mean the *m'allem* must rely on a *qraqeb* player to assist him by singing some of the spiritual repertoire. *Qraqebi* also dance during *fraja* performances, as seen in Figure 3.1, with the crowd sitting around them or standing to watch. Sometimes *qraqebi* perform alone and sometimes with a group, stomping their feet to the rhythm of the *guinbri*.

The day before *fraja* performances occur, animal sacrifice provides the spirits with blood that attracts them into possession: the bigger and more numerous the sacrifices, the happier the spirits. Typically, the events of a sacrifice center around a diviner and her client(s). During the sacrifice that I witnessed at an annual ceremony held by the diviner Halima Meses, the musician with whom she worked, M'allem Omar Hayat, purified the roosters and goat designated for sacrifice as one washes for prayer, using water mixed with a type of incense called *jawi* (Plate 2). Hayat waved a brazier with burning incense around the animal's body three times. After the animals were ritually prepared, he placed a knife between his teeth, knelt, and bowed down to the four corners of the room, saluting the spirits present in this ritually charged space. As Meses watched the proceedings, waiting for blood to flow, she occasionally let out a low growl accompanied by belching, which, she later told me, was the spirits inside of her speaking, indicating that the spirits controlled her bodily functions. One of Hayat's *qraqebi* played the *guinbri* and was joined by men on the *qraqeb*, performing a very slow-moving and solemn song called *Ftih ar-Rahba*, meaning "The opening of the space," welcoming the spirits into the room.

After the animals' throats were slit, a man assisting Hayat filled a bowl with the first blood to flow before it fell onto the ground. One of Meses's clients, a woman confined to a wheelchair, was moved to a small stool and sat near Halima. Although the ceremony was not specifically organized to heal this afflicted woman, those present understood that the woman had contributed to finance Meses's annual ceremony, something that commonly occurs, giving her a place of honor at the ceremony. After the sacrifice of a goat that the client had brought, Meses dabbed drops of blood on her client's ankles, elbows, wrists, and temples as well as in the corners of the venue and its doorways to please all the spirits who come to drink the blood. I was often warned by women not to pass near the scattered drops of blood, because this would cause the *jnun* (spirits) to inhabit me. The blood consecrates the space as ritually pure and ready to receive the spirits but also marks vortices of spiritual power that are potentially

dangerous. Simply put, it sets the space apart from the mundane world and declares it as sacred.

Stories abound about how Gnawa diviners drank sacrificial blood in the past. The documentary *Les 7 couleurs de l'Univers* (The 7 colors of the universe), directed by Jacques Willemont in 2005 and based on the research of French anthropologist Viviana Pâques, features footage from 1969 that shows a female diviner (*mqaddema*), unaware of the camera, drinking from the blood of a sacrificed bull while in trance. Another segment filmed in 2001 shows the *mqaddema* reaching for a bowl of blood when Al-'ayachi, Pâques's primary Moroccan informant, stops her from drinking from it. In a voice-over, the film's narrator explains that Al-'ayachi was aware of the camera, while the diviner was not. They do not explain Al-'ayachi's reasoning, but presumably he was conscious of the fact that people outside this community would consider her actions taboo and certainly in violation of Islamic prohibitions against the consumption of blood.

While I have never witnessed women drinking blood at a Gnawa ceremony, many recounted that it occurred in the not-so-distant past. During most *lilas* that I attended, a *mqaddema* collects a bowl with the first blood to flow from the animal's neck to which she adds incense associated with the spirits and orange-blossom water for use later in healing her clients. Both the film and my conversations with Gnawa practitioners suggest that people began to self-regulate their behavior to bring it into alignment with their perceived understandings of Islam. Furthermore, increased global interest in Gnawa ceremonies by anthropologists as well as musicians, both inside and outside Morocco, has altered the mechanisms of Black identity-construction, resulting in Gnawa diviners' conforming their actions to the expectations of outsiders—especially those with cameras.

Notwithstanding prohibitions against drinking blood, my experience at Gnawa *lilas* revealed that the sacrifice of animals continues to be integral since it is essential to the process of engaging spirits into possession. I often observed women fall to the ground after an animal sacrifice, screaming and moving uncontrollably as the possessing spirit made itself known. When this would happen, the diviner would apply small drops of blood on their ankles, the inside of their elbows, wrists, and temples in order to placate their inhabiting spirits and thus allow the possessed to regain composure. The spirits constantly threaten to get out of control and unmanageable, but proper sacrifices and behavior appease them. Afterward, the diviner dances in front of the musicians, and as the pace of the songs increases, she dabs sacrificial blood on the musicians' instruments, sharing some of the blood with the spirits that inhabit the instruments. Meanwhile, someone grills and distributes the internal organs of the animals, which people believe transmit *baraka* (an Arabic word meaning "God's blessings"). Use of the word *baraka* to refer to the benefits gained from spirits demonstrates how people employ beliefs associated with local forms of Islam to validate their spiritual practices in a society that privileges a Muslim identity.

The fact that Gnawa practitioners are situated within a Muslim majority culture means their participation in blood sacrifice is marked by ambiguity and ambivalence.[6] The scholar Bertrand Hell notes that, on the one hand, blood represents a life-giving force for Gnawa spirits; on the other hand, it is associated with transgressions against Islam (2002, 37). A similar attitude toward animal sacrifice for spirits occurs in other areas of Muslim Africa, such as Niger, where Hausa *bori* adherents make sacrifices to satisfy the spirits' taste for blood in exchange for protecting their village. They kill animals at strategic points in a village and along cardinal axes to set up a ritually protected space that prevents evil influences from entering a village. However, the anti-*bori* sentiments of some Muslims in Niger have led to a drastic decline in these practices.

Animal sacrifice that encourages spirits to materialize and induces trance in their human hosts is considered unorthodox by some Moroccans who told me that the sacrifice and consumption of animals dedicated to anyone or anything other than God is considered *haram*, or forbidden, something also stated in the *Encyclopaedia of Islam* (Francesca 2012). On the other hand, animal sacrifice, called *dbiha* in Arabic, is common to many Moroccan ceremonial occasions such as weddings and seven-day naming occasions, where the meat is shared with guests. Animal sacrifice can even be an act of piety, as, for instance, during the religious holiday `Aid el Adha, "the feast of the sacrifice," when Muslims enjoy a portion of the meat and give the rest away to the poor.

Therefore the sacrifice of animals during a Gnawa ceremony carries multiple significations, revealing that Gnawa practices simultaneously carry multiple meanings and identities as both Sudani (i.e., pre-Islamic animist) and North African (i.e., Muslim). But the ceremony also features many actions that are perceived as conforming with Islamic law: a Gnawa male musician, rather than the female diviner who organizes the ceremony, cuts the animal's throat while on its left side, facing the *qibla* or direction of Mecca. When the throat of the animal is slit, Gnawa musicians chant, *La`fu ya Mulana*, which means "God heal us oh Master," with the word "Master" referring to God.[7] Viviana Pâques interprets the phrase as a mystical term common to Sufi groups in Morocco, calling on God to have pity and cleanse them from their sins. At the same time, she recognizes that the phrase carries an additional semantic weight, with the word "Master" simultaneously referring to healing from the literal bondage of slavery and to the figurative bondage that separates the soul from reunion with God (1991, 250). The intertwining of elements meant to convey a Muslim identity together with those some might interpret as animistic illustrates how Gnawa animal sacrifice conforms to hierarchies of power that prioritize practices deemed appropriate within Islam and, at the same time, exist outside of them. It also expresses the idea of simultaneity where people belong to multiple spheres of belonging at the same time. Animal sacrifice at the beginning of a *lila*, therefore, has multiple and overlapping meanings. It is perceived of in Morocco as both evidence of Muslim religiosity as well as a remnant of pre-Islamic, Sudani animism.

When I was invited to a *lila*, we gathered the day following the animal sacrifice, at around nine or ten in the evening, outside the diviner's house, ready to perform a public procession called the ʿaada. Unmarried girls stand in the alleyway in front of the house, scrambling to light their white candles. When the diviner emerges from her home with a bowl of milk balanced on a tray filled with dates, it is the signal for the m ʿallem to begin pounding a distinctive rhythm associated with Gnawa drumming on the larger of two barrel drums. Several younger musicians begin playing their metal cymbals, walking behind the group of women led by the diviner with the drummers bringing up the rear. The group winds its way through the city streets, occasionally stopping to perform. During these performances, *qraqeb* players form a straight line, dancing forward to approach the drummers. One by one they leave the line and dance in front of the m ʿallem, spinning in a circle, jumping in the air, and bowing down in front of the drummers to show respect.

As the diviner approaches her house, she uses a wooden spoon to place drops of milk on each instrument, thereby distributing *baraka*. As the group gradually makes its way back to the house, it inevitably draws attention from those in the neighborhood and passersby. While admission is often restricted at some ceremonies organized in private homes, others have an open-door policy, claiming that since the ceremony is meant to heal the sick, denying anyone entry is inhumane and uncaring. While both men and women attend Gnawa ceremonies, the majority of participants are women, often with children in tow. Everyone pushes and shoves to be the first to enter the diviner's home in order to grab the best seats near the musicians or against a wall to watch the ceremony in comfort, beginning with the *fraja* portion of the *lila*, before spirits are evoked into possession. People take their seats and prepare to be transported through *fraja* performances to Africa south of the Sahara.

ULED BAMBARA, "CHILDREN OF BAMBARA" PERFORMANCES

The particular function of *fraja* performances places Gnawa ceremonies within a narrative that links them to the Sudan, emphasizing a unified and fictionalized "Bambara" identity. The two distinct sections that comprise *fraja* performances—*Uled Bambara*, meaning "children of Bambara" in Arabic, and *Nksha*—are accompanied by an extensive repertoire of songs played on the *guinbri* and accompanied either by hand-clapping, in the case of the *Uled Bambara*, or with the addition of iron cymbals, in the case of the *Nksha*.[8] Both groups of songs express and protest the hypocrisy of a slavery system that permitted Muslims to enslave fellow Muslims. Performing a Bambara identity provided the enslaved with the means to grapple with their situation as minorities in an Arab-Amazigh nation, while contemporary performances by those without enslaved ancestry express current frustrations of the underclass failing to thrive in Morocco's current socioeconomic system. However, as we will see, what it means to identify as Bambara is just as complex as trying to identify the meaning of the term "Gnawa."

Timbuktu as Homeland

In a call-and-response format, the first song performed as part of the *Uled Bambara* repertoire establishes the two primary themes of *fraja* performances: the Gnawa connection to the Sudan and the history of enslavement.[9] References to Allah and the Prophet precede any mention of enslavement, suggesting that Gnawa feel obliged to situate themselves within the parameters of what they perceive to be acceptable Islamic practice before recounting their historical origins and the injustice they experienced.

> Allah nabina, ya Rasul Allah
> [Allah, our Prophet, oh messenger of God]
>> Ya Rasul Allah
>> [Oh Messenger of God]
> Bghina nzuru nabi Allah, ya rasul Allah
> [We want to make a pilgrimage to the Prophet, oh messenger of God]
>> Ya Rasul Allah
>> [Oh Messenger of God]

As the song continues, it describes the experience of being captured and forced to migrate across the Sahara. The visual images evoked during this portion of the song clearly posit an ancestral link between Gnawa practitioners (referring to themselves as "Bambara people") and the Sudan and establish a dichotomy between the people of Sudan and their enslavers:

> Bambrawi ya Sidi Rasul Allah
> [Bambara people, oh Messenger of God]
>> Ya Rasul Allah
>> [Oh Messenger of God]
> Jabuni jabuni ya sidi Rasul Allah
> [They brought me, they brought me, oh Messenger of God]
>> Ya Rasul Allah
>> [Oh Messenger of God]
> Bladi Sudan ya Rasul Allah
> [My homeland is Sudan, oh Messenger of God]
>> Ya Rasul Allah
>> [Oh Messenger of God]
> Dawzuna ʿala Timbuktu. Sudani A yma
> [We passed by Timbuktu, people of Sudan, oh my mother]
>> Sudani A yma
>> [People of Sudan, oh my mother]

Jabuna flkhnashi, Sudani A yma
[They brought us in sacks, people of Sudan, oh my mother]
Min Sudan jabuna
[From Sudan they brought us]
Farquni `ala yma, Sudani A yma
[They separated me from my mother, people of Sudan, oh my mother]
Sudani A yma
[People of Sudan, oh my mother]

Beyond the general evocation of the Sudan, *fraja* songs frequently allude to the legendary city of Timbuktu, a respected center of Islamic scholarship. Ali Mazrui describes Timbuktu during Songhai rule (1325–1591) as a Black intellectual center where scholars from Timbuktu, Cairo, and Fes engaged in intellectual exchanges. "These were the years," Mazrui writes, "when Blackness was recognized as compatible with excellence" (2005, 72). Evoking Timbuktu gives Gnawa a prestigious place within Islamic history. It also reinforces a popular version of the Gnawa origin story previously discussed, namely their descent from Black people enslaved during the Moroccan monarch Ahmad al-Mansur's 1591 conquest of the Songhai Empire and the historically significant city of Timbuktu, in what is today known as Mali. In the sixteenth century, Timbuktu was a city on the edge of the Sahara where constructions of race and religion played out as various empires sought to control it. This was also a period when Arabic- and Amazigh-speaking groups in the Sahara and Sahel began to invoke Arab Muslim origins and to define the Sahelian region of Africa as the Sudan, referring to its inhabitants as other (i.e., Black). Some Amazigh groups adopted Arabic as a language of daily life, and Islam became a more important marker of status. Embracing what were understood as Arab cultural and religious practices and claiming genealogical connections to Arab ancestors, especially those descended from the Prophet Muhammed, led to the emergence of an elite in the Sahel that defined itself in opposition to non-Muslim Black people (Hall 2011, 57–58).

Timbuktu functions in *fraja* performances as a multivalent symbol, pointing to both a Sudani and a Muslim identity simultaneously. By invoking Timbuktu, Gnawa recall the experience of mass enslavement, while simultaneously legitimizing a connection to Islam, since Timbuktu was known as a historical center of Islamic learning. Making a connection to Islam legitimizes a claim that the trans-Saharan slavery system unjustly enslaved their ancestors.

After the conquest of Timbuktu by the Moroccan sultan in 1591, North African jurists debated whether it was ethically permissible under Muslim law to buy slaves from the Sudan who professed to be Muslims. Among them was Ahmad Baba (died 1627), a scholar who was forcefully removed from Timbuktu by Moroccan conquerors and brought to the city of Marrakech. Once in Marrakech, Baba wrote a treatise that refuted the equation of Blackness with slavery. He challenged the assumption that *all* Black Africans were

non-Muslims and could thus be enslaved, but at the same time acknowledged that Black people who were pagans or "unbelievers" could justifiably be enslaved (Hall 2011, 52).

Therefore, Timbuktu serves as a powerful imaginary that allowed performers to lay claim to an alternative empire and a powerful, positive elsewhere. Claiming Timbuktu as a homeland served to reinforce the idea that the ancestors of the enslaved were Muslims and were, therefore, wrongly enslaved—a notion that remains alive and well in contemporary Morocco, as many people descended from slaves shared this idea with me. Lacking the large networks typical of extended families in Morocco, enslaved people sought identifiers that would fill in for missing biological family, and Timbuktu serves this purpose.

Another image from this *fraja* song of being carried in sacks forges a sense of community through shared suffering: the enslaved person's blind terror and complete powerlessness. The image of people being kidnapped and separated from their mothers is not meant here as a metaphor but as historical fact. Historian James Webb wrote about how nomadic warriors would often ride horses into agricultural fields, quickly stuffing small children into sacks that they tied onto their horses' backs. If time permitted, they would abduct older children and adults, fleeing quickly before they had to face the wrath of the raided community (1993, 222). His account may be based on stereotypes about the Sahara, but I heard similar stories from people whose grandparents had been enslaved. They recounted how their relatives had been grabbed as children by camel-riding nomads and sold in slave markets. Many explained that children were often enslavers' targets because it was cheaper to care for children than adults. They told me that whenever I met a Black person with little extended family, I should recognize this as a sign that the person's ancestors were enslaved. Hence, the references in *fraja* songs to being a motherless child should be taken as both literal and figurative, historical and symbolic, invoking the experience of being uprooted from one's family and alone in the world, powerless and without the large network of familial support so valued in Moroccan society, not least because such a network can provide economic assistance in times of need. Such uprooted-ness and motherless-ness contributed to the sense of invisibility experienced by the enslaved and their descendants, who existed outside larger, more visible social networks of support.

Some may relate to the examples of racism and discrimination evoked during *fraja* performances under the larger conceptual umbrella of *hogra*,[10] a Moroccan Arabic word that describes the sentiment of being devalued due to class and race, and the concomitant animosity toward those in power. The following line of the song feeds the sense of *hogra* or social injustice and reifies indignation toward the institution of slavery,

Ba`uni lkafara ba`uni, Sudani A yma
[They sold me, the nonbelievers, they sold me, people of Sudan, oh my mother]
Sudani A yma
[People of Sudan, oh my mother]

"They sold me, the nonbelievers" appears to accuse the enslavers of engaging in behavior at odds with Islam. It expresses the tensions that exist between a social hierarchy that associated Blackness with slavery and the Islamic principle that all Muslims are fundamentally equal and part of a global community (*umma*). Thus in a complex loop of righteous indignation, the accusation of unorthodox practices are turned back on those who have used the same accusation as a justification for enslaving them.

As previously noted, Muslim jurists debated whether the Black people whom Ahmad Baba identified as Muslims could in fact be enslaved. Many asserted that regardless of whether or not these people claimed to be Muslims, the contamination of their religious practices with savage, animistic rituals, together with the defective or debased nature of their Islamic beliefs and observances, rendered them essentially nonbelievers and thus available to enslavement under Islamic law—especially, one juror wrote, if they acted like "the Bambara" (Hall 2011, 85). "Bambara" was a term used by Muslims of West Africans whom they identified as nonbelievers. So what does it mean when Gnawa refer to themselves as "children of Bambara"? Since Gnawa self-identify as Muslim today, are they reclaiming their pre-Islamic identity or are they adopting a moniker given to them by others without critically accessing its derogatory meaning?

Dancing as a Bambara Hunter

In order to address these questions, we must consider another visual image incorporated into the *fraja* repertoire—that of a man loading and shooting a gun, representing one of the several threads that constitute Gnawa identity and forge an ancestral connection to a Bambara ethnicity. The act of shooting a gun is evoked during one of the most recognizable Gnawa *fraja* songs, which repeats the word *bangar*.[11] When I interviewed musicians, none was able to define the word for me, although there was a consensus among them that it is a Sudani word, and that the accompanying dance performed by a *qraqebi* was meant to imitate a hunter.

During the performance of this call-and-response song, one of the *qraqebi* faces the *guinbri* player and performs quick steps from side to side, holding a cane or stick to imitate the motions of loading a gun. Gnawa performers themselves described the gesture to me as simulating a hunter stalking prey in a forest. When the *guinbri* player strums a distinctive rhythm on his instrument, this serves as a signal to the dancer to jerk the cane backward, imitating the act of shooting a gun:

> Hayi bangar musayir
> [Come on, bangar leader]
>> Hayi bangar bangar, Allahu akbar bangar bangar
>> [Come on bangar bangar, God is great, bangar, bangar]
> Allah ukbar bangar musayir
> [God is great, bangar leader]

> Hayi bangar bangar, Allahu akbar bangar bangar
> [Come on bangar bangar, God is great, bangar, bangar]

'mmer lkabus 'mmer musayir
[Load the gun, load [the gun] leader]

> Hayi bangar bangar, Allahu akbar bangar bangar
> [Come on bangar bangar, God is great, bangar bangar]

Gnawa luwleen bangar musayir
[The first Gnawa, bangar leader]

> Hayi bangar musayir
> [Come on bangar leader]

The repetition of the word *musayir* ("director" or "leader" in Arabic) is meant to encourage the dancer who "leads" the song. The phrase "load the gun" is accompanied by the dancer holding a stick in the air to mimic the act of shooting a gun and suggests that the "leader" is also a "hunter." Many Gnawa practitioners identify the hunter in this song as Bambara and, furthermore, claim a Bambara origin for themselves. Such a direct provenance is tempting but elusive.

To begin with, the term "Bambara" is considered to be a derogatory variant commonly used in North Africa for "Bamana," the term favored by scholars to refer to a particular ethnic group and language spoken in Mali. As discussed by Jean Bazin in his article "A chacun son Bambara" (1985), throughout history the names "Bambara" and "Bamana" have served as common labels across Africa to identify a given people as the "other." As an othering mechanism, it was used by those in power-dominant positions to lump together groups who spoke different languages and whom those in power perceived to be ethnically distinct from and religiously inferior to themselves. For example, urban Muslim merchants living in Djenné used the word "Bambara" as a pejorative term for rural farmers, in essence designating them as pagans, peasants, and savages. Further complicating matters is the fact that during the precolonial period, Senegalese slave-owners referred to their captives under the catchall term "Bambara."[12]

Despite its pejorative association with Africa south of the Sahara, use of the word "Bambara" by Gnawa in contemporary Morocco is a means of asserting a Sudani identity and indicating an ancestral relationship across the Sahara. In an act of reappropriation, a word that was at one time a pejorative descriptor given by Muslims to Black Sahelian Africans has been adopted by the very group it was meant to insult, demonstrating the power of speakers to revise meaning by "owning" stigmatizing language. By calling themselves "children of Bambara," Gnawa create group solidarity by connecting to an elsewhere on the other side of the Sahara similar to what some in Morocco do by invoking Andalusian Spain. Since those enslaved from the Sudan were stolen from a multitude of geographic sites in West Africa, Gnawa musicians emphasize a plausible yet historically streamlined connection to a place that now functions as an ideal of elsewhere.

Performed exclusively by men, *fraja* songs celebrate masculine qualities, which, in this song, are epitomized in the figure of the hunter. In particular, with its focus on the choreography of the hunt, this song describes Mande societies in Mali, of which the Bamana are a part.[13] Despite its decline as a subsistence activity in West Africa, hunting continues to be equated with the exalted male values of bravery and physical prowess (Durán 2003), and the hunter is believed to be surrounded by powerful mysticism. Referred to as *donsow*, hunters were traditionally seen as leaders and extraordinary individuals endowed with supernatural skills that render them both very potent and potentially dangerous. They formed part of an exclusively male organization that required members to demonstrate strong character, courage, and stamina in the bush (Durán 2003, 145). So revered were hunters in Mande societies that they merited their own class of musicians, the *donso-jeliw*, who performed praise songs in their honor on a seven-stringed harp (Figure 3.2). Musical celebrations commonly occurred after a successful hunt, to fortify the hunter against the unseen, potentially harmful forces (*nyama*) released upon the death of an animal (Durán 2003, 143). In some areas, especially Mali, hunters still gather for secular celebrations where they wear amulet-covered tunics and shoot their locally manufactured muskets into the air (Durán 2003, 143). Furthermore, while in Mali in 2004, my visit with hunters' musician Sekouba Traoré revealed that he had several musical apprentices living in his home, who learned music from him much as Gnawa hereditary musicians are trained within their communities. Are Gnawa musicians aware of the status of Bamana hunters and their musicians in West Africa? Might the enslavement of actual hunters have impacted this Gnawa performance?

While there are obvious cognates between Bamana hunters and this Gnawa *fraja* performance, the historical complexity that surrounds the word "Bambara" makes verifying a claim of Bamana retention impossible and, frankly, unnecessary. More significant than teasing out which thread is the authentic one is seeing the dance as a tribute to "the First Gnawa" (*Gnawa luwleen*) or Gnawa ancestors, evoking a preenslaved Sudani collective past. In referring to aspects of a Gnawa ceremony as "Bambara," a Gnawa performer is designating himself as a powerful historical figure from the Sudan. Therefore, tracing a literal Bambara/Bamana origin for Gnawa is less important than recognizing the meaning implicit in the archetype of the gun-carrying hunter—to wit, the ability to overcome adversity through prowess and courage.[14] We only need to place the gesture of holding a stick as if raising a rifle beside the image of children being kidnapped in sacks and sold into slavery to see that the gun images in Gnawa songs serve as emblems of an empowered alternative history. Rather than depicting themselves as arriving helpless and passive in chains, these images portray men as accomplished weapon-wielding hunters.

In addition to that of the West African hunter, another historical association of people with guns may be retained in this image: memories of the sultan's Black army whose rifle-carrying members represented a diverse, hybrid community unified by their

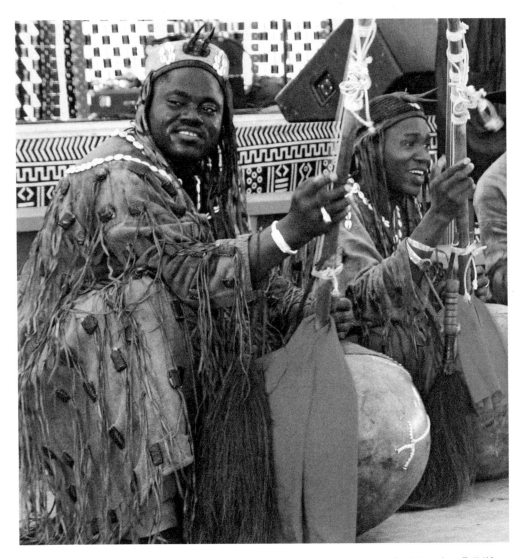

Figure 3.2. Sekouba Traoré was invited to perform hunters' music at the Smithsonian Folklife Festival, Washington, D.C. Photograph by the author, 2003.

subaltern status as "others" due to their dark skin. In his book *Black Morocco*, Chouki El Hamel notes that the status of Black men in the army of the sultan "fluctuated between privilege and marginalization" (2013, 238). As the Black army gradually disbanded during the nineteenth century with the economic and political destabilization of the monarchy, they settled across Morocco, where their status and that of their descendants was a matter of dispute and discomfort among the general population. El Hamel's scholarship demonstrates that even in the nineteenth century, Moroccans associated Blackness with low status and infidelity or paganism and resisted the idea that the sultans' Black soldiers were equal members of society. The resulting conflicts necessitated the

intervention of legal scholars, who ultimately declared that former members of the sultan's Black army should be regarded as free people and "may serve as notaries and witness" in courts and even lead Friday's prayers in a mosque (El Hamel 2013, 239). Nonetheless, it is clear that Blackness indicated alterity and non-Muslim status in the eyes of a majority of Moroccans, regardless of whether these Black Moroccans self-identified as Muslim or not.

With all this in mind, the image of a dancer mimicking the act of shooting a gun speaks for itself as a gesture symbolizing power or the aspiration toward it, and the will to assert oneself against the disempowered status of enslavement. Implicit in the gesture of shooting a gun is a response to the violence that resulted in enslavement. Importantly, the "children of Bambara" express courage and strength in the face of hardship due to enslavement and its aftermath.

NKSHA SONGS AS EXPRESSIONS OF POVERTY

The *Uled Bambara* suite is followed by a group of songs referred to as *Nksha*. While the word *Nksha* itself does not have any agreed-upon meaning among Gnawa practitioners, the Moroccan colloquialism *feltet-lu nksha* is often used to mean "he's gone mad," more specifically that someone is doing something outside of his control. This suggests that the term may have denoted a connection between madness and loss of consciousness and Gnawa spirit possession—which can both mimic a condition associated with madness or mental illness and serve as a cure for it.

Among the several salient differences between *Nksha* and *Uled Bambara* performances is the fact that while *Uled Bambara* songs are typically in the past tense, *Nksha* songs are performed in the present tense. Rather than making a historical connection to the Sudan, they recount the experiences of the enslaved once they arrived in Morocco, and the use of the present tense suggests an ongoing experience. And while *Uled Bambara* songs foreground the *guinbri*, *qraqeb* are the acoustically foregrounded accompaniment to the *guinbri* during *Nksha* songs. The *qraqeb* are made of iron and consist of two concave, circular cymbals with a straight bar between them. A cord attached to the middle of the instrument allows it to be held (Figure 3.3). One pair of instruments is held in each hand, and the two plates are struck against each other by opening and closing the hand, making a clacking sound. In fact, the names *qraqsh* and *qraqeb* are both probably onomatopoeic, referring to the noise they make when played. Like the *guinbri*, which will be discussed in chapter 6, this instrument is uniquely associated with Gnawa musicians in Morocco.[15]

The iron *qraqeb* exists throughout the Maghreb where it is given different names by various Black communities linked to the history of enslavement. In Tunisia, for instance, descendants of enslaved people play cymbals called *shqashiq* to evoke spirit possession, although, according to ethnomusicologist Richard Jankowsky (2010), they are generally

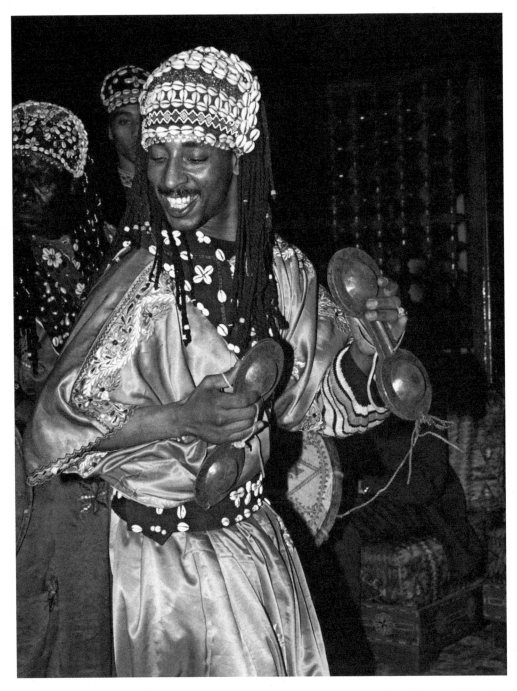

Figure 3.3. Homani Abdellawi performs with cymbals (*qraqeb*) in Essaouira. Photograph by the author, 2001.

heavier than the Moroccan *qraqeb* and the style of playing is different.[16] In Morocco, each pair of *qraqeb* is held together with a small circle of metal placed through a hole at one end of each cymbal, restricting the movement of each metal plate and limiting the volume that each pair can produce.[17]

Some scholars speculate that these instruments were originally made of wood or bone and brought from sub-Saharan Africa to the north where they were transformed by blacksmiths, often of West African ancestry, into instruments forged from iron (Erlmann 1986, 14).[18] This explanation raises more questions than it answers because if the smiths were of West African ancestry, why wouldn't they have made them from iron before going north? The art historian Labelle Prussin, on the other hand, argues that the iron cymbals played by Gnawa musicians derive from the fluted iron discs used to create doorknockers and ornate hinges that decorated massive wooden doors in the Iberian Peninsula made by Jewish blacksmiths from Andalusia and carried into North Africa. According to Prussin, an iron design on a door "can be viewed as a prophylactic amulet" that protects "interior, private space from the outside world of strangers" (2005, 103). Prussin contends that enslaved people repurposed the iron amulets that adorned architectural space into instruments played during healing performances (2005, 105). While there is no consensus among scholars as to the historical origins of the instrument, there is no doubt that West African beliefs in the mystical and spiritually mediating powers of blacksmiths are preserved in this instrument (e.g., McNaughton 1988).

Iron Cymbals in Morocco and Ghana

Within Morocco the meaning of iron cymbals differs greatly. The fact that the cymbals are made of iron, a base metal, in itself relegates them to a lowly status and stigmatizes them as an instrument of the underclass. Their very materiality renders them more akin to farming implements, chains, horseshoes, and window grills than to the delicately constructed wooden lutes or violins that typify Moroccan Andalusian music. Moreover, iron cymbals were, at least until the mid-twentieth century, hand-forged by blacksmiths, a historically low-status occupation in Morocco. René Brunel described blacksmiths in early twentieth-century Morocco as occupying the same low status as butchers, peddlers, bath workers, menial laborers, and freed slaves (1926, 51–52).

However, among the majority Moroccan population, the fact that iron is stigmatized as lowly in no way vitiates its power. In the 1920s, Edward Westermarck noted the power attributed to iron in Morocco to "scare away the *jnun* [spirits]" (1968, 1:115). The smiths' skill at handling and controlling fire was believed to equate to skill in handling and controlling these spirits. At the same time, iron itself—as well as the water used by blacksmiths to quench hot iron—was believed to possess healing qualities. Westermarck reported that just as iron could be used to protect one from harmful spirits, the blacksmith's water, having been in contact with iron, could be used for prophylactic baths (1968, 1:115). And, indeed, these beliefs persist among the Moroccan population

in general. While I was living in Morocco, female friends, who were embarrassed to do so themselves, often sent me to the market to purchase a jug of water from a blacksmith that they would use to cleanse themselves from harmful spirits. I also found widespread among rural Moroccans the belief that people who sleep alone should keep an iron-bladed dagger near their pillows to protect them from spirits (*jnun*).

Descendants of enslaved people in rural southeastern Morocco (Ismkhan) lace water with salt in the concave portion of iron *qraqeb* during healing ceremonies to exorcise evil *jnun* from people's bodies. After each man dips his finger in the water, the ill person drinks three sips of the water, suggesting the power of iron as well to expel evil spirits. Furthermore, as dark-skinned people, their Blackness and connection to Western Africa grants them the healing abilities to cure illness. During Gnawa ceremonies, however, iron cymbals attract rather than repel spirits, and when animals are sacrificed at the beginning of a ceremony, blood is placed on the cymbals to feed the spirit inhabiting them.

In rural areas, ironworking was often the job of Harratin, and the implication was that high-status elites chose not to do such jobs since it put them into powerful proximity to supernatural spirits (*jnun*), which are attracted to fire. Renowned Gnawa musician Omar Hayat explained to me that his own father was an ironworker who worked in Essaouira and made iron cymbals for Gnawa. His close proximity to these instruments encouraged him to learn the Gnawa spiritual repertoire, and he began participating in ceremonies as a cymbal player (*qraqebi*) and ultimately became possessed by spirits. Growing up in this milieu encouraged Hayat to learn the *guinbri*, and now he is an accomplished Gnawa musician who plays private ceremonies in homes, at public ceremonies in shrines, and public staged concerts.[19]

In all of these examples, the material of iron embodied supernatural power and had the ability to transcend the mundane and transmit energy to and from the spiritual realm. Some scholars believe that the association between ironworking and the spirits was carried from south of the Sahara into the north, which would attest to the spirits evoked by Gnawa being entirely part of a pre-Islamic belief system. Viviana Pâques (1964), for example, speculated that a primordial blacksmith played a central role in the creation story that was part of what she identified as a homogeneous mythos that united the massive region of Northwest Africa before the arrival of Islam. According to Pâques, West Africans believed that a blacksmith descended from the heavens, bringing iron, a hoe, and rainfall—endowing humans with the objects and elements necessary for the advent of agriculture (1964, 151–52). She wrote that the enslaved carried the association of the blacksmith with the metaphysical with them across the Sahara, contributing to ritual beliefs held by Gnawa today.[20] As we will see in chapter 4, the genealogy of Gnawa spirits is extremely complex and includes the incorporation of Sufi saints. Without judging the validity of Pâques's creation story, there is no doubt that the iron cymbals bear centuries of accumulated semantic and symbolic weight.

The narrative to which most locals ascribe coincides with the scholarly conjecture that iron cymbals were carried across the Sahara by the enslaved who re-created them in North Africa. Due to their association with slavery, they became racialized as Black and associated with a pre-Islamic belief system and, by extension, with spirit possession. As those who experienced the trauma of slavery played them to assert a unified identity as "Gnawa," the instrument came to connote enslavement, powerlessness, and uprootedness, a connection that is embraced and promulgated by performers themselves who claim that the repetitive sound made when *qraqeb* are played mimics the sound made by the chains used to shackle the enslaved. At the same time, when they are played, the sound they make is extremely loud and demands to be heard—so that powerlessness, as it were, is given an assertive public voice. The fact that they are intimately associated with a Gnawa identity in contemporary Morocco illustrates how a mundane instrument made of iron gave the enslaved a means to tell their own history.

Similar instruments exist south of the Sahara where they also carry a connection to an imagined elsewhere, but the story they tell is very different. Double-headed iron cymbals that resemble those played by Gnawa were once played in West Africa during Hausa spirit-possession ceremonies called *bori*. An illustration from an article written by Akin Euba in the journal *Ibadan* from 1965 shows a Hausa woman playing the same instrument, called *sambani* in Nigeria. Interestingly, in Hausa, the word *ba-sambani* means "a slave of Arab traders" (L. Anderson 1971, 159; Bargery and Westerman 1934, 91). According to the author, when the nineteenth-century Islamic Sokoto Caliphate condemned *bori* spirit possession as un-Islamic, the instruments were repurposed by Muslim women to accompany the performance of Islamic religious songs (Erlmann 1986; Euba 1965, 54).

Complicating the historical path of these instruments is that they are played today in northern Ghana by Dagbamba blacksmiths where they are called *sabaani* rather than *sambani*. Due to the large number of Hausa loanwords in the Dagbani language, it is likely that Hausa traders brought this cymbal with them when they carried iron goods from Nigeria to Ghana in the eighteenth century. During a visit to Tamale in northern Ghana in 2017, I interviewed a group of blacksmiths who play a similar instrument at funerary performances, during which I was told some are possessed by ancestral spirits who allow them to touch fire without burning themselves. When I commissioned a pair of cymbals to be made, I was warned that if they were played outside of a funeral context, someone would die—evidence that the instrument continues to be associated with supernatural power. Issahaku El Hassan, the chief of the blacksmiths, explained to me how they play cymbals as part of funerary performances, during which the sprits of ancestors possess those present:

Sometimes when we play it, you see someone sitting quietly, and then, all of a sudden, you see them dancing and getting up and acting as a mad person. So the spirits come down, enter them, dance, and then go away. And when someone is about to fall sick and

die, when they hear *sabaani*, they can become possessed and start dancing. The spirits speak through the person and can tell the future. They even say the reason that a dead person passed away.[21]

Older pairs of cymbals are kept by the chief blacksmith under lock and key in a metal box from which they are removed only for ceremonial occasions; however, he granted me permission to photograph a group of them placed in front of a blacksmith (Figure 3.4). People explained to me that they were locked away to keep them away from children, who might accidently play them and bring misfortune to the community. I was told that the instrument is now only played for the funerals of blacksmiths or butchers.

An intriguing linguistic point is that while the instrument is associated with ancestral spirits, I was told that the word *sabaani* is of Arabic derivation. El Hassan explained, "We have a lot of Arabic words in our language, and *sabaani* is one. We believe that our ancestors might be Arabs." So, the same iron object on both sides of the Sahara has different biographic meanings and different origin stories attached to it. The Arabic words in the Dagbani language are largely loanwords from Hausa, which contains a great deal of Arabic, but El Hassan prefers to connect the cymbals to Arabs directly rather than to Hausa traders. Identifying the instrument as "Arab" reveals how locals understand the hierarchical nature of Islam in the Sahel; linking themselves to an Arab identity gives the otherwise low-status users of these instruments more prestige in a region that has increasingly oriented itself toward the global Muslim community.

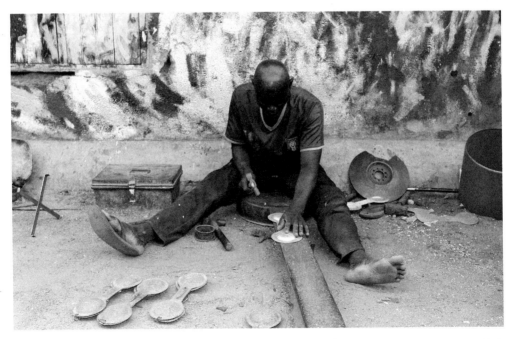

Figure 3.4. Afa Iddi makes *sabaani* (cymbals), Tamale, Ghana. Photograph by the author, 2017.

Thus, on both sides of the Sahara, iron cymbals are connected to an imagined else-where and a cultural identity meant to challenge local histories that equated them with subservient status. The work of Igor Kopytoff (1986) provides a useful lens through which to view the life of an object over time and space as its meanings change and are renegotiated. As stated by Kopytoff, throughout their life histories, things may become recognized by a group as having cultural relevance and take on the "weight of cultural sacredness." As objects move across time and space, they may move from having mun-dane status to achieving prestige as collectible items to be displayed in museums. Often behind the changing cultural values of particular objects are conflicts over power and struggles of cultural, class, and ethnic identity (1986, 81). In the field of African art his-tory, Prita Meier's work on Swahili stone architecture reminds us that objects gather onto themselves a multiplicity of experiences and meanings as they cross geographic and sociopolitical boundaries (2016, 3). Her work also encourages scholars to ask how power and politics help shape the meaning of things, especially during moments of sociopolitical crisis (2016, 6).

The very portable iron cymbals played by Gnawa have moved across both time and space. Apparently carried across the Sahara by the enslaved, in Morocco they embody a distinct body of knowledge that associates them with Sudani origins and the super-natural. As we have seen, a comparison of the different meanings attributed to iron cymbals on opposite sides of the Sahara exposes how religious and social designations become embodied in objects in response to changing historical and social conditions.

Uncle Mbara's Song

The distinctive sound of the *qraqeb* accompanies "Uncle Mbara's song," which relates the details of the poverty that was—and still is—integral to the situation of Black Moroccans. While we cannot date this song with accuracy, unlike other *fraja* perfor-mances that contain "Sudani" words, the words of this song are performed in the pres-ent tense and entirely in the Moroccan dialect of Arabic, suggesting that it was created by people in Morocco rather than carried from West Africa. The call-and-response song recounts the hardships experienced by the archetypal Uncle Mbara:

Allah Allah mulana, Allah la tansana, khali mbara darwich wa rja fi Allah ta`ala. Hada wa`do meskin
[Allah, Allah, oh Mulay, Allah don't forget us, My humble uncle Mbara, our hope is in
 Allah, the Highest. This is his destiny, poor man]
 Allah Allah mulana, Allah la tansana, khali mbara darwich wa rja fi
 Allah ta`ala. Hada wa`do meskin
 [Allah, Allah, oh Mulay, Allah don't forget us, My humble uncle Mbara,
 our hope is in Allah, the Highest. This is his destiny, poor man]
Lalla takoul lhima, Sidi yakoul lhima, wa Mbara ygaddad `adima, Hada wa`dao meskin

[Lalla eats meat, Sidi eats meat, and Mbara chews the bone. This is his destiny, poor
 man]

 Allah Allah moulana, hada wa`do meskin

 [Allah, Allah, oh Mulay, this is his destiny, poor man]

Lalla ycharbu atay, sidi ycharbu atay, wa Mbara yakoul likama, hada wa`do meskin

[Lalla drinks tea, Sidi drinks tea, and Mbara eats the leftover herb. This is his destiny,
 poor man]

 Allah Allah moulana, hada wa`do meskin

 [Allah, Allah, oh Mulay, this is his destiny, poor man]

First to the terminology, "Lalla" and "Sidi" are honorifics generally applied to those
descended from the Prophet, "Lalla" referring to a woman and "Sidi" to a man, as well
as being the terms by which enslaved people historically addressed their enslavers (anal-
ogous to Mistress and Master). The term "uncle" here refers not necessarily to a rela-
tive but to any older male with whom the singer has a close, familial-like relationship.
"Mbara" is a name Moroccans associate with a Black person, as I found during my
research in rural southeastern Morocco in the 1990s. Indeed, certain first names—
Mbara and Mbark (which mean "blessed" in Arabic, deriving from *baraka*), along with
Bilal and Faraji—are immediately recognizable as belonging to those descended from
enslaved (i.e., Black) men, whose last names were those of their so-called owners.

According to Jeremy Prestholdt's work on slavery in Zanzibar, the names and nam-
ing practices of enslaved people can give us a sense of how slaves were classified and
organized as well as how these individuals chose to be known in society at large.
Prestholdt wrote: "Naming was a profound act of the owner's domination, for it evi-
denced an ability to deny the enslaved's history and publicly constitute their identity
anew" (2008, 122). In Zanzibar, slaves were given Muslim names similar to those in
Morocco, such as Baraka (blessing) and Mabruki (blessed), in effect erasing the indi-
vidual's connection to a non-Muslim past. However, bestowing an Arabic Muslim name
on an individual did not mean he or she was being invited to blend into the larger
population. These names were Muslim and Arabic but were exclusively slave names,
and thus served as a marker of difference.

As in Zanzibar, slaves in Morocco were given new Arabic names that distinguished
them as enslaved people. In fact, I witnessed how the process of naming slaves is re-
created in rural southeastern Morocco in the 1990s where descendants of enslaved
people re-create a slave market and participate in the fictive buying of children whose
parents bring them to be protected from harm, especially if parents have had several
children die after childbirth. Referred to by the Tamazight name for slaves, Ismkhan,
descendants of the enslaved hold an annual festival at the small town of Khamlia, which
includes Ismkhan and non-Ismkhan parents requesting that their children be "bought"
by Ismkhan. Ismkhan men pretend to be bidding on the child, and the bid goes higher

and higher until the purchase is made. They present the mother of the child with three small pieces of wood, each representing a different Ismkhan name, and she is told to choose one. The child must be called the name represented by the piece of wood for three days. Although the child may return to his or her previous name after three days, many continue to use their Ismkhan names throughout their lives, and he or she is expected to send a small offering to Ismkhan each year during the time of the festival.[22] These children are the only people without slave ancestry who are allowed to participate in Ismkhan ceremonial performances, which are restricted to those with West African ancestry. Thus, names reinforce outsider status and have been used as a marker of difference.

Gnawa retain the use of a "slave name" in the *fraja* song to indicate Uncle Mbara's status as a marginalized other. While Lalla and Sidi eat meat and drink tea, Uncle Mbara sucks on his enslavers' leftover tea herbs and scrapes meat from their discarded bones. Indeed, the call-and-response song is replete with images associated with economic hardship:

> Lalla talbas balgha, sidi yalbas balgha, wa Mbara yalbas hashkara, hada wa`do meskin
> [Lalla wears balgha [shoes], Sidi wears balgha, and Mbara wears old torn shoes. This is
> his destiny, poor man]
>> Allah Allah moulana, hada wa`do meskin
>> [Allah, Allah, oh Mulay, this is his destiny, poor man]
> Lalla yerkbu baghla, Sidi yerkbu baghla, wa Mbara yarkbu hmara, hada wa`do meksin
> [Lalla rides a mule, Sidi rides a mule, and Mbara rides a donkey. This is his destiny,
> poor man]
>> Allah Allah moulana, hada wa`do meskin
>> [Allah, Allah, oh Mulay, this is his destiny, poor man]
> Khali Mbara yasgui bi llil
> [Uncle Mbara fetches water at night.]
>> Hada wa`do meskin
>> [This is his destiny, poor man]
> Hada wa`do meskin
> [This is his destiny, poor man]
>> Hada wa`do meskin
>> [This is his destiny, poor man]

While "Lalla" and "Sidi," Uncle Mbara's "owners," wear *balgha*, a type of slip-on leather shoe commonly worn in Morocco, Uncle Mbara, because of his lowly status, wears a pair of worn-out shoes, suggesting that those responsible for outfitting him are refusing to buy him a new pair. His owners also ride mules, a more prestigious animal than Uncle Mbara's donkey. While others enjoy the luxury of sleep, he has to perform the lowly task of fetching water.

Along with material hardship, the song conveys the psychological hardship of being condemned to poverty and inequality as a predetermined future over which one has no power. Uncle Mbara gives voice to the fatalistic realization that there is no escape from one's social, racial, and economic status. However, this is not a sentiment confined to the enslaved of the past; the repetition of that word "destiny," *wa`do*, resonates with many urban youth living in today's Morocco who see themselves as suffering class oppression, *hogra*—the consciousness of being victimized by an unjust system that favors the elite and condemns one to economic impoverishment, social marginalization, and cultural degradation. For them, this *fraja* song theatricalizes and exposes the abuse of power by the elite and invites us to empathize with those experiencing marginalization.

On the other hand, viewed from a spiritual rather than political perspective, the song speaks of the universality of suffering and the inherent worthiness of a life lived in humble submission to God, as noted by Timothy Fuson (2009, 290). The idea that each person has a divinely ordained future is fundamental to Moroccan religious and social life, according to anthropologist Dale Eickelman (1976, 125–28), as is the idea that humility and servitude are virtuous. Other scholars have interpreted Moroccans' belief in destiny or divine design as a means of rationalizing misfortune and failure, enabling them to draw meaning from adversity (Menin 2015, 893). This particular piece of musical theater seems to convey Uncle Mbara's resigned acceptance of his poverty as being preordained by God, while at the same time exposing it as unjust in a worldly sense. Abdelkarim `Asiri, a Moroccan teacher who published a book on Gnawa traditions in Arabic, explained the sentiments expressed in this Gnawa *fraja* song to me as follows: "Suffering is not part of any culture but is simply suffering. A Gnawa musician shares his sentiments through his performances and we can all relate to his sufferings [because] we have all suffered."[23] Hence, the condition of being Gnawa becomes a synecdoche for the general human condition; while the music may appeal especially to those who experience social injustice and political disenfranchisement, it speaks beyond that to all who endure the adversities inevitable in any human life.

The songs, dances, and styles of dress that characterize *fraja* performances have remained vital and popular in Morocco because they remember and repurpose the history of enslavement and a connection to the Sudan in a postslavery environment. In recent decades, as more and more of those who perform Gnawa music have no actual connection to the history of slavery, the music itself has found a widening audience both locally and globally (see, for example, El Hamel 2013, 295, and Kapchan 2007 and 2009). Since the end of the colonial period in 1956, Gnawa membership has become more porous; those without an ancestral connection to enslavement and those who do not self-identify as phenotypically Black participate in all aspects of Gnawa ceremonies— as musicians, diviners, clients, and spectators.

Gnawa ceremonial performances are reaching larger audiences than ever before due to the fact that they appeal to the urban poor, who find their struggles reflected within them. Many aspects of a Gnawa ceremony mirror social hierarchies in Morocco that privilege a Muslim, Arab identity. However, the association of Gnawa practices with otherness contributes to their success, since, while aspects of their ceremony include what they perceive to be Islamically appropriate behavior, they also allow people to express themselves outside of established social hierarchies. In other words, Gnawa ceremonies express the primacy of Islam, but within them is a critique of hegemony through the desire to retain and evoke an essentialized connection to the Sudan. The result is a creative tension that plays out in the spirit-possession portion of the ceremony.

4

Spirits in the Night

Blackness, Authenticity, and Potency
in a Gnawa *Lila*

GNAWA PRACTITIONERS refer to the spirits by several different but interchangeable names, each of which opens an aperture to the nature of the spiritual realm. *Malk*, meaning "possessor" or "owner" (plural, *mluk*), indicates that the person sees him- or herself as controlled by the spirit, as a slave is controlled by a master. *Jwad* (plural, *jouad*), meaning "beneficial ones," is also used to indicate that the spirits are the source of blessings, but these words are often used in a coded manner to appease potentially dangerous spirits. Another term used is *jinn* (plural, *jnun*), which is a reminder that the idea of possession is far from alien to Islam. *Jnun* are understood throughout the Muslim world as invisible spirits, defined in the Qur'an as having been created by fire, while humans were created from earth. Humans coexist with *jnun* as beings made by God, but one must exercise caution in dealing with these capricious beings. In Morocco, people explained to me that *jnun* thrive in empty spaces and passageways, such as wells, fireplaces, and toilets. A person who pours hot water down a drain, for example, may accidently burn a spirit, who then takes revenge and attacks the offending person. A person with an incurable and puzzling illness may visit a *fqih*, a Muslim theologian (Fuson 2009, 23). The *fqih* may try to exorcise the spirit by reading Qur'anic verses, burning incense over the victim or bathing him or her with water in which a paper with Qur'anic writing has dissolved, endowing the water with *baraka*. Often family members take the sick person on a pilgrimage to a saint's shrine or a spring, tree, or grotto believed to have healing properties (Crapanzano 1973, 134, 152, 155, 159).

But less orthodox options are available as well. They may visit a Gnawa female diviner, whose close affiliation with the spiritual realm allows her to identify the specific *jinn* causing a person's illness and help the person achieve a symbiotic relationship with this spirit, rather than exorcising it. Gnawa diviners specialize in helping people appease spirits who may be angry because of neglect or disrespect. "The spirits are like

young children," one Gnawa diviner explained to me; "they get angry easily if you do not placate them." Healing is achieved when the spirit's anger is appeased or its hunger satisfied, but the relationship is dynamic. At any time spirits can act up, causing strokes, mental breakdowns, and even death, if they are not honored properly.

My personal experience with Gnawa divination began in 1997, after I met M`allem Mahmoud Gania. I expressed an interest in learning about Gnawa diviners, and he recommended that I visit his sister, Jmiaa Gania, a healer in the town of Essaouira. I went to her home, and she discussed the process of divination with me and suggested that I submit myself as a subject of divination so I could experience the phenomenon firsthand. I understood that women who work as diviners are able to call up their possessing spirits at will and to coax from them the identity of spirits responsible for causing an inexplicable illness or misfortune. Once they have identified the origin of a malady, they can also prescribe a cure or bestow a dose of *baraka* upon the sufferer. I was initially reluctant, not because of skepticism, but because I feared that I might learn something disturbing about my future. Ultimately, my curiosity and desire to learn in this uniquely experiential manner outweighed my hesitation.

Some diviners inherit both their skills and the items used in divination from their deceased relatives. Others visit shrines, streams, or even trees associated with various spirits, collecting small stones, shells, or other items believed to hold the essence of a particular spirit. In Jmiaa Gania's case, many of the items she used in divination were inherited through her family. She waved her tray of divination items (called a *tbag* or *tbiga*) over a small brazier burning incense and draped a multicolored cloth over herself and the tray. The cloth represented her spirit, named Buderbala, who would possess and speak through her to diagnose my illness. Each Gnawa diviner has certain spirits with whom she works, and while possessed by those spirits, she gathers the objects in the tray, tossing and mixing them with her right hand. The placement of the objects indicates the origin of a person's problems, as well as the path of healing (Chlyeh 1998, 77). When I expressed interest in seeing the contents of Jmiaa's divination tray, she lifted the cloth covering its contents and allowed me to photograph her with it (Figure 4.1), revealing such mundane contents as egg-shaped pieces of wood, shells of various sizes and types, various colored rocks, cloth sashes, pieces of copper, and fragments of coconut shells.

A leathery black pod of some kind was in the center of Jmiaa's *tbiga*. Jmiaa could not identify exactly what it was but explained that her grandfather brought it from the Sudan—its power presumably derivative of its provenance and affiliation with her ancestors and their place of origin. This unidentified black "Sudanese" pod thus encapsulates and materializes the association of Blackness with authenticity and potency, which we will encounter throughout this chapter.

Although I did not suffer from any physical illness, Jmiaa identified a black spirit named Sidi Mimun whom she declared was blocking my path, preventing me from moving on with my life and accomplishing my goals (at that time, finishing my dissertation).

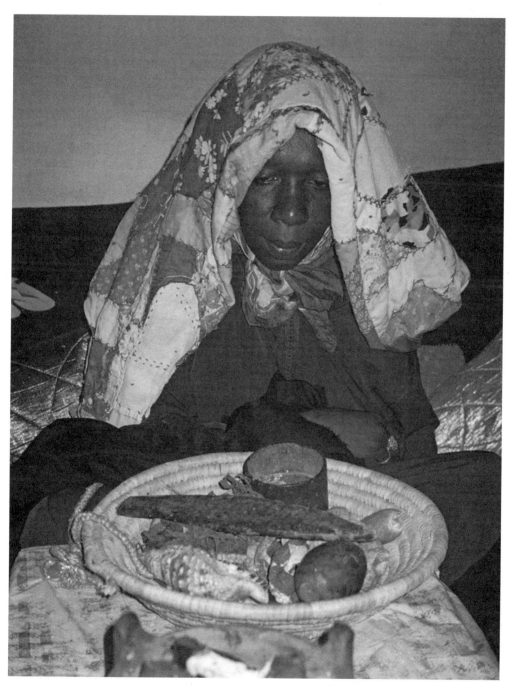

Figure 4.1. Jmiaa Gania with her divination tray, Essaouira, 1997. Photograph by the author.

This diagnosis required me to return the next day with various items that she would offer to the spirit in order to open the course of my life, including a piece of black cloth and a black chicken. I spent the next morning making my purchases and carefully carried a live chicken to her home.

When I arrived at her house the next day with the black chicken, Jmiaa instructed me to sit down with the black cloth draped over my head. Since only men sacrifice animals in Morocco, her son circled it over my head three times. Jmiaa held a brazier under my nose in which she burned incense called *jawi khal* (black benzoin).[1] While Gnawa ceremonies involve music, this healing ritual did not. I could hear the chicken clucking above my head, and the black cloth draped over my head captured the smoke from the incense, creating the sense that I was enveloped in a comforting cocoon. Before I knew it, her son quickly slit the animal's throat and carried it out of the room. On his way out the door, he handed Jmiaa the bloody knife, and she used it to place drops of blood on my temples, my wrists, and my ankles, giving me instructions not to bathe for three days. She promised me that this would please Sidi Mimun and solve my problems, a fact reinforced by one of Jmiaa's friends who was there during the divination and sacrifice, assuring me that Jmiaa was from a powerful Gnawa family who brought their powers with them from the Sudan. Blackness was an indicator of her prominent status and potency as a healer. I was later told by other diviners that Jmiaa's prognosis was excessive, as such actions were reserved for those suffering from serious spirit-induced illnesses, which was not my case. Regardless, the practice led me to see Jmiaa as part of a cultural alchemy that transfigured Blackness from a legacy of marginality and slavery into a source of agency and self-respect through a connection to spiritual potency. As Paul Stoller reminds us in his work on spirit possession, the bodies of spirit mediums "become replicas of the ancestors which embody the past, make contact with the present and determine the future" (1995, 43).

I begin with my experience of divination because it demonstrated to me how Blackness and a connection to the Sudan "works" as a means to express spiritual potency. While I start this chapter with the story of a female diviner, my discussion of the efficacy of Blackness does more than look specifically at gender, since both men and women are possessed during a Gnawa *lila*. While women work as diviners more than men, even men can engage in Gnawa divination and many men become possessed at Gnawa ceremonies. Rather, this chapter consists of a series of case studies where Blackness was used to claim legitimacy and spiritual power. A consideration of both divination and spirit possession allows for an understanding of how authenticity and spiritual authority are linked to constructions of Blackness as a nuanced racial signifier connected to particular embodied behaviors, styles of dress, dance steps, material objects, and songs.

The expression of Blackness is linked to issues of interpretation and authenticity, which increasingly underlie and invade Gnawa spirit possession due to the rapidly expanding public audience for what was once a sacred form of music. This is especially the case in the city of Essaouira where this study is focused, largely due to the annual

Gnawa and World Music Festival being held there since 1998 (Witulski 2018, 58–59). The spiritual power associated with Blackness translates into and, in some cases, equates to the concept of "Gnawa authenticity," referred to as *tagnawit* in Arabic. As Deborah Kapchan notes, "Those possessing *tagnawit* are most often born into a Gnawa milieu and come up through the ranks, learning the ritual in all its complexity by observation, participation, and slow initiation" (2007, 23). But "the boundaries of who is authentically *tagnawit* are never easily drawn, and, in fact, they are continuously evoked and contested, especially through the process of possession" (2007, 23). As we will see, the embodiment of black spirits has become especially relevant with the ever-increasing porosity of the boundaries of Gnawa identity, causing an increased interest in defining and recognizing Gnawa authenticity.

During my time in Essaouira, I was told that few diviners practicing today were considered authentic, and many criticized those who fell into trance during ceremonies as fakes. In other words, most practicing diviners learned rather than inherited their abilities to contact the spirit realm, and many accused the former of simply learning how to go through the motions at a ceremony. Some women declare themselves diviners but do not have clients who visit their homes or hold their own private *lila*. Rather, they simply become possessed on a regular basis at public shrines. Among them, some may eventually purchase a *tbiga* and its associated objects representing the various spirits. They may learn the skill of divination, eventually working with a particular Gnawa *m'allem*. In fact, I witnessed one such musician instructing a novice diviner on what to wear and which incense to burn during the course of a *lila*.

Gnawa musicians now commonly perform in clubs, restaurants, and the massive Gnawa and World Music Festival in Essaouira. Indeed, many Gnawa musicians today have never performed at private spirit-possession ceremonies, never worked with a female diviner, and never witnessed spirit possession. Even during ceremonies, people carefully watch the possessed for clues that they are truly possessed, including the expressions on their faces, the gestures of their hands, and the actions of their feet. Authentic possession "can only be determined by reading the *surfaces* of bodies as ciphers of what dwells within," writes Paul Christopher Johnson (2014, 11). However, several people explained that one could hit, punch, and even poke a possessed person with a needle, and if a person was truly possessed, he or she would not notice it. While I never saw anyone try this method of authentication, such stories indicate anxiety about authenticity. We shall see in this chapter how the community confronts the challenge of distinguishing what is authentically Gnawa from fakery and how this anxiety has manifested itself in heightened expressions of Blackness in both divination and possession.

BORN THIS WAY: THE STORY OF TWO DIVINERS

Divination reifies the association between Gnawa and the spiritual realm, and it is largely the province of women: it is they who initially diagnose a client's affliction (often

attributed to the victim having committed an infraction against a spirit, typically inadvertently), decide that a *lila* is called for, and then organize it. During a *lila*, anyone can fall into possession: the diviner, the client, the audience watching the spectacle, or the musicians. The same spirit can possess many people at once, impacting people in very different ways. For example, possession by a black spirit named Sidi Mimun can cause one woman to wave her hands in the air with her face upturned, one to dance with knives, and another to hold lit candles on her arms. One woman may fall into the arms of another while crying, while another woman may become angry at a spectator in the audience, causing her to go into a rage until the person leaves the *lila* (Hell 2002, 291).

As I made an effort to locate those still practicing divination in Essaouira, my discussions with people often centered on questions of legitimacy, whether particular women were truly gifted as diviners—that is, the spirits had in fact chosen to work through them—or were making false claims. In rare cases, women are born diviners, that is, they inherit both the status and the spirits themselves (i.e., a mother who was possessed by a certain spirit can hand that spirit down to her daughter). But whether the claim to diviner status is based on blood or not, diviners often experience spirit possession first through dreams and visions (Kapchan 2007, 4). By the time they reach puberty, they may have developed clairvoyant powers. Diviners experience the spirits as moving from the dream world (of unconsciousness) into the material realm (Kapchan 2007, 119). Ultimately, during the process of divination, the spirit becomes visible by controlling the diviner's body and her consciousness for the purpose of communicating through her with others. Over time, a woman may have other spirits inhabit her body, so that she can interact with more than one. Gnawa diviners describe the experience as *having* a spirit, as one *has* an illness, indicating a sense of powerlessness over the experience; during possession the person's actions are determined by the desires of the spirit inhabiting him or her (Spadola 2014, 88). When a spirit resides in that human body, the spirit lives there permanently and expects to be served through that person's daily behavior, demanding that the possessed wear the spirit's favorite perfume, eat foods that please the spirit, and attend ceremonies that allow the spirit to manifest him- or herself materially.

Just as Blackness is intimately enmeshed with spirit possession so too is it enmeshed with divination, which also requires the presence of spirits to make a diagnosis. Since the early twentieth century, observers of Morocco have noted the connection between Blackness, spirits, and healing. In a 1934 article entitled "Negro Influence in Morocco," Edward Westermarck wrote that "there is a close connection between *jnun* [spirits] and Negroes; they are 'like brothers.'" He then recounted a story related to him by a Moroccan informant, whose sister

> had a black slave girl, whose presence in the house led to all sorts of uncanny events, stones fell down there, furniture and clothes caught fire, plates were broken, mattresses were moved from one place to another, and all this happened without any apparent

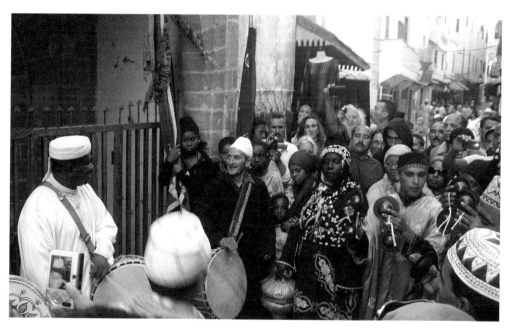

Plate 1. Zaida Gania (wearing black) processing on the streets of Essaouira before her annual *lila*. Photograph by the author, 2010.

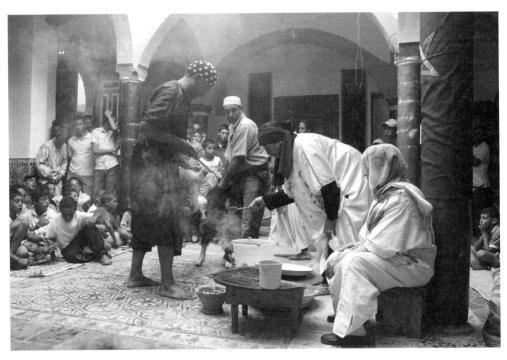

Plate 2. M`allem Omar Hayat (wearing red) and Halima Meses (standing and wearing white) purify animals to be sacrificed before the start of a *lila*. Dar Dmana, Essaouira. Photograph by the author, 2009.

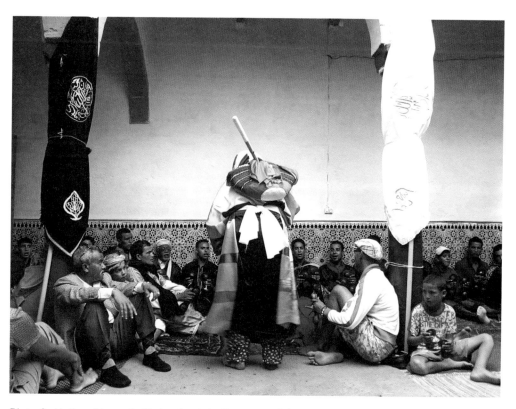

Plate 3. Halima Meses (with her back to the camera) is possessed by the spirit Buderbala, who wears patchwork clothing. Essaouira, 2010. Photograph by the author.

Plate 4. The Zawiya of Sidna Bilal in 2006, before the renovations that occurred in 2007. Mbarka, one of the shrine's keepers, cleans the courtyard. Photograph by the author.

Plate 5. The renovated interior courtyard of the Zawiya of Sidna Bilal, 2008. This photograph was taken after initial renovation of the shrine, which included retiling the floors and walls and adding stone masonry around the courtyard's arches. New construction of a second floor is also visible, which has since been completed. Photograph by the author.

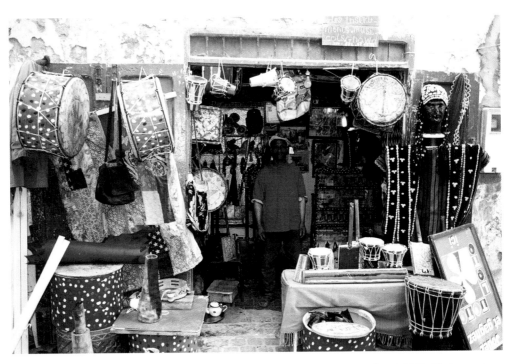
Plate 6. Najib Sudani stands in the entry of his Gnawa shop in Essaouira, 2016. Photograph by the author.

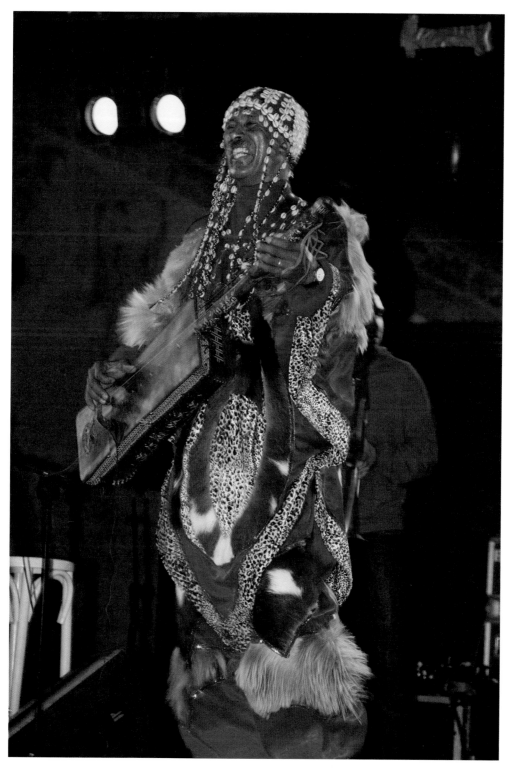

Plate 7. M`allem Omar Hayat performs at the Gnawa and World Music Festival, 2006.
Photograph by the author.

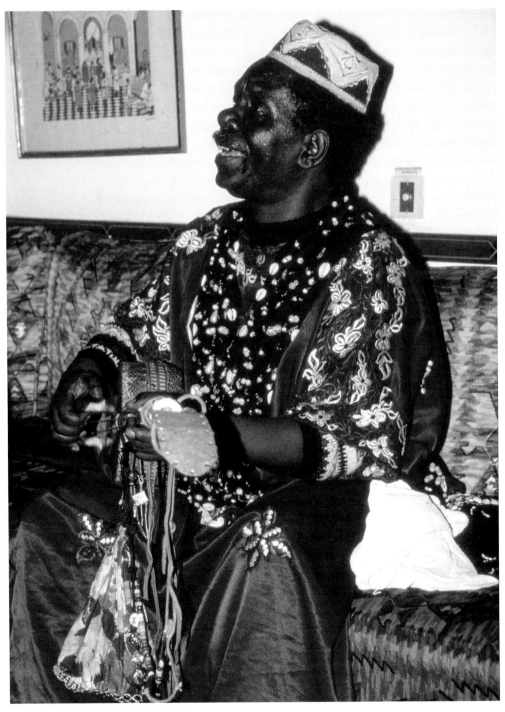

Plate 8. M`allem Mahmoud Gania performing on his *guinbri,* from which a string of beads is attached. Photograph by the author, 2002.

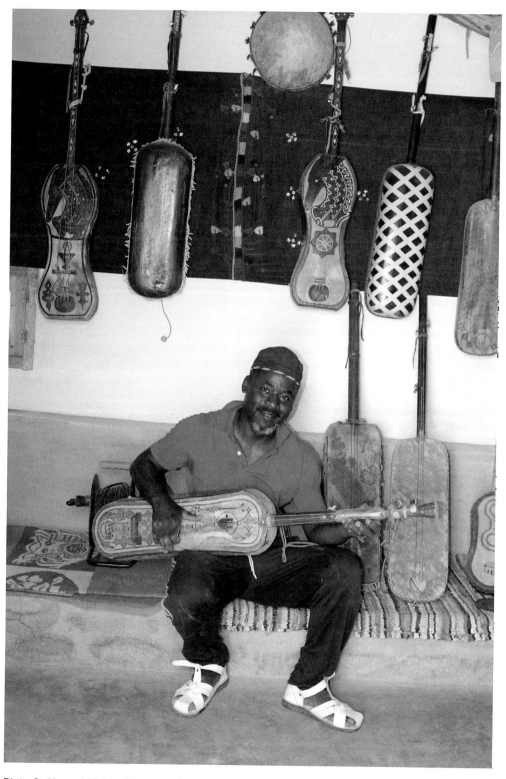

Plate 9. Hamad Mahjoubi poses with his collection of *guinbri*s in Khamlia, Morocco, 2016. Photograph by the author.

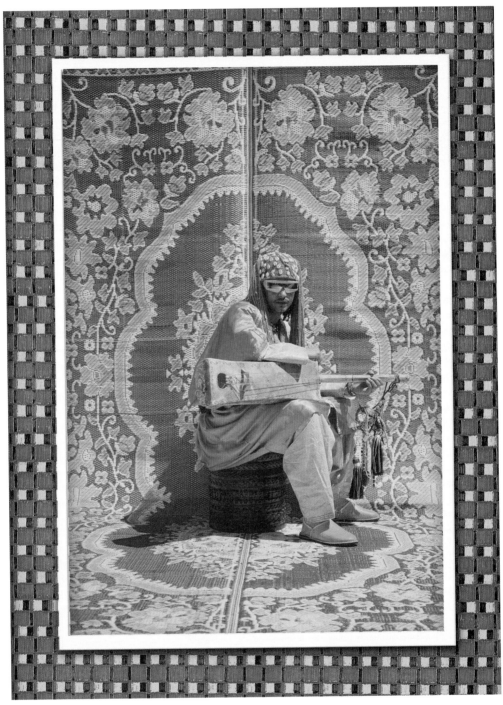

Plate 10. Hassan Hajjaj, *Maalem Simo Lagnawi,* 2010. Metallic Lambda print on 3mm Dibond, 136 × 101 cm. Collection of the Newark Museum 2015.5.4. Purchase 2015, Helen McMahon Brady Cutting Fund. Copyright Hassan Hajjaj.

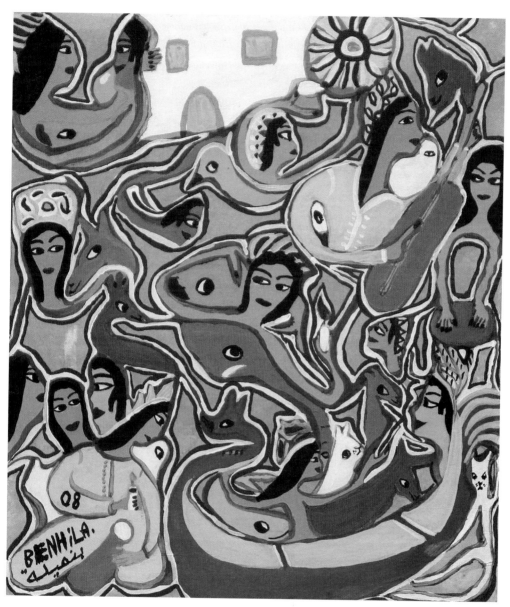

Plate 11. Regreguia Benhila, *Untitled,* 2008. Acrylic on paper, 35.5 × 25.4 cm. This self-taught painter used elongated animal forms and female figures to convey the mysticism associated with Essaouira, a city closely linked to Gnawa spirit possession. She placed women at the center of Gnawa ceremonies, showing two women holding lit candles. On the top right, a woman plays a Gnawa *guinbri,* an instrument not played by women until recently. Collection of the author.

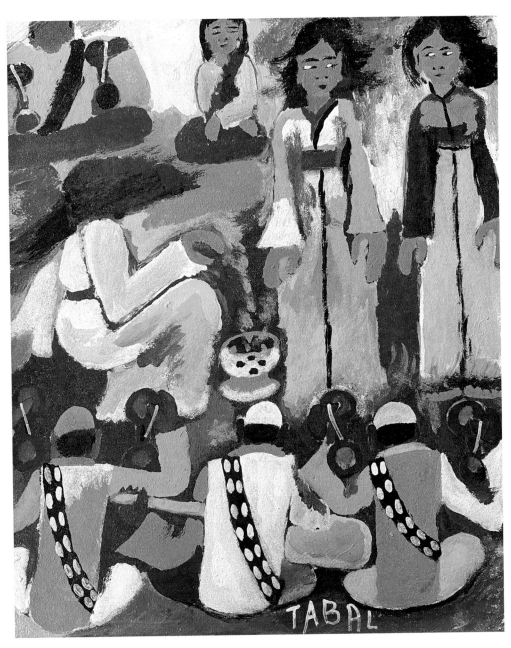

Plate 12. Mohamed Tabal, *Untitled,* 2006. Acrylic on pressed wood, 50.8 × 38.1 cm. This artist painted Gnawa musicians playing music to induce possession by Lalla Mira, a female spirit who loves the color yellow and is attracted to women. Collection of the author.

cause. The house was haunted by *jnun* on account of the black girl; this was proved by the fact that when she was sold, those strange things ceased to occur. (1934, 624)

Interestingly, Westermarck's account does not consider that the woman whom he refers to as "a black slave girl" could have had any agency or intentionality in causing disruption in her enslaver's home. She is seen as a passive conduit of the demonic incursion, one whose mere "presence in the house" is sufficient to summon the spirits. We have few primary accounts of Gnawa diviners, but an unpublished manuscript by a Moroccan Jewish woman in the 1950s includes a vivid description of what was probably a Gnawa diviner on the streets of Rabat: "One could see in an isolated corner some Senegalese sorceresses. They were stirring the future in a wicker basket, full of black and white shells, horrible shells that resembled eyes pulled out of their sockets."[2] This passage reflects local perceptions of Gnawa as distinctively Black ("Senegalese" here stands in for Black) and thus having special knowledge of and access to spirits, which is a source of both fear and fascination, as expressed in her use of the loaded term "sorceresses."

Some women who work as Gnawa diviners use concepts of Blackness to their own advantage to assert their access to spiritual power. In her book *Traveling Spirit Masters*, Deborah Kapchan convincingly argues that Gnawa spirit possession gives women a sense of agency and an identity that is independent both of their place in the social hierarchy and of men (2007, 97). Kapchan sees the master–slave trope as framing the relationship between women and the spirits. Kapchan notes that when a woman first becomes possessed, she is subject to the whims of a spirit, as a slave is to his or her master. But when she gains more experience, she achieves a mastery over the act of possession and can "enter their [the spirits'] ranks, so to speak, to 'work' them instead of being worked over by them" (2007, 58). The master–slave relationship is thus reversed, the historical trope reimagined. Kapchan asserts that those who eventually learn to control their possession can will the spirits to manifest themselves physically and can thus become diviners, using spirits instead of being used by them, but as we will see, the power dynamic between diviners and their possessing spirits can be extremely ambiguous.

Born into a renowned Gnawa family, Jmiaa Gania and her sister Zaida inherited their spiritual prowess from their ancestors. Zaida told me that her paternal grandfather was enslaved in Timbuktu, taken into the Sahara, and sold as a slave in southern Morocco, while her paternal grandmother was an Arab woman from the Tafilalet oasis in southeastern Morocco. Her maternal grandfather, Samba, was a Fulani from Senegal brought to Morocco as a soldier by the French. During the colonial period, he worked at the hospital in Essaouira. "The doctor would recommend that patients he could not cure see my grandfather. He would keep them in his home for seven days and he would make them the food of the *mluk* [spirits]. On the eighth day they would be healed."

According to Zaida, her Senegalese grandfather decided to settle in Morocco. Her maternal grandmother had been stolen from West Africa when she was a child and was enslaved in the house of an affluent family in Essaouira. After her grandfather married her, they had their only daughter, Zaida's mother, to whom he passed his medicinal and spiritual knowledge. Their deceased father, Boubker Gania, was a legendary Gnawa musician, and their mother, `Aisha Samba, was a locally famous diviner (*mqaddema*). Hence it was not the Gania sisters' skills in healing spirit-induced illnesses alone that earn them high status, but their family lineage, which emphasized their Sudani (i.e., Black) ancestry.

Not all women who work as diviners inherit their powers from their family. For example, Hajja Brika, a Gnawa female diviner living in Agadir, recounted how she came to the practice: "You see," she explained, "I did not choose the spirits but they chose me." Because all of her previous children had died, her mother visited a Gnawa diviner who told her that the spirits inside of her would not let her children live. The diviner gave her mother a string to put around her waist "like an African woman," Brika said, pleasing the spirits and enabling her to become pregnant and give birth to Brika.[3] The newborn Brika was covered with a black cloth and incensed with black *jawi* by her mother, essentially dedicating Brika to the black family of spirits (*Lkuhl*). On the seventh day after her birth, Brika's family held a Gnawa *lila*, during which they symbolically sold her to a Black Gnawa practitioner in a ceremonial re-creation of a slave market with the belief that if the Gnawa practitioner symbolically purchased Brika, the child would be under the protection of Gnawa spirits.[4] The act of symbolically selling one's child revises the historical slave system insofar as the child who becomes the property of the spirits is guaranteed protection and favor, but at same time, it reproduces that system in surrendering the child's autonomy and rendering her vulnerable to being used, if not exploited.

Throughout Brika's life, she attended Gnawa *lilas* on a regular basis, and if she went for a year or more without going, she would fall ill until she attended a ceremony; the spirits demanded her continued devotion. After her marriage, the spirits became even more possessive, and she found herself unable to cook for her husband, keep up the house, or have sex with him. "One of the male *mluk* [spirits] came to me at night and slept with me," she explained, "so I slept in a separate room [from my husband], and even held my nose when my husband walked by because the spirit did not even want me to smell his scent." Brika then had a dream in which she saw a beautiful Black man holding a basket filled with seven colors of cloth. He told her, "This is what we want you to do," pointing to the basket, "we will help you with this." Hajja Brika identified this spirit as Sidi Mimun and understood that she was chosen to work as a Gnawa diviner. This was why the spirits would not leave her alone; they wanted her complete devotion, and attending *lilas* was no longer enough. In doing so, she appeased the spirits; in return for her devotion they healed her estrangement from her husband, to whom she remains married to this day and by whom she has several children.

For both Jmiaa Gania and Hajja Brika, working as Gnawa diviners meant having a buffer against economic hardship. A Gnawa diviner can provide an underclass family with a much-needed income outside of the patriarchal system in which men are the primary economic providers and women have few employment options. I have seen a diviner charge fifty to two hundred dirhams (five to twenty dollars) for a consultation at the diviner's home. A ceremony can be much more expensive, and in addition to the five hundred to two thousand dirhams (fifty to two hundred dollars) paid to the diviner who organizes the ceremony, a master musician typically receives between one thousand and five thousand dirhams (one hundred to five hundred dollars) to perform music for possession, which he shares with members of his ensemble. In addition, the dozens who attend the ceremony offer donations of twenty to one hundred dirhams (two to ten dollars) during the course of the night, which is split between the musicians and the diviner.[5] Within the household, the economic status that comes with divination can mean that women are empowered to assert their authority.

At the same time, a diviner's relationship with spirits can reproduce gender hierarchies and stereotypes. Emilio Spadola writes that when a person submits to a Gnawa spirit, she lends her voice and body to a foreign being who inhabits and speaks through her: "Hers [the possessed's] is a power that presumes a state of powerlessness" (2014, 88). The possessed, then, becomes an ambivalent vehicle, publicly manifesting the desires of a spirit as her own, but in such a way that she is not held responsible for her actions while possessed (2014, 88). For example, Spadola recounts how women possessed by Lalla Mira will blame the spirit for their habit of smoking cigarettes, an activity generally not condoned for women in Moroccan society. Only insofar as a woman is seen as being at the mercy of the spirits is she exempted from the normal sanctions of behavior.

Spadola's interpretation complicates that posed by Kapchan, who sees the relationship between the diviner and the possessing spirits as one where the diviner controls the spirits. Numerous scholars have emphasized the relationship between spirit possession and oppression. Paul Stoller writes that spirit possession sparks countermemories and historical struggles and, in the process, engages all of the senses to embody the pain experienced by the marginalized, histories rarely found in texts or in epics (1997, 63). Scholar Paul Christopher Johnson interpreted spirit possession as premised on Western notions of ownership and the transatlantic slave trade, which reduced enslaved Africans to property. Johnson defined acts of spirit possession as the "absence of control, the body without will, and, by extension, the figure of the slave" (2014, 4–5). Anthropologist Michael Lambek, on the other hand, complicated the slave–master binary and suggested that the power play between a spirit and the possessed is not just about ownership and control. Rather "possession" goes both ways, and the process can be both controlling and liberating at the same time (Lambek 2014, 262–63). For example, a medium possessed by a very powerful spirit emerges more tired than if possessed by a

lesser spirit. Furthermore, powerful spirits subject their mediums to more daily constraints and more control, requiring diviners to hold ceremonies each year, which can be a financial hardship for many. One diviner, for example, expressed concern that she needed to keep her possessing spirits happy and struggled to buy the proper animal sacrifices for them. Another explained that she must consume particular types of foods and wear the colors preferred by her possessing spirit or risk the spirit's wrath. Possession contains a great deal of ambiguity of experience and enables more than one thing to be said, meant, or understood at the same time. Based on my experience, the more powerful diviners feared their spirits, recognizing their potency, and were very careful to keep them happy.

When I met her in 1997, Jmiaa Gania was probably in her early sixties and struggling to maintain control over the spirits. She had suffered a stroke (an illness often attributed to the wrath of the *jnun*) that affected her speech. Because of this impediment to communication, Jmiaa invited a close friend over to the house to repeat her words (in Arabic) to me, which she did, while adding her own commentary. Pointing to the long, unfamiliar black pod-like object in Jmiaa's divination tray, the friend said, "That is something powerful. A woman comes sick and when she [gently] hits her with this, she leaves cured. They [Jmiaa's family] are from the Sudan . . . the greatest Gnawa in Essaouira are the Gania family. There are no other Gnawa . . . only them." Clearly the ritual object's efficacy was seen as a function of its Sudani origins and its long connection to this particular Sudani family. Contact of this object with the body has the power to heal.

Unfortunately, Jmiaa Gania suffered a fatal stroke in 2005, which some attributed to her close proximity to spirits. But this explanation is far from unique. People recounted many stories to me of vengeful spirits causing illness or death, even among those who had presumably "mastered" them, such as diviners, especially if the spirits felt they had not been properly honored.[6] The relationship of humans to the spiritual realm is always precarious, inherently flexible, and potentially dangerous. Hajja Brika's relationship with Sidi Mimun was beneficial to her, and yet she still feared his anger, frequently telling me how she was careful in her dealings with him and made a point of always following the "rules." She is certain to hold an annual ceremony to honor Sidi Mimun in her home, at which she wears black, the color of Mimun, to please him, and regularly burns his preferred incense, black benzoin (locally called *jawi khal*).[7] Hajja Brika, like all diviners, treads carefully, for, in the words of a practicing Gnawa diviner named Habiba, "All the Gnawa eventually get sick from working the *mluk*. I know a woman who died after holding a *lila* and they said this was from the *mluk*." In this sense, those who self-identify as Gnawa diviners perform a service for others, putting themselves at risk due to their close proximity to spirits who can be potentially harmful. The spirit world in many ways reproduces the dominant patriarchal system of control, in which Black women's bodies are used by and sacrificed on behalf of others, as the spirits demand obedience from their female human hosts.

Following Jmiaa's death in 2005 (their mother having died in 1984), Zaida inherited her sister's divination tray, along with its venerable family history. As she was the next in line, the *mluk* came to her one by one. In my conversations with her, she explained that "the *jouad* [spirits] said we have nowhere to go and we came to you. This only happens to families who have ancestral connections to the Sudan. My grandfather left everything to my mother, my mother left me everything, and I can leave everything to my children. We did not learn about the spirits from someone. We are the original Gnawa—the slaves." Zaida plainly used the words "Sudan" and "slaves" as markers of pride, enhancing her status by associating her slave background with spiritual efficacy. The descriptor "Sudani," historically pejorative in mainstream Moroccan culture, has become an indicator of high status among some Gnawa practitioners.

Even Hajja Brika, who does not claim West African ancestry, uses Blackness to signify authenticity, describing her possessing spirit, Sidi Mimun, as a "beautiful Black man." In fact, she explained to me that her ancestors had slaves. "We bought them and sold them here in Essaouira. They [the slaves] would marry and have children and their families would work for us in our house. We do not come from the Sudan."[8] Her attempt at Blackness-by-association underscores the fact that Blackness functions as a signifier of spiritual strength. In the absence of a genealogical connection to West Africa, Blackness becomes a metonym for the ability to access the spirits and reinforces one's claim to authenticity (*tagnawit*).

GNAWA SPIRITS

A Gnawa *lila* is structured into groupings of spirits with similar traits that are banded together, sharing provenances, personalities, and proclivities, with a single group referred to in Arabic as a *mhalla* (see Appendix).[9] These spirit groupings identify and announce themselves according to their preferred colors (white, green, red, black, yellow, etc.).[10] Each spirit has a particular song with a distinct rhythm, melody, dance, and lyrics, and spirits from a particular *mhalla* are played together without stopping.[11] While there is some flexibility and regional variation concerning the order in which each group of spirits appears, each Gnawa ceremony, regardless of the region, begins with a *mhalla* of white spirits associated with Islam. Spirits who engage in behaviors associated with the Sudan, such as dancing with fire or knives, appear later in the ceremony. In order for a ceremony to be complete, at least a few songs from each group must be played.

Spirits make an appearance one by one, and Bertrand Hell (2002) describes their arrival as a theatrical performance or an "ethnodrama," where the possessed take on the personalities of the spirits, becoming excessive and extroverted if the spirits demand such behavior. Although people might exhibit different individual behaviors when possessed, certain spirits have clear personality traits that appear during a *lila*. For example, Sidi Musa, the spirit of the waters, is calm, and Lalla Mira is a coquette who wears

brilliant yellow clothes, makeup, and perfume and likes to admire herself in a mirror. The *lila* thus proceeds through an unfurling of ritual colors that accompany a sequence of sensory and material encounters with these distinct spirit families.

When the musicians begin evoking the spirits, the crowd sits in a semicircle facing the musicians, who lean their backs against a wall. A diviner arranges a woven tray filled with small containers of varying types of incense, as well as a collection of brightly colored cloths, tunics, and other ritual paraphernalia in front of the musicians for the possessed to use, including candles for Sidi Mimun, makeup and perfume for Lalla Mira, and prayer beads for Shamharush (Figure 4.2).

Spirits appear in a particular order, which can be found in the Appendix. Each color represents a different grouping of spirits with the color of the cloth and style of dance reflecting their personalities. For example, in Essaouira, Gnawa musicians first evoke white spirits, who are referred to as *salihin* or "saints," since this group includes historical figures associated with Sufism. White is a color equated with purity and blessing in Islam and when they appear at a *lila*, people wear white and typically move as if they are entranced by the music rather than possessed by an actual spirit, rocking back and forth slowly similar to those who attend Sufi ceremonies in Morocco. Black spirits (*Lkuhl*) follow white spirits in a Gnawa possession ceremony. Like the enslaved, these black *mluk* are said to originate in West Africa, and among them are Lalla Mimuna and Sidi Mimun, a female/male pair referred to as the "guardians of the door," who enable the other spirits to pass and enter the space of the *lila*. Dances for these spirits tend to be more aggressive than the slow deliberate movements performed by dancers possessed by white Muslim spirits. During the dance for black spirits, the possessed person may don a black tunic, cowrie-covered sash, and headdress adorned with cowrie shells. Many words from the so-called Gnawa "Sudani" language are repeated in these songs. For example, *Fofo Denba*, a "Sudani" expression meaning "light the candle," is sung while possessed people dance with candles in their hands, holding the flames up to their chins, arms, and ankles. People say that the spirit protects them from burning themselves.

Light blue signals a group of spirits associated with the sea, such as Sidi Musa, whose followers dance using graceful swimming movements and sometimes balance bowls of water on their heads while wearing blue scarves. These are followed by dark blue spirits associated with the sky, and possessed individuals often tighten scarves around their necks to simulate the loss of air. Aggressive red spirits include Sidi Hamu who requires his devotees to wear red cloths draped around them, and some dance with knives in their hands. Another black spirit grouping known as *Uled Lghaba*, "children of the forest," having West African names and origins, follows the red spirits. These spirits cause their devotees to beat their chests and crawl on the ground, which people say simulates animals in the wild. This group also includes a snake spirit, as well as a subcategory of spirits referred to as *Hussawiyine*, a designation that derives from the word "Hausa," the name given to a cultural group and language widely spoken in West Africa. Gnawa

Figure 4.2. The circular tray filled with small round boxes contains the various kinds of incense burned to please the spirits. The basket on the far left contains small bundles of incense that M`allem Omar Hayat sold during breaks. On the right is a bundle of colored cloth that will be draped over the bodies of the possessed. Photograph by the author, Essaouira, 2010.

musicians then play the rhythms of the group of green spirits who are said to be *shurfa* (descendants of the Prophet Muhammed), as green is a color associated with Islam. The final category of spirits includes the multicolored feminine spirits, including the vain female spirit Lalla Mira, who adores makeup and sweet-smelling perfume and wears the color yellow. (See the Appendix for a list of spirit families and their characteristic objects.)

While individual spirits in the pantheon can be referred to by the overarching term *mluk*, people sometimes distinguish between *salihin* and *mluk*, defining them as two different categories of Gnawa spirits (Chlyeh 1998, 43–44; Hell 2002, 118; Sum 2012, 45). Maisie Sum, for example, defines white, blue, and green spirits as *salihin* or "saints," with tombs and holy sites of pilgrimage existing across North Africa and the Middle East. She classifies black and red spirits as *mluk*, spirits who originated in West Africa. The group of playful, female spirits who appear at the end of a *lila* fall in between these two categories, according to Sum. At the same time, both scholars recognize that the distinction between these categories can be somewhat ambiguous. Both Abdelhafid Chlyeh and Maisie Sum note that black spirits, like Lalla Mimuna and Sidi Mimun, have sacred sites associated with them in Morocco and are said to come from West Africa, making them both *salihin* and *mluk* (1998, 43–33; 2012, 45–46, 304). This is also the case for the spirit Shamharush who is saint (*salih*) with a tomb in Morocco's High Atlas Mountains. At the same time, I often heard him referred to as "king of the jinn," so he is also considered a *malk*. Bertrand Hell asserts that the *salihin* do not exist in opposition to *mluk* and recounts how Gnawa practitioners have varying understandings of how these categories of spirits relate to each other (2002, 119). Chlyeh explains this as a result of practical syncretism where the veneration of Sufi saints has become integrated into sub-Saharan spirit possession (1998, 43–44). For the purposes of this book and its central concern with the construction of Blackness in Gnawa culture, this chapter focuses on the manifestation of two groups of black spirits (*Lkuhl* and *Uled Lghaba*) and, as a related issue, their relationship to conceptions of West African religiosity and Islam.

FROM WHITE TO BLACK: THE SPIRIT BUDERBALA

Consistently across Gnawa practice in Morocco, the spirit-possession portion of a *lila* begins with the evocation of the white spirits, the color white being associated with purity in Islam. I collected more than eleven discrete songs dedicated to the white spirits that can take two or more hours to perform in their entirety. These songs contain few if any words of West African origin and are the most Islamo-centric of the spirit repertoire. They repeat the Muslim profession of faith (*shahada*)—"There is no God but God and Muhammed is the Prophet of God"—and repeatedly invoke the Prophet Muhammed by various names, including *Meccawi* ("the one from Mecca"), *Rasul Allah* ("Messenger of God"), and *Nabina* ("Our Prophet"). Those possessed by these spirits

typically rock back and forth slowly and drape their bodies with white cloth. Their movements are similar to how Moroccan Sufis perform when they repeat chants (*thikr*) that include repetition of the name of God and the *shahada*.

In addition to frequent references to the Prophet and various Sufi saints, the name of a twelfth-century Sufi master, Moulay ʿAbdelqader Jilani, is featured in one of the songs. Jilani's name (typically pronounced Jilali in Morocco with the "n" shifting into an "l") was given to the widespread Qadiriya Sufi order. The song dedicated to him includes the following call-and-response lyrics:

Allah ya Baba Jilala, Allah Baba Jilala
[God, oh father Jilala, God, oh father Jilala]
Allah ya Baba Jilala, Allah Baba Jilala
[God, oh father Jilala, God, oh father Jilala]
A Mulay ʿAbdelqader Sultan
A Mulay ʿAbdelqader Sultan

Originally from Iran, Moulay ʿAbdelqader Jilali founded the Qadiriya Sufi order in his adopted city of Baghdad. When he died in 1165, his son created a school that eventually spread his father's teachings across northern Africa and the Middle East, even into India. The Qadiriya order reached the Moroccan city of Fes via Spain, and break-off Sufi groups, such as the Jilala order in Morocco, practiced chanting and dancing with knives during their gatherings, despite the fact that such practices were historically condemned by Moulay ʿAbdelqader Jilali himself (Bouasria 2015, 8). The widespread popularity of Qadiriya orders resulted in Moulay ʿAbdelqader Jilali achieving the title "Sultan of the Saints" or "The One of the Flag," meaning the leader of this Sufi tradition. As eloquently expressed by Bertrand Hell, it is the light of Moulay ʿAbdelqader Jilali that guides a Gnawa ceremony through the labyrinth of spirits evoked during the *lila* (2002, 143). But more broadly, the evocation of Sufi saints, such as ʿAbdelqader Jilali, at the beginning of the *lila* demonstrates the primacy accorded Islam during a Gnawa ceremony.

Among this white cohort, the final spirit to appear, Buderbala, possesses characteristics that both locals and scholars associate with marginality. Although considered one of the white spirits, those possessed by him wear multicolored, patchwork gowns or scarves rather than white clothes (Plate 3). Buderbala represents a connection to Sufism through the character of a wandering vagabond, collecting donations in exchange for the distribution of *baraka*, blessings. However, his actions, his song, and his style of dress position him at the margin of what people perceive to be Islamically acceptable behavior. The materiality of the spirit Buderbala as expressed through dress, dance, and performance is rooted simultaneously in Sufism and the Sudan and signals a transition from *salihin* (Sufi saints) and into black spirits classified as *mluk* who are said to have West African ancestry. As we will see, black spirits signal empowerment and fierceness,

demonstrating how dominant hegemonies associated with Islam persist and coexist with ideologies of resistance.

Buderbala's song, for example, refers to the Gnawa practice of making pilgrimage to the shrine of Sidi Heddi, a saint revered by the Heddawa, another socially marginalized Sufi group. Visiting the holy place of Sidi Heddi is a way for Gnawa to celebrate solidarity with others who share their outsider or marginalized status. In his 1955 book *La monachisme errant dans l'Islam: Sidi Heddi et les Heddawa*, René Brunel wrote that members of the Heddawa engaged in socially and religiously "unorthodox" behavior. They never bathed, dressed in rags, and wore multicolored patchwork cloaks (similar to those worn by Gnawa during possession by Buderbala). Heddawa members also carried staffs, had long hair and disheveled beards, took drugs, and engaged in sexually promiscuous behavior (1955, 141). Such deviant or stigmatized behavior, as well as the low social status of both groups, rendered them natural allies in the eyes of Brunel, who wrote that among Heddawa, "blacks or more simply mixed-race are in high numbers."[12]

Brunel's account illustrates colonial efforts to classify and control socially fluid populations, which involved ranking them and stereotyping their characteristics. For example, the French ethnographer L. Mercier described Gnawa as "nearly all blacks and includ[ing] only people of low birth and slaves." He wrote that some Sufis refused to attend Gnawa ceremonies, viewing them as uncouth and vulgar (1906, 125), and that Moroccans in the early twentieth century considered them a sort of quasi-Muslim spiritual group at the bottom of Morocco's spiritual hierarchy. Mercier's comments reveal the power structures within early twentieth-century Morocco that devalued Gnawa ceremonial expression as marginal to and existing outside of Sufism. In other words, Gnawa ceremonial practices were understood as an inferior form of Islam, largely due to the incorporation of behaviors historically associated with Blackness and a Sudani identity. In short, Brunel and Mercier attributed practices deemed "other" and "marginal" to Islam to Blackness and a sub-Saharan origin, and such practices were understood as "lesser" expressions of religiosity superimposed over Islam.

This focus on classification and labeling has permeated academic discussions of Gnawa spirit possession and other low-status Sufi groups in more recent years. For example, in his book on the Hamadsha Sufi brotherhood, a Sufi group typically classified as "popular" (i.e., low status), Vincent Crapanzano wrote that while belief in *jnun* is an accepted part of Islamic mythology, belief in "named-*jnun*"—that is, spirits with specific personalities, characteristics, and formal names such as manifest in the *lila*—was due to the influence of sub-Saharan Africa. Crapanzano asserts that Gnawa practitioners' presumed sub-Saharan retentions in turn influenced Hamadsha and other so-called popular Sufi groups, such as the Jilaliyya and 'Aissawa (1973, 141).

I argue that it is precisely this association with otherness that also exists within Moroccan popular culture and has contributed to the success and popularity of Gnawa spirit possession. A Gnawa identity speaks to those who suffer hegemonic inequality

and desire to protest hierarchical power structures. Possession by a spirit such as Buderbala allows Gnawa practitioners to express what we may interpret as a counternarrative to conceptions of Islamic orthodoxy that understand Gnawa practices as more "bastardized" forms of Islam. But it is important to continually remind ourselves that for Gnawa practitioners, theirs constitutes a parallel rather than counternarrative and the ceremony central to their Gnawa identity is also permeated with Muslim elements. The same diviner, Brika, who is at pains to please the fierce spirit Sidi Mimun, earned the honorific "Hajja" by making the holy pilgrimage to Mecca in accordance with her duty as an observant Muslim. And, clearly, the many who perform their Muslim prayers at a Gnawa *lila*, facing Mecca, in the midst of a spirit-possession ceremony, do not perceive themselves as being in conflict with Islam.

This is not to say that practitioners do not recognize the sub-Saharan influences on Gnawa spirit-possession practices. In fact, in studying Gnawa spirit possession, one encounters over and over again a kind of Du Boisian "double consciousness," which allows ideas that appear incompatible or contradictory to outsiders to coexist. In his 1903 book, *The Souls of Black Folk*, Du Bois characterized double consciousness as a self-conscious internal conflict in the African American individual, between what was "Negro" and what was "American," viewing themselves from their own perspective as well as how they might be perceived negatively by the outside (i.e., white) world, "looking at oneself through the eyes of others" (1903, 351). The relationship of Gnawa spirituality to Islam displays a sense of double consciousness, holding on to behaviors associated with Islam but also engaging in actions that many Moroccans view as negative remnants of pre-Islamic animism.

Gnawa spirit possession, in other words, replicates actions and stereotypes that some Moroccans and even scholars might perceive as negative or counter to Islam, but participants in a *lila* display ambiguity toward—or, indeed, refusal to acknowledge—boundaries and classifications (*jnun* vs. "named-*jnun*" and *salihin* vs. *mluk*, for example). This permits a cultural inclusiveness that can also be seen in the claim of an ancestral link to Bilal and has contributed to the viability of Gnawa practices over time.[13] Furthermore, Muslim Sufi saints (*salihin*) are the first to appear during a *lila*, prayers from the Qur'an are evoked throughout the ceremony, and music at a *lila* stops during Muslim calls to prayer.

When living in Essaouira, I had several female friends who refused to attend Gnawa *lilas* with me despite my frequent invitations. This was less because they disapproved of Gnawa practices and characterized them as un-Islamic. Rather, they were generally fearful of the power inherent in Gnawa spirits and feared they would fall into possession inadvertently. Gnawa spirits, in general, are considered so powerful that many fear them, leading the scholar Bertrand Hell to describe them as "jealous and vindictive creatures, angry and versatile, feverish and unpredictable" (2002, 291). M`allem Abdellah Gania explained to me that as recently as twenty years ago, parents would forbid their sons

from joining Gnawa musical troupes because they feared the awesomeness of Gnawa spiritual power.[14] During the *lila*, I came to understand Gnawa music as activating the spirits, causing them to swirl around the space. An infraction could cause them to inflict their wrath. Because spirits were known to occupy water, for example, people reprimanded me if I wanted to drink water during a ceremony, as they worried that I would become inadvertently possessed. One woman literally snatched a cup of water from my hand when I first started to attend *lilas*, telling me, "You don't live in Morocco and maybe one year you can't travel here for a *lila*. The spirits will become angry and you will fall very sick." However, tea and coffee were often served to the crowd when the musicians took a break, and that was when I could safely drink.

Several studies have analyzed the relationship of spirit possession to Islam on the African continent, and while they proved helpful to this study, none fully captured the power dynamics that exist in Morocco. For example, Adeline Masquelier has argued that despite the Islamic expansion that threatened to end *bori* practices in Niger, *bori* remained relevant but exists in a tenuous relationship with Islam. *Bori* practitioners "tend to protest the hegemony of Islam while paradoxically borrowing from the Muslim repertoire of signifiers that they see as a reservoir of power ready to be tapped" (2001, 8). Richard Jankowsky also discussed the relationship of spirit possession to Islam in his study of *stambeli*, a spirit-possession ritual created by enslaved sub-Saharan Africans in Tunisia. Jankowsky found that *stambeli* spirit possession emphasized a historical linkage to sub-Saharan Africa while simultaneously revealing a common ground or compatibility with Islam (2010, 74). His study of white (Muslim) and black (sub-Saharan) spirits revealed that their manifestation emphasized "connections between these two Africas [North and sub-Saharan] rather than setting them apart." He found the encounters between Muslim saints and sub-Saharan spirits in Tunisia "helped shape the geocultural encounter of sub-Saharans with Arab Tunisians in terms other than those of slavery and servitude" (2010, 91).

In counterpoint to Masquelier's collaborators in Niger, Gnawa practitioners whom I met in Morocco did not feel anxious about their relationship to Islam and did not see themselves as existing in conflict with it. Also, the history of slavery and servitude is not completely erased in a Gnawa ceremonial context, as in Tunisia. In fact, an analysis of how black spirits manifest themselves and embody racialized identities during a Gnawa *lila* reinforces the hierarchical relationship that existed between North and sub-Saharan Africa historically, especially when black spirits appear.

FIRE AND THE FIERCENESS OF BLACK SPIRIT POSSESSION

Based on my experience attending many Gnawa *lilas* over more than two decades, I understood black spirits as the most potent and powerful, largely due to the actions of those possessed by them. One of the most intense spirits to appear at a *lila* is Sidi Mimun

from the black spirit family, who appears in conjunction with a song specifically refer-encing his travel from the Sudan into Morocco (see Appendix). At most of the cere-monies that I attended in Essaouira, the performance of his song sent a dozen men and women into possession, and they draped black scarves over their heads and began to shriek, throwing their hands above their heads while overtaken by a spirit. On several occasions, women wearing black tunics danced with lit candles, passing them under their chins, over their arms, and holding them to the bottoms of their feet without being burned. The lyrics and music performed during this powerful possession matched the intensity of the spirit.

Lwali a lwali, lwali Baba Mimun
[Oh Saint, oh Saint, Father Mimun]
Lwali Baba Mimun
[Oh Saint, Father Mimun]
Lgnawi ha huwa ja, min Sudan ha huwa ja
[The Gnawa, here he comes, from Sudan, here he comes]
Lgnawi ha huwa ja, min Sudan ha huwa ja
[The Gnawa, here he comes, from Sudan, here he comes]
Gnawa jaw min Sudan
[Gnawa came from Sudan]
A lgnawi
[Oh, the Gnawa]

Sidi Mimun is among several spirits explicitly linked to the Sudan and referred to explic-itly in the song as "Gnawa." He is also referred to as Baba, meaning "father" in Arabic. Bertrand Hell recounts that some Gnawa practitioners perform ceremonies to dedicate their children to Baba Mimun by draping a black hat covered with cowries over a child's body and giving the child a piece of sacrificial meat cooked without salt, as salt is said to repel the spirits (2002, 185).

At the same time that Sidi Mimun is protective, he is seen as jealous and overly posses-sive, and although he can possess either men or women, many women blame him for ruining their marriages due to his jealousy. Sidi Mimun, therefore, is a paternal, protector figure that is also ferocious and jealous; people emphasized that he demands a great deal from those possessed by him, further illustrating the capricious nature of Gnawa spirits. Sidi Mimun demands much from people, but he also rewards those dedicated to him.

Over the years in Essaouira, I came to know Halima Meses, one of the city's most expressive diviners, who typically became possessed by Sidi Mimun at each *lila*. For many years she worked with M`allem Omar Hayat, and they allowed me to take photo-graphs at their *lilas*, which they held in a small shrine named Dar Dmana. She accom-panied Sidi Mimun's song with a distinctly lively and uninhibited dance. When a *qraqebi*

(cymbal player) passed her a set of twelve lit candles wrapped in string, she would grunt, burp, and moan, which she later explained was the spirit rising up and speaking through her. All the others who were possessed moved to the edges of the dance space, as she held the candles behind her, pounding her feet to match the rhythm of the *guinbri*, while waving fire under her chin and across her arms and her ankles. She pushed other dancers away as she began to move quickly forward and backward toward the musicians. She finally fell to the ground exhausted after her vigorous performance, her black tunic covered in white candle wax. The *m'allem* put down his *guinbri* and held up the candles that she danced with, offering them for sale to the female audience members, as they contained the *baraka* of Gnawa spirits.

Unfortunately, like many diviners who work the spirits over the years, Meses became sick and discovered that she had throat cancer, and she tragically passed away in 2018. One of the last times that I saw her at a *lila* held by M'allem Omar Hayat was in 2015. Meses was largely subdued due to her illness, but at one point, the spirits overtook her and she stood up to dance. Hayat abruptly stopped playing when he saw her and instructed her to sit, worried about the impact of spirit possession on her health. While the spirits heal, they can also harm. Some people told me that Meses's close affiliation with Gnawa spirit possession may have contributed to her illness.

The act of dancing with fire materializes both the power and powerlessness of the dancer's relationship with Sidi Mimun. The ability to touch the flames to one's skin without feeling pain, sensing the hot wax melting on one's skin, or being burned by the flame indicates that the human has entered into a relationship variously understood as surrender to or cooperation with a spirit, which allows her body to be both taken over and capable of performing superhuman feats. The urgent and insistent present tense of Sidi Mimun's song—"here he comes, from Sudan, here he comes"—seems to express a mixture of anticipation, awe, and trepidation.

On some levels, possession by Sidi Mimun re-creates the relationship between a master and slave, as the possessed must be completely devoted to him, both during and outside of a ceremonial context, subjugating herself to his whims. However, when a human diviner dances with fire while possessed by Sidi Mimun, his power is transmitted to and through her, and she then partakes, if briefly, of his potency. In a complex interplay between dominant and counterhegemonic discourses, dancing with fire conveys strength in the face of marginality. Reified in the black spirit Sidi Mimun, Blackness itself is seen as both an empowering and potentially harmful force.

THE POWER OF BLACK WORDS:
EVOKING SPIRITS FROM THE FOREST

One of the two groups of black spirits is called the *Uled Lghaba* or "children of the forest" (see Appendix), who are considered the fiercest and most dangerous of the spirits

evoked during a *lila*. The first song played in this group opens with the line "Marhaba w Allah ya baba Marhaba b Sultan Lghaba," meaning "Welcome, I swear to God, oh Father, Welcome to the sultan of the forest" (see Appendix). The Arabic word *ghaba*, best translated as "forest" or "jungle," reflects a North African imaginary in which Africa south of the Sahara is equated with primitive wilderness. This primeval forest or jungle is the imagined dwelling place of aggressive and untamed spirits who engage in unconventional and physically aggressive actions during possession.[15]

I witnessed people become possessed by these spirits numerous times, but one particularly memorial possession event occurred in 2010 at the Zawiya of Sidna Bilal in Essaouira. As I watched the musicians begin the melody and sing the songs that welcome these black spirits, a group of men and a few women abruptly fell to their hands and feet, crawling until they reached the area in front of the musicians. The diviner quickly dressed them in black, using a gown or sashes placed in front of the musicians for such a purpose after they manifested possession. The rhythm of the song moved rather slowly as the musicians welcomed the forest spirits and the possessed crawled forward and backward, slowly moving toward and away from the musicians while shaking their heads. When the song's rhythm changed slightly and the musicians stopped singing, the possessed rose to their knees, closed their eyes, threw back their heads, and beat their chests forcefully, following the tempo of the *guinbri* (Figure 4.3).

While men dominated the space of the *lila* during this welcoming song, I also noticed one young woman who was a frequent participant in the *lilas* I witnessed. As the daughter of a prominent family of hereditary Gnawa musicians, she grew up in a Gnawa milieu as a member of the Gania family and was exposed to spirit possession at a young age. While I knew that many in her family believed that she had a strong connection to the spirits and expected her to become a *mqaddema* one day, I was nevertheless surprised when I saw this very quiet and reserved young woman join the group of men, pounding her chest alongside them. In fact, her possession continued through most of the songs performed to honor the "children of the forest," including a spirit referred to as Bu Gangi (see Appendix). This song was not performed at every *lila*, but because her uncle was the *m'allem* at this ceremony, he was aware of his niece's possessing spirits and played it for her. She stood up and danced, rocking back and forth with a black scarf draped over her face, then bent down and reached out toward the cymbal players, one of whom handed his instrument to her. A man holding a brazier with incense approached her; she held the set of cymbals over the smoke and then began to hit the top of her head with the iron instruments, in keeping with the song's rhythm. Another young man began to do the same, but he hit his head with such force that members of the audience intervened to restrain him. This young woman, however, hit herself in a controlled manner and at a steady pace, not causing the audience to react. We could all see that she clearly had control over her possession, and the spirits protected her from harming herself.

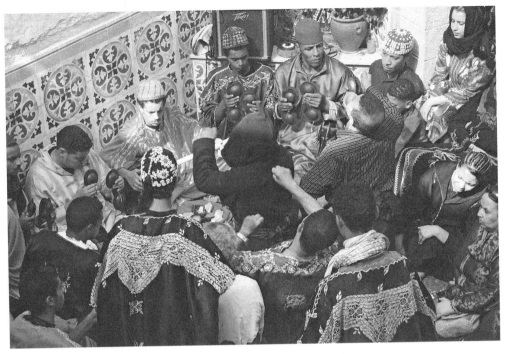

Figure 4.3. This group of men pound their chests with their fists during the performance of a song for *Uled Lghaba*. Photograph by the author, Essaouira, 2010.

The songs used to invoke the "children of the forest" are notable in the Gnawa repertoire for their abundance of so-called Sudani words, believed by Gnawa to derive from West African languages. In the following song, one among the thirteen songs I recorded and transcribed for this family of spirits, the words in italics were identified to me as Sudani; the remainder are Arabic.

> *Gubani bu Gangi, Gubani bu Gangi*
> > *Gubani bu Gangi*
> Ma ʿandi wali
> [I don't have a guardian]
> > *Gubani bu Gangi*
> Rebi lwali
> [Allah is my Guardian]
> > *Gubani bu Gangi*

English translations are provided only for the Arabic text because none of the people with whom I spoke were able to define the Sudani words, even those who self-identified as hereditary musicians and had enslaved ancestors. Only a few musicians and diviners whom I interviewed claimed to know the meaning of particular Sudani words, and even

then, most gave conflicting definitions.[16] I asked native speakers from Senegal, Mali, and Niger if they could identify any of the Sudani words that I collected. While I had some success, the majority of words were unrecognizable to them, indicating to me that words from West African languages had changed a great deal after their arrival in Morocco. I found that the actual meaning was less important than the fact that they were considered distinct from the Arabic words that dominate Gnawa songs. This suggested to me that the enslaved probably incorporated words from various Sahelian languages into their ceremonial repertoire, but as people did not pass these languages to their children and grandchildren, the words gradually became incomprehensible.

Based on discussions that I had with people in Niger, the Sudani words "bu Gangi" in this song may derive from Zarma. A language spoken in Niger and Mali, the Zarma word *ganji* (also spelled *genji*) generally means "spirit" but more specifically refers to spirits associated with the wilderness, which is the same designation given to this family of spirits in Morocco.[17] Furthermore, the Zarma word *kubayni* means "welcome," which suggests that the "k" in Zarma became modified into a "g" once the word arrived in Morocco. In the local Amazigh (Berber) language, Tamazight, the term *bu* means "owner of" or "one of," perhaps reflecting Amazigh influence on a word brought by Zarma speakers. Therefore, the phrase could be a mixture of Tamazight and Zarma and may be translated to mean, "Welcome One of the Spirits."

However satisfying it might be to hunt down possible word derivations, the actual genealogy of such words is ultimately less pertinent to the present project on how Blackness is used and understood in contemporary Morocco. What does it mean for the musicians to use "Sudani" words that are largely unintelligible? As noted by Kristina Wirtz in her discussion of unintelligible ritual speech in Cuban spirit possession, such words reflect "a stigmatized yet playful voice of the near historical past" that is understood by speakers and their listeners as the "voice of African-born slaves and their spirits" (2014, 155). Sudani words gather several meanings into Gnawa songs: they project a sense of otherness and mystery that carries spiritual connotations; they gesture toward an authenticating past; and they highlight the limits of humans' understanding of the spiritual realm. In their book *Making Spirits*, Diana Espírito Santo and Nico Tassi argue that words, like objects, are capable of holding spiritual energy since they can "transmit something divine which can become located in the spirit of those who listen to them" (2013, 19). Thus, even while the exact meanings of these words are unknown, they retain the incantatory potency to summon the spirits of distant "wild" places.

The second song in the repertoire for the spirits of the forests contains the repeated Sudani words *juju nama*, which are sung in conjunction with lyrics in colloquial Moroccan Arabic. Once again, words from the so-called Sudani language are in italics:

Juju Nama, ya juju nama
[Eat meat, oh eat meat]

Eh eh *nama, Juju Nama*
[Oh meat, eat raw meat]
Yakul lham neya, ya *juju nama*
[You eat meat, oh eat meat]
Eh eh *nama, Juju Nama*
[Oh meat, eat raw meat]

The word *nama* means "meat" in Hausa, a language common to northern Nigeria and Niger. When this song is performed, the possessed eat raw meat mixed with black benzoin (*jawi khal*), cilantro, and cumin and dance with their hands held in a curved claw-like gesture to look like wild animals. Eating raw meat and gesturing like a wild animal signal the spirit's savage nature, while mixing incense with food activates the sense of smell (generally regarded as the most "animalistic" or primordial of the five senses) together with the sense of taste, as noted by the scholar Deborah Kapchan. Furthermore, adding nonfood substances to food represents a transgression of categories; violating this taboo transforms what is ingested into a ritualized substance intended for spirits rather than humans (2007, 75).

The act of eating raw meat further solidifies the association of this spirit with a conception of Blackness equated with savage and uncivilized behavior in a Moroccan context. Black spirits from the forest are seen as originating in sub-Saharan Africa and are racialized as Black. Because of this, black spirits reinforce historical stereotypes that many North Africans associated sub-Saharan Africans with animism. Historically, even if West Africans claimed to be Muslim, they were often understood by North Africans as practicing an inferior and marginal form of Islam. This likely contributed to the fact that some Sudani spirits have faded from the Gnawa pantheon, and the claim made by many that Gnawa ceremonies have become more Arabized in recent years. For example, among the female spirits, who are the last group to be evoked, is a spirit referred to as *Muso Korni Nana*, a phrase I was told meant "old woman came" and derives from a Mande language, such as Jula or Bamanakan. During possession a woman would wear black cloth and crawl on her knees, offering people snuff made from powdered clove and scratching herself, as if she is experiencing drug withdrawals. During the dozens of *lila* that I attended, I only saw this spirit evoked once.

As asserted elsewhere in this chapter, the exaggeration of qualities associated with Blackness during a Gnawa *lila* transfigures Blackness from a legacy of marginality and otherness into a source of agency through a connection to spiritual potency. At the same time, many aspects of a *lila* indicate that the enslaved have accommodated themselves to a North African context when performing spirit possession. While some Gnawa practitioners embrace the West African aspects of a Gnawa *lila*, others reject them, a source of tension discussed further in chapter 5.

HEGEMONY AND HIERARCHY:
REPRODUCED AND REPUDIATED

Gnawa practitioners are aware that their use of music, incense, and animal sacrifices for healing and to induce possession causes some in Morocco to disparage them as pagans who deviate from proper Islamic practice. Also, among those who do attend ceremonies, there are many who leave after the white spirits (*salihin*) have departed and before the first cohort of black spirits (*Lkuhl*) is evoked. Some of these even stood to dance during songs for white spirits without being possessed. As one woman explained to me, "I am not possessed but feel a sense of relief and calm after the songs for the whites."

Of course, some who leave are simply tired. Since the most potent and intense spirits are called later, this part of the *lila* occurs late at night, usually after two o'clock in the morning. But it is important to note that some purposefully leave to avoid the appearance of the black spirits, which they equate with sorcery and the ability to do magic. The connection between Blackness, magic, and sorcery has a long history in Morocco. People historically viewed the religiosity of Black Africans as idolatrous and associated with pre-Islamic pagan behaviors. Even if West Africans claimed to be Muslim, they were accused of practicing an inferior form of Islam. This judgment is what allowed for them to be enslaved, as Islamic law prohibited the enslavement of fellow Muslims. Such an association between Blackness and sorcery continued into the twentieth century. Black women were often recruited by well-to-do families with sick children to work as wet nurses, as their breast milk was seen as having supernatural healing powers. Such a practice reinforced the mysticism associated with Blackness but, at the same time, reinforced the negative link between Blackness and servitude.

The arrival of black spirits during a *lila* reinforces a link between Blackness and spiritual efficacy by reinforcing many historical stereotypes concerning sub-Saharan Africans. There are two primary groups of black spirits (*Lkuhl* and *Uled Lghaba*) who arrive during a *lila*, and they cause their human hosts to engage in animal-like behaviors, aggressively beating their chests, dancing with fire, crawling on the ground to imitate wild beasts, making clawing gestures, and eating raw meat. Such actions are seen as brutish and uncivilized and also provide evidence of the otherworldly power of black spirits. As spirits who are said to have originated in western Africa, these behaviors emphasized their otherness, but as we will see, people have used black spirits as an asset to suggest spiritual potency, turning the marginality associated with Blackness and a sub-Saharan origin into an asset and, in recent years, a resource that could prove a Gnawa authenticity.

Several scholars have noticed a similar cultural strategy among Haitian Vodou practitioners in Cuba. As low-status migrants doing agricultural labor in Cuba, they were discriminated against and exploited, but they cultivated a reputation as tough, daring, and spiritually powerful in order to protect themselves from aggression. The Vodou

rituals of Haitian migrants and their descendants in Cuba often feature intense acts of possession that include standing on the sharp blades of machetes as well as eating fire and broken glass. Such spectacular acts of possession demonstrated their mystical power and knowledge of potent "African" forms of healing, emphasizing their outsider status but also earning them respect and a reputation as dangerous (Carr 1998, 95; James Figarola, Alarcón, and Millet 2007, 76; Viddal 2013, 213–14). Scholars such as John and Jean Comaroff have noted the process by which underprivileged groups within hegemonic systems internalize and then reproduce self-exoticizing tropes that contribute to their own subordination. But even while this self-subordination is occurring on one level, imaginative acts of cultural subversion can be occurring on another (1991, xii).

In her book *Performing Afro-Cuba*, Kristina Wirtz also considers how Blackness is often manifested in unexpected ways. She asserts that the folkloric performances of Afro-Cuban religious practices often feature gestures, dance steps, and dress styles that portray Blackness as savage, primitive, and aggressive, reinforcing negative racialized caricatures of Black behaviors. She refers to such moments as "transhistorical," allowing the perceived past of enslavement and ritual enactments of inequality to inform the present. The performance of stereotypical behavior by people who self-identify as Afro-Cuban is a means of "claiming ritual power and controlling a spirit to harness its power for present purposes" (2014, E18). A similar phenomenon is discussed by Paul Stoller in his book on Hauka possession in Niger. Having emerged in 1925 after the colonization of Niger by the French, those possessed by Hauka spirits march with wooden rifles, crack whips, and wear inverted gourds as pith helmets, mimicking behaviors associated with the French military (1995, 123–24). Stoller explains that the Hauka understood French military might and engaged in mimesis in order to master whiteness and symbolically appropriate its power for themselves (1995, 123).

When subaltern groups define themselves in opposition to others within their communities, the result is that they may engage in behaviors deemed as exotic and savage, even tending toward caricature. Performance studies scholar Joseph Roach asserts that for African Americans in New Orleans, particularly during the Jim Crow era, it was risky to perform their own local traditions with pride; it would have been seen as threatening to the dominant culture. Rather, they engaged in what he defined as surrogation, or the process of substitution as a means of remembering histories that involved unspeakable horrors and transposing them onto something else less painful (Roach 1996, 4–5). Roach gives the example of African Americans performing as "Zulu" during Mardi Gras parades, wearing grass skirts and blackface with white circling the eyes and mouth and throwing coconuts as they strut down city streets (1996, 19). The New Orleans Zulu Social Aid and Pleasure Club parades on the streets before Rex, the predominantly white, exclusive carnival group that features elite citizens dressed as royalty. While Zulu walks a fine line between ridiculing and reinforcing racist imagery, they perform an identity that mocks Eurocentric stereotypes of white supremacy seen during

the Rex parade (1996, 21). Roach asserts that Zulu performance responds to racist policies that have historically limited Black participation in New Orleans Mardi Gras through surrogation. Black performances negate the very social structures that try to control them by engaging in "the imaginative re-creation and repossession of Africa" (Roach 1996, 207).

These discussions of how Black performance often exaggerates historical stereotypes as a means of empowerment are relevant to this book. I include specific examples from Cuba and New Orleans, as they both illustrate how people impacted by racialized social inequalities respond by engaging in internal contradictions and appropriating stereotypes as a means of self-empowerment. As noted by Mimi Sheller, the historian who "seeks traces of subaltern agency must also look beneath conventional definitions of political agency" (2012, 6). She advocates that people look to embodied material and spiritual practices to understand how empowerment and freedom are enacted. The embodiment of Blackness that occurs during possession of black Gnawa spirits provides people with a means of handling their marginality by reinforcing a connection to sub-Saharan Africa through exaggeration of characteristics associated with Blackness in a North African context. In the process, they secure respect as authentic Gnawa, which is extremely important in contemporary Morocco, especially the city of Essaouira where Gnawa music has been intensely marketed. A connection to the Sudan has become increasingly linked to claims of Gnawa authenticity, especially among those who self-identify as Black.

The performance of Blackness offers people an alternative mode of living within a hierarchical social structure in Morocco that historically viewed the religiosity of sub-Saharans as lesser and associated with pre-Islamic pagan behaviors. While possession by black spirits reinforces a painful historical connection to the Sudan, it also becomes a means through which a community perpetuates itself and its spiritual potency. Those possessed by black Gnawa spirits engage in behaviors that others might interpret as negative, behaviors often understood as lesser and primitive in a Moroccan context. The taste of bloody raw meat, the pain of hitting oneself on the head with an iron cymbal, the sounds of Sudani words, the smell of incense burning, the color of the black fabric draped over one's head, and the heat of melted wax on one's skin are all experienced by those possessed by black spirits, engaging all of the senses. Through the embodiment of Blackness and an exaggeration of attributes associated with pre-Islamic West Africa, the possessed embrace the mystical power associated with the Sudan and use it to their advantage.

Black Gnawa spirits may engage in behaviors that reinforce stereotypes associated with West African animism, but they also perform an identity that mocks historical claims of North African supremacy over sub-Saharan Africans that allowed for the latter's enslavement. Furthermore, the embodiment of Blackness during possession allows people to reclaim their Sudani identity and increase their spiritual renown within their

local communities, especially in the face of increased commodification of Gnawa identity. Many intentionally emphasize a historical connection to Africa south of the Sahara, claiming the ritual power of the Sudan for themselves, increasing their spiritual efficacy, and, in the process, defining themselves as authentic.

BLACKNESS AND THE POWER OF THE UNSEEN

While Gnawa spirit possession largely relies on the visibility of Blackness—gestures, adornments, dances, and dress that materialize the immaterial—to convince observers of the authenticity of possession, the diviner Zaida Gania relies instead on invisibility. Invisibility is typically associated with silence and marginalization, but Zaida Gania used invisibility to demonstrate her privileged access to knowledge inaccessible to ordinary people. In particular, Zaida invoked invisibility during possession by the spirits she inherited from her mother, whom she referred to as *Uled Sudan,* meaning "children of Sudan." At some point during her ceremonies, she would ask everyone who was not related to her family, including me, to sit on one side of her house, after which she would block our view with a heavy black curtain that she had erected to divide the central, covered courtyard.

Members of the spirit cohort whom she referred to as *Uled Sudan* were only capable of being sensed ("seen") by members of her family, inheritors of supernatural power through their bloodline. Those of us sitting on the other side of the curtain had to rely on our aural and olfactory senses to experience what was concealed from sight. Zaida turned off all of the lights, and the majority of us sat in darkness on one side of the curtain, listening to shouts, screams, and moans, as Gnawa musicians sang lyrics such as, "Sudani manindo, Fulani manindo, Bambrawi manindo, Timbuktu manindo." The Gania family attributed extreme spiritual potency to this song, owing to its being carried by their ancestors from south of the Sahara. As M'allem Omar Hayat explained, "This song was brought by Samba from Senegal, and no one here knows the meaning of this song. It is only performed by the Gania family."

While this is only a portion of one song performed as part of the *Uled Sudan* repertoire, like many other Gnawa songs, the words conjure up various places and ethnic groups in West Africa, such as Fulani, Bamana, and the city of Timbuktu, in addition to using the term "Sudani." The word *manindo,* however, is unique. It probably derives from the Tamazight phrase *mani s nra nddu,* meaning "where are we going?" In addition, the word *manindo* resembles a Zarma phrase, *mannindogo,* meaning "what is your origin?" Regardless of the exact origin of the word *manindo,* through my collection of Gnawa songs I have confirmed that words from various Sahelian languages such as Zarma and Hausa, in addition to Tamazight and Arabic, are incorporated into them, suggesting that many different languages and peoples mingled to produce contemporary Gnawa songs. People refer to any unfamiliar words simply as "Sudani," which, in

many people's imagination, evokes ideas of mysticism and supernatural power. Of course, there is the possibility of intentional obfuscation on the part of the people with whom I worked, and if this was the case, designating a word as Sudani indicates that the word was given a special spiritual significance and its power guarded. Most importantly, the phrases "where are we going" and "where are we from" suggest a desire to remember origins, which, in this case, is the source of Zaida Gania's spiritual power.

When the song was sung during the *lila*, none of us sitting behind the curtain could be certain what was taking place on the other side. Occasionally, we would hear loud guttural screams, loud stomping feet, and deep gasps for breath, indicating the severity of possession that was occurring. It was rumored that Zaida swallowed several needles and regurgitated them while in trance—something not typically done by other diviners. When I later asked Zaida about this, she confirmed that it was true and explained that she had learned both the feat and the value of keeping the act out of view from her mother, recounting that once when her mother was possessed and in the act of swallowing needles, her mother's possessing spirit heard a man mumble that she was faking. Her possessed mother grabbed his hand and forced it into her mouth, proving that she did not hide the needles in there. People were screaming and crying. Some were scared that the man would upset her possessing spirit and her mother would die. Afterward the man got sick and his hand stopped working as if it were dead. She used this story to explain why she was secretive about her possession: "In the past I would get possessed at people's houses and now I only do so at my house. I know the people who I invite. I am afraid that someone will criticize me and I will get sick or something. I learned this from my mother."

Zaida distinguishes herself from other Gnawa healers based on her ancestral connections to Africa south of the Sahara—especially given the fact that many who participate in Gnawa ceremonies today can claim no such lineage. The role of Black women in Gnawa spirit possession was largely ignored by outside observers as inconsequential and was thus rendered invisible. Zaida exploits invisibility (including prohibiting photography) to preserve cultural forms distinct to her ancestral heritage, including objects, language, symbols, and practices that she valorizes as essentially "Sudani." I assert that the act of disappearing is a strategy to conserve the potency of her heritage. Concealment allows her to engage in fierce and potentially death-defying acts of possession that verify the efficacy of her inherited power.

Zaida Gania's attribution of her spiritual powers to her inheritance from her parents, whom she pointedly and proudly identifies as Black, naturalizes spirit possession as something transmitted by genetic code and blood relationships. Such a discourse contributes to understandings of the body as a natural vessel of identity, expressing a notion of race that connects Africa south of the Sahara with a predisposition to spirit possession. Thus, Zaida Gania essentializes her identity as Black to embrace a "Sudani" identity that despite confirming recognition of her family's history of enslavement, elevates her self-esteem and associates Blackness with dignity and pride.

BLACKNESS AND DANGER

During my time in Essaouira, people often told me of the existence of a "snake spirit," always with the caveat that this spirit—from the black spirit group known as the "children of the forest"—was so dangerous that few people could survive being possessed by it. This snake spirit made a rare appearance in 2010 when I attended the annual *lila* at the public Zawiya of Sidna Bilal in Essaouira, which attracts hundreds of people. Several hours after the *lila* began, when many had gone home to sleep, an adept of a snake spirit, a bearded, middle-aged man, underwent possession, an event announced by his hitting the ground with a thud as women scrambled to find a white sheet to cover him. I had been asked to videotape and photograph the *lila* that year and was directed by some women to be careful while filming this spirit, as it was especially dangerous. I climbed the stairs and, from my position on the flat roof of the shrine, watched the man being covered with a white sheet. I could barely see the shape of the man's body moving under the sheet as people placed an uncooked egg at each end of his body, one near his head and one near his feet (Figure 4.4). He later told me that his spirit made a small hole in the egg in order to drink its raw yolk, and he distributed the eggshell to people after the possession was completed in order to spread its *baraka*.

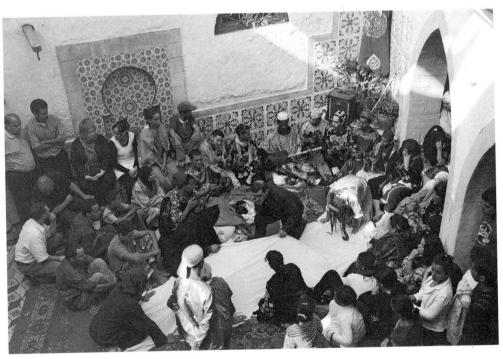

Figure 4.4. The snake spirit appeared fourteen hours after the beginning of the *lila*, around four o'clock in the afternoon, near the end of the *lila*. Photograph by author, Essaouira, 2010.

The *m'allem* of the *lila*, Abdellah Gania, confirmed that he only played the snake's rhythm if it was specially requested, as few are possessed by this dangerous spirit. A few months later I had the opportunity to meet the man who had been possessed by the snake spirit at his home near the Zawiya of Sidna Bilal. He told me that those who become possessed by this spirit must be ritually clean—for example, the devotee must abstain from sex and alcohol before undergoing possession—otherwise the snake spirit might be roused to anger, which could be very dangerous since this spirit is associated with death. He reported that the cloth held over the possessed symbolized a burial shroud, which in Muslim cultures is white. "This spirit is very difficult and could kill you," he explained. "People die if they are faking because they can suffocate." At a later date, Mokhtar Gania shared the words of the spirit's song with me. Indeed, it featured references to death and mortality, including the Arabic phrases *Denya ma dayma* (meaning "life is not eternal") and *Khali Mbara, ma daym shay* ("Uncle Mbara, nothing is forever"), indicating the life-and-death seriousness of possession by this spirit.[18]

The dangerousness of the snake spirit is not incidental or peripheral to its cultural meaning. Indeed, the snake spirit symbolizes the overlapping of danger and Blackness. In her study of Cuba, Kristina Wirtz describes Blackness in the city of Santiago de Cuba as a marker of social, physical, and spiritual danger. She discusses the fear of violence, unruly crowds, and chaos that are associated with carnival, which primarily occurs in Black neighborhoods, the sites where carnival traditions are the deepest, most fully realized, and most authentic (2014, 124). Wirtz asserts that Blackness is both a source of pride as a distinct and powerful form of creative cultural expression and a source of anxiety to the larger Cuban population. So too, the theatrical and performative dangers of possession by black spirits in Morocco represent both a pure and potent expression of Gnawa-ness and a signpost of disturbing otherness.

Danger of another kind also attends one of the most popular spirits in Morocco today: that of 'Aisha Qandisha (or Lalla 'Aisha). While she was often described to me as a part of the black spirits (*Lkuhl*), she can be evoked anytime during a Gnawa *lila*, as long as she appears before sunrise. This flexibility is due to the fact that Lalla 'Aisha was introduced into the Gnawa spirit repertoire relatively recently via the Hamadsha Brotherhood.[19] In fact, I often heard 'Aisha Qandisha referred to as 'Aisha Hamdushiya, referring to the fact that many Gnawa practitioners told me that in the 1970s her song entered the Gnawa repertoire from the Hamadsha Brotherhood, who are renowned for curing illness caused by this powerful and dangerous female spirit.

As a female spirit (described by scholar Bertrand Hell as arrogant and insensitive), when 'Aisha Qandisha appears, the mood of a *lila* drastically changes. The possession that accompanies 'Aisha resembles the fury seen during possession by "children of the forest," and much like the spirits of the forest, her spirit causes both men and women to be intensely possessed (Hell 2002, 336). 'Aisha's song during a *lila* must always be played

before sunrise since ʿAisha requires complete darkness. Musicians put down their *qraqeb* and clap their hands to accompany the *guinbri*.

A *lila* is normally lit by electric lights, but when ʿAisha's song is performed, all of the lights are turned off so that the room is pitch black, which increases the intensity of the experience. As soon as the first notes of her songs are played and the lights turned off, many let out blood-curdling screams; some throw their heads back and start to cry. Others are thrown forward toward the musicians, crawling on their hands and knees, unable to restrain themselves, because ʿAisha has control over them. Some attendees roll on the ground, and many stomp their feet on the ground with great force, the rhythm of their footsteps accompanying the beat of the music. There are many versions of ʿAisha that appear during a *lila,* but ʿAisha Qandisha, the most volatile, is classified as black, revealing that the color black has taken on qualities associated with Africa south of the Sahara.[20]

Over the years, I have collected stories about how and why Lalla ʿAisha afflicts both men and women. Typical of these stories is an anecdote recounted to me by the Gnawa Mʿallem Abdellah Gambori. He told of a beautiful woman who followed his father one night when he was walking alone near a dry riverbed, on his way to his early shift at the slaughterhouse. When his father looked carefully at the woman, he noticed that she had goat's hooves, so he tried to run away, realizing that she was a *jinniya*. But before he could escape, Gambori said that ʿAisha "struck" his father. From then on, his father regularly attended Gnawa *lilas,* ʿAisha's possession manifesting itself when his father danced frantically to songs dedicated to her.[21] ʿAisha Qandisha is not a seductress who cajoles and flirts in a playful fashion with her victims. Rather, she is an "attractive and dangerous she-demon" (Kapchan 2007, 112). Lalla ʿAisha is a taciturn figure who, somber and sad, goes out alone at night, luring unsuspecting victims.

Like the other spirits, Lalla ʿAisha can seriously injure those who fail to honor her correctly. Even those who attempt to honor her by visiting her pilgrimage site—a cave outside the town of Meknes where people leave offerings of sugar, henna, olive oil, and black olives—can be the target of her wrath. Gnawa diviner Zaida Gania explained to me that people have to be careful about these sacrifices, telling me that we could visit the cave where there was a large and very old fig tree. At the base of it sits an elderly woman who keeps a bowl of henna, and you can apply some after you give an animal sacrifice. ʿAisha really likes people to sacrifice black female goats or black chickens, and if it shrivels up after it is killed, this means that ʿAisha is satisfied with the sacrifice and has consumed it. But Zaida explained that the meat from the sacrificed animal is so dangerous that if you eat any of it, you can be possessed by Lalla ʿAisha. This happened to one girl who was very beautiful with black hair, according to Zaida, but when you looked at her eyes, she stared blankly ahead and never blinked, having become emaciated because she ate the meat of Lalla ʿAisha. Zaida recounted that the girl came to a *lila* at her house the previous year, but her mother would not let her come again this year

because she got married. However, she was unable to sleep with her husband until she brought Zaida an animal, which Zaida sacrificed in Lalla `Aisha's honor. What was most memorable about this story was its simple, yet powerful ending: "`Aisha is hard, and you must sacrifice to her every year."

`Aisha Qandisha afflicts both men and women, primarily in sexual terms. During an informal conversation with a *mqaddema* at a *lila*, she told me how `Aisha would take off her clothes and sleep next to a certain woman's son every night. Despite her son's protests, screaming at `Aisha to leave, `Aisha refused to go because she considered herself married to him. In addition to his nightly outbursts, the young man started to act strangely, always sitting alone and refusing to talk or eat with other people, which finally prompted his mother to bring him to a Gnawa *mqaddema*. She organized a Gnawa *lila* for him, and now he is happily married to a human wife and has several children. The *mqaddema* ended her story by saying, "`Aisha is not bad—she gives good things to those who are good with her and helps them in their lives and gives them money—but if you are not good to her she can destroy your life." For infertile women who devote themselves to Lalla `Aisha by placing offerings near fig trees (her votive tree) or at the bottom of the cave in Meknes, `Aisha can resolve their fertility issues (Hell 2002, 340).

I was told that men possessed by Lalla `Aisha can become impotent and lose interest in human women; they are married to `Aisha until she is brought under control by pleasing her through attendance at a Gnawa *lila*, burning incense for her in your home, and making animal sacrifices to her each year. According to the anthropologist Vincent Crapanzano who wrote about the appearance of `Aisha during Hamadsha ceremonies, she is the manifestation of what Moroccan society deems the problematic feminine qualities of treachery and sexual insatiability—qualities that need to be controlled. Men in this male-dominated society who do not live up to expected societal norms often blame `Aisha Qandisha.[22] According to Crapanzano, as long as a man obeys `Aisha Qandisha's commands, she enables him to live up to the ideals of male dominance and virility expected in Morocco's patriarchal society. Those men who do not obey or honor her become sick and effeminate because she takes away their health and fertility (1980, 224–27). Interestingly, this gives power over male potency to a female spirit, but also blames a female spirit for any failure on the part of a man.

How do we interpret the popularity of this dangerous sorceress and her prominence among Gnawa and Sufi groups, such as the Hamadsha? Kristina Wirtz's discussion of the representation of Blackness in Cuban folkloric performances is once again relevant. Wirtz notes that the appropriation of Blackness serves as a mask that "can be donned for performances of primordial authenticity, national folklore, or cultural resistance, quite apart from everyday racial identifications or consequences" (2014, 76). Her work suggests that Blackness in Cuba represents tradition and authenticity as well as rebelliousness and struggle, since the spirit possession developed by enslaved groups in Cuba

is associated with liberation from oppression. By extension, possession by black spirits has become valued as liberation from social mores (2014, 76–87).

When ʿAisha Qandisha entered the Gnawa pantheon, she was likely classified as a black spirit due to her unruliness and unpredictability. When a person is possessed, he or she is subject to the spirit's whims and cannot be held responsible for exhibiting behavior that falls outside of societal norms. ʿAisha Qandisha's sexuality, voracity, and ferocity are reproduced in the behavior of those whom she possesses: both men and women dance with abandon, scream loudly, and disrobe, women ripping off their head-scarves to fling their hair wildly. Possession by ʿAisha Qandisha relies on the perfor-mance of marginalization and rebelliousness against both personal responsibility and gender norms in a conservative, patriarchal society.

Despite ʿAisha's popularity, some older musicians refuse to play her song at cere-monies (Witulsky 2018, 76). According to Christopher Witulski, musicians with whom he worked dismissed the spirit as relatively new to the Gnawa pantheon, and newness for them equated with inauthenticity. I also heard musicians criticize the popularity of ʿAisha and claim that when her song was played, it simply transformed a sacred occa-sion into a dance party. They accused young women attending rituals of exaggerating and faking possession by Lalla ʿAisha. Furthermore, during public *lilas* in Essaouira, some young men took advantage of the darkness, and the wildly charged atmosphere, to grope young women. Others criticized ʿAisha as an example of the Arabization of Gnawa *lila*. While some might refuse to play the song, others welcome its popularity. I attended a *lila* where Mʿallem Mokhtar Gania played an extra-long, ninety-minute version of ʿAisha Qandisha's song in order to please a particular client.

As this chapter has illustrated, Blackness is enmeshed with claims of Gnawa authen-ticity and spiritual potency. The materialization of Blackness during Gnawa spirit pos-session can be interpreted as a means by which Gnawa assert their own agency and express a counterhegemonic religiosity that survives on the edges of so-called accept-able forms of Islam. It is through an emphasis on marginality and their own otherness that Gnawa spirit possession has survived over the past century and continues to thrive. Possession by black spirits, in particular, represents agency and an alternative to hege-monic power structures and as such is restorative and liberating to the community while being paradoxically linked to and continually reasserting certain stereotypes that asso-ciate Blackness with animism, savagery, and primitiveness. The black Gnawa spirits both reinforce and contradict stereotypes associated with West African religiosity but, by doing so, offer Gnawa-identified Moroccans both an alternative mode of spirituality and access to healing.

5

Marketing Gnawa Authenticity

The Shrine of Sidna Bilal and Hats of the Bambara

ACH YEAR A MASSIVE *lila* is held in the shrine known as Zawiya (shrine) of
Sidna Bilal in the coastal town of Essaouira that attracts hundreds to its annual
Gnawa possession ceremony, and I was among the attendees during most sum-
mers. A *lila* typically begins a few hours before midnight, but in 2010, due to the massive
crowd and the resulting chaos, Hajja Latifa Essaguer, the female leader of the shrine,
suddenly announced that that year's *lila* had been cancelled.[1] Men took down the sound
equipment and lights that had been set up for the musicians, who were scheduled to
play the spirit-possession repertoire in the shrine's courtyard. Most of us refused to
move, sensing that the cancellation announcement was a bluff meant to thin out the
crowds. Two hours later, realizing that the crowd would not budge, the *lila* began at two
o'clock in the morning and continued over the next sixteen hours until completion
around six o'clock in the evening.

Having attended two previous annual spirit-possession ceremonies at that same
shrine (and others in subsequent years), I was prepared for the chaos and pandemo-
nium that surrounded the Zawiya of Sidna Bilal. Since spirits are inactive during the
month of Ramadan, numerous private Gnawa ceremonies, held in diviners' homes,
occur during the Islamic month of Sha`ban, which leads up to the holy month of prayer
and fasting. Out of deference for the shrine, people in Essaouira schedule these private
ceremonies so that they end a few days before that of Zawiya of Sidna Bilal, the last
Gnawa ceremony of the season, which is meant to unite all practitioners under one roof.

Despite the respect accorded the shrine, by 2010 it had become the site of tensions
between tradition and commercialization. The wish to maintain cultural and spiritual
traditions vied with the impulse to profit from the popularity of Gnawa music. Many
complained that the massive crowds had turned the shrine into a circus; others claimed
that its female caretaker, who did not go into possession herself, was not an authentic

mqaddema or "diviner," and therefore should not be the authority figure at the shrine. There was also a growing objection that the four days of events scheduled to precede the possession ceremony itself, including performances by local Sufi groups, had turned this sacred gathering into a secular festival-like event. They linked commodification to cultural appropriation, which heightened the impulse to protect identity by drawing boundaries around belonging and authenticity. In their book *Ethnicity, Inc.*, John and Jean Comaroff report on the phenomenon whereby rampant cultural appropriation of the kind that characterizes global neoliberalism in the twenty-first century reconfigures identity constructs: "Identity is increasingly claimed as property by its living heirs, who proceed to manage it by palpably corporate means, to brand it and sell it, even to anthropologists, in self-consciously consumable forms" (2009, 29). While this book has asserted that photography during the colonial era contributed to the formation and visual fixation of Gnawa as a racialized identity, the increased popularity of Gnawa music and healing practices in the last few decades has created tensions between those who claim to be the original, authentic Gnawa born into hereditary families and those who recently made the decision to self-identify as Gnawa. Gnawa musicians now have the opportunity to travel to Europe and the United States and perform on massive concert stages. Female diviners can amass a large number of clients, control their own ceremonies, and even claim ownership of local shrines. In other words, commodification and self-marketing are not contested, but what is at stake is who controls it and profits from it.

This chapter considers how the processes of cultural commodification exist in an open-ended dialectic with authenticity claims and, in particular, how rampant marketing has effectively shaped Gnawa material and visual culture to amplify its associations with Africa south of the Sahara and Blackness. Gnawa practitioners, recognizing the marketability of their culture, strive to remove cultural mediators from the equation to assure they are the ones to benefit. Since those who desire to maintain Gnawa authenticity are not immune from commercial motives, it has been in their interest to promote the affiliation of authentic Gnawa-ness with Blackness and a history of enslavement. They engage in ethnic incorporation, branding themselves as authentic Gnawa—that is, Black people enslaved from Africa south of the Sahara—in order to sell a cultural inheritance that is essentially theirs alone. In the following, I deploy two case studies to illustrate how Gnawa practitioners market ethnicity, beginning with the commodification of the only Gnawa shrine in Morocco, Zawiya of Sidna Bilal, and ending with a discussion of the Gnawa song that repeats the phrase "Hats of the Bambara." These examples not only illustrate how an authentic Gnawa identity (referred to locally as *tagnawit*) continues to be produced but how, in doing so, it empowers marginalized populations, such as those attracted to Gnawa ceremonies. The creation of an authentic identity provides minority communities with "access to markets, money, and material enrichment" and creates "something essentially their own and theirs alone, something

of their essence, to sell. In other words, a brand" (Comaroff and Comaroff 2009, 15). This chapter chronicles contemporary efforts in Essaouira to create an authentic Gnawa brand linked to a Sudani identity and, by doing so, return that brand, that identity, to its perceived original creators—the descendants of the enslaved.

In the case of the Zawiya of Sidna Bilal, efforts to open up the ceremony more widely to the public drew both approbation and disfavor from some of the local population. Unlike private *lilas*, those held in the shrine did not require an invitation, which meant that many tourists wandered into the space with their cameras. In 2010, surrendering to this trend, those in charge of the shrine even hired a professional Moroccan videographer to record the ceremony. A Moroccan television crew also shot a short segment of the proceedings to be shown on national television. While one part of the community applauded these attempts at outreach and inclusiveness, another saw the introduction of cameras and the use of microphones to amplify music as commercializing and diluting the sacredness of the shrine's ceremonies. Some prominent male musicians in Essaouira, who had performed at ceremonies held at the Zawiya of Sidna Bilal in the past, had become frustrated by the shrine's overcrowding and overt commercialization and were refusing to play there.

One particularly vocal critic was Zaida Gania, who complained that those controlling the shrine did not have slave heritage and had usurped the rightful place of those with enslaved ancestry as its guardians. Despite her objections, Zaida Gania respected the sacredness of the shrine and attended ceremonies held there each year, including in 2010. While Zaida may not have considered the circus-like atmosphere of the ceremony spiritually meaningful, her presence there signified her belief that the blessedness of the shrine itself and its historical importance as a focal point of Gnawa identity took precedence over concerns about the shrine's increased commercialization and leadership.

We already begin to see how the shrine became a nexus for competing notions of what constitutes Gnawa authenticity. One barely needed to scratch the surface to reveal how the notion of Gnawa identity was being contested at the shrine in 2010. For example, neither Zaida Gania nor Hajja Latifa actually underwent possession during this *lila*, though they abstained for very different reasons that further illustrate divergent ideas about what constitutes appropriate Gnawa practice. Zaida had held her own private *lila* several days before, during which, as I witnessed, she had been possessed numerous times. This ceremony essentially shut down her spirits for Ramadan. Having attended numerous ceremonies at Zaida's home, I knew that she forbade talking and laughing during the ceremony, viewing such behavior as disrespectful and often ejecting those who engaged in it from her private ceremonies. She also forbade the presence of cameras and video, often banning those who pulled out their cell phones to take quick videos. Thus, having already satisfied her spirits during her own private ceremony, and disapproving of the circus-like atmosphere of the shrine, she was certainly not going to undergo possession in that environment. At the same time, Hajja Latifa reported that

since she had made the pilgrimage to Mecca (thus earning her the honorific), it would not be proper for her to become possessed by spirits. In other words, she did not partake in the one activity that is fundamental to a Gnawa ceremony—spirit possession—perhaps because she perceived it to be in conflict with the teachings of Islam. All that was left for both was to enjoy the shrine's communal setting and lively music.

The tensions that surround the Zawiya of Sidna Bilal in Essaouira provide a point of entry for consideration of the larger question of how cultural appropriation and marketing of culture influences collective identity. As we have seen, the descendants of enslaved people have marketed their identity to outsiders for a long time. In order to survive in postslavery Morocco, recently manumitted slaves relocated from rural areas to urban centers (often international zones), looking for opportunities. Playing music on the streets, posing for the camera, and dressing in distinctive attire contributed to the formation of "Gnawa" as an ideological construct and a distinct identity. Women with enslaved ancestry control their own self-representation in the face of a patriarchal power system that dissociates dark complexions from beauty by creating an influential niche for themselves as reservoirs and conduits of mystical powers. By enacting and embracing a Gnawa identity for themselves, they deploy their Blackness as an asset rather than a hindrance, selling themselves as powerful healers.

Although Black musicians have always engaged in self-marketing, in the past few decades the marketing of Gnawa identity by outsiders has been accelerating. Scholars, public intellectuals, music producers, and advertisers who are not Gnawa practitioners themselves have flooded the local marketplace with consumable versions of Gnawa traditions, turning "Gnawa" into a consumable brand. Not surprisingly, the profits from such commercialization have not been evenly distributed within the Gnawa community. For example, since female Gnawa healers are not included in staged performances, they have not profited financially from the booming concert business. And while male Gnawa musicians have profited to some degree from opportunities to perform in music festivals, they complain that they are not fairly compensated for their massive concerts, which draw hundreds of spectators (Figure 5.1). The local museum displays Gnawa hats, tunics, and even a diviner's tray with incense; people sell Gnawa cowrie-adorned hats at local shops; Gnawa music arrives in homes via radio and cassettes; photographs of Gnawa musicians are used to sell such products as cell phone service on television and on billboards (Figure 5.2).

Illustrative of the uneven distribution of the benefits from commodification is the case of a Black musical group from the remote southeastern Moroccan town of Khamlia, a twelve-hour bus ride from Essaouira. This group was featured on a billboard advertising the Gnawa and World Music Festival in Essaouira, despite never having been invited to play at the festival. Seen in the billboard on the right in Figure 5.3, it was modified with photo editing software to make it seem as if these musicians were performing on the festival stage. As seen in Figure 5.4, the men in the photograph typically

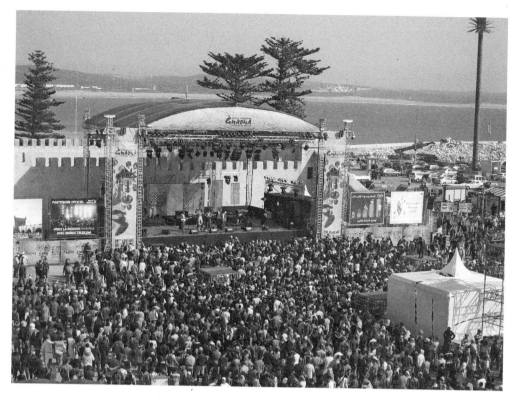

Figure 5.1. Massive crowds gather at the Gnawa and World Music Festival, Essaouira, Morocco. Photograph by the author, 2016.

Figure 5.2. A billboard banner at the Gnawa and World Music Festival advertises a cell phone company. Photograph by the author, 2008.

Figure 5.3. A billboard banner *(right)* at the Gnawa and World Music Festival in Essaouira uses a group from rural southeastern Morocco to advertise the festival—yet this group has never been invited to play there. Photograph by the author, 2010.

perform in a modest adobe house they have transformed into a cultural center, sitting on a bench rather than under the bright lights of a stage. Having managed to receive a copy of the billboard advertisement, they nailed it to the wall of the house where they perform for foreign tourists for tips. They salvage only modest financial benefits from the popularity of Gnawa music while serving as one of its iconic images.

The strongest catalyst for Gnawa commercial popularity was the creation of the Gnawa and World Music Festival in Essaouira,[2] the goal of which was to present Gnawa music as a national heritage and a reflection of Morocco's tolerance of ethnic diversity. The first festival was a small-scale event organized in 1998 by the Essaouira-Mogador Association, a group affiliated with André Azoulay, an advisor to Morocco's king. Due to its success, it was contracted to A3 Groupe, an event-management company located in Casablanca, going from attendance of around twenty thousand in 1998 to two hundred thousand in 2001. Attendance increased to four hundred thousand in 2005 (Majdouli 2007, 76–81; Ross et al. 2002, 40), and it continues to gain global popularity.

As noted by scholar Aomar Boum, the more than 150 festivals held throughout Morocco each year are occasions for Moroccans to celebrate diverse cultural identities

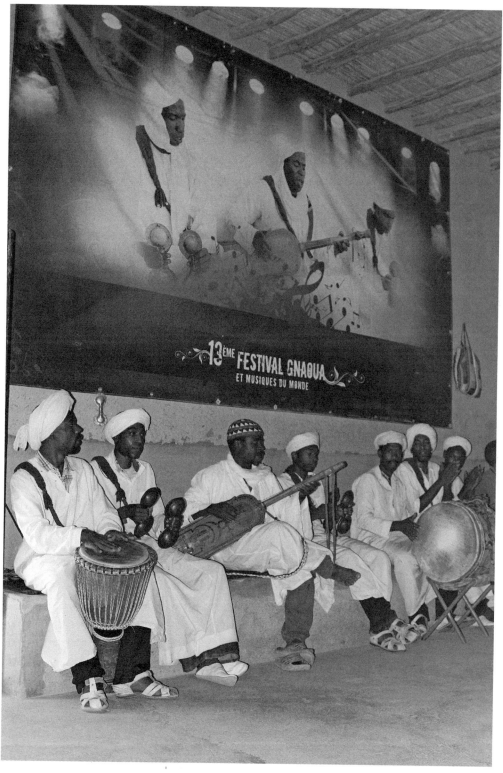

Figure 5.4. The same sign on display at Dar Gnaoua in Khamlia (rural southeastern Morocco), where these musicians usually perform. Photograph by the author, 2013.

and tolerance. Overseen by the Ministries of Tourism and Culture, these numerous festivals have had the effect of turning diverse cultural forms into a "single, centralized vision of national authenticity." According to Boum, "the state turned these cultural forms into something exotic, folklore to be consumed by foreign tourists and more 'modern' Moroccan citizens" (2012a, 23). While these festivals help local economies, they only provide a seasonal income and are reliant on outside economies to ensure an influx of tourists (Boum 2012a, 25).

Unlike the majority of festivals in Morocco, the Gnawa and World Music Festival is not organized by the Ministries of Tourism and Culture, which perhaps contributes to the sentiments by Gnawa that they are exploited by the festival organizers, whom many identify as members of Morocco's elite. Many Gnawa musicians complain of the low pay they receive, and they imagine that the organizers make immense quantities of money. However, Neila Tazi, the director of A3 Groupe, explained that she has a hard time generating support from local officials, and many major contributors fail to pay their promised contributions, assuming that André Azoulay can provide unlimited funds from his personal wealth or from his connection to the monarch (Ross et al. 2002, 44–45). Gnawa musicians lament that the festival organizers fail to consult them in the organization of "their festival." Indeed, when the phrase "World Music" was added to the festival's name in 2001, Gnawa musicians were not consulted and the content of Gnawa music was reduced in favor of popular world music acts (Ross et al. 2002, 42). Boum described Morocco's state-backed festivals as token efforts at tolerance rather than real agents of social change (2012a, 25; 2012b, 140). Festivals, such as the one organized in Essaouira, provide an outlet for the tens of thousands of young Moroccans who drive from Casablanca and other northern cities, camping on the beach as they attend late-night concerts, as well as a temporary respite from conservative social pressures that limit the individual choices and personal expression of Moroccan youth.

At the Gnawa and World Music Festival, Gnawa aesthetics are festivalized and marketed to the public. Colonial-era photographs of Black male musicians are blown up to larger than life–size to adorn the walls of the old city. It even re-creates aspects of Gnawa sacrality, presenting mock spirit-possession ceremonies—shortened reenactments of authentic *lila*s, but without the presence of female healers. During the festival, the Zawiya of Sidna Bilal becomes a venue for small concerts that unlike the rest of the festival, require paid admission, which has the effect of limiting the audience to foreign tourists.

The increased commercialization of Gnawa culture has prompted some to lament the loss of a pure and authentic Gnawa heritage uncontaminated by the consumptive attention of the non-Gnawa world and the global music scene. The scholar Deborah Kapchan notes that those who identify as Gnawa fear being dispossessed of their culture, an unease that has increasingly caused people to emphasize the idea of *tagnawit*, translated to mean "Gnawa-ness," to distinguish between what is "authentic" Gnawa and what is "imitation" and "inauthentic" (2007, 22–23).[3]

Among musicians, those said to possess *tagnawit* are men who learned Gnawa music from their fathers and grandfathers, acquiring ritual knowledge through a slow process of observation and participation. On the other hand, those who do not possess *tagnawit* are seen as "popularizers who, for purposes of commercialization, have adopted the Gnawa identity and music but know little of its deeper ritual significance, its history in the bones" (Kapchan 2007, 23). In response to what people understand as commodification and the increased participation of people without slave heritage, those who see themselves as authentic Gnawa insist upon their cultural and aesthetic connection to Africa south of the Sahara, stressing their Sudani or Black identity. It is in this context that Gnawa, who self-identify as Black in the Arab-Amazigh majority nation of Morocco, actually promote a form of racial discourse in order to create and preserve their distinct identity.

ZAWIYA OF SIDNA BILAL:
A HISTORICAL SPACE FOR BLACK PEOPLE

Issues of *tagnawit,* Gnawa authenticity and identity, are played out in a concrete and vivid way at Zawiya of Sidna Bilal where this chapter began.[4] Situated in the interior of the old city, *medina,* of Essaouira, it was built inside the city's surrounding walls along the edge of the Atlantic. Details concerning the origin of the shrine remain murky, and as one man explained to me, the historically marginal status of Gnawa due to their history of enslavement meant that for most of its history no outsiders took an interest in it. However, one origin story that more than one person recounted to me states that during Essaouira's early history, enslaved people who performed on the streets sometimes gathered to play on empty parcels of land and public squares. At the turn of the twentieth century, a wealthy family named Ait El Moukh, grateful for the healing accomplished by these Black musicians, gave the enslaved an empty plot of land located inside the *medina,* upon which they eventually built a series of rooms, known today as the Zawiya of Sidna Bilal. Gnawa musician Abdellah Gambori told me, "Gnawa built the *zawiya* brick by brick. People gave them materials and they slowly built it themselves." According to local lore, the space was used only by Black people in Essaouira to hold their possession ceremonies and to this day retains that unique status.

Notwithstanding its very special status as the only Gnawa shrine in Morocco, the Zawiya of Sidna Bilal shares many features with Sufi shrines throughout Morocco, demonstrating the historically hybrid nature of Gnawa practices. Surrounded by multistoried buildings on either side, its external form is nondescript, but its interior consists of a large courtyard surrounded by several smaller rooms. The photograph of its interior seen in Plate 5 was taken in 2008 and can be compared to the image in Plate 4, which was taken before the shrine's renovation in 2007. This comparison reveals that the shrine's newly painted and tiled interior differs greatly from the shrine's appearance before its

renovation. When I first visited the *zawiya* in 1997 the interior courtyard was paved with an inexpensive style of black and white tiles, which also covered the bottom half of its white-washed walls. When I took the photograph in 2006, it had remained largely unchanged since 1997 (Plate 4). The courtyard had a nonfunctioning fountain in the middle and, underneath an arched portico, a series of red and white tiles placed in a rectangular formation, indicating that someone was buried in that spot. I was told that several men had been buried in the shrine, but their identities were somewhat unclear. Gnawa musician Omar Hayat told me that the tiles marked the grave of the first Black male musicians in Essaouira, including M`allem Bilal and M`allem Belkhir. While no one seemed to remember the dates of the deaths of those interred, most people believed that they died in the first half of the twentieth century, before independence from France in 1956, and that the burials occurred over a period of time after the shrine was constructed.

The name of the shrine, Zawiya of Sidna Bilal, refers not to the musician named Bilal buried in the shrine but to an enslaved Abyssinian (i.e., from modern Ethiopia) who became one of the Prophet Muhammed's first followers and through whom many Black Moroccans trace their ancestral link to Islam. The Prophet's companion, however, was not buried in Essaouira, despite the fact that his name was given to this Gnawa shrine. By evoking Bilal, Gnawa practitioners are constructing an affiliation to a spiritually important personage within early Islamic history in a manner similar to Sufi brotherhoods who affiliate themselves to the teaching of a particular *wali*, or Sufi "saint."

Although Bilal was not buried in Morocco and did not leave behind teachings or writings for his followers, scholars have long recognized that many aspects of Gnawa spirit-possession ceremonies represent a fusion of Islamic and West African ideas and beliefs (see, for example, Bravmann 1995; Benachir 2001; Hell 2002). The Zawiya of Sidna Bilal, as we will see, has much in common with Moroccan Sufi shrines, although, as previously discussed, Gnawa have never been considered a legitimate Sufi brotherhood and the shrine is not the focal point for all Gnawa in Morocco. It remains the focus of Gnawa activities within Essaouira, but Gnawa practitioners in other cities of Morocco commonly visit shrines of various Sufi brotherhoods. In his unpublished dissertation, Timothy Fuson discusses how Gnawa practitioners make visits to Sufi shrines during celebrations associated with the Prophet Muhammed's birthday. During the two-week period inaugurated by the Prophet's birthday, festivals occur at hundreds of saints' shrines, and Gnawa practitioners often rent houses at the towns of Mulay Brahim or Tamesloht, both of which house important Sufi shrines and are relatively close to the city of Marrakech.[5] Gnawa organize possession-trance ceremonies, which, according to Fuson, allow practitioners to "renew ties with the saints, the sources of divine grace (*baraka*) under whose spiritual wing the Gnawa claim protection and spiritual authority" (2009, 52).

Saint's shrines are typically square enclosures built around a tomb, covered with a dome, often with the later addition of courtyards for devotional gatherings (Figure 5.5).

Figure 5.5. Shrine (*Zawiya*) of Sidi Musa, southeastern Morocco. Photograph by the author, 2016.

Inside the enclosure, places of burial are often covered with raised stone markers adorned with carved calligraphy, over which a simple wooden frame was built and covered with layers of cloth, typically green, a color associated with Islam. Scott Kugle writes, "The shrine then becomes analogous to a 'house' in which the dead body 'dwells'" (2007, 47). Shrines can also include a mosque or designated prayer space, a Qur'anic school, and other ancillary buildings. Patrons visit shrines for many reasons, including to receive *baraka* believed to be housed in the shrine. Sufi shrines also serve as gathering places where patrons meditate, sing devotional songs outside the norms of ritual prayer, offer gifts, and make petitions to the saint (Kugle 2007, 47). Pilgrims to a Sufi shrine typically circumambulate around the tomb itself, often kissing its four sides, lighting a candle, and reciting prayers. Some pilgrims press their heads against a saint's tomb, tie pieces of cloth to its wooden frame, or pass the night in the mausoleum to reap more of the saint's *baraka*. If they make a request of the saint and it is granted, they typically return with an animal sacrifice (Crapanzano 1973, 173–75).

As we have seen, the Zạwiya of Sidna Bilal in Essaouira was not built around the tomb of an Islamic saint or scholar and lacks a domed roof. It was built on what was essentially an empty lot in the middle of a city, and the graves of prominent Gnawa musicians and healers were added after the shrine was constructed.[6] They were not and are not the focal point of worship, and indeed the fact that few people remember

who was buried in the shrine's courtyard signals a loss of historical memory. The Zawiya of Sidna Bilal, however, does feature several rooms that serve as gathering places for men and women who visit the shrine, where, instead of venerating a tomb, visitors view the musical instruments played by Gnawa male musicians to induce spirit possession and partake in the curative powers of Gnawa female healers. The focus of worship is thus the ongoing and living aspects of a spiritual practice that make "Gnawa" difficult if not impossible to represent as a fixed identity.

Around the central courtyard a room considered the purview of men was referred to as the "*ganga* room" because Gnawa stored their large barrel drums, *ganga*, there. When I visited the shrine in 2006, one drum hanging from the wall had been completely covered in small pieces of cloth and had handkerchiefs tied onto it by women seeking the *baraka* associated with Gnawa to grant them such things as pregnancies or healing from illnesses (Figure 5.6). As in Sufi shrines, if their requests were granted, they brought an animal sacrifice to the shrine.

The Zawiya of Sidna Bilal also featured a "girl's room" (*beit el bnat*) where women and girls could become possessed and dance away from the eyes of men. People told me that in the past, men and women occupied separate sections at the shrine. While some women continued to sit in a separate section during the ceremonies that I attended, both men and women sat together in the shrine's central courtyard. This allowed them to sit facing the musicians who played in the courtyard. The shrine also houses a room

Figure 5.6. Interior of the *ganga* room, Zawiya of Sidna Bilal. Photograph by the author, 2006.

used for healing that was primarily the domain of women (during both ceremonial and nonceremonial occasions). The modest room has benches where bundles of cloth used in ceremonies are stored and a kitchen where sacred food for ceremonies is cooked. Sometime in the distant past, an enslaved man named Salem, who had the gift of divining water, instructed that a well be dug in the kitchen (Chlyeh 1998, 23). Women sometimes visit the shrine simply to drink the *baraka*-laced water, or they may pay to fill up a bottle with it, sometimes bathing in it or using it to wash their house. In addition, there is a small altar, called a *mida*, meaning "table," where women place small bowls filled with the foods preferred by each of the major spirits. At the end of a *lila*, the contents are distributed to participants. Similar to the feasting that takes place during weddings, the distribution of food at the end of the *lila* evokes celebratory feasting.

As we have seen, the notion of *baraka* is not unique to Gnawa practice, and Sufi shrines are also seen as a source of healing; indeed, many feature springs whose water is believed to contain healing properties. A primary difference between Sufi and Gnawa practices, however, lies in the powerful role accorded women in the latter. At the Zawiya of Sidna Bilal women are the wielders of distinct healing powers, and, therefore, women from all over Morocco, including those without any ancestral connection to slavery, visit the shrine to be healed.[7] In contrast, a male leader, called a *mqaddem*, administers a Sufi shrine and manages everyday activities at the shrine, safeguarding the alms collected and organizing ceremonies (Crapanzano 1973, 82). While a Sufi shrine may also have female caretakers who clean the shrine and oversee female participants during Sufi gatherings, the male *mqaddem* is the ultimate authority. Over the decades, the Zawiya of Sidna Bilal has had both male and female caretakers, but since I have been visiting the shrine since the 1990s, women are much more visible, and while the shrine is said to have a *mqaddem*, this man is not present on a daily basis. One or two men will assist when a *lila* is held in the shrine, providing the possessed with incense and the proper colored garments, but they do not work in the shrine on a daily basis. Perhaps this is because women visit the shrine outside of a ceremonial context to be healed rather than men. Once again here we see in Gnawa practice a certain ambiguity and blurring of boundaries that resist definition and delineation. It might be tempting to describe the situation in binary terms, suggesting that the Gnawa shrine is run by women and Sufi shrines by men, but in fact a great deal of variation exists, making such simple typological distinctions impossible. While I never saw a man being healed outside of a *lila* at the Zawiya of Sidna Bilal, it is possible outside of a ceremonial context. However, it is women who make regular visits to the shrine, making the figure of the *mqaddema* more relevant to the shrine's everyday needs.

The shrine's *mqaddema*, Hajja Latifa, inherited her role from her mother, who, unlike her predecessors, did not self-identify as Black or Sudani. Many recounted to me that Hajja Latifa's mother, who lived near the Zawiya of Sidna Bilal, helped an aging man who was the caretaker at the shrine and upon his death placed herself in charge. It is

therefore accepted that she usurped power in an unorthodox way, rather than being chosen by the Gnawa community. Like her mother, Hajja Latifa neither healed the visitors who made pilgrimages to the shrine nor entered into spirit possession. Her role consisted of administrator of the shrine who also controlled its finances, a job that she shared with her husband. In her stead, a dark-skinned woman named Mbarka served as the shrine's resident healer for several decades until she passed away in 2013.

Mbarka (whose family name I never learned) was a constant presence at the shrine for years, and I witnessed her heal numerous women; she was clearly the shrine's primary healer, but she never held the title of *mqaddema*. However, since Hajja Latifa, the official *mqaddema*, did not share Mbarka's knowledge of Gnawa ritual life and in any event she lived the majority of the year in Casablanca, Mbarka quietly and meticulously took over. One of her most important roles during Gnawa ceremonies was to cook a ritual dish called *mssous*, a salt-less chicken dish cooked with various spices and *jawi*, a resinous substance burned as incense to attract spirits during Gnawa spirit possession. Historically salt was transported across the Sahara as one of the commodities traded for slaves, who also excavated salt from the Sahara. Therefore, food without salt harks back to a time before slavery, and the presence of *jawi* signals that it is food associated with the spirits (Diouri 1994, 198). In order to heal women of skin rashes, Mbarka mixed ashes from the shrine's small hearth used to cook *mssous* with water from the well, as its water was believed to hold *baraka*. She spread the mixture onto a woman's skin using a feather from a red or black rooster, then disposing of it by dropping the feather into the rocky coastline behind the shrine, a revered spot called Sidi Bourisha.

While Mbarka and her assistant Fatima ran the shrine's daily affairs until its renovation in 2007, this shrine, which was slightly dilapidated, could charitably be described as modest, and many of its most sacred objects and spaces were in states of neglect or disrepair. Although Mbarka saw numerous women each day who came to her to heal their spirit-induced illnesses, she clearly did not profit from the small sums paid for her services. Her modest wardrobe and humble demeanor gave the impression that she was simply the shrine's caretaker rather than serving as its primary healer. The rundown state of the shrine reflected the marginal financial state of many Gnawa practitioners, who did not have the economic means to contribute to its upkeep. Moreover, practitioners and supplicants alike attribute more importance to the spiritual significance of the site than to its aesthetic qualities.

Evidence of decline could also be seen around the exterior of the site, especially the side that faced the sea, which was covered in trash. People related to me that part of the shrine's putative power lay in its external rather than internal environment. In particular, the rocky shoreline behind the shrine, Sidi Bourisha, was regarded as spiritually powerful. *Bourisha*, meaning the "one of feathers" in Moroccan Arabic, referred to a place where people made sacrifices of chickens and roosters, in other words, a repository for offerings. One woman explained to me, "There is something strange about that

place. It is only water from the ocean, but there is something there." When Mbarka, the shrine's resident healer, rubbed a rooster feather on a woman's skin rash, the spirit that caused the illness was absorbed into the feather and thrown into Sidi Bourisha. Many in Essaouira indicated that in an unspecified distant past, young girls often washed at Sidi Bourisha, as it was seen to be a place filled with *baraka*, and women who wished to get pregnant would leave eggs there to invite fertility. During my visits to Essaouira, it had become a somewhat dangerous place where men drank and smoked hash. But as such it was representative of the overall decline of the city of Essaouira itself, which fell into a state of disrepair and neglect until the creation of the Gnawa and World Music Festival in 1998, which led to renovation by the national government and private investment in its infrastructure, including renovation of the Zawiya of Sidna Bilal.

Recent Renovations and Changing Definitions of the Shrine

Since the 1990s, the Zawiya of Sidna Bilal has been the focal point of converging but incompatible ideas about Gnawa culture and worship that center on issues of authenticity and Blackness. In 2007, the shrine's interior underwent renovation under the supervision of Abderrahmane Naciri, Hajja Latifa's husband. The shrine was retiled with brightly colored yellow, red, and patterned tiles, including costly patterned tiles on the lower halves of the walls. A fountain was added on one of the courtyard's walls and, notably, the shrine's graves were paved over and forgotten, becoming invisible (Plate 5). The erasure of the graves of men who had once been important members of Essaouira's Gnawa community was symptomatic both of increased commercialization and of the fact that the renovation was carried out by those without an ancestral connection to the early Black community. As Gnawa identity grew diffuse throughout Morocco and attracted followers with no connection to slavery, the shrine's renovation deemphasized a spiritual connection to the community's Black ancestors in favor of increased visual appeal to outsiders in preparation for inclusion in the Gnawa and World Music Festival. It was clear to me from my discussions with Naciri that he made decisions concerning the shrine's renovation without the consent of Essaouira's larger Gnawa community, and he told me that he financed the renovations himself.

The following year, Naciri created an official group, the Association Dar Gnaoui (Gnawa House Association), to manage the shrine and declared himself its president. Several men helped to manage the ceremonies held at the shrine, wearing specially designed shirts to distinguish them. These black T-shirts featured the name of the association in both French and Arabic, as well as the iconic musical instruments associated with Gnawa framed against a stereotypical Moroccan archway done in red and green, the colors of the Moroccan flag, signaling a connection between Gnawa and Morocco's national identity. Naciri discussed plans to add a music school and a museum to the shrine's second floor. In my discussions with him, he recounted that he envisioned the museum space filled with photographs of the great male musicians in Morocco, along

with their musical instruments, hats, and other items used by Gnawa throughout Morocco. Photographs of female diviners were not to be included in their museum; instead an exhibition explaining spirit possession in psychological terms would be mounted, presenting healing as folkloric heritage rather than a deeply experiential spiritual and physical practice. Naciri's ambition signaled a reorientation of the shrine from being a place of spirit possession and healing to being a secular-oriented Gnawa cultural center. Even the name Association Dar Gnaoui was resolutely secular, removing from the Zawiya of Sidna Bilal any religious reference and widening its appeal to tourists and others outside of the Gnawa community.

While many people in the Gnawa community appreciated the association's renovation of the shrine, which was in a severe state of disrepair, others complained to me that the majority of the association's members did not self-identify as Black or have ancestors who were enslaved. Other discontents followed on this: people with whom I spoke accused the Association Dar Gnaoui of pocketing money that had been donated to the shrine to help defray the cost of the annual ceremony or as an offering for healing. There is no proof of corruption and theft, and clearly Naciri spent a great deal of money on the shrine's renovation, but such rumors indicate an attempt at resistance. The most deeply felt objection to the shrine was articulated to me by Zaida Gania: "They [the association] want to make a school. Did my brother learn from a school? We learned from our blood." Zaida's comments are representative of how many Gnawa conceptualize their identity as rooted in blood and bones, family relationships and ancestry. In short, they did not share the goals of the association, which reflects a sense of group identity shaped by contemporary social discourses and emphasizes Gnawa as a style of music and entertainment rather than a form of sacred religiosity centered on spirit possession.

I attended numerous ceremonies organized by the Association Dar Gnaoui. In 2009, as in most years, they organized a multiday series of events that culminated with an all-night *lila* ceremony at the shrine. Leading up to the *lila* are processions modeled on those organized to honor the memory of saints at Sufi shrines, typically on the anniversary of the saint's death. One of the most prestigious annual Sufi processions in Morocco, which I witnessed, occurs in Fes, as hundreds of people march from the royal palace to the shrine of Mulay Idris al-Azhar, a descendant of the Prophet and the founder and patron saint of Fes. This procession includes various Sufi groups led primarily by men who sway in rows while chanting invocations, blowing horns, and beating drums and tambourines. Male devotees carry large braziers filled with smoking incense on their heads and brightly colored banners, driving animals through the streets to be sacrificed at the threshold of the shrine. Upon arrival, a new, richly embroidered cloth replaces the old one hung over the tomb (Kugle 2007, 52).

The 2010 procession organized by the Zawiya of Sidna Bilal was similar in many ways to the Fes procession, including being exceedingly large, swollen with stragglers

and spectators picked up along the way (Figure 5.7). At its head, a group of flag bearers led a large black cow that had been covered with bright swaths of cloth draped over its back in colors corresponding to the different spirit families that would be evoked during the possession ceremony itself. Members of the Association Dar Gnaoui wore their matching T-shirts and tried to keep the procession moving at a steady pace, maintaining order as they waved away the adolescents or drunken men who tried to join the procession.

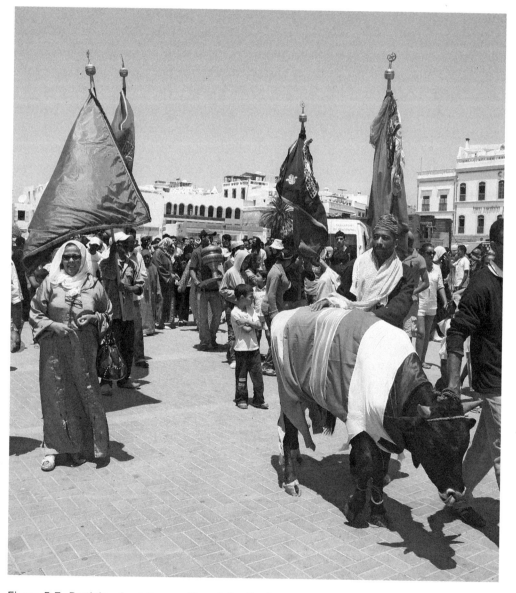

Figure 5.7. Participants at the sacrifice at the Zawiya of Sidna Bilal process through the streets of Essaouira. Photograph by the author, 2010.

Keeping the rhythm and providing entertainment were a few Gnawa drummers playing barrel drums, *tbul*, accompanied by young men playing iron cymbals. When they occasionally stopped, the crowd taking photographs with their cell phones surged around the group as male Gnawa cymbal-players made a straight line, dancing forward to approach the drummers. One by one dancers left the line and danced in front of the drummers, spinning in a circle, jumping in the air, and bowing down in front of them to show respect, as drummers are usually more established, elder musicians. The crowd rewarded those who did particularly high jumps and splits with shouts, ululations, and applause, much as they would at a staged musical performance.

Unlike male-led Sufi processions, women dominate Gnawa processions. In fact, the *mqaddema* typically leads it. Women also carried incense braziers, a tray with dates, or a large bowl filled with milk that they sprinkled at Sufi shrines along the procession's route. This gesture not only pays homage to various Sufi saints, but also indicates the influence of Moroccan Sufism on Gnawa practices. When the group arrived at the Zawiya of Sidna Bilal, Hajja Latifa welcomed all who entered with sprinkles of orange-blossom water, a gesture that publicly distinguishes her as the host of the ceremony and further demonstrates the predominance of women, rather than men, during Gnawa ceremonial occasions. A festive and joyous outburst occurred with men and women making a circle around the drummers, singing and clapping. The *qraqebi* danced, one by one, in front of Abdellah Gania, the *m'allem* of the *lila* and seen on the right of Figure 5.8. Mbarka, the Black female healer discussed earlier, toiled silently in the shrine far from public scrutiny.

It is notable that in 2010, the Association Dar Gnaoui invited a local Sufi group to join the procession and animal sacrifice that followed. Many men who perform Gnawa music do not have a history of ancestral slavery, and some of these men are also members of Sufi orders. Despite this, some told me that they felt that the incorporation of male Sufi adepts diluted the authenticity of the Gnawa ceremony and relegated its primary connection to spirit possession to invisibility. Such comments reinforce a perceived dichotomy between Sufi practices as Arab and Gnawa as those derived from West Africa. Together with the renovation, people felt that this incorporation of male Sufi adepts contributed to the perceived Arabization of the shrine. In other words, people worried that the elements that rendered Gnawa ceremonies authentic and distinguished them from Moroccan Sufism were slowly being diluted. Furthermore, that year television cameras were invited to film the procession, and local officials attended the animal sacrifice that followed. All was reported on by the press and featured on a report about the shrine's annual *lila* on the local television. In fact, I was told by those in the shrine that the reporters wanted to interview me, one of the only foreigners present at the event, but I was relieved when their plans changed. Regardless, numerous people were documenting the event, using everything from video cameras to cell phones.

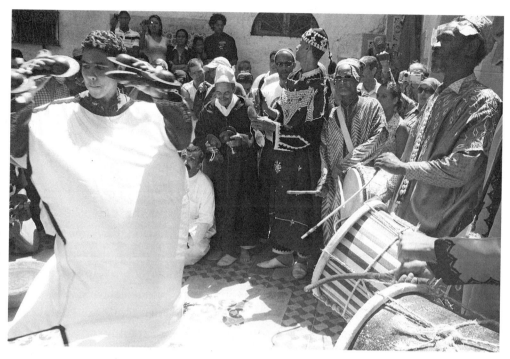

Figure 5.8. The Zawiya of Sidna Bilal before the animal sacrifice. A *qraqebi* dances in front of three drummers, including M'allem Abdellah Gania and Hamza Sudani. Photograph by the author, 2010.

A few years later many things had changed at the shrine. Mbarka had passed away, leaving the shrine devoid of a Black female healer. Hajja Latifa was no longer the *mqaddema*, the Association Dar Gnaoui had been disbanded, and Zaida Gania, a Gnawa woman who self-identifies as Black and is from a family of hereditary Gnawa practitioners, had taken over as the female leader of the shrine. Zaida took on the roles of both Hajja Latifa and Mbarka, serving as both the shrine's public *mqaddema* and its primary healer. I heard many conflicting reports of the actual events that led to Hajja Latifa's abdication, including one that accused her brother of usurping power from her. What is certain is that she refused to enter the Zawiya of Sidna Bilal again. In 2013, Hajja Latifa invited me to a private Gnawa possession ceremony held in her home for invited guests, and as of 2017, she continued to hold similar private ceremonies in her private home near the shrine. Although she does not go into a state of possession at her private ceremonies, they are meant to proclaim her continued devotion to Gnawa practices, and she still feels that she is the shrine's rightful heir.

Clearly, critics of the Association Dar Gnaoui had won the day and returned the shrine to the people they considered to be authentic Gnawa in the city of Essaouira—specifically, members of the Gania and the Sudani families, whose ancestors were enslaved from West Africa. For example, Najib Sudani traces his descent from a paternal

grandfather who was enslaved from a village called Chnafou, which he identifies as a village in "the Sudan," meaning West Africa—hence the origin of his family name. On his paternal grandmother's side, he traces his roots to Bamako, Mali. His personal connection to the history of slavery in Africa south of the Sahara, together with the fact that his late father, M`allem Gubani, was a renowned Gnawa musician in Essaouira, authenticates him as a Gnawa musician and thus worthy of inclusion. This history is selective and curated in that it ignores the fact that Sudani's grandparents married people without enslaved ancestry; they intentionally downplay the family's Arab-Amazigh heritage in favor of their West African origins.

In contrast, M`allem Omar Hayat, who grew up listening to and eventually playing Gnawa music in Essaouira, explained to me that since he was neither the son of a Gnawa *m`allem* nor the descendant of enslaved ancestors, he had to work hard to prove himself as a Gnawa musician. He began to host his own *lila*s at a local shrine called Dar Dmana. For one week each year he hosted a short *lila* each afternoon, culminating in an all-night ceremony on the final day, fending for himself rather than playing in the city's communal shrine. His experience, as well as the removal of Hajja Latifa from the shrine, illustrates how many continue to conceive of Gnawa as an ancestral rather than a learned or acquired tradition, despite the increased involvement of those without slave ancestry. In fact, Hajja Latifa hired M`allem Omar Hayat to play at the private *lila* she organized in her home after her removal as head of the shrine.

When I attended a *lila* at the Zawiya of Sidna Bilal in 2013, women from the Sudani and Gania families dominated the procession, deploying their claims as possessors of *tagnawit* to take control of the shrine. Interestingly, both the Gania and Sudani families claim descent from locally famous male musicians who were married to female healers but, in reality, only represent the third generation of Gnawa practitioners, meaning that their families' involvement in Gnawa ceremonies goes back about one hundred years, further illustrating my claim that the solidification and codification of "Gnawa" as an identity connected to enslavement dates only to the late nineteenth century.

During the ceremony itself, a metal barricade had been set up to separate the women's area from that of the men in an attempt to restore order in the shrine since, in previous years, young men and women had been accused of using the ceremonies as a venue for flirting and talking. They wanted to make the shrine into a pious and referential space, since Gnawa practitioners do not see their ceremonies as existing outside of Islam. The division of men and women also signaled a return to what was perceived as Gnawa tradition, before its corruption by outsiders. Gone were the huge jostling and shoving crowds that made previous ceremonies so theatrical and chaotic. The barricades were meant to bring the same kind of order that Zaida Gania demanded in her own private ceremonies to the public shrine. For the first time, the number of people allowed into the area was limited once the space was deemed filled to capacity.

In addition to segregating the crowd by gender, Gania and Sudani family members served as supervisors, watching the crowd for rowdy and disrespectful behavior, which included attempts to photograph or film the possession ceremony. Malika, the wife of musician Mahmoud Gania and a *mqaddema*, announced at the beginning of the ceremony that cameras were strictly forbidden, despite the fact that a man from the Sudani family filmed the entire ceremony perched in a small window overlooking the courtyard from the second floor, and since his family, along with the Gania family, saw themselves as controlling the shrine, we assume he did not ask anyone's permission. Nor did he inform the crowd. The general rejection of photography by the *lila* organizers signaled an attempt to retain the rights to images generated by the *lila* and to prevent outsiders from profiting from the sale of photographs or film. The presence of a donation box closed with a padlock in the women's area of the shrine indicated that both families took pragmatic attitudes when it came to profiting from the popularity of "their" culture. They wanted to make certain that the money was used for the shrine and not used by a single family for personal profit.

During that year's *lila*, Zaida Gania did not go into possession. This was largely due to the fact that her brother M`allem Abdellah Gania had passed away that year, and she considered it unseemly to go into a possessed state while in mourning. However, while I sat on the ground watching the musicians, I observed Abdellah's daughter approach a possessed woman with a brazier filled with smoking incense, helping her adjust her headscarf, and make sure the woman had what she needed to please her possessing spirit. Indeed, other members of this fourth generation of Gania women not only fell into possession themselves but assisted other possessed women the entire night. In other words, as Zaida looked on, the next generation of Gania women were in the process of becoming Gnawa diviners in their own right. The Gania and Sudani families had proclaimed themselves, and were recognized by the community, as authentic Gnawa—worthy of controlling the shrine and confidant that they could restore it to its previous sacred status as a space dominated by those whose families had a connection to the history of enslavement and Blackness.

PERFORMING AFRICAN HERITAGE ON THE FESTIVAL STAGE

While the right to perform Gnawa ceremonies is frequently linked to claims of ancestry and blood (i.e., Blackness and enslavement), as in the cases of the Gania and Sudani families, attendance at such ceremonies has never been confined exclusively to the Gnawa community. And as we have noted heretofore, many who self-identify as Gnawa and perform Gnawa music do not have a history in slavery. In fact, the *lila* has always attracted non-Gnawa, and over the last decade, increasingly, the Moroccan elite. However, such broad appeal has not always been the case. The early twentieth-century ethnographer

L. Mercier, for example, described Gnawa ceremonies as attended by "nearly all blacks and includ[ing] only people of low birth and slaves" (1906, 125). During this period the Moroccan elite, as well as the French, viewed those who participated in *lila* as occupying the lowest level in Morocco's social hierarchy with the exception of enslaved women who brought their female "owners" with them.

According to M`allem Omar Hayat, who was born in 1959, "If you carried the *guinbri* you hid it from people because people viewed Gnawa negatively. They did not value them. When people came to *lilas*, they would only give Gnawa a cone of sugar."[8] Throughout much of the twentieth century, Gnawa music was negatively associated with superstition and paganism, and Gnawa musicians and healers were paid paltry sums, which they supplemented by working in the trades or else were consigned to poverty. Today only a few male musicians who perform Gnawa music support themselves through their music alone, making money performing at international and local concerts; despite the popularity of Gnawa music, most cannot earn a living from their musical performances and are forced to hold day jobs. For example, Najib Sudani, who comes from one of the two Gnawa families controlling the Zawiya of Sidna Bilal, is from one of the families considered to be authentic by locals. He supports himself by selling drums and other musical instruments at his shop in Essaouira (Plate 6). The money he earns performing possession ceremonies and concerts for both locals and foreigners is likely not sufficient for him to support his family. His shop also serves as a gathering spot for many Gnawa musicians, who may informally play music there.

The stigma associated with attending Gnawa ceremonies began to weaken in the 1970s when popular Moroccan musical groups increasingly incorporated Gnawa music into their repertoire, but the majority of Gnawa musicians did not profit from the music's popularity. Groups such as Nass El Ghiwane, musicians who were also political activists, emerged during the "Years of Lead," when thousands of Islamists, Amazigh activists, and others who dared to criticize King Hassan II (ruled 1961–99) were arrested and kept in secret prisons under inhumane conditions. Nass El Ghiwane adopted Gnawa instruments to create a form of protest music that resonated with Morocco's lower classes and provided a counterpart to the state-imposed emphasis on Arab-Andalusian high culture, solidifying an association between Gnawa subculture and social and economic disenfranchisement while, at the same time, exposing the general public to Gnawa music (Aidi 2014, 151; El Hamel 2013, 295). From that beginning, Gnawa music increasingly infiltrated mainstream Moroccan culture, especially with the infusion of global interest in world music. In the last decade, as Morocco has become more tolerant and inclusive, recognizing human rights and ideas of diversity, hereditary Gnawa musicians complain that they have been reduced to a counterculture brand. They decry cultural appropriation and the failure of authentic Gnawa, who learned music from their familial connections rather than apprenticeships, to profit from the popularity of their music.

The Gnawa and World Music Festival has become increasingly popular among young Moroccans as a venue for self-expression; Gnawa music has become *en vogue* among Morocco's upper and middle classes. Local people, as well as the Moroccan government, turned to local expressions of culture to counter the negative image of the Middle East that followed the terrorist attacks of September 11, 2001, to essentially delineate Morocco from the culpable Middle East. As noted by Ziad Bentahar, the Moroccan identification with the Middle East and the Arab world, as well as its massive consumption of cultural products, including music, from the region during the 1980s and 1990s, became worrisome for a monarchy fearful of Islamic extremism (2010, 45). As a new generation of musicians arose, as the Ministry of Tourism created more music festivals, and as the Internet became more accessible, the monarch was provided with a means to shift his country's focus from the Middle East to Africa south of the Sahara.

Over the years, the Gnawa and World Music Festival has increased in popularity and has become known as a site of tolerance and diversity. Moroccan police do not strictly monitor people's behavior. Accordingly young people camp on the beach, stay up to attend concerts that continue all night until sunrise, and often smoke hash, seeing Gnawa music as validating or sanctioning behavior outside of the constraints of conservative Islam. Gnawa musicians who perform at the festival emphasize and, indeed, exaggerate their African-ness to please these crowds, who look to these musicians to embody an alternative lifestyle and culture. M`allem Omar Hayat, for example, is known for performing at the festival wearing African-inspired attire. During a concert in 2006, he wore a striking bright red tunic over red pants, trimmed in leopard-skin print and long brown fur (Plate 7). He wore a similar outfit in green when he performed at the Gnawa and World Music Festival in 2019.

Since for Hayat and many Moroccans, the concept of "Africa" refers to the region south of the Sahara, his leopard-trimmed clothing invokes the stereotype of a wild, untamed Africa. However, in interviews it becomes clear that Hayat, a widely traveled and experienced performer, does not himself ascribe to such stereotypes but merely exploits them for theatrical effect. Moreover, although he does not have West African ancestry, he is fully cognizant of the distinction between the kind of music he performs at world music festivals and "real Gnawa music." When I asked him about his stage performances, he responded, "I am known for the spectacles that I do on stage but when I play a *lila*, I only play traditional music. I do not deviate from this. I do not play fusion music. The young men of today do not play real Gnawa music—they do not think about the Gnawa as art but only want to travel abroad and make money." Acknowledging the tension between theatricalized and authentic Gnawa music, he opts to segregate them for the sake of preserving the purity of the latter. But, as we will see, the notion of purity remains contested since Gnawa culture is innately hybrid and dynamic; its authenticity is constantly under construction. Despite his attempts to maintain the authenticity of Gnawa music, Hayat, who learned through apprenticeship rather than

lineage, would be considered inauthentic by those who associate Gnawa exclusively with
sub-Saharan African-ness.

Uled Bambara for the Stage

As discussed throughout this book, "the Gnawa" do not represent a homogeneous
ethnic group and, as the discussion of the shrine illustrates, what is authentically Gnawa
is under debate as Gnawa musicians and other practitioners deal with increased com-
mercialization of their music by perceived outsiders. Like Hayat, many musicians per-
forming at the Gnawa and World Music Festival include references to Africa south of
the Sahara in their performances and wear clothing designed to convey their connec-
tion to it in order to declare their authenticity. Of particular cultural resonance is the
performance of a variation of the *Uled Bambara* song discussed in chapter 3. In 2008, at
a midnight concert on a massive stage set up near the ocean, one of many such concerts
I have attended since 2001, the well-known musician M'allem Mahmoud Gania (some-
times written Guinéa, emphasizing his West African ancestry) performed a particularly
popular song building on the *Uled Bambara* musical repertoire performed during
Gnawa ceremonies. The thousands gathered to watch the performance began to sing
the song "Hat of the Bambara" along with Mahmoud Gania. While strumming a *guinbri*,
an instrument clearly derived from Sahelian African prototypes, he sang in his deep,
husky voice:

> *Sudani mama yo, Shashea d Bambara*
> [Sudani *mama yo*, Hat of the Bambara]

Repeating these lines was a chorus of ten men, most wearing just such hats as are re-
ferred to in the song as *Shashea d Bambara* or "hat of the Bambara" (Figure 5.9). Gania
used the word "Bambara" to describe these hats. Repetition of the word "Bambara"
in Gnawa songs reinforces a popular version of the Gnawa origin story, namely their
descent from enslaved Black people captured during the 1591 victory of the Moroccan
monarch Ahmad al-Mansur (ruled 1578–1603) when he conquered the Songhai Empire
and the famed city of Timbuktu in contemporary Mali—a story that assigns a Bambara
ancestry to contemporary Gnawa. To refer to Gnawa as Bambara is to emphasize the
association of Gnawa with Blackness and the history of enslavement.

Gnawa songs refer to their diverse Sahelian origins, and Gania's call-and-response
song included references to various groups within West Africa.

> Fi souk tba' ya yo
> [In the market sold]
> Shashea d Bambara
> [Hat of the Bambara]

Bambrawi mama yo

 Shashea d Bambara

 [Hat of the Bambara]

Hausawi mama yo

 Shashea d Bambara

 [Hat of the Bambara]

Fulani mama yo

 Shashea d Bambara

 [Hat of the Bambara]

Historically, categories such as "Hausa" and "Bambara," like the word "Gnawa," never represented homogeneous ethnic groups. The word "Hausa," for example, refers to a widespread sociocultural group formed from various kingdoms united by a common language. Due to a Fulani jihad in the early nineteenth century, people constructed a unified Hausa–Fulani identity linked to Islam that extended across northern Nigeria.

Given the dozens of ethnic groups from which West Africans were enslaved, the repetition of these names suggests the phenomenon by which ethnic categories are collapsed over time by the loss of collective memory. However, it is useful to recall Frantz Fanon's observation, in his book *Black Skin, White Masks*, that Black men are often seen by the hegemonic power, which he defines as white, as having no culture, no civilization, and no long historical past (1967, 17). Interpreted through the lens of Fanon, the repetition in Mahmoud Gania's song of the names of various Sahelian African groups

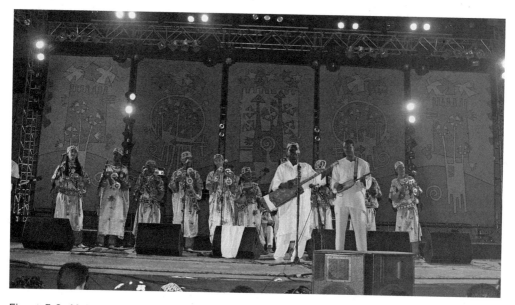

Figure 5.9. Mahmoud Gania performs a fusion concert with Malian musician Bassekou Kouyaté. Photograph by the author, 2008.

can be understood as an act of incantation, an attempt to invoke into presence a history and culture for the enslaved and their descendants, to remind them that they are not culturally rootless and motherless.

In addition to the lyrics, the performative aspects of this song assert a Black, West African heritage for Gnawa that recognizes the history of slavery, but at the same time, locates them as coming from specific West African ethnic groups. In the course of the performance, the chorus of men led the audience in a quick staccato clap to complement the solo Mahmoud Gania performed on his *guinbri*. The string of multicolored pendants hanging from his instrument's neck swayed back and forth as Gania leaned back, closed his eyes, and played furiously. These pendants perform both aesthetic and spiritual functions: they are believed to be religiously efficacious as they represent petitions made by women who tie beads or cowrie shells to the *guinbri*, requesting spirits evoked by the instrument to heal them from various illnesses. The performance demonstrated to the audience Gania's status as an authentic Gnawa musician with the power to distribute *baraka*. Meanwhile, a series of colored lights flashed on top of a multicolored stage backdrop covered with geometric, symmetrical patterns vaguely reminiscent of masks from West Africa, creating an intentional connection to stereotypical artistic forms from south of the Sahara.

In the course of transcribing and translating the song's lyrics, I was stumped by the repeated words *mama yo* and decided not to translate them here. The several Moroccans I enlisted for assistance found the words equally unintelligible. Mahmoud Gania's brother Mokhtar himself later told me that it was a "Sudani" word meaning "are coming." At the same time, the Tamazight words *mama inu* and *mama yinu* mean "my mother," and perhaps *mama yo* derives from one of these terms. Most importantly, the term *mama yo* is incomprehensible to the general Moroccan public to whom it would only communicate "Sudani" (i.e., not Arabic, other).

It became clear that the many untranslatable words in Gnawa songs perform an important function in demarcating a boundary between, in the words of philosopher and cultural theorist Kwame Anthony Appiah, "those outside and those within." Appiah has pointed out the importance of secrecy in maintaining social boundaries, as "it is the power of secrets both to bind together those who share them and to keep others out that makes them such a crucial locus of social power" (1993, 16). Gnawa practitioners use and protect their power over the spirit realm, a power that is based on their access to and control over secret knowledge, including words that only they can understand, to enhance their social status as healers.

It is hence no accident then that scholars, including myself, have faced insurmountable barriers in translating Gnawa songs. In fact, Deborah Kapchan, a scholar fluent in Moroccan Arabic, wrote about the frustration that she faced when, after recording various ceremonies, her attempts at transcription and translation proved unsuccessful

(2007, 223). While I had the advantage of many hours spent working under the patient guidance of Mokhtar Gania and his daughter Sana in translating and transcribing Gnawa songs, I still ran into various linguistic anomalies and cul de sacs. I found that many "Sudani" words have no equivalent in any sub-Saharan language, and indeed, Mokhtar revealed that the entire song was constructed for stage performance by borrowing and merging phrases from various songs performed during the *fraja* portion of a *lila*. In an interesting case of reverse transmission or a cultural feedback loop, since Gania first began performing this song in concert in the early 1990s, it has become so popular that I have witnessed some musicians performing a version of it as part of the *fraja* repertoire preceding the spirit possession. A tragic loss to Gnawa music occurred when Mahmoud Gania passed away in 2015, but his songs not only continue to be popular on the festival stage but have been absorbed back into the sacred tradition from which their original inspiration came and are now accepted as canonical.

While many both within and outside the Gnawa community conceive of ceremonial songs as originating in Africa south of the Sahara and remaining untouched for generations, the reality is that Gnawa musicians serve as cultural producers who are continually creating new forms of authentic Gnawa culture, engaging in self-marketing through the fetishization of Blackness and, at the same time, trying to protect their culture from appropriation by perceived outsiders. The particular feedback loop involving the *Uled Bambara* song is a clear illustration of this book's thesis that Gnawa culture is dynamic, self-renewing, and under constant construction.

In today's Morocco, the Gnawa and World Music Festival sometimes features joint concerts of Gnawa and West African musicians intended to reinforce and underscore the historical connection between Gnawa and Africa south of the Sahara. For example, at the concert described earlier, after Mahmoud Gania completed his set, he performed a fusion concert with the Malian musician Bassekou Kouyaté. Gania's dark complexion, his family name, and all the elements of his music and stage presence (the lyrics, rhythms, dance, instruments, and headdresses) were carefully fashioned to assert his identity as a Black African of enslaved descent. While in the past both Blackness and enslavement were stigmatized, today the same characteristics have become a source of empowerment due to their connotation of authenticity. Gania's performance was held on a massive stage constructed in front of Essaouira's seventeenth-century city walls and amid the bright lights and high-tech speakers associated with twenty-first-century music concerts, bringing the past into the present and connecting the local to the global. As we have noted earlier, music festivals such as this serve multiple purposes for the Moroccan government as well, advertising the country's tolerance and openness and, as Aomar Boum has written, blunting "the force of social movements" by appeasing potential youth unrest, given Morocco's high unemployment and lack of economic opportunities (2012a, 25). Moreover, the festival is designed to make Morocco look good to those

beyond Morocco's own borders by creating the image of a fun-loving society geared toward consumption and tourism.

Blackness has become a source of cultural self-empowerment and pride despite the association of Blackness with the history of slavery and associated marginal status. In the instances we have cited in this chapter—the song created by Gania as a staged performance piece and the struggle over control of the Zawiya of Sidna Bilal—we see how the increased commoditization and festivalization of culture can actually serve as an impetus for ongoing artistic creation rather than result in its decline.

6

The Gnawa *Guinbri*

From Concealment to Exhibition

ABDESLAM ALIKANE is now an accomplished Gnawa musician, but his career got off to an inauspicious start when he began performing on the *guinbri* in the 1980s. He recounted to me the taboo surrounding Gnawa music at the time: "My family did not like my playing Gnawa music at first because they were scared of spirit possession and because Gnawa music was known as the music of the poor. Gnawa had a bad reputation, and those who played the *guinbri* would hide it under their *jellaba* [tunic] so no one would see them." Alikane recalled a period when Gnawa music was regarded by the majority of Moroccans as the province of marginalized and low-status outsiders, such as enslaved people and their descendants. Moreover, because Gnawa music was associated with spirit possession and thus with heterodoxy, it was relegated to the fringes, or beyond, of acceptable Islamic practice. Alikane explained how an instrument associated with Gnawa, the *guinbri*, consequently held marginal status: "The first *guinbri* I had, I made for myself. I had a hard time finding a carpenter to make one for me. They were afraid to make it because people were scared of Gnawa spirits and the instrument was sacred." Alikane is Amazigh and does not self-identify as Sudani (i.e., Black), and he did not learn the *guinbri* from his male relatives. Because of the taboo status of the instrument, he was obliged to learn on his own and ultimately make his own instrument (Figure 6.1).

Given its sub-Saharan African origins, the *guinbri* can serve as a case study in how Morocco has understood and reconfigured its relationship with Blackness and to the rest of the African continent over the years. The *guinbri*, fashioned by hand from skin and wood, derives from Sahelian African prototypes. It falls to the *guinbri* player to accompany and perform the lead vocals in the call-and-response songs that evoke the spirits and thus allow possession to occur in Gnawa ceremonies. Because of the instrument's key role, men who play the *guinbri* occupy the highest rank among Gnawa musicians. Most begin by first playing metal cymbals called *qraqeb*, and then the large barrel drum, before tackling the

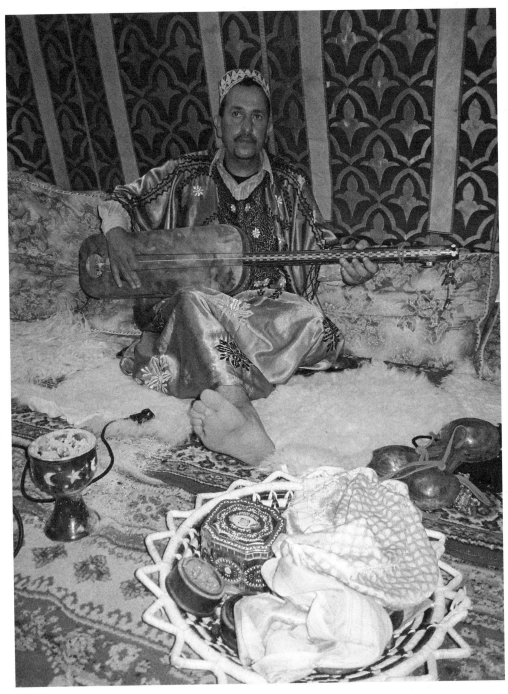

Figure 6.1. M`allem Abdeslam Alikane posed with his *guinbri* after performing a *lila* in Agadir. Photograph by the author, 2009.

guinbri. Years of apprenticeship are necessary to learn the more than one hundred songs that constitute the spirit-possession repertoire. Those who master it earn the title *m'allem*, meaning "master," a term typically applied to a man who has mastered a particular skill, such as carpentry or masonry, but in this case applied to a man who has memorized how to sing spirit songs and play the entire spirit-possession repertoire on the *guinbri*.

Until recently, a *m'allem* crafted his own instrument, but today *guinbri*s can be purchased ready-made in the market. In the past, a *guinbri* player specialized in songs for a spirit-possession ceremony, but since Gnawa music has become extremely popular in the last two decades within Morocco, some *guinbri* players have never attended, much less played at, a spirit-possession ceremony. Rather, they learn isolated songs from the spirit-possession repertoire, often from the Internet, recording them and playing them in professional venues. In short, what it means to perform on the *guinbri* has profoundly changed. The term *m'allem* has evolved, or devolved, to the point that it now denotes a maestro or virtuoso—in other words, a professional musician rather than someone who has learned an esoteric and spiritually charged craft.

Gnawa material culture has always been a dynamic hybrid, constantly responding to new circumstances and defying easy categorization as West and/or North African. Writing about rhythm and blues music in the United States, the scholar Brian Ward describes African American music as continuously dynamic, "reinventing itself in the context of multiple overlapping influences and needs" (1998, 11). Likewise, Gnawa music and the *guinbri*, its most significant instrument, readily adapt themselves to changing social and economic power structures. As it was originally the instrument of enslaved people, it long carried an association with disenfranchisement and marginality that readily transferred to political protest and the counterculture in the 1970s. Since the 1990s, the *guinbri* has developed into an empowering icon of a global awareness that allows musicians in Morocco to connect themselves to the larger world music community and express a transnational hybrid identity. The descendants of enslaved people from rural Morocco have begun to utilize the *guinbri* as a means of economic and racial empowerment. As Morocco's citizens migrated to Europe and beyond, the prominence and significance of the *guinbri* has also changed. The London-based Moroccan artist Hassan Hajjaj, for example, includes a *guinbri* player in his multimedia projects exploring the African diaspora, linking the Gnawa *m'allem* to other African and Afro-Caribbean musicians and, in so doing, purposefully linking Morocco to the African continent, rather than to the Middle East. As we shall see, the *guinbri* has undergone significant shifts in meaning as its function in and outside of Gnawa culture has been reinvented.

THE CHANGING APPEAL OF THE GNAWA *GUINBRI*

The *guinbri* is so inseparably entwined with Gnawa identity that as we trace the changing cultural significance of the instrument over the last century, we are simultaneously

observing the evolution of what it means to be Gnawa. Gnawa identity has been inti-
mately linked to this instrument since at least the late eighteenth century, when Georg
Hjersing Høst recorded the first known mention of a word resembling "Gnawa" in 1798.
He used the term to describe his sketch of a "getára genáua" or "Gnawa guitar," which,
he noted, was played by Black men in Morocco. Thanks to Høst's sketch of the instru-
ment, we know that it resembled the *guinbri* played by Gnawa today (Figure 6.2).

Høst's use of the word *genáua* is one of the earliest references to a word similar to
"Gnawa." He also used the Danish word *Negerne* (or "Negro") as an identity marker to
refer to the people who played the instrument. He specifically wrote that *Negerne* were
brought by caravans from Guinea as enslaved people.[1] More than forty years later, a
Berber–French language dictionary from 1844 does the same, using the word *ghanawé*
to describe a guitar with three strings from Guinea played by Black men (Venture de
Paradis 1844, 83). As these examples demonstrate, the *guinbri* served as a synecdoche
for Gnawa identity even before that identity had been recognized or codified.

During the colonial period, French photographers and writers took an interest in
Black musicians as exemplars of the "exotic." This foreign interest, together with the
decline of the hierarchical social structure that supported Moroccan slavery, ultimately
encouraged Black musicians to codify their identities as "Gnawa." During this same
period, colonial policy promoted "Berbers" and popular Sufi groups, with whom Gnawa
shared many practices, as indigenous and authentic to Morocco as opposed to Arabs,
whom they represented as alien invaders. For example, Eugène Guernier, former profes-
sor of political science at the University of Paris, wrote that Arabs, whose strength came
from their centralized military organization, never emerged from feudalism, making it
impossible for them to adapt to Western life and fully accept French rule. Berbers, on
the other hand, who lived in mountain villages and followed rational and democratic
ancestral customs derived from ancient Rome, were more open-minded and closer bio-
logically and socially to Europeans. Guernier wrote that Berbers would be more likely
than Arabs to embrace Western democratic ideologies and eventually be absorbed into
French society (1950, 353–54).

There was a geopolitical motive behind this favoritism: France sought to vilify
Salafi and Arab nationalists because their more puritanical form of Islam and solidarity
with the wider Arab-Muslim world and the Middle East posed a threat to French rule.
France supported populations presumed to be more "open-minded," that is, more
accepting of French colonial dominance (Aidi 2014, 149). However, despite French offi-
cials' promotion of popular forms of Sufism as authentically "Moroccan," many Moroc-
can nationalists, as previously noted, looked down upon such practices as backward
and superstitious, and as such an impediment to Morocco's claims to independence
(Aidi 2014, x, 30). During the postcolonial period, the Moroccan ruling elite, largely
Arab nationalists, continued to marginalize Gnawa music, viewing its connection to
spirit possession as lowbrow and culturally embarrassing. In its stead, they promoted

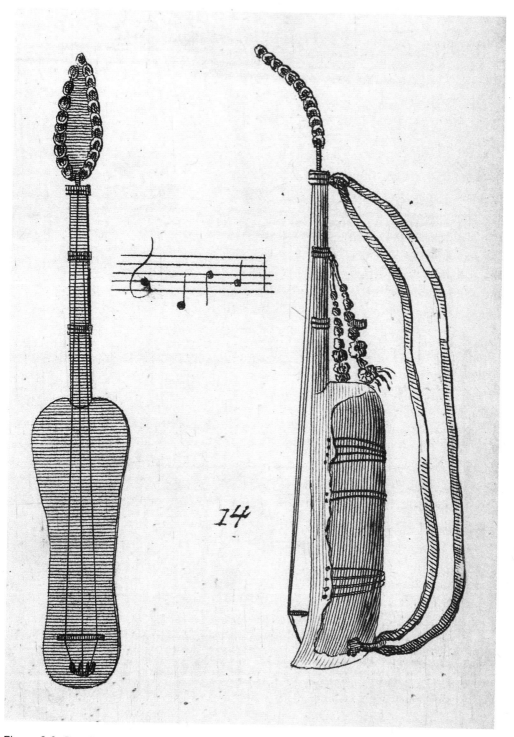

Figure 6.2. Drawing of a *guinbri*. Reproduced from Georg Hjersing Høst, *Efterretninger om Marokos og Fes: Samlede der i Landene fra ao. 1760 till 1768* (Kiøbenhavn: N. Müller, 1779). Melville J. Herskovits Library of African Studies, Northwestern University. Photograph by Clare Britt.

Andalusian music as the nation's favored musical form, relegating Amazigh culture, Sufism, and the Gnawa subculture to secondary and inferior status relative to the nation's Arab–Middle Eastern identity.

During this period, the *guinbri*, played by descendants of the enslaved, served as a social resource or as "cultural capital" in the sense described by Bourdieu (1977), both signaling and creating a sense of collective identity. Gnawa men played the *guinbri* accompanied by *qraqeb* (metal cymbals) in ceremonial contexts, using its repetitive rhythms and melodic tunes to induce spirits to possess humans and, in the process, facilitate healing. But, as Bourdieu notes, some forms of cultural capital are more valuable than others; the cultural capital of an individual or collective can either help or hinder social mobility. Europeans were intrigued by the colorful Black musicians who played on the street for money, but they dismissed them as examples of colorful folklore and as figures of amusement and entertainment, a type of "clown of the street" (Brunel 1955, 238). Europeans rarely, if ever, saw them performing their own cultural ceremonies; their ritual music was decontextualized as busking. The fact that Gnawa musicians presented theatricalized versions of themselves to the camera and often played to European stereotypes of Blackness only solidified their status as other.

In the 1970s, however, the counterculture musical group Nass El Ghiwane adopted the *guinbri* to create a form of protest music that resonated with Morocco's youth culture and provided an alternative to the state-imposed emphasis on Arab-Andalusian high culture. Because of its association with sub-Saharan Africa, the *guinbri* challenged Arab nationalist discourse and became a symbol of Moroccan hybridity. Gnawa music found its place on the world music scene when international jazz musicians such as Randy Weston, Pharoah Sanders, and Archie Shepp collaborated and recorded with Gnawa musicians. Its influence has since spread further, to popular Western musicians such as Robert Plant and Peter Gabriel, and in particular to a wide range of African American musicians, who recognize in Gnawa music a shared diasporic experience (Aidi 2014, 121–22, 134, 137, 157).

Interest in the Gnawa *guinbri* increased in the late 1990s, with the end of the nation's politically oppressive "Years of Lead," as the Moroccan government began opening up politically. It was in this progressive atmosphere that prominent businessmen, politicians, writers, and intellectuals from Essaouira and beyond, including the Moroccan king's advisor André Azoulay, created the Gnawa and World Music Festival in 1998 (Majdouli 2007, 76–81). In an interview with me in 2011, Azoulay noted that even as late as the 1990s, Gnawa were still stigmatized.

> From the first time I spoke about holding such a festival, people said that I was crazy to hold a festival with slaves—with blacks, with the poor, people who had been completely marginalized, who were pushed aside. We [Moroccans] had to reconcile ourselves with this part of our history. We were born among these people and grew up among them. It

was the moment when we gave them decency and the possibility to explain who they are without being a clone of us.

Gradual acceptance encouraged Moroccan musicians, such as Alikane, whose Amazigh grandfather had enslaved people, to take Gnawa music out of the ceremonial context in which it had been historically embedded and to expand its currency beyond the association with Blackness and slavery. He learned to play the *guinbri*, eventually becoming a successful recording artist, and performed with his group Tyour Gnaoua on the world music scene, even traveling throughout Europe and Africa with the Congolese musician Ray Lema. Ultimately, Alikane became artistic director of the Gnawa and World Music Festival, where the *guinbri* completed its metamorphosis from taboo to an icon of Moroccan national identity.

The role played by the Gnawa and World Music Festival in the diffusion and rebranding of Gnawa music cannot be overstated. The festival now attracts as many as four hundred thousand locals and foreigners to Essaouira each year, revealing how Gnawa music has become one of the most popular forms of world music in Europe. International musicians, such as Amazigh Kateb, the France-based Algerian musician, and Simo Lagnawi, the self-described Gnawa-Berber musician based in London, have embraced the Gnawa *guinbri*. Upper-class Moroccans now hire Gnawa musicians to play at their social gatherings. Under the influence of Western tastes, the attitudes among the local elites have altered (Aidi 2014, 122–23), and the Gnawa *guinbri* has gone from stigmatized to chic.

Even in the midst of widespread popularity, though, there are some who continue to view the *guinbri* with scorn, associating it with heterodox religious beliefs and anti-Islamic behavior. Public concert performances of Gnawa music are linked to such "outrageous" behavior as adolescent Moroccan girls throwing off their headscarves and swinging their long hair while dancing, and young Moroccan men smoking hashish, camping on the beach, and walking hand in hand with their girlfriends. Religiously conservative Moroccans naturally see Gnawa music as encouraging such illicit behaviors, just as an older generation in the West saw rock and roll music of the 1950s and 1960s as corrupting youth.

For a Moroccan government wary of Islamic extremism, the *guinbri* functions as a peaceful weapon against radicalism. In my 2011 discussion with him, André Azoulay told me that the message of the Gnawa and World Music Festival is one of tolerance:

I see Morocco as an African country. Even if people do not understand that the dominance of Arabs is recent, African roots are very strong. There is a long history of Islam, but Jews were here 1,200 years before Islam. The goals of the festival are to make a connection to sub-Saharan Africa and the diaspora, such as Brazil. Gnawa music is the most universal of all music.[2]

Thus the Gnawa *guinbri* and its performance culture represent inclusion, a counter to Islamism, and an expression of Morocco's African history. Gnawa *guinbri* players have been increasingly integrated into the Moroccan national consciousness and the international music scene as a symbol of hybridity and proof that Morocco is a tolerant and diverse society.

HISTORICIZING THE *GUINBRI* MUSICIAN

The ethnomusicologist Timothy Fuson provides one of the best descriptions of the Gnawa *guinbri* as a

> 3-stringed long-necked lute with a skin stretched over the open face of its rectangular body. The long cylindrical neck transfixes the body of the instrument under the skin and emerges again at a sound hold near the bottom of the body, where it tapers into a three-pronged fork. The strings are attached to this fork, pass over a wooden bridge, and are tied to the top end of the neck with leather strips. A metal plate with small rings, called a *sersara*, is typically attached to the top of the neck. (2009, 8)

The player plucks the strings and strikes the skin so that it is also percussive, producing a deep bass sound, augmented by the rattling noise of the metal *sersara*, which shakes as the instrument is played (Figure 6.3). It is these sounds, in combination with singing and the repetitive rhythms of the iron cymbals that accompany the *guinbri*, that induce spirit possession.

The Gnawa *guinbri* is also known in Morocco as the *guimbri, gimbri, hajhouj, hajuj*, or the *sentir*. The term *guinbri* is used in Morocco to refer generically to skin-covered lutes across Morocco; according to ethnomusicologists, the instrument played by urban Gnawa is the only one with a rectangular body while other Amazigh and Arab musical traditions feature a more rounded or teardrop-shaped body (Fuson 2009, 9). The questions of how much the form and use of the *guinbri* developed once the instrument arrived in Morocco and to what extent it was influenced by Amazigh and Arab instruments are rarely considered, since most scholarly inquiries stop at the instrument's Sahelian origin and do not contemplate its more recent evolution.

A Sahelian African Connection

While the exact origin of the *guinbri* remains contested, most scholars assume that the instrument originated in Africa south of the Sahara and was re-created by the enslaved once they arrived in Morocco (Charry 2000, 130). According to Charry, the word *guinbri* may have a sub-Saharan etymology, deriving from the word *gambara*, the name given to the Soninke lute, which may in turn derive from the instrument that the fourteenth-century traveler Ibn Battuta called a *gunburi*, played by musicians of the Malian sultan

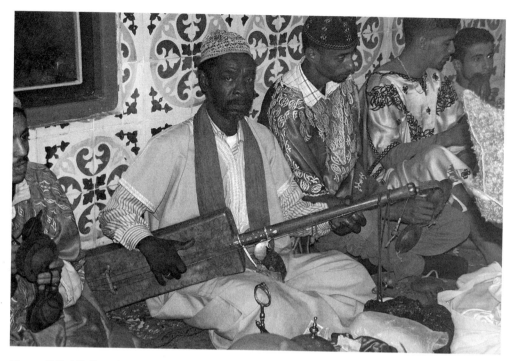

Figure 6.3. M'allem Abdellah Gania performed in the Zawiya of Sidna Bilal using a *guinbri* with a metal *sersara*, which shakes as the *guinbri* is played. Photograph by the author, 2008.

(cited in Charry 2000, 128–29). The addition of a metal plate to the instrument's bridge connects it to various plucked lutes played throughout Sahelian Africa, which have metal plates that produce a buzzing and jingling sound similar to the *guinbri* (Charry 1996, 5).[3]

Plucked lutes are ubiquitous throughout Sahelian Africa, but each has a slightly different form and specific function, making it impossible to identify the authentic and original ancestor of the Gnawa *guinbri*. In the western region of the Sahel, praise singers and historians, referred to as griots, commonly perform on three-stringed lutes that resemble smaller, rounded *guinbris*. For example, Bamana praise singers in Mali perform on a lute called the *ngoni* while reciting the names and events of hundreds of years of oral history. In Niger, Mali, and southern Algeria, Tuareg griots entertain at weddings, births, and small parties, singing praise poetry to the accompaniment of a three-stringed lute known by the name of *tahardent* (Figure 6.4). In Senegal, a praise singer performs on a similar instrument referred to as the *xalam*.

A Gnawa *guinbri* player differs from the above examples in that he does not recite tributes in honor of specific historical figures or recite lists of ancestors. Instead, he uses his instrument to honor the spirits and invite possession. In this functional sense, the Gnawa *guinbri* more closely resembles the one-stringed bowed lutes played farther east in the Central Sahelian region, which are also played to induce spirit possession. Called the *godji* by Songhai and *goge* by Hausa, these are fashioned from gourd bowls and

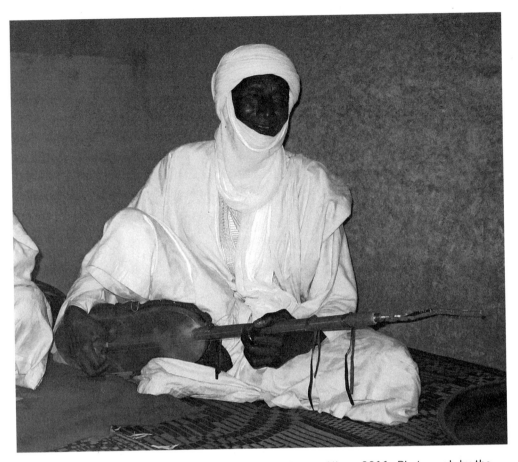

Figure 6.4. A Tuareg musician plays the *tahardent*. Niamey, Niger, 2011. Photograph by the author.

played with bowstrings like a fiddle rather than plucked like the *guinbri* (Figure 6.5).[4] During Hausa *bori*, the possessed dance toward the musicians, which resembles the spatial configurations of a Gnawa *lila*. Interestingly, early photographs from Algeria and Tunisia depict Black men playing a similar instrument, indicating that it did travel across the Sahara. The absence of a similar fiddle from the Moroccan photographic archives may mean either that the instrument itself was not carried into Morocco, or that it was not photographed, or that it disappeared from use at an early date, before the introduction of photography.

Gnawa musician M'allem Mokhtar Gania, who learned to play from his father, Boubker Gania, also a renowned Gnawa musician, is among the dwindling number of Gnawa musicians who still construct their own instruments in twenty-first-century Morocco. He explained to me how the form of the *guinbri* has changed over the decades. His father told him that the first instruments played by Gnawa in Morocco were much smaller than the *guinbri* played today. Until the 1990s, the square-shaped resonator of

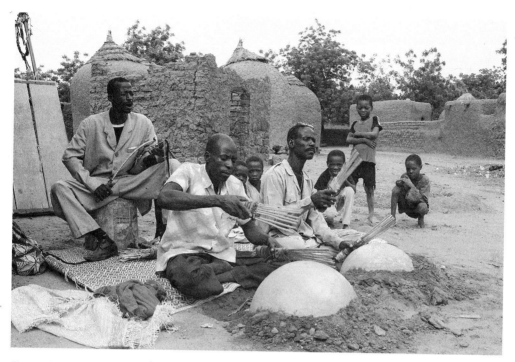

Figure 6.5. A Hausa *goge* musician with calabash players performs in Tsernaoua, Niger. Photograph by the author, 2011.

the *guinbri*, like other sacred instruments of Sahelian Africa, was commonly carved out of a single block of wood. Today he and other *guinbri* makers typically construct the wooden body from several small planks of wood glued together to make a box-like form (Figure 6.6) that they then cover with soft leather made from the neck of a camel, attached with glue made from animal hides. He emphasizes the spiritual significance of the materials used. He never uses metal nails to hold together the body of the *guinbri*, for example, because, according to him, the instrument is metaphorically alive after it is constructed and must therefore be made from natural materials provided by God, such as wood and animal skin. While iron naturally occurs in the environment, it requires humans to extract it, high temperature furnaces to heat it, and tools to manipulate it into specific forms. As discussed in chapter 3, iron is largely believed to repel rather than attract spirits, and the goal is to attract spirits to the *guinbri*, which can be inhabited by spirits. According to Gania, a *guinbri* made from fig tree wood can be especially difficult to control, because *jnun* are believed to inhabit fig trees, which is why most musicians today prefer instruments made of walnut wood. Gania recounted how his father passed on his *guinbri* to his brother Mahmoud by ritually touching his *guinbri* to his right shoulder, his left shoulder, and then his head, before passing it to his eldest son, in recognition that the instrument was *meskoun*, meaning possessed with the spirits that it had evoked during the hundreds of ceremonies that he had played.

Figure 6.6. M`allem Mokhtar Gania constructs a *guinbri* from wooden planks that he decorated with carved designs. Photograph by the author, 2010.

Another Gnawa *m`allem* whom I interviewed, Adil Amimi, also learned to play the *guinbri* from family, when his mother married into the Sudani family, who, along with the Gania family, are regarded among local Essaouirans as representing the most prominent Gnawa lineages. When he was young, he learned to play from his stepfather, M`allem Allal Sudani, and today he constructs his own *guinbris*. As he explained the process of making a *guinbri* to me, including creating the instrument's strings from the intestines of a goat, it became clear that he relished the entire process. Indeed, he made the point that accomplished musicians in the past mastered not only the music, but also the making of their own instruments. "Before each *m`allem* knew how to make instruments. I learned to make *guinbris* from my *m`allem*. It was part of the process. When you first make it, you must feed it with white *jawi* [a type of incense] and give it milk."[5] The "feeding" of the newly created instrument with incense and milk emphasizes its status as a living thing with a soul. Incense and milk not only metaphorically nourish the instrument but also serve as offerings to welcome the spirits into the instrument and prepare it for use in spirit-possession ceremonies.

The musician Adil Amimi typically makes two instruments at a time. "I use one for *lilas* and the other for concerts," he explained, distinguishing between sacred and secular functions.[6] Other than the fact that instruments used onstage can be amplified, I have

observed no structural difference between instruments used to evoke spirits in a ceremonial context and those used on the stage. It would appear that such distinctions are largely conceptual constructions of the maker. The increased commercialization of Gnawa culture has prompted some to lament the loss of an authentic Gnawa heritage uncontaminated by the consumptive attention of the non-Gnawa world and the global music scene. Those who see themselves as authentic Gnawa have responded by protecting the sacredness of their instruments. The feeling that authentic Gnawa instruments should not be used in commercial performances has thus prompted the segregation of the pure from the impure instrument among some makers.

Early Accounts of the *Guinbri* in Morocco

While we cannot pinpoint the date of the *guinbri's* introduction into Morocco, Høst's account and sketch confirm that the *guinbri* existed in Morocco in the eighteenth century. In addition to the few extant sketches, there are only a few postcards and photographs from the early twentieth century depicting Black men playing the *guinbri*; meanwhile there are hundreds showing them performing with the barrel drum and metal cymbals. The relative absence of visual representations of the *guinbri* is a strong indicator that it was reserved for private spirit-possession ceremonies, while drums and cymbals were used by buskers in public. Moreover, empirical study of early instruments is hindered by their rarity in museums or in private collections. Typically handmade from rudimentary materials such as carved wood, animal skin, and forged iron, and falling outside of the rubric of "fine art," they were of interest to few collectors inside or outside Morocco. Museums concentrating on Moroccan art tend either to collect Amazigh silver jewelry and handwoven rural textiles or objects considered to be part of the canon of Islamic art, such as architectural fragments, handwritten Arabic manuscripts, embroidered textiles from privileged households, or wheel-thrown and hand-painted pottery. Given these collecting parameters, musical instruments and other objects associated with Gnawa, such as cowrie-adorned headdresses, very rarely made their way into museums.

Those few instruments that do exist in museums, in conjunction with the few that were depicted in the early photographic archive, attest to the absence of standardization of form. The *guinbri* in the collection of the Musée du quai Branly-Jacques Chirac in Paris, for example, dates to the end of the nineteenth century and, according to their records, was originally given by a Moroccan authority named Caid Mecaud to the Paris-based Musée de l'Homme (Figure 6.7). While this nineteenth-century instrument is shaped like the *guinbri* of today, its length (96 cm) distinguishes it from contemporary models, which tend to be larger in general (as long as 116 cm), as reported by M'allem Mokhtar Gania. Just as Gnawa identity did not become codified until the late nineteenth century, it is likely that instruments of various sizes existed in the past and this handmade instrument was not standardized until recently.

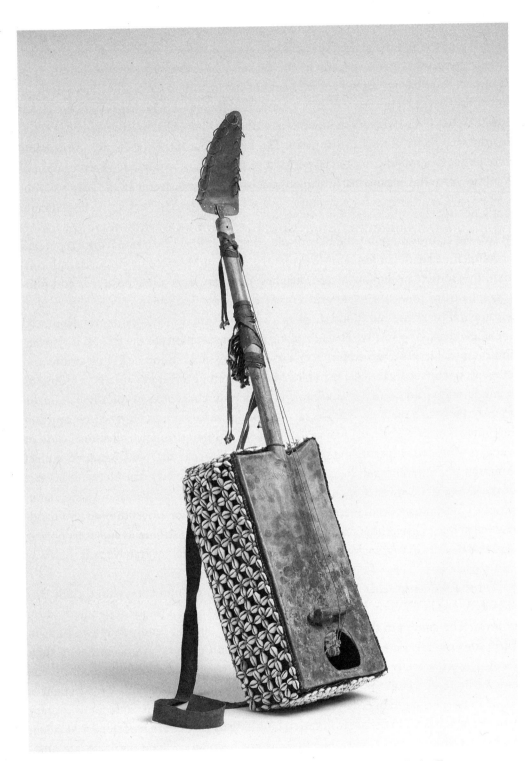

Figure 6.7. *Guinbri*. Collection of Musée du quai Branly-Jacques Chirac, Paris, France.
Copyright Musée du quai Branly-Jacques Chirac. Dist. RMN–Grand Palais/Art Resource, NY.

The shell mesh that decorates the nineteenth-century *guinbri* held at the Musée du quai Branly-Jacques Chirac suggests that the instrument was considered of value by its owner. Cowries are one of many items thrown by Gnawa diviners in divination trays to contact the spirits. During a conversation that I had with M`allem Mahmoud Gania in 1997, he told me that during Gnawa ceremonies, Moroccan women often brought him cowrie shells or beads (items associated with wealth and fertility), each of which represents a wish or request for a blessing. When her request is granted, the woman would bring a small offering to the *m`allem* in exchange for the return of the token object, which has meanwhile absorbed *baraka* from the instrument and may continue to be worn by its owner for protection. Indeed when I looked back at the photographs that I took of him with his *guinbri*, dangling from his instrument's neck were strings filled with beads, each representing a special request for healing and also revealing his status as a respected musician (Plate 8).

A *GUINBRI* APPRENTICE IN
LATE TWENTIETH-CENTURY MOROCCO

M`allem Mokhtar Gania of Essaouira is notable not only for his expertise as an instrument maker but because his personal journey from apprentice to master of the *guinbri* represents both the past and future of the instrument, reaching back to a time when the *guinbri* was passed down within select families and forward to its infiltration of mainstream Moroccan culture and its elevation onto the world music scene. Gania's journey entailed a long training by his father and older brothers. As a young boy he was prohibited from handling the *guinbri* and could only observe the older males in the family play; later his father would pass the *guinbri* to him and encourage him to compose songs: "After I finished playing, my father would give me suggestions on how to improve." After his father's death, Mokhtar primarily performed with his eldest brother M`allem Mahmoud Gania, first accompanying his brother by playing the iron cymbals before being entrusted to play the *guinbri* at a ceremony. Even then he was not allowed to play the entire spirit-possession repertoire: "For seven years, my brother played the beginning of the *lila* and handed me his *guinbri* to finish the *lila* for them."

When he was twenty-six years old, his apprenticeship was deemed sufficient and he performed his first public ceremony. In the city of Essaouira where the family lives, such ceremonies were typically held in the Zawiya of Sidna Bilal, but Mokhtar's parents held his ceremony at their private home, inviting other members of the community. Elder master musicians as well as local female healers attended, while Mokhtar's family provided all of the guests with a feast. The older, more experienced musicians began by performing the ceremony's opening procession, `aada, with the barrel drum, handing it to Mokhtar to finish the processional song. However, when the spirit-possession portion of the ceremony commenced, Mokhtar was expected to perform the entire

repertoire by himself. Such a ceremony was meant to introduce a master musician to the city and prove his worthiness of the designation *m`allem* or "master" of the *guinbri*.

In addition to learning to play the instrument from his family, Mokhtar Gania also learned to make his own *guinbri* from his carpenter father. Mokhtar explained to me that in the past, many Gnawa musicians could not support themselves on the nominal fees gained from performing spirit-possession ceremonies, so they usually plied more practical and profitable trades, such as carpentry or metalworking. Mokhtar supported himself and his family by making wooden chests and bedframes, but since Gnawa music has gained in popularity, he now supports himself, albeit modestly, entirely from the performance of music at a local hotel, as well as occasional international concerts. Since the death of his older brothers in recent years, Gania is the eldest surviving *m`allem* in his prestigious family, responsible for carrying his family's reputation into the future. The father of four girls and no sons, he has encouraged his daughters and nieces to form a musical group called Bnate Gania, meaning "Gania Girls." One of his daughters even began to play the *guinbri*, and the women play various concerts around Essaouira.

M`allem Mokhtar Gania's model of musicianship based on apprenticing to a family member stands in marked contrast to that of Abdeslam Alikane, who, as discussed at the beginning of this chapter, did not grow up in a Gnawa milieu, does not self-identify as Sudani, and whose ancestors enslaved people. Indeed, Alikane's journey to mastery of the instrument required that he leave his family and community. He moved from his hometown of Essaouira to Casablanca in order to learn the spirit-possession repertoire from Gnawa musicians.[7] Alikane returned home to work as a musician, and as artistic director of the Gnawa and World Music Festival in Essaouira, he contributed to the city's growing reputation as the epicenter of Gnawa music.

Alikane plays the *guinbri* for Gnawa possession ceremonies, and he generously invited me to attend one that he played in Agadir. At the same time, he is known for his professional recordings and concerts as founder of the musical group Tyour Gnaoua. When asked what it means to be a Gnawa master musician, Alikane emphasizes hard work and devotion rather than family connections. He told me, "If you want to become a *m`allem*, you must learn to play all of the instruments and you must also be responsible and achieve the respect of others. You must work from your heart." Alikane, like many musicians in the 1990s, took Gnawa music out of its familial context and decoupled it from its association with Blackness as essential to its authenticity.

Alikane remembers his first exposure to Gnawa music was as a child hearing the music of the Black men and women who worked in his grandfather's house. Whether or not he is seen as appropriating this music, he pays respect and gives credit to its Black originators. Alikane's prominent position as the artistic director of the Gnawa and World Music Festival owes in large part to the fact that his perspective is shared by the Moroccan state that, since the late 1990s, has embraced Gnawa culture as part of its effort to celebrate the nation's ethnic diversity and linguistic pluralism, and in doing so,

to challenge the dominance of Middle Eastern music and culture in Morocco. Moreover, for the Moroccan state, as noted earlier, the Gnawa and World Music Festival not only promotes the country's image as a crossroad of cultures, and acknowledges a connection to Africa south of the Sahara, but also acts as a counterweight to the growing Islamist movement (Aidi 2014, 152), especially among the youth. It is within this context that musicians who do not identify as Sudani (i.e., Black) can adopt Gnawa music as an expression of national identity rather than of a personal connection to trans-Saharan slavery.

As Alikane's example demonstrates, what it means to be a Gnawa master musician or *m'allem* and to play the *guinbri* in contemporary Morocco has changed greatly in the past few decades. The previously stigmatized *guinbri* can now be easily purchased in the city of Essaouira, where artisans devote themselves entirely to making this instrument for both local and international clients, setting up small workshops where they sell *guinbris* decorated with inlaid pieces of lemon wood. Given that the *guinbri* plays a central role in the Gnawa ceremony, musicians take great pride in their instruments, and even if they purchase them from a carpenter in the market, they often personalize them by painting the skin with henna designs or adding charms, such as small hand pendants or cowrie shells, to ward off the evil eye. Some, such as Mokhtar Gania, painstakingly carve the instrument's wooden body with personalized designs (Figure 6.6), which not only display his pride in his workmanship, but fetch a higher price for the instrument among foreign collectors and/or musicians. Musicians are not immune to market influences. Even an instrument that is destined for use in a secular performance by musicians in Europe and the United States must bear the decorative adornments that have become a standardized and commodified symbol of "Gnawa-ness" in recent years.

The wide availability of the *guinbri* in local markets inevitably alters its meaning and status. Young Moroccan men can now easily purchase one and teach themselves how to perform, using YouTube videos or recorded music to pick and choose from the spirit-possession repertoire, or from any other repertoire, rather than mastering it in its entirety in a ceremonial context. Gnawa music is performed at tourist restaurants and on the street, its rhythms and songs entering into the public life of Moroccan cities. While some have misgivings about the increased commercialization and resulting proliferation of Gnawa music, even they see the opportunities, both musical and economic, that have emerged. Alikane, for one, told me that he interprets the diffusion of Gnawa music across the wider public arena in positive terms:

The [Gnawa] festival has changed everything. Gnawa are much better known. Before their ceremonies were held only in homes or in the shrine and were much more family oriented. Not many knew their music. Now people buy their music, and the festival is a force for Gnawa from various parts of Morocco to get together. Before they did not know each other and you did not hear others play. Now they exchange ideas and musical styles and the musical standard has become much higher.

Thus the festival highlights and celebrates ethnic diversity and emphasizes Morocco's identity as an African rather than Arab nation, regardless of whether a musician can trace his ancestry to the Sudan or not. Some *guinbri* performers deliberately emphasize their African-ness to please crowds, such as M`allem Omar Hayat, who wears leopard-skin print onstage (see Plate 7). Some in the Gnawa community have raised concerns about outsiders appropriating their music, much as white musicians appropriated African American music in the United States. They worry that cultural mediators, interpreters, and promoters from outside the community, such as Alikane, achieve recognition and success, while Black, hereditary musicians are sidelined. However, while there is no question that outsiders have exploited the popularity of Gnawa music, there is little evidence that Black musicians are undervalued. In fact, it can be argued that Blackness is often a commercial advantage. Mahmoud Gania, who could claim elite Gnawa ancestry, achieved more fame during his lifetime than has Alikane. Since the unfortunate death of Mahmoud to cancer in 2015, one of Mahmoud's sons has started to perform as a Gnawa *m`allem* and plays concerts during primetime slots and on the main Gnawa and World Music Festival stage, which is considered prestigious. The Gania familial history allows him to market himself as an authentic Gnawa from one of the original Essaouiran families, which carries great cachet among Gnawa music fans and connoisseurs, who are always seeking out the real, unadulterated Gnawa music connected to sub-Saharan Africa. Therefore, one can assert that public recognition is reliant on multiple factors, including family history, the ability to self-market, and one's connections to the nation's cultural mediators, including festival organizers.

ADOPTING THE *GUINBRI* IN RURAL MOROCCO

Along with its increased acceptance by the Moroccan mainstream and its global recognition, the Gnawa *guinbri* has also taken on new meanings as it has diffused into rural Morocco. Throughout the south, from the small town of Tamanar on the Atlantic coast to the town of Khamlia more than eight hundred kilometers to the east, there are communities of dark-skinned Tamazight-speaking people, who are descendants of those enslaved by Imazighen, who still refer to themselves using the local Amazigh term for "slaves" (Ismkhan or Ismgan). Here, far from the urban settings where the *guinbri* has become associated with the hip world music scene, the *guinbri* represents a positive identification with a historically based Black community. In a rural geographic space where racial and ethnic hierarchies of "master" and "enslaved" still persist, the *guinbri* allows the economically depressed Black population to claim "Gnawa-ness," an identity that carries commercial opportunities as well as connection to a self-empowering Black collective experience. While it might be easy to dismiss the adoption of the *guinbri* by these rural populations as a blatant attempt to appeal to the global tourist market and cash in on the instrument's rising status, a by-product of this marketing tactic has been

that rural populations of slave descendants have acquired a new means to express their racial consciousness.

For unknown reasons, only enslaved people living in urban centers adopted the *guinbri* to induce spirit possession. Rural groups evoke spirits into possession through the performance of the large barrel drum (*tbal*) and iron cymbals (*qraqeb*). Therefore, one of the chief distinctions between Gnawa and Ismkhan music has long been the fact that Ismkhan/Ismgan do not play the *guinbri*. The cultural features that centralize the *guinbri*—the existence of master musicians, or *m'allem*, who distinguish themselves from other musicians, and female diviners who contact the spirits for healing purposes—are also absent among the Ismkhan. For rural musicians, music is a communal affair, a means of bonding as a collective; they do not seek to stand apart as individual soloists, nor do they go through the intense years of apprenticeship necessary to perform the musical repertoire of a *lila* on the *guinbri*.

Like Gnawa groups in urban Morocco, these rural communities perform healing ceremonies. But it is the barrel drum, called *ginga* or *ganga* in Tamazight (*tbal* in Arabic), that is the beating heart of Ismkhan ceremonies; indeed, Ismkhan musical groups are often referred to by locals as "Ganga" due to the centrality of the barrel drum as well as double-headed domed cymbals, using the pan-Moroccan term *qraqeb* and the local word *qraqsh* for them, which is probably in onomatopoeic imitation of the clacking noise the cymbals make when played (Figure 6.8). They perform during an annual ceremony

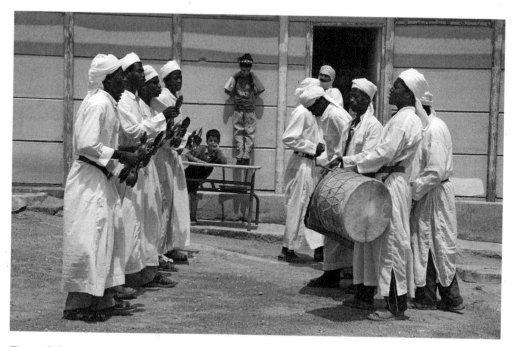

Figure 6.8. Ismkhan musicians collect offerings in front of a local school in Khamlia, Morocco. Photograph by the author, 2006.

called a *sadaka*. The word *sadaka* means "gift" or "offering" in Arabic, and during the annual *sadaka*, they pay tribute to their ancestors and to Bilal, the Black first *muezzin* of the Prophet Muhammed, from whom they believe they derive their *baraka*. Many Ismkhan recounted that if the *sadaka* were not held each year, drought, famine, or some other natural disaster would afflict the region. They distribute food to all those present, heal the sick, and even hold a mock slave market where Ismkhan symbolically bid on non-Ismkhan children, as if to purchase them. The act of "selling" one's child to the Ismkhan is thought to protect the children from illness, because of the community's *baraka*. The child is expected to bring offerings to the community over the course of his or her entire life (C. Becker 2002).

While Ismkhan take pride in their collective identity as healers, local Imazighen have an ambivalent relationship with the descendants of the enslaved. They value the healing abilities of Ismkhan, but the two groups do not intermarry and local racial constructions continue to marginalize those with dark skin. In the town of Khamlia, some Ismkhan have begun to redefine themselves in order to increase tourist appeal and, in the process, directly engage with local constructions of race and issues of authenticity.

ISMKHAN VERSUS GNAWA: WHO IS AUTHENTIC?

Since my initial work on the healing ceremonies of Khamlia in the 1990s, Ismkhan there renamed themselves "Gnaoua of Khamlia" in 2001.[8] Certainly a major incentive for their rebranding was to profit from the relatively recent popularity of Gnawa music, and, indeed, in recent years their annual ceremony has attracted larger crowds of both locals and foreigners.

Despite the name change, significant differences exist between Ismkhan and Gnawa healing techniques. Most notable is that Gnawa spiritualism fundamentally aims to achieve a condition of mutually beneficial coexistence between the possessing spirit and the afflicted person. Ismkhan, on the other hand, seek to remove the spirit from the afflicted person; consequently, the ceremony is more an exorcism than a possession invocation. A distinct feature of an Ismkhan ceremony is that men use both their clothing and their instruments for healing purposes, covering the heads of those who wish to be healed with their white turbans. After each man places his finger in water contained in an iron cymbal (*qraqeb*) and adds salt, two men beat rhythms on the barrel drum (*ginga*) while the cymbal players circle those who wish to receive blessings. Those who wish to be healed are told to drink water from the cymbal. As the water is consumed and sprinkled on the afflicted's head, harmful spirits (*jnun*) are removed from the person's body (Figure 6.9).

Another distinct feature of the Ismkhan ceremonies is their differentiation between in-group and out-group. Exorcism is used to remove spirits from non-Ismkhan, but

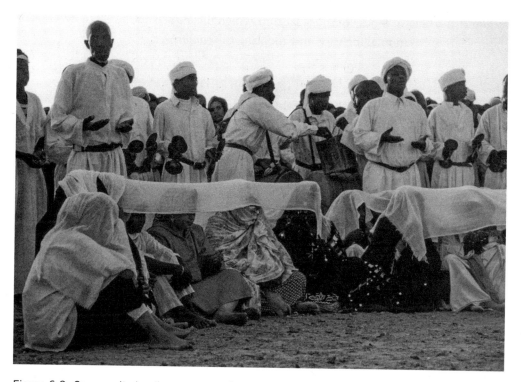

Figure 6.9. Community healing ceremony in Khamlia at the Ismkhan *sadaka*. Photograph by the author, 2006.

Ismkhan engage in spirit possession, although on a smaller scale than that seen at Gnawa ceremonies. During one particular portion of their ceremony, Ismkhan employ the barrel drum and cymbals to induce possession among themselves, but unlike Gnawa ceremonies, in which anyone can become possessed by spirits regardless of their racial identification, only those who self-identify as Black are possessed during Ismkhan gatherings, indicating that locals conceive of spirit possession as intertwined with constructions of race.

As with urban Gnawa, the question of authenticity and priority (in the sense of coming first) preoccupies rural Ismkhan. They consistently asserted to me that their music and culture were more "real" and "authentic" than that of urban-based Gnawa, and that Gnawa traditions originated with them, including the belief that they inherited *baraka* from Bilal. In their understanding, as Black Moroccans moved from rural to urban settings, they moved away from and adulterated their African roots by intermarrying with those from outside the group and, in the process, incorporated aspects of Moroccan popular culture and Sufism into their spirit-possession repertoire. Their version of history is that Ismkhan music is uncontaminated by outside influences and closer to its sub-Saharan origins—and for those reasons less commercially viable than that of urban Gnawa musicians. But, as we shall see, some rural musicians have been choosing

to follow the Gnawa model of musicianship, which means separating themselves from the collective ceremonial identity, and adopting the *guinbri*.

RACIALIZING ALTERITY:
FROM ISMKHAN TO GROUPE DES BAMBARAS

While Ismkhan communities as a whole began to capitalize on the appeal of Gnawa, resulting in increased attention being paid to their annual ceremony, young Ismkhan men went a step further and began to play the *guinbri*. Hamad Mahjoubi, for example, founded an all-male musical troupe in the early 2000s called Groupe des Bambaras, made up of his neighbors, family, and friends (Figure 6.10). Mahjoubi took the initiative to learn and play the *guinbri* and, until recently, was one of the few in Khamlia who could do so. He makes no claim to be versed in the entire Gnawa ceremonial repertoire but plays a few well-known Gnawa songs that he taught himself by listening to recordings. He also accompanies older songs long performed by Ismkhan during the *sadaka*, but transposed for the *guinbri*, changing the rhythms and in some cases including a Senegalese drum called a *djembe*. His music is thus somewhat syncretic, freely crossing musical boundaries.

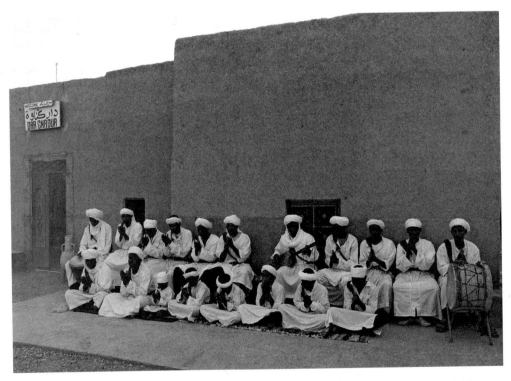

Figure 6.10. Groupe des Bambaras performs outside the Dar Gnaoua in Khamlia in 2013. Photograph by the author.

Nonetheless, the *guinbri* is an integral marker of the group's claim to "Gnawa-ness." For example, the sign that Mahjoubi uses to advertise the location of Dar Gnaoua, or "Gnawa House" (Figure 6.11)—the performance space and tourist accommodations that Mahjoubi annexed to his adobe house—features frontal views of three musical instruments associated with Gnawa in contemporary Morocco: the barrel drum (*ginga*), metal cymbals (*qraqeb*), and the *guinbri*. Mahjoubi adopted the name "Bambara" from the popular Gnawa song *Uled Bambara*, or "children of Bambara," in which Gnawa sing about their origins. Mahjoubi's use of the name references a popular version of the Gnawa origin story, although it must be kept in mind that "Bambara" is used generically in North Africa to refer to non-Muslims from West Africa. In fact, Mahjoubi admitted to me that most in Khamlia are not aware of the pejorative history of the term "Bambara" and do not trace their ancestry to the group. Nonetheless, the label has been adopted with pride by Ismkhan in Khamlia.

Adoption of the term "Bambara" by the Dar Gnaoua group also signals a racialized notion of identity that excludes Imazighen and Arabs who do not identify as Black. Prior to independence in 1956, Ismkhan were attached to Amazigh families, working for them as herders and doing other labor. Both groups speak Tamazight and at one time considered themselves to be part of the same Amazigh group—the Ait Khabbash. However, a hierarchical racial divide has separated the two groups and prevents them from

Figure 6.11. The sign for Dar Gnaoua in Khamlia. Photograph by the author, 2013.

intermarriage. Furthermore, Ait Khabbash identify themselves as indigenous Africans, but rather than unite with Black descendants of the enslaved, who also identify as African, Ait Khabbash consider themselves Imazighen, which means "free people," thus excluding the Black descendants of enslaved people from this self-definition.

As the indigenous people of North Africa, Imazighen living in Khamlia and nearby Merzouga commonly claim an African identity, connecting themselves to Tuareg in the Sahara. For many Imazighen, Tuareg represent pure Imazighen uncorrupted by Islam and Arabization, freely crossing borders and living in a pristine cultural state. Local Ait Khabbash men, who dress in flowing blue gowns and turbans when working with tourists, market Tuareg culture as an ethno-commodity. Increasingly, even when they are not working, men continue to dress in this fashion. As noted by the Comaroffs in their book *Ethnicity, Inc.*, "the producers of culture are also its consumers, seeing and sensing and listening to themselves enact their identity," becoming the "authentic," the "original" (Comaroff and Comaroff 2009, 26). These styles of dress give visual form to a transnational Amazigh identity that crosses the Sahara, representing what might have been if national borders had not been created, their nomadic ancestors had not settled down, and Amazigh culture had not been corrupted by Arabization (C. Becker 2016).

Many of the hotels run by Imazighen in rural southeastern Morocco have names such as "Kasbah Le Toureg" and "Les Hommes Blues," while Ismkhan call their tourist establishment "Dar Gnaoua." For Imazighen, "Tuareg" denotes an Amazigh group that, unlike those in northern Africa, did not experience Arabization and has retained the purity of its culture and language. For Ismkhan, adoption of the term "Bambara" pays homage to their sub-Saharan ancestry, their authentic ancestors. Since Amazigh musical groups in southeastern Morocco never perform using the *guinbri*, the inclusion of the *guinbri* on the Dar Gnaoua sign is understood locally as an expression of Blackness.

Members of Groupe des Bambaras are not the first Ismkhan to play the *guinbri*. In 2001, I attended a possession ceremony held by Ismkhan near the town of Rissani. Such ceremonies were extremely rare. They appear to have been imported into the region by one Ismkhan family (with the surname Ben Zegane) who had learned some songs on the *guinbri* while living in Meknes. When the three Ben Zegane brothers visited their larger extended family in the southeast, they often would organize shortened, localized version of Gnawa *lilas* that included playing variations of well-known Gnawa songs as well as spirit possession. One of the brothers was the primary person to become possessed. Women would leave headscarves in front of the musician while the possessed man picked up one of the scarves and danced until it was wrapped around his neck and/or his hands and arms (Figure 6.12). The owner of the scarf would come to untangle her scarf to "untangle" the influence of spirits who had afflicted her with problems. Occasionally one or two women became possessed, but men were the most active. An Ismkhan *lila* would only go on for a few hours and used music to evoke a handful of spirits, unlike a Gnawa *lila*, which lasted for at least twelve hours.

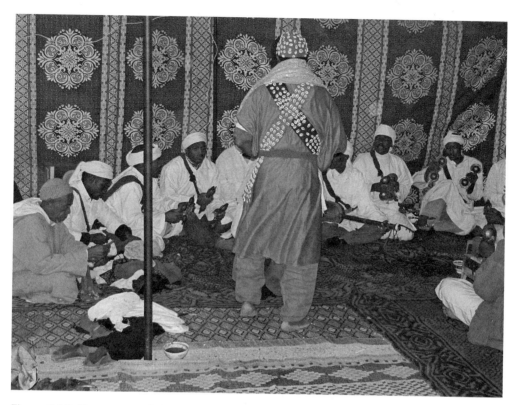

Figure 6.12. The possessed dances with scarves from various women wrapped around his neck. They will approach him to untie their scarves, symbolizing that the spirits unraveled their problems. Photograph by the author, Erfoud, 2010.

These men were often asked to hold a *lila* after a three-day wedding when a large extended family was already gathered together, holding the *lila* on the fourth day. However, as one of the musicians has recently fallen ill, such ceremonies have become increasingly rare, indicating that the development of such ceremonies represents an anomaly introduced by a single family rather than a norm.

Hamad Mahjoubi confirmed that he never played at spirit-possession ceremonies such as the *lila* of urban Gnawa, explaining that he was more interested in the musical rather than the spiritual aspect of Gnawa performances. I saw evidence of this when Mahjoubi and I attended a Hausa spirit-possession ceremony (called *bori*) together in Niger. He became so uncomfortable that he was compelled to leave because he felt such practices were contrary to Islam. However, when I dug deeper his response was much more complex. He took the ceremony very seriously since he saw his mother suffer from illness attributed to spirit possession, so he was guarded about being in such a spiritually charged atmosphere. However, he was comfortable performing a secular concert on the *guinbri* in Niger for a conference organized by the West African Research Association and the American Institute of Maghreb Studies in 2011 on the topic of cultural and

artistic connections across the Sahara. When he traveled to Niger he forgot to bring his *sersara* (a metal plate with small rings) with him to attach to his *guinbri* in order to produce its characteristic buzzing noise. I suggested that he purchase one from a Nigerian blacksmith, but he refused, fearing that a *sersara* made in Niger would be particularly potent and attract too many spirits.

Mahjoubi's response to spirit possession in Niger demonstrates that identifying as Gnawa, playing their musical instruments and adopting their style of music, does not mean adopting, or embracing, the practice of spirit possession itself. For Mahjoubi identifying as "African," "Gnawa," and "Bambara" has certainly opened up new possibilities economically; simply put, identifying as Gnawa carries more commercial capital than identifying as Ismkhan. But the cultural capital is just as important: his adoption of the *guinbri* allows him to perform as part of a wider pan-African musical style. He even painted one of the most iconic forms of African sculpture, a Bamana *chi wara* headdress, on the skins of two *guinbris* that he used to decorate his performance space (Plate 9). Groupe des Bambaras builds upon and reinforces racial differences that have existed between local Imazighen and the formerly enslaved, and in the process, each relates to the African continent in a different way.

THE ENTRANCE OF THE *GUINBRI* INTO THE INTERNATIONAL ART SCENE

Like many at home, Moroccans living outside Morocco have latched onto the political implications of the *guinbri* (Aidi 2014, 158). The image of the *guinbri*-playing Gnawa musician has infiltrated the consciousness of Moroccans of all ethnicities living abroad who identify with Gnawa marginality. The long-standing stigma that still associates Gnawa practices with heterodoxy within certain circles in Morocco itself is largely absent in the European context where Gnawa music is positively received. Hisham Aidi, in his book *Rebel Music*, writes that young Moroccan migrants in Europe feel a stronger connection to the African continent than to the Middle East, regardless of whether they self-identify as Arab or Imazighen. Aidi recounts that those musicians living in Europe who did not grow up in a Gnawa milieu integrate Gnawa instruments and sounds into their music, preferring to sing in North African dialects of Arabic rather than in the classical Arabic of the Middle East (2014, 154–55). This trend is exemplified by the musician Amazigh Kateb from Algeria, son of Algerian novelist and anticolonial activist Kateb Yacine, who leads a band called Gnawa Diffusion. He often performs in Morocco, regularly appearing at the Gnawa and World Music Festival, and has attracted a huge following among Moroccan youth with his use of the Gnawa *guinbri* to perform social protest songs. When I met Amazigh Kateb one summer in Morocco, he told me that people are attracted to the outsider status of Gnawa identity and its concomitant political, economic, and social claims as they are to the music itself. Moroccans who have left their

homelands frequently express their sense of displacement and otherness by adopting Gnawa aesthetics.

The British-Moroccan artist Hassan Hajjaj, whose family migrated to London in the 1970s, purposefully includes a *guinbri* player in his multimedia installation entitled *My Rock Stars*, which also features musicians performing jazz, capoeira, and hip-hop, all of whom are members of the African diaspora in London. As Morocco's citizens migrated to Europe and beyond, the *guinbri* came to represent for them "a symbol of a new diaspora consciousness, an Africa-centered brand of European Muslim internationalism" (Aidi 2014, 158). Hajjaj's photographs are a reflection on transnational diasporic communities, capturing the innovative cultural and aesthetic forms immigrants have created in their new homes. In his work we see the full trajectory of the *guinbri* from a stigmatized to a glamorized object.

New Jersey might seem an unlikely place for an encounter with Gnawa music, but when I visited the multimedia installation by Hajjaj at the Newark Museum in 2015, I came across Hajjaj taking photographs of museum visitors on a pop-up studio that he created on the museum's grounds. His set featured a patterned plastic mat, similar to those that Moroccans use on their floors. He created a patterned studio backdrop reminiscent of those used by Malian photographers Seydou Keita and Malick Sidibé, but his primary source of inspiration was having his own picture taken as a child by itinerant Moroccan photographers. Hajjaj welcomed the spontaneity of people interacting with him and continued his aesthetic of photographing people from below to give them an empowering and theatrical appearance. Among those who came to have their photographs taken was Samir Langus, a musician originally from Agadir, Morocco, who currently plays in the New York City–based Gnawa group Innov Gnawa (Figure 6.13).

When I entered the museum, the sounds of the *guinbri* unmistakably signaled the presence of Gnawa. The video portion of Hajjaj's *My Rock Stars* project, completed in 2012, titled "My Rock Stars, Experimental, Volume 1," includes nine separately filmed performances by musicians who inspire him, all of whom are associated with the African diaspora. The musicians perform one by one, and each, in turn, listens to the performance of the others, tapping and swaying in response to the music. The purpose of the project is to highlight the similarities among the various African-diaspora-based cultural and musical forms, whether Gnawa, Jamaican, or Brazilian. He explained to me in New Jersey, "Everyone in my series has touches of Gnawa—there is an African bloodline among them. They have moved around. Not by slavery but by choice—some are struggling to survive, but they live by the code of what they believe in." Rather than playing music that might be more commercially viable, they choose to play on instruments largely unknown in the mainstream music world that express their identity as members of the African diaspora.

When Hajjaj moved to London as a teenager in the 1970s, he felt like an outsider but eventually befriended other immigrants—people from the Caribbean, Brazil, Nigeria,

Figure 6.13. Hassan Hajjaj photographs Samir Langus, a musician in the New York City–based Gnawa group Innov Gnawa. Photograph by the author, 2016.

and elsewhere—as they bonded over a shared sense of alterity. As he explained to me, "As immigrants, we were thrown together in the same place, we were searching and we had to find our own way and create our own village." He worked as a DJ in underground clubs in the 1980s and eventually began working with fashion stylists on music videos and on fashion shoots. Though he never attended art school, one of his friends taught him how to use a camera, and he joined a British friend on a fashion shoot in Morocco in 1997 where he discovered that all the designers, models, and stylists were European. Morocco was simply being used as an exotic backdrop; no one bothered to photograph the local people. After this trip he began his own photographic project to capture the uniqueness of Morocco. Central to that project were dozens of photographs of Gnawa musicians. He explained to me the particular power Gnawa culture held for him: "Gnawa music was for local people—ceremonial music. It was so strong that you could not keep it down, and the Gnawa and World Music Festival took it to another level. Moroccans said we have something unique. There is this pride that we have something to offer." For Hajjaj, Gnawa represent the unique hybridity of Morocco as well as a larger connection to the African continent. On the day that I saw Hajjaj in New Jersey, he was photographing several New York–based Gnawa musicians with the goal of capturing the Gnawa scene on camera and documenting it for the future.

Many Moroccans living abroad embrace a Gnawa identity. Their encounters with other Arabic speakers sometimes make them feel as if they are peripheral to the Arab world. Middle Easterners scorn them for speaking an inferior dialect of Arabic and accuse them of practicing a lower form of Islam steeped in magic, mysticism, and sorcery. Gnawa culture is a measure of Moroccans' distance from the Arab world (Aidi 2014, 153), a distance many Moroccans have now come to embrace. Those who embrace Gnawa music in Europe do so in large part as a means of rejecting conservative Islam. While less interested in the spiritual and metaphysical aspects of Gnawa culture, Hajjaj admires its aesthetic and political content: "Gnawa is a lifestyle, Gnawa are timeless— they have their own world and their own system." Hajjaj conveys this timelessness in his photographs. Among the nine musicians that he included in his video installation "My Rock Stars, Experimental, Volume 1" on display at the Newark Museum is the Gnawa musician Simo Lagnawi, who wears a green gown and cowrie-adorned headdress (Plate 10). The only hint that Lagnawi lives in London is the reflective sunglasses that betray a contemporary, perhaps cosmopolitan, context.

Hajjaj's refusal to contextualize or situate Simo Lagnawi is indicative not only of the "apartness" of Gnawa identity but its expansiveness. Simo took the stage name "Lagnawi" to signal his identification as Gnawa. In fact, he calls himself "the Gnawa Berber"—an arresting conjunction given that Berbers, the indigenous peoples of North Africa, are not only not descended from enslaved people but were in some cases enslavers. However, like the Gnawa, Berbers (who prefer to call themselves Imazighen or "free people") were also marginalized in postcolonial Morocco when its politicians strove to connect the nation to the larger Arab-Muslim world. Like Lagnawi, some people take on both identities. Hajjaj does not engage with authenticity or ethnicity claims, focusing instead on those neglected by mainstream society—his own "rock stars."

The manner in which Hajjaj prints each photograph—on a high-gloss aluminum panel that gives the images a sharp and vivid finish that resembles product packaging—signals his embrace of the commercialization rejected by many of the Gnawa participants discussed in chapter 5. The commercial feel of his work, however, does not detract from the seriousness of his artistic mission to empower individuals who have historically been viewed as victims. His work reminds us that Gnawa are part of a larger and longer diaspora experience of Africans. Those Africans who forcibly migrated due to enslavement were the first cosmopolitans. According to ethnomusicologist Richard Jankowsky, African musicians continually adapted to new circumstances, "creating spaces for engagement and interaction with other traveling musical traditions" (2010, 196). Gnawa music is one instance of such diasporic music that has proven itself resilient and adaptable.

A GNAWA SYMPHONY IN THE SAHARA

My experience writing about Ismkhan, Groupe des Bambaras, and Hassan Hajjaj came together in April 2018, when I was invited to speak at the sixth International Festival of

Merzouga, in eastern Morocco, on the theme of "Mama Africa." Its four-day schedule featured cultural programs and live music performed on a stage set up outside the town. I gave a presentation, with Hamad Mahjoubi, the leader of Khamlia's Groupe des Bambaras, to an international gathering of festival visitors about the history and culture of Gnawa.

The festival proved to be a mirror of the complex nexus of identifiers that characterize contemporary Morocco, a place where ideas about the *guinbri* and its connection to Black, Gnawa, and African identities meet and compete, especially during a concert referred to as a "Gnawa Symphony." Directed by London-based Simo Lagnawi, the musician photographed by Hassan Hajjaj, the group also featured Marouane Lbahja, a Gnawa musician from Marrakech, and several men from Groupe des Bambaras (Figure 6.14). In London, Lagnawi performs Gnawa music infused with psychedelic sounds with a group called Electric Jellaba. He has also performed fusion concerts with Jally Keba Susso from the Gambia and Amadou Diagne from Senegal. His experience performing in the UK and at international festivals and his expertise at fusing various musical forms from Africa indicate his familiarity with staged performances. By working with West African musicians in the UK, he situates Gnawa music in relation to the wider transnational African diaspora, rather than the Middle East or the Arab world.

The music performed by Lagnawi tends to be upbeat and fast-paced; performing at clubs in London, he does impressive acrobatic jumps onstage, and his energetic

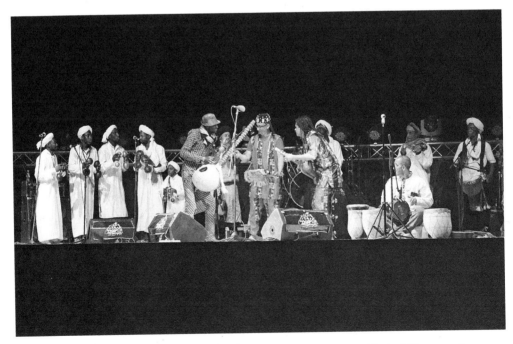

Figure 6.14. The Gnawa Symphony performs at the International Festival of Merzouga in 2018. Photograph by the author.

performances encourage his audience to get up and dance. His style contrasts with the music played by Groupe des Bambaras, who tend play the *guinbri* at a slow and steady pace. During the "Gnawa Symphony," Groupe des Bambaras wore the white turbans and gowns worn by their fathers and grandfathers, rather than the colorful outfits worn by Lagnawi to create a more flamboyant stage presence. Lagnawi also invited the Senegalese *kora* player Mbemba Diebaté to join him on the stage; Lagnawi, Diebaté, and Lbahja dominated the performance, both visually and musically, standing in the center of the stage and dancing vigorously while the members of Groupe des Bambaras were much more reserved and often stood on the sidelines.

Groupe des Bambaras performs daily for the large number of tourists who pass through the region of southeastern Morocco to visit its famous golden sand dunes, but members have less experience than the other musicians in playing large-scale staged concerts. Groupe des Bambaras has never performed at the Gnawa and World Music Festival, and the group's music tends to feature more relaxed and measured rhythms than that of urban Gnawa musicians. A large part of their musical repertoire continues to include the songs their enslaved ancestors performed when they gathered offerings to hold their local *sadaka*, a ceremony held each year to give offerings of food to the local community and to offer their services as healers. Ismkhan consider themselves to be performing a more authentic, less hybridized version of the music of their enslaved ancestors than Gnawa musicians living in London and Marrakech (see C. Becker 2002). However, on this festival stage, the most authentic was sidelined to its edges. Furthermore, Ismkhan musicians played as part of Groupe des Bambaras without their names individually listed on the festival program as soloists. Having witnessed dozens of Ismkhan performances in southeastern Morocco since 1996, I came to realize that performers strive to maintain composure and present a more stoic image of themselves than urban Gnawa musicians, such as Lagnawi and Lbahja, who wear bright colors and dance vigorously around the stage to entertain the crowd. This is not to say that Ismkhan musicians do not like to entertain outsiders. In fact, after their staged performances in Merzouga, they asked me to drive them to their next gig at a nearby hotel, which I did.

A concept carried throughout this book is that what it means to be "Gnawa" has become more flexible and porous over the past few decades, and today many without a connection to slavery and Blackness perform Gnawa music, as we can see with Simo Lagnawi, who self-identifies as a "Gnawa-Berber," a moniker that suggests he is a Berber who adopted Gnawa music similar to Abdeslam Alikane. Here we see an intensification of self-marketing continue, as Gnawa identity becomes increasingly marketed and enacted repeatedly for tourist-consumers. As this example illustrates, there are different versions of Gnawa authenticity that exist across Morocco. While Ismkhan see themselves as authentic Gnawa, musicians in urban Morocco do not classify those in rural areas as authentic Gnawa, typically referring to them as Ganga, after the name of the large barrel drum in Tamazight. As previously discussed, the adoption of the *guinbri*

by so-called Ganga in rural Morocco is relatively new. As one can see, performing as a Gnawa musician works differently in London than it does in rural Morocco. Learning a Gnawa instrument, wearing one's hair in dreadlocks, and playing on a stage in London expresses a desire to be seen as African rather than Arab or Middle Eastern; it is a sign of rebellion and indicates a certain degree of hipness. But racialized boundaries still exist in rural southeastern Morocco, and Groupe des Bambaras see their performances as continuing the authentic traditions of their enslaved Sudani ancestors.

THE INCREASED VISIBILITY OF GNAWA WOMEN

While the artist Hassan Hajjaj included a *guinbri* player in his *My Rock Stars* installation, the female artist Regreguia Benhila also painted one in her untitled work from 2008. I had the good fortune to interview Benhila in 2008 a year before her death from cancer, during which she shared with me her love of women's music. As a self-taught painter active in Essaouira since the 1980s, the painting that I purchased from her in 2008 is typical of her style; it features bold colors, flowing lines, and numerous female figures, all of whom appear to have a slight smile forming on their red lips. Most of the women hold an object or engage in an activity typical of the city of Essaouira: one rides in a boat and another holds a fish. On the top right, a woman wearing blue plays a *guinbri*, an instrument not played by women until quite recently (Plate 11).

Benhila told me that she often held *hadarate* gatherings in her home. *Hadarate* refers to an all-women's musical group that performs exclusively for other women in private homes. The name *hadarate* derives from the Moroccan Arabic word *hadra*, meaning "presence," referring to the state of transcendence or heightened meditation inspired by God or a possessing spirit or *jinn* (Kapchan 2007, 63). Women sing while beating rhythms on frame drums and small clay drums or using tea glasses on tea trays. Their repertoire includes the veneration of holy figures from Islam, singing songs of praises to the Prophet and various Sufi saints. There is a great deal of variation among the styles of women's *hadarate* groups, as they are influenced by the practices of local Sufi orders (Rausch 2000, 101). Given the overwhelming popularity of Gnawa music in Essaouira, the repertoire of the *hadarate* groups that I saw perform there was permeated with Gnawa influences. In fact, the Gnawa diviner Zaida Gania had her own group of *hadarate* who performed *lilas*. She explained to me that she remembers her grandmother doing the same for women who, out of modesty, preferred to experience possession in the company of other women rather than in front of men. Gania organized a *hadarate lila* for me in 2010 and allowed me to photograph her and the other women, since she was not possessed during the ceremony; rather she played rhythms on a tea tray and led the singing, causing many other women to become possessed by Gnawa spirits (Figure 6.15). While the musical instruments that she and the women in her group played were different, she followed a shortened version of the same repertoire of a Gnawa *lila*.

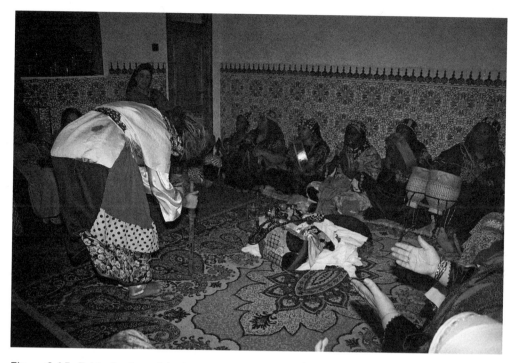

Figure 6.15. Zaida Gania and *hadarate* ceremony in Essaouira. Photograph by the author, 2010.

Hadarate groups have proliferated across Morocco in recent years, resulting in the creation of an international Women's Festival of Hadra and Trance Music that has been held in Essaouira each summer since 2012. During this festival, women allow themselves to be photographed and videotaped, presenting themselves on their own terms. These all-women groups dress in modest clothing with headscarves and elaborately embroidered gowns or matching kaftans to create a uniform stage presence. They play for large audiences that consist mostly of Moroccan women. During the fifth edition of the festival, the Algerian musician Hasna el Becharia, who has the distinction of being the first publicly recognized female *guinbri* player, performed *diwan* music, the Algerian version of Gnawa.

When Benhila painted the image of a woman playing a *guinbri* in 2008, very few Moroccan women played the instrument publicly. This has changed in the past five years with women seeking to become visible representatives of Gnawa identity in Morocco by adopting and mastering the *guinbri*.[9] The Gnawa Symphony at the 2018 International Festival of Merzouga ended with a performance by Hadia Ofkir, an Ismkhan woman from the southern town of Zagora, who performed on the *guinbri* (Figure 6.16). Ofkir figures among an increasing number of young women who play the *guinbri* in contemporary Morocco and was introduced during the festival as such. Her performance in public on a stage says a great deal about women's changing roles, especially in an area such as southeastern Morocco where modesty requirements result in

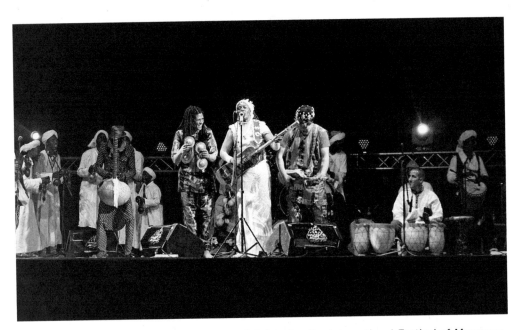

Figure 6.16. Hadia Ofkir performs on the *guinbri* during the International Festival of Merzouga. Photograph by the author, 2018.

women singing oral poetry (*ahidous*) with men while covering their faces. Hadia Ofkir disregarded these gender restrictions, and not only did she perform in public, she dressed formally, taking pride in her stage presence.

As previously discussed, young women have begun to perform Gnawa music in public. M'allem Mokhtar Gania encouraged his daughters and nieces to form a musical group called Bnate Gania, "Gania Girls," who occasionally play concerts with him in Essaouira, but they also perform at smaller festivals without his accompaniment, with one of Gania's daughters playing the *guinbri*. When I attended the 2016 Gnawa and World Music Festival in Essaouira, I interviewed M'allem Abdenbi El Meknassi and his all-female troupe of *qraqeb* players who call themselves Bnat Gnaoua ("Gnawa Girls") (Figure 6.17). The young women told me they were unmarried, and some were finishing their university degrees. A few worked as nurses or in the medical professions, which, Meknassi told me, "makes sense given that Gnawa music has healing properties. And women have always been key to a *lila*."[10] Meknassi's daughter Fatima Zahra performed with the troupe, learning Gnawa music from her father and joining the group because, as she said, she has Gnawa in her blood, "I find Gnawa music relaxes me. If you have stress and listen to it, it goes away."[11] All the women emphasized the healing nature of Gnawa music, but also stressed that they did not play at *lilas*. Rather, they concentrated on staged concerts, but they told me that they would probably stop playing once they married. For them, performing as Gnawa gave them a measure of freedom and an opportunity to travel.

Figure 6.17. M'allem Abdenbi El Meknassi and Bnate Gania. Photograph by the author, Essaouira, 2016.

The most successful and ambitious Gnawa female musician today is Asmae Hamzaoui, who is one of the only women in Morocco who plays the *guinbri* professionally, touring across Morocco and internationally to play concerts (Figure 6.18). When I interviewed her with her family in 2016, Asmae told me that she views the opportunity to perform with the *guinbri* as a feminist act:

> People had bad ideas about girls playing music with Gnawa. They would say that she should not be with them. What is she doing? But this is a false and misleading idea. Because if girls were not *tagnawit* [authentic Gnawa], men could not do the work of Gnawa. A woman organizes a *lila* so that the men can work. We want to overturn ideas that women can't do certain things. That is not true. Women can do lots of things. Thanks to God, that idea is in the past. People give me a great deal of respect because of my father. They know him and respect him. And I gain a lot of respect.[12]

Hamzaoui started to play at the age of seven, at home and under the guidance of her father, Rachid Hamzaoui, who is a Gnawa *m'allem*. This twenty-year-old woman with an amazing singing voice formed a professional musical troupe consisting entirely of women that she named Bnat Timbouctou, "Girls of Timbuktu." She collaborated with Malian singer Fatoumata Diawara at the 2018 edition of the Gnawa and World Music

Festival, earning the distinction of being the first female *guinbri* player to play a major concert at the festival (Figure 6.18). The pairing made sense since Diawara's lyrics refer to the emancipation of women, especially those in northern Mali who have been the victims of Islamic extremism in recent years. Both women use music to carry a message of liberation. Unlike the other female musicians whom I interviewed, Asmae also performs private Gnawa *lila*, assisting her father who passes the *guinbri* to her when he gets tired. Asmae noted that during a *lila*, the women of Bnat Timbouctou do not accompany her on the *qraqeb* as they do during staged concerts, stating that it would be difficult for women to have the stamina to perform on *qraqeb* for twelve hours straight, which is required for a *lila*. Asmae's ultimate goal is not to perform *lilas* but to be recognized internationally as a professional musician and artist. For Asmae Hamzaoui, identifying as "Gnawa" is a means to present herself as a professional musician, to travel the world, and to gain both local and international respect. Although she trained as a pastry chef, she admitted to me that she is able to achieve much more personal satisfaction and economic prosperity as a musician; through Gnawa music, she has negotiated a place of enterprise, creativity, and agency for herself outside gender norms.

As this chapter demonstrates, the *guinbri*, a modest, handmade instrument, has become a site of multiple meanings over the years. How the *guinbri* has been used and marketed over time reveals how Moroccans have responded to changing racial constructions,

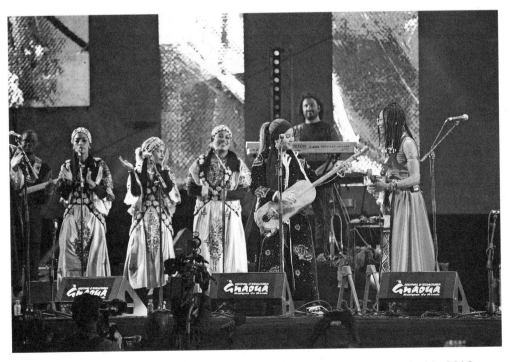

Figure 6.18. Asmae Hamzaoui in concert at the Gnawa and World Music Festival in 2018. Copyright festivalgnaoua2018-karim-tibari.

national politics, gender roles, and marketing strategies in an increasingly globalized world. An instrument associated with the marginality of enslaved Sahelian Africans, the *guinbri* has been adopted by youth in Morocco and beyond to protest and proclaim identity, to suggest national solidarity, and to reinforce a sense of belonging for those who exist on the fringes of society. What began as a taboo symbol associated with Blackness and otherness has become an icon that appeals to those both within and outside Morocco because of its very connection to alterity. It has moved from under the robes of the Black male musician and into the art world, and finally it has made its way into the hands of women.

Conclusion

Utopian Visions and Trans-Saharan Realities

IVEN THAT ESSAOUIRA IS HOME to Morocco's massive Gnawa and World Music Festival, it is no surprise that Gnawa music has impacted the dozens of artists who exhibit in the city's multitude of art galleries. In addition to high-end galleries, small and large art associations show local work in permanent and temporary gallery spaces to European and American tourists. `Abd El Gaouzi is among the many painters working in and near the city of Essaouira whose work is inspired by Gnawa practices. I met this Essaouira-born painter in 2013 when he was displaying his work in a tent set up just outside the city's eighteenth-century walls. As Figure C.1 demonstrates, El Gaouzi's artistic style stood out from the other artists selling at the fair that day. When I spoke with El Gaouzi, he explained that he never starts with a finished composition in mind, but as he works, forms emerge, much as spirits appear during Gnawa possession. His use of particular colors is also keyed to specific Gnawa spirits: red represents Sidi Hamu, the fiery master of the slaughterhouse; yellow the coquettish spirit Lalla Mira; and blue the soothing and calm Sidi Musa, a spirit associated with waters (see Appendix).

The popularity of a Gnawa-inspired painting style has been the direct result of active promotion by the Danish art dealer Frédéric Damgaard. Damgaard first visited Morocco in the 1960s and opened an art gallery in Essaouira in 1988, and his approach to art collecting and display concentrated on self-taught artists whose work featured bold colors, two-dimensional curvilinear patterns, and mythical creatures. The same year Damgaard opened his gallery, he met the twenty-nine-year-old Mohamed Tabal, who traveled the thirty-five kilometers from his village outside Essaouira to show his paintings to him. Damgaard encouraged him to paint full-time and to include scenes of Gnawa *lilas* in his work. This was largely due to Tabal's ancestry, as a dark-skinned musician living in the Amazigh countryside—musicians that locals call Ganga after the barrel drum that they play. Tabal's family took their surname from the Arabic word for the drum, *tbal*.

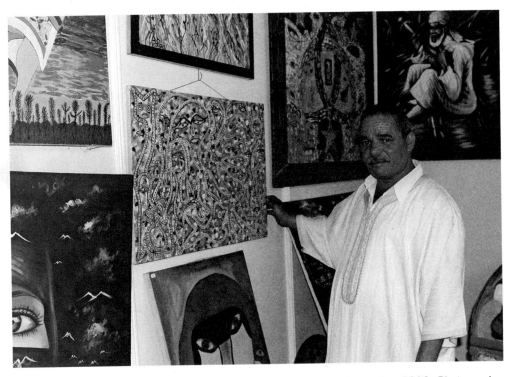

Figure C.1. Painter 'Abd El Gaouzi poses in front of his artwork, Essaouira, 2013. Photograph by the author.

Living in a village outside of Essaouira, Tabal's father supported the family by wandering from house to house across the countryside, playing his drum and dispersing his *baraka* (blessings) in exchange for money. Tabal joined him when he was a young boy and described their life of wandering from house to house and playing music as being difficult and impoverished. Frustrated and exhausted by his meager existence, Tabal moved to Casablanca in 1974 and joined a Gnawa troupe. He supported himself by performing for ten years, learning the repertoire of a Gnawa *lila*. It was only upon his return home, when he witnessed the burgeoning art market of Essaouira, that he began painting scenes from his daily life, hoping to sell them as an alternative to the hardships of the wandering musician's life.[1]

Until his retirement in 2006, Damgaard held exclusive rights to sell Tabal's work at his Essaouira-based Galerie d'Art Damgaard.[2] Damgaard actively promoted him as a Gnawa painter, featuring Tabal in numerous publications and international art exhibitions. In the edited volume *The Gnawa and Mohamed Tabal*, Damgaard described his role in shaping Tabal's work:

From the day we met, Tabal abandoned his drum and became a painter. Every week he brought me fascinating paintings, each more imaginative than the last. He drew inspiration

from his African roots and from the tradition of the Gnawa. His work did not reflect the conscious mind of the itinerant musician but was steeped in the mystic atmosphere of the Gnawa ritual and the fabulous tales told by traditional storytellers. His paintings brought Africa to life, in all its timeless, mysterious depth. I was so taken by Tabal's painting that, barely six months after our first meeting, I decided to organize a major exhibition of his work. (1997, 76)

Tabal, who paints on pressed wooden boards, fills his crowded compositions with scenes from a *lila*, including Gnawa musicians wearing sashes adorned with cowrie shells and performing for women who appear in the throes of possession (Plate 12). When I asked him about this painting, Tabal indicated that they were possessed by Lalla Mira, the spirit who loves the color yellow. The women wear long, formal dresses belted at the waist; Lalla Mira is so concerned by her appearance that some even apply makeup while possessed by her.

The primary author of the book *The Gnawa and Mohamed Tabal* writes that Tabal's "paintings are inhabited by the spirit which possessed his slave ancestors. They are alive with the rhythms of the ritual dances and the sound of the *guinbri* which brings together movement and colour" (Mana 1997, 113). His romantic characterization of Tabal as a visionary Gnawa painter can be seen as a marketing ploy that turns Gnawa spirituality into a commodity for the international art market. But this is no ploy as far as Tabal is concerned; he attributes his commercial success as a painter to the spirit Sidi Mimun, by whom he claims to be possessed when he paints. Tabal said that he performs ablutions before painting, similar to those performed by Muslims before prayer, to ensure that he is ritually pure and ready to receive his spirit. Engagement in the global art market has fed into his own conception of himself as a Gnawa artist.

Indeed, for Tabal, as for many Gnawa performers, there is no contradiction between the commercial and the spiritual. Given the abject poverty in which his life began, he holds out hope that his painting will enable him to support his family and that the end of his life "[will be] better than the beginning."[3] Tabal is continuing a long tradition of self-marketing that began in the nineteenth century as Gnawa musicians performed for the European camera, and, as we have seen throughout this book, the consumption of Gnawa culture by outsiders feeds back into its production, encouraging more artists follow Tabal's lead.[4] Damgaard's nurturing of the art scene in Essaouira led to the opening of dozens of galleries featuring artists working in a similar abstracted style, many of whom copy each other's work. In fact, on his Facebook feed Tabal often posts photographs of paintings in order to expose them as fakes, despite their featuring his signature and being done in his distinct painting style.

Clearly, many people seek to profit from the popularity of Gnawa culture, and as Damgaard noted as early as 1999, it has effectively permeated the larger Moroccan culture: "Morocco is located on the African continent—and one can draw inspiration from

the signs, symbols and colors of this [Gnawa] culture, one can even be an adept of Gnawa music without being either Black or Gnawi" (1999, 89). Whereas at the turn of the twentieth century Gnawa identity was closely linked to Blackness and enslavement, it is now available for all Moroccans to claim. Many young Moroccans who visit or live in Essaouira fashion their hair in Rastafarian hairstyles, walk shoeless, and dress in brightly colored clothing, as popular culture appropriates aspects of Gnawa culture associated with Africa.

Gnawa music and identity is being pulled in different directions. Young Moroccans adopt a Gnawa identity as a form of rebellion against conservative social norms. American listeners see Gnawa music as an "African retention" and an extension of the African diaspora (Aidi 2014, 153). Moroccans living abroad may adopt a Gnawa identity in order to profit from the world music circuit. The scholar Moulay Driss El Maarouf (2014) specifically describes the process by which cultural artifacts associated with Gnawa music circulate across geographic and cultural borders as resulting in a heightened awareness of the uneven process of cultural exchange. For example, musicians performing Gnawa music in New York City or London can freely travel the world and profit from music festivals. Those living in Morocco, however, might see themselves as more authentic, but they struggle to get a visa and "are gripped by cross-border disability" (El Maarouf 2014, 266). As this book has shown, anxiety about the commoditization of Gnawa music has contributed to practitioners debating who is authentic Gnawa (tagnawit), with people struggling to maintain control over scarce resources.

The rise in popularity of Gnawa music has coincided with a national dialogue about inequality and racism, which is largely due to the multitude of undocumented sub-Saharan migrants who have entered Morocco in recent years. In the last decade, the geographic location of the Maghreb on the northern border of the Sahara has made it a place of refuge and passage for migrants fleeing war, drought, and political oppression. Migrants from sub-Saharan Africa often experience precarious and dangerous conditions at the hands of smugglers, who sometimes abandon them in the Sahara. Spain and other European countries are pressuring North African countries to stop undocumented migrants from crossing into Europe, so some decide to stay in Morocco but describe the racism, fear, and marginalization they experience there. Thus, crossing the Saharan divide, both then and now, is a journey often marked by violence and exploitation (El Guabli and Jarvis 2018, 5). Today, it is now common to see West African women braiding women's hair in the market of Casablanca or men hawking goods on the sidewalk. The increased visibility of dark-skinned Africans in public resulted in a national dialogue about Morocco's historical and contemporary relationship with the African continent.

MOROCCO'S AFRICAN IDENTITY

As we have seen throughout this book, "Africa" (Arabic, Ifriqiya) and "African" are multivalent terms that may or may not be equated with Blackness. For hereditary Gnawa

musicians and diviners who learned music and spirit possession from their parents and grandparents, Africa as an identity is racialized as Black and assumes a connection to the Sudan (i.e., West Africa) and the history of enslavement. However, this version of Africa is very different from Moroccan Imazighen (Berbers), for whom the idea of "Africa" refers to the struggle to gain cultural autonomy from domination within the Arab-Islamic nation-state; "Africa" for them is not racialized as Black. However, there are complications: within the category of Imazighen is Ismkhan/Ismgan, a Tamazight word for "slaves" and a term also equated with Blackness. As Imazighen means "free people," a debate exists within Morocco as to whether the Black descendants of enslaved people can identify as Imazighen, with some asserting that the descendants of enslaved people cannot consider themselves "free" (Silverstein 2011).

The African identity of Imazighen is closely related to the cultural and political construction of Morocco as an Arab-Islamic nation during the postcolonial period, which coincided with efforts to distance it politically from the rest of the African continent. Morocco achieved independence in 1956, and King Hassan II came into power in 1961, strengthening the power of the monarchy, who was no longer referred to as a sultan but as a king. He established a constitution that declared the king as the final authority for each branch of government as well as the commander of the faithful, so that he also guided Muslim teachings. Hassan II fully controlled the political system and repeatedly emphasized the nation's Arab-Islamic ideology, adopting Arabic as the official national language of Morocco and estranging Imazighen. His relationship with the Organization of African Unity (OAU), a postcolonial continent-wide bloc, became fractious, as he preferred to trade with Europe than sub-Saharan Africa. The Saharan divide widened when Hassan II left the OAU in 1984 due to disputes over who controlled the Western Sahara, as the organization recognized the independence of the Sahrawi Arab Democratic Republic, despite Moroccan claims of absolute sovereignty. Throughout his thirty-eight-year reign, Hassan II worked to create economic and political links to Europe and the United States, rather than the African continent. Hassan II is often quoted as saying that Morocco has its roots in Africa but its foliage breathes in Europe, but his estrangement from the OAU meant that the Saharan divide widened (Cherti and Collyer 2015, 601; Bentahar 2011, 5).

After decades of alternating orientation toward the Arab world and Europe, Morocco entered the twenty-first century facing south. Since Mohammed VI became king in 1999, Morocco has increased its economic and social engagement with the African continent and has made Africa the focal point of the nation's foreign policy. The government provides scholarships to half of the sixteen thousand sub-Saharan African students who attend Moroccan universities, and King Mohammed VI has made more than forty visits to sub-Saharan African nations. Morocco has become the next largest investor in Africa after South Africa (Bozonnet 2017). In 2016, the king made a highly publicized tour of Rwanda, Ethiopia, and Tanzania, where he inaugurated the Mohammed VI

Mosque of Dar es Salaam and made plans to open a Moroccan embassy. The next year, Morocco rejoined the African Union (AU)[5] after a hiatus of thirty-three years, prompting the king to begin his remarks to the AU Summit in Addis Ababa (Ethiopia) with the following:

> It is so good to be back home, after having been away for too long! It is a good day when you can show your affection for your beloved home! Africa is my continent, and my home. I am happy at last and happily reunited with you. I have missed you all.[6]

During his speech, he also shared information about Morocco's "regularization" program to help bring undocumented sub-Saharan migrants who live on the fringes of society out of hiding. Since 2013 Morocco has granted legal residency to approximately twenty-four thousand migrants, mostly from African countries, with the goal of helping them gain access to employment, housing, and education (Lindsey 2017). An article in *Le Monde* in 2017 titled "Maroc: L'empire africain de Mohammed VI" (Bozonnet 2017) asserted that Morocco had no choice but to engage with the continent of Africa, being overpowered by the political power of Europe to the north and overwhelmed economically by the Gulf's oil monarchies in the east.

Taking advantage of the void left by Muammar Gaddafi's death in 2011, Morocco has also used its religious capital to engage with sub-Saharan Africa, namely the Tijani Sufi order, which is the most widespread in West Africa. The fact that its founder, Ahmad al-Tijani, is buried in the city of Fes provides Morocco with religious clout. Unlike the Moroccan elite and Salafists of the early twentieth century, Muhammed VI promotes Sufism as an expression of a tolerant and peaceful form of Islam, using it as a weapon to fight against Islamic extremism (Bozonnet 2017). The creation of a prominent festival to celebrate Gnawa music also contributes to these political goals.

Private enterprise has followed the government's lead, and in 2016, the Moroccan entrepreneur Othman Lazraq opened the Museum of African Contemporary Art Al Maaden (MACAAL) outside the city of Marrakech, featuring the family's private collection of contemporary art from the entire continent. In 2018 the 1–54 Contemporary African Art Fair was held in the city of Marrakech, drawing hundreds of gallery owners, curators, and collectors from around the world. On the occasion of 1–54, MACAAL organized its first temporary exhibition focused on the work of forty established and emerging photographers, titled *Africa Is No Island*, with the goal of emphasizing the continent's diversity and historical complexity. After living in Marrakech for more than fifty years, the Dutch museum owner Bert Flint received financial assistance from the Fondation Jardin Marjorelle to publish a catalog that reflected his perception of Morocco as an African nation. The title *La Culture Afro-Berbère, de tradition néolithique Saharienne en Afrique du nord et dans les Pays du Sahel* (2018) is based on the collection from his Marrakech-based museum, Musée Tiskiwin, which includes art from southern

Morocco, Niger, and Mali and emphasizes the African origins of Amazigh culture, which he refers to as Afro-Berber.

Countering this atmosphere of reunion and harmony between Morocco and the rest of the African continent, there continue to be conservative forces that tend toward divisions. Relations between Morocco and nations south of the Sahara are often strained due to what many perceive as Morocco's superiority complex and racist tendencies. For example, in 2015, Morocco asked for the African Cup of Nations soccer tournament but asked for it to be postponed due to fear of Ebola, despite the fact that Royal Air Maroc was the only airline to maintain its flights to countries affected by the Ebola outbreak. The Confederation of African Football, Africa's soccer-governing body, refused Morocco's request, fined them, and held the games in Equatorial Guinea instead. Such actions projected an image that Moroccans view sub-Saharan Africans as other, inherently dangerous and potentially disease-ridden.

In an article by the Tunisian historian Salah Trabelsi in *Le Monde* (2019), he asked, "How has the Maghreb come to reject its Africanity?" He attributed racial intolerance as a remnant of trans-Saharan slavery. Indeed, some Moroccans shout `abid (Arabic for slave) or the pejorative `azzi at dark-skinned people when they walk down the street. Unfortunately, the government's move to grant legal work permits to migrants from south of the Sahara has had the adverse effect of increasing the visibility of West African migrants, which has in turn led to increased racism and acts of violence, since they are viewed as economic competitors in a country with a high unemployment rate (Lindsey 2017). The large number of students in Morocco from countries located south of the Sahara, who often come from elite families, also complain of racism and marginalization and fear that they will be mistaken for undocumented sub-Saharan migrants, since the latter have been the victims of vicious attacks in recent years (Alexander 2019). In an interview with *Al Jazeera*, Camille Denis, from the organization Groupe antiracist de defense et d'accompagnement des étrangers et migrants, stated that "In [Moroccans'] minds, black skin equals undocumented" (Alami 2014).

During the past few years, a debate emerged concerning the negative experiences of sub-Saharans in Morocco. In 2014, several NGOs formed a collective called Papers for All (Papiers pour tous) and launched an antiracist campaign on March 21 to coincide with the International Day for the Elimination of Racial Discrimination. They went into action producing posters, banners, and T-shirts that featured the photographic portrait of a Black man with the Moroccan Arabic words *Masmiyitcih Azzi* and *Je ne m'appelle pas Azzi* in French (meaning "my name is not Azzi"). The campaign used the word `azzi, the pejorative Moroccan Arabic term for "Black," to bring awareness to the plight of sub-Saharan migrants, who may have received legal permits to stay in Morocco but are far from integrated into the society (Harit 2014). Its goal was to counter reports of migrants being subjected to police brutality, violence, and sometimes fatal attacks, as well as racially charged harassment. Morocco's culture of silence concerning issues of

racism has begun to erode as the targets of such incidents have become more public, vocal, and visible.

Dark-skinned Moroccans also fear being labeled and targeted as undocumented sub-Saharans, since, as recounted by Isabella Alexander, they often live in the same neighborhoods as migrant laborers (2019, 787). Over the years, I heard stories of dark-skinned Moroccans being bombarded with racist comments that continued until they responded in the local dialect of Arabic. Tensions quickly dissolved when these Moroccan nationals were able to prove their citizenship. Many Moroccans assert that referring to someone as ʿazzi or ʿabid is harmless; friends often tease each other using such terms.

How do dark-skinned people feel about the use of such language? For many, an ancestral connection to the Sudan and the history of enslavement remains an essential part of their identity. At the same time, it is important to note that theirs is not a utopian vision of the past. Gnawa performances preserve memories of the suffering entailed in trans-Saharan crossings and the atrocities committed against the enslaved. But such suffering is not only historical. An event that I experienced in Niger while traveling with Hamad Mahjoubi, the leader of Groupe des Bambaras from Khamlia, illustrates this point. Mahjoubi and I sat with Djeliba Badjé, a famous Zarma griot who recited local history while accompanied by a musician playing a plucked lute (molo). The performance lasted almost an hour as we listened to the griot recount the genealogies of noble ancestors and their feats of greatness. When Badjé's performance ended, he asked Mahjoubi to reciprocate and do the same on his guinbri, an instrument related to the molo. Clearly touched by the performance, Mahjoubi sadly responded that he could not do so, as he was the descendant of enslaved people and was uncertain of his origins and that of his people. While Gnawa lyrics do reference the Fulani, Bambara, and Hausa as ancestors, their songs do not contain the same level of specificity as the genealogy recited by Badjé.

While some Moroccans have been attempting to redress the racism and violence that sub-Saharan migrants experience, it is still rare for people to discuss the history of trans-Saharan slavery. Even at the Gnawa and World Music Festival, the history of trans-Saharan slavery remains largely invisible. Slavery is sometimes the topic of scholarly forums held during the daytime far from the main stages where musical performances occur after sunset, but the larger Moroccan public and Gnawa practitioners themselves rarely attend.[7]

The historian John Hunwick interpreted this absence of public dialogue as a sign of a lack of "Black consciousness" among the descendants of the enslaved in North Africa:

> On the one hand this could mean that former slaves became so successfully integrated into these Arabo-Berber societies that they have no cultural need to explore their remote past or question their present social status, and in one sense this may be true. . . . On the other hand, the lack of what may be called a "black voice" in the Mediterranean lands

may also be due to the relatively small number of clearly identifiable descendants of slaves and to their depressed social status and lack of education. (2002, xii)

Hunwick was correct that a poor education and economic marginality has contributed to the lack of studies written by Gnawa practitioners themselves. However, he was incorrect that descendants of the enslaved do not question their ancestors' predicament and the low status of many dark-skinned Moroccans today. Gnawa *lilas* give ceremonial form to a Black consciousness that draws authenticity from their connection to the Sudan and retains remnants of West African languages in a ceremonial context. As seen in chapter 3, certain songs performed during a *lila* call out the injustice of pagan status having been used to justify the enslavement of their ancestors. Furthermore, Gnawa practitioners embrace Timbuktu as a homeland, establishing group solidarity by connecting to a prestigious Muslim elsewhere on the other side of the Sahara. Black Moroccans can achieve social capital and income by working as diviners and musicians. Gnawa performances provide insight into how the enslaved used a racialized label to recount their historical experiences and give themselves a voice.

Historian Eve Troutt Powell wrote that the stories of the enslaved must "be both seen and heard and not relegated to the background of political and cultural affairs," because this history bears weight on the twenty-first century, especially in areas where people still experience racism and injustice (2002, xxvii). In contemporary Morocco, increased attention paid to racism against sub-Saharan migrants has contributed to the manifestation of Black consciousness among dark-skinned Moroccans, even in the visual arts. Artists are not simply presenting utopian visions of what it means to be Black but are confronting difficult social issues that have plagued Morocco for centuries. For example, curator Omar Berrada organized an exhibition of work by the Black artist M'barek Bouhchichi in 2016 at the Kulte Gallery in Rabat, Morocco. In the catalog's "Foreword," Berrada (2016) called for Moroccans to embrace their Africanity rather than let the nation's relationship to sub-Saharan Africa be determined by migration laws and economic investment strategies. Bouhchichi's work, Berrada explains, deals directly with the "wound of growing up black in Morocco" and contributes to presenting the little-known and rarely discussed history of racial discrimination experienced by Harratin. In one powerful work he presents the existence of a segregated cemetery in the region of Zagora with "Blacks" and "Arabs" buried in separate sections. He confronts this as a remnant of racism (Bouhchichi 2016, 11, 17–19). Unlike the artists El Gaouzi and Tabal, Bouhchichi's work does not romanticize a connection to Africa but squarely exposes the history of racial inequality in southern Morocco.

As I conclude this book, I turn to what initially drew me to this topic: my surprise to discover that people in rural southeastern Morocco still referred to themselves as Ismkhan, a word that means "slaves" in the local Amazigh language. I can remember Mbark, a very dark-skinned man, telling me, "When you see a pure *Ismkh*, a real black

slave, he is accepted. . . . We are accepted more than others with light skin because of *baraka* [blessings] from Bilal" (C. Becker 2002, 104). Then I recall a song performed during Ismkhan gatherings with the words "Let's unite, let's unite, people of Sudan." I am reminded that Black Moroccans see themselves as active agents who perform the history of their enslavement. Their Blackness unites them into unique communities where they bring spirits into the world to heal themselves and others. While there may not be any monuments to slavery and plaques do not mark the locations of former slave markets, the history of trans-Saharan slavery has not been forgotten. Gnawa visual and performing arts serve as a means through which the history of enslavement is remembered and Blackness remains relevant.

APPENDIX

Gnawa Spiritual Repertoire

This partial list of Gnawa spirits includes the colors preferred by spirits, the type of incense and food that they like, and some actions taken by spirits when they appear. The order in which they appear in this list is the order in which they typically appear during a ceremony in Essaouira. Spirits are organized into various groups, called *mhalla* in Arabic. Each spirit has a particular song with a distinct rhythm, melody, dance, and lyrics, and spirit songs from a particular *mhalla* are played together without stopping.

Group of Spirits (*Mhalla*)	Name or words repeated in song	Color of cloth worn by the possessed	Incense	Other accessories	Ceremonial foods or specific actions
Muslim Saints (*Salihin*)	Jilala	white	*jawi*		possessed slowly rocks back and forth
	Salat 'ala Nabi, meaning "Prayers upon the Prophet" in Arabic	white	*jawi*		possessed slowly rocks back and forth
	Mulay Abdelqader Jilali	white	*jawi*		possessed slowly rocks back and forth
	La ilaha illa Allah, meaning "there is no God but God" in Arabic	white	*jawi*		possessed slowly rocks back and forth
	Buderbala (also called *buhali*), meaning the "Wanderer" in Arabic	multicolored	*jawi*	patchwork tunic, basket filled with bread and and sugar	possessed wanders in crowd giving out bread and sugar

Group of Spirits (Mhalla)	Name or words repeated in song	Color of cloth worn by the possessed	Incense	Other accessories	Ceremonial foods or specific actions
Black Spirits (*Lkuhl*)	Lalla Mimuna	black	*jawi khal*	sash and hat with cowries	no specific type of dancing
	Sidi Mimun	black	*jawi khal*	lit candles	possessed holds flame to his/her body
	Fofo Denba	black	*jawi khal*	lit candles	possessed holds flame to his/her body
	Ghmami	black	*jawi khal*	dagger	possessed dances with dagger
	Keriya	black	*jawi khal*		possessed holds a cone of sugar
	Lalla `Aisha	black	*jawi khal*		passing a tray with black olives, olive oil, and bread (made without salt) for the crowd to consume
Spirits of the Sea (*Musawiyyin*)	Sidi Musa	light blue	*jawi*	bowl of water with benzoin, dried coriander, mint, and orange-flower water	possessed balances the bowl of water on her or his head
	Kubayli bala	light blue	*jawi*	knife	no specific type of dancing
Spirits of the Sky (*Samawiyyin*)	*Lef-a-briyi*, meaning "turn and circle," with *lef* coming from Arabic and meaning "turn"; *briyi* is from the so-called Sudani language	dark blue	*jawi*		possessed spins in a circle
	Bu landi ya samawi	dark blue	*jawi*		possessed spins in a circle
Spirits of the Slaughterhouse (*Mluk Lgourna*)	Sidi Hamu	red	*jawi hmar*	dagger	possessed saws at the skin and tongue as well as stabs self in stomach
	Hammuda	red	*jawi hmar*		possessed eats honey and passes it around for the crowd to partake

Group of Spirits (*Mhalla*)	Name or words repeated in song	Color of cloth worn by the possessed	Incense	Other accessories	Ceremonial foods or specific actions
Children of the Forest (*Uled Lghaba*)	*Marhaba w Allahya baba Marhaba b Sultan Lghaba*, meaning "Welcome, I swear to God, oh Father, Welcome to the sultan of the forest"	black	*jawi khal*	black cloth wrapped around the waist	possessed crawls back and forth toward musicians, stopping occasionally to beat his or her chest
	Sandy	black	*jawi khal*		no specific type of dance
	Bu Gangi	black	*jawi khal*	*qraqeb* (iron cymbals)	possessed hit themselves repeatedly on the head with *qraqeb*
	Serku Belayji	black	*jawi khal*	animal skin, tray filled with flour, sugar, orange-blossom water, parsley, and benzoin	people dance around the tray imitating wild animals; some wear animal skins and steal objects from the crowd and return them only when given money
	Juju Nama	black	*jawi khal*		possessed eats raw meat mixed with cumin, dried coriander, and black benzoin; possessed makes hands look like animal claws
	Lhensh, meaning "the snake" in Arabic	white	*jawi khal*	large white sheet, a bowl with a raw egg and mint	possessed stays under the sheet and sucks raw egg out of shell
Hussawiyine (a subgroup within *Uled Lghaba*)	Fulani	black	*jawi khal*		no specific type of dancing
	Bussiyi	black	*jawi khal*	net or fishing pole	possessed dances with the net or fishing pole as if fishing

Group of Spirits (*Mhalla*)	Name or words repeated in song	Color of cloth worn by the possessed	Incense	Other accessories	Ceremonial foods or specific actions
Saints (*Shurfa*)	Mulay Brahim	green	Oud Qmari, *jawi*, and orange-blossom water		no specific type of dancing
	Shamharush	green	Oud Qmari, *jawi*, and orange-blossom water	prayer beads and a white cloak	possessed covers face in cloak and holds beads while rocking back and forth aggressively
	Uled Sidi Hajaj	green	Oud Qmari, *jawi*, and orange-blossom water	white pigeon, tea glasses	possessed dances on broken tea glasses; pigeon sacrificed on top of the glass; person rubs broken glass on arms, face, and legs
Female Spirits (*Al ʿayalat*)	Hajja Malika Sudani	black	*jawi khal*		no specific type of dancing
	Muso Korni Nana, meaning "old woman came"	black	clove		possessed sniffs clove-like snuff and passes it around the crowd
	Dada Johra	black	*jawi khal*	silver jewelry	possessed wears silver rings on various toes and index finger
	Lalla Mira	yellow	musk, *jawi*, dried coriander	mirror and makeup	possessed applies makeup while looking in the mirror
	ʿAisha Gnawia	white	*jawi* and dried coriander		possessed eats raw meat
	Lalla Maryam Shelha	red	a small bag with *jawi*, dried coriander, *jawi khal*, Oud Qmari, and other herbs but no salt	cooked flour mixed with spices (*zamita*)	*Zamita* is passed around after possession ends
	Hajja Malika	mauve	Oud Qmari, perfume, gum Arabic	a tray with sweets, walnuts, dates, and almonds; a bottle of perfume	possessed tosses the food on the tray into the crowd and applies perfume

NOTES

INTRODUCTION

1. The precise origin of the word "Gnawa" remains unknown, and the historical opacity surrounding this term further illustrates the various cultures that contributed to the creation of this group. The historian Chouki El Hamel writes that Arabic texts from as early as the twelfth century used the words *janawa* or *kanawa* to designate a dark-complexioned person from West Africa. These terms, which may have led to the word "Gnawa," possibly derive from the word "Guinea" (Guinée in French) or the former West African Kingdom of Ghana that thrived from approximately 750 to 1076 CE in southeastern Mauritania and western Mali (2013, 275–76). Alternatively, I believe that the word may derive from Imazighen, the indigenous peoples of Morocco, who use the Tachelhit word *agnaw*, a possible cognate of "Gnawa," to describe a man who is mute or mumbles and is difficult to understand. It is conceivable that Imazighen used this word to describe an enslaved African whose native language was incomprehensible to them. Another possibility is that the term "Gnawa" migrated from the Kanuri region of southeastern Niger and northeastern Nigeria, an area that was heavily involved in the trans-Saharan slave trade. The Kanuri noun *ganawa*, which can mean the "little ones" or "inferior ones," referring to someone of lower status, such as a slave, is a possible cognate of "Gnawa."

2. An important commentary that reveals outsider attitudes toward enslaved communities can be seen in the nineteenth-century description of rituals by the West African scholar Al-Timbuktawi. Historian Ismael Montana translated Timbuktawi's condemnation of spirit-possession practices in Tunisia and Morocco as existing at odds with Islam; his goal was to encourage local authorities to ban them (2004). Studies of Black communities in Tunisia increased in the twentieth century and afterward, including Ferchiou 1991, Gouja 1996, Jankowsky 2010, Rahal 2000, and Tremearne 1914. Viviana Pâques (1964) wrote about enslaved communities in Libya, and Andrews (1903), Champault (1969), and Khiat (2006) discussed different regions of Algeria.

3. In this book, I use the terms sub-Saharan, West, western, and Sahelian to consider the region of Africa south of the Sahara, an area referred to by Moroccans as Sudan. *Merriam-Webster* (https://www.merriam-webster.com) defines West Africa as "the part of Africa lying north of the Gulf of Guinea excluding Western Sahara, Morocco, Algeria, and Tunisia."

4. The Gnawa and World Music Festival is run by a private company, but the Moroccan Ministry of Tourism organizes most other festivals in Morocco.

5. An exception is the 2006 article by Chouki El Hamel, "Blacks and Slavery in Morocco," published in *Diasporic Africa: A Reader*, which was edited by Michael Gomez.

6. See, for example, Boddy 1994, Johnson 2014, Lambek 2014, Masquelier 2001.

7. An overview of the historical origins of Sufism was given by Crapanzano (1973). He defines Sufism as a form of Islamic mysticism that seeks to escape the bondage of the self and achieve a union with God. With the development of Islamic law and theology, many Muslims viewed Sufis as practicing heterodoxy, as many followed the teachings of "saints." Referred to as *wali* in Arabic, a Sufi saint was someone whose holiness brought him near to God and, due to this closeness, often had the ability to perform miracles as a sign of God's favor. By the eighth century, Sufi gatherings may have included recitation of the Qur'an, the prolonged repetition of shorter phrases (*thikr*), as well as musical instruments and dancing. More extreme practices also featured religious ecstasy, tearing clothes, and self-mutilation, practices condemned by some Muslims (Crapanzano 1973, 15–16).

8. Today many people associate the word "Sudan" with the Republic of the Sudan in North-East Africa. In this book, Sudan corresponds to the historical use of the term *bilad al-Sudan*, which indicates western Africa south of the Sahara. It is also referred to as the western Sudan by scholars.

9. In Arabic, adding a suffix such as an "i" to the end of a noun, as in "Sudani," turns the word into a *nisba*, an adjective indicating a person's place of origin or ancestry, in this case as Africa, south of the Sahara. In fact, a prominent family of Gnawa musicians in Essaouira uses the family name "Sudani" to indicate their ancestral connection to Africa south of the Sahara and to proclaim their Blackness as a signifier of authenticity.

10. Badoual (2004, 343) also includes a similar list of terms in n. 16.

11. A compelling argument for capitalizing the B in Black was recently made by scholar Kwame Anthony Appiah (2020). Across the Middle East and North Africa (MENA), there is no one term that is equivalent to the English word "Black." A person may be described using various Arabic words for the color black, such as *khal* or *aswad*, but dark-skinned people across the MENA region typically reject such colorized terms as carrying pejorative connotations. In the Republic of the Sudan, for example, Afro-Arab is preferred, as many see themselves occupying a complicated space between the Arab world and the African continent. However, the experience of dark-skinned people varies a great deal across the MENA region, depending on whether one is talking about Afro-Arabs, national citizens with sub-Saharan African ancestry, or recent migrants from sub-Saharan Africa. Each has been integrated or excluded to a different extent and may experience varying degrees of privilege and/or discrimination (Amin 2020). Hence, the use of a singular term to describe the Black experience in the MENA region becomes extremely difficult, and racialized designations must be understood within their particular cultural and historical contexts.

12. See Rouch (1960) for information on Songhai possession. Also see Tremearne (1914). Information on *nya* possession can be found in Colleyn (1988).

13. I made three summer research trips to Niger, which involved attending Songhai and Hausa spirit-possession ceremonies and interviewing practitioners (2007, 2009, and 2011).

14. The Hausa *goge* was retained in some areas of North Africa, as it appears in early twentieth-century photographic postcards from Algeria and Tunisia.

15. For critiques of her work, see reviews by Fernandez (1968) and Gellner (1966).

16. The reference to Bilal may also suggest a more specific historical connection to Manding speakers in West Africa. Praise singers (griots) in the Manding oral tradition begin the epic of Sundjiata, which recounted the founding of the Empire of Mali in the thirteenth century, by evoking the name "Bilali," clearly derived from Bilal. This is likely meant to suggest that the founders of the Empire of Mali are historical descendants of the Prophet's *muezzin*, but it is, in fact, an imagined history. David Conrad noted that the figure of Bilal also began to occupy an important role in Manding oral traditions in the nineteenth century; however, it is likely that their evocation of Bilal extends back to medieval times. The inclusion of the character of Bilal in Gnawa oral history and performances may actually derive from enslaved Manding speakers brought north across the Sahara, replicating aspects of Manding oral genealogy in Morocco. Furthermore, a connection to Bilal allowed Gnawa to claim that they were unjustly enslaved, since, during the medieval period, Muslim jurists debated whether or not Sahelian Africans who identified as Muslim could be enslaved or not. It is by virtue of the *baraka* inherited from Bilal, a formerly enslaved man, that Gnawa have taken on their role as healers within Morocco. See David Conrad (1983).

17. This book has been supported by numerous grants that have allowed me to do extensive archival and field research, including a Fulbright-Hays grant to Morocco (2009–10) and a fellowship at the Radcliffe Institute (2009–10).

18. A few art and architectural historians have attempted to cross the Saharan divide by looking at the impact of Islam in West Africa (see, for example, Bravmann 1983 and Prussin 1986). René Bravmann in his 1983 publication *African Islam* wrote that "Africa and Islam have made something of each other that is fertile and enduring" and that "secures them [sub-Saharan Africans] a sense of place within the Islamic community" (16). Bravmann has the distinction of being the first art historian to write about Gnawa spirit-possession practices, which he valuably compared to similar ones in Burkina Faso. However, in his endeavor to study the "creative interactions between Islam and traditional African artistry and values" (Bravmann 1995, 58), he maintained a rigid distinction between "Islam" and "traditional Africa" without acknowledging that both are historically constructed categories. Regardless, his article remains one of the few to even consider artistic interactions between sub-Saharan Africa and North Africa.

19. Johnson and Foster's edited volume *Dress Sense: Emotional and Sensory Experiences of the Body and Clothes* was written to honor the renowned scholar of African textiles and dress, Joanne Eicher.

1. FROM ENSLAVEMENT TO GNAWA

1. French spelling is Gnaoua, but this word is also uncommon in written texts until the early twentieth century.

2. Companies such as George Washington Wilson & Company sold lantern-slide sets of Morocco out of their headquarters in Scotland in the 1880s. Washington's online archive, however, did not show any photographs of Gnawa musicians; as this is not a complete collection of all of Washington's inventory, it is possible that photographs of Black musicians simply do not exist in this particular archive. See https://www.abdn.ac.uk/special-collections/george-washington-wilson.php.

3. Photographs from the Moroccan colonial archive can be found in the United States at such archives as the Library of Congress, the Getty Museum, as well as the National Museum of American History Archives Center. Collections in France and Morocco include the Archives Gabriel Veyre in Paris, the Ministère des Affaires Etrangère in Nantes, the Archives Nationales du

Maroc in Rabat, and the Maison de la Photographie in Marrakech. Photographs of colonial-era Morocco, many of which were turned into the postcards discussed here, can also been seen in the Roger-Viollet photo agency in Paris.

4. The original in French is "Foullah, Il y a un chevalet sur lequel passent des cordes." Since the note cannot be discerned in either online or published reproductions of the image, I corresponded with Louvre curator Christophe Leribault on February 18, 2010, who examined the original image for the exact words.

5. See Bry (1874) for an account of Raffet's travels.

6. The studio was originally called Cavilla & Co. Then it was renamed Cavilla & Molinari and finally became A. Cavilla. Cavilla died in Tangier in 1908 at the age of forty-one. See https://antoniocavilla.blogspot.com/2015/03/biografia.html.

7. Although the photographer was not listed on the postcard, I was able to identify him as Cavilla, since the original photograph from which this postcard was made exists in the private collection of Xavier Guerrand-Hermès.

8. Cavilla's photograph was used to illustrate the story of Ion Perdicaris's kidnapping in Morocco. See Perdicaris (1906, 135).

9. The cards of this "friend of the tourists" are similar to the so-called "Roi de Dakar" who posed in Senegal for French tourists and in return received gifts (in the 1880s). Special thanks to Christraud Geary for pointing this out to me. The Senegalese case is discussed in Hickling (2014).

10. The person who composed the postcard's caption wrote *Yaouled*, a misnomer deriving from the Arabic word *uled*, meaning "sons" or "children."

11. Christraud Geary, personal communication, January 2018.

12. None of the captions used on these postcards or the messages written on them, however, uses "Gnawa" or a similar term to describe this man, despite the fact that he plays a musical instrument associated with Gnawa musicians today. While we know that postcard captions were created in Europe by people uninformed about the photograph's subject, the absence of this word indicates that the moniker "Gnawa" was not in common use by Europeans in the early twentieth century.

13. In Tunisia, the ruler Ahmad Bey outlawed the sale of slaves in 1842 and in 1846 made slavery illegal. The French, who had occupied Algeria since 1830, outlawed slavery there in 1848.

14. Enslaved people were not exported to Europe in the nineteenth century but were still sold in the Moroccan urban markets of Fes, Marrakech, Meknes, and Taza. In the coastal towns of Tangier and Essaouira, slaves were led through the streets of the market by an auctioneer (*dallal*) on certain days of the week for sale to Moroccan purchasers.

15. The term "ba" was commonly given to the eunuchs who guarded the sultan's *harem* and to the servers of the sultan himself. See Badoual (2004, 341).

16. The largest slave army was assembled by Moulay Ismail, and it was estimated to have consisted of 150,000 Black men when he died in 1727 (Hell 2002, 73; Meyers 1977, 435). Moulay Ismail's Black Guard became known in Arabic as `Abid al-Makhzen, meaning "slaves to the government" or `Abid al Bukhari, meaning "slaves of al Bukhari," for the oath of allegiance to the sultan that they pledged on al Bukhari's *hadith*, one of the most trusted collections of the words and deeds of the Prophet Muhammed and a fundamental source for Islamic law (El Hamel 2008a, 248; El Hamel 2013, 163). After his death, the sultanate continued to be supported by Black soldiers, who were displayed in public as a sign of the sultans' power, especially during times of turmoil. By the nineteenth century, the procession of the sultan with his Black Guard had become a spectacle

that drew the attention and curiosity of Europeans, who featured it prominently in sketches, written lore, paintings, and photographs. This image also became a common visual trope of early twentieth-century photography.

17. This holiday is often referred to in Morocco as `Aid el Kebir, or "the Great Sacrifice" in English. It involves the sacrifice of a ram in order to reenact the offering made by Abraham in place of his son.

18. Sultans in the Kingdom of Morocco were supported by armies of soldiers enslaved from Sahelian Africa. This started with the conquest of Timbuktu, and the defeat of the Songhai Empire in 1591 resulted in the enslavement of thousands of men and women by Sultan Ahmad al-Mansur, the leader of the Sa`adian Dynasty that ruled Morocco between 1549 and 1659. Al-Mansur (ruled 1578–1603) conscripted men from among those Sahelian Africans he enslaved into his army and forcibly married them to enslaved women (El Hamel 2013, 152). In Morocco, Al-Mansur initiated massive processions on the Prophet's birthday and held court in his newly built, sumptuous palace (Combs-Schilling 1989, 158–61; Cory 2013, 176–78). Al-Ifrani, a scribe and historian in Al-Mansur's court, wrote a firsthand account describing how the sultan, dressed entirely in white, was followed by a procession of enslaved Black soldiers, an image that was imitated by later sultans and replicated by painters and photographers in the nineteenth century (Al-Ifrani 1889, 241).

19. This same statement was repeated in Dermenghem (1954, 285).

20. As previously discussed, French ethnographies reinforce this early date since G. Salmon wrote in 1904 that Gnawa in Tangier wore "shells and glass beads" on their bonnets (264).

21. Since the Rastafarian movement began in the 1930s, the Gnawa are clearly not imitating dreadlock hairstyles, which postdate both the formation of Gnawa communities and the documentation of this headdress style in photographic images.

2. BLACK WOMEN, PHOTOGRAPHIC REPRESENTATION, AND FEMALE AGENCY

1. Jewish Moroccans adopted photography in the early twentieth century more readily than Muslims, photographing events and architectural spaces of interest to the Jewish community.

2. An exception to this in early twentieth-century Morocco were the Jewish photographers who opened the earliest photographic studios and concentrated on portraying Jewish life. Many of these studios were opened in European areas of Moroccan towns, which, during the colonial period, were divided into European and indigenous Moroccan sections.

3. For a discussion of the Swahili elite embracing photography and other forms of Western technology to engage in a globalized sense of modernity, see Meier (2013, 102–4).

4. Prita Meier's book *Swahili Port Cities* demonstrates that women forced to pose at the presentation palace built by the Zanzibari Sultan Barghash in the 1870s turns them into decorative objects. Meier identifies them as "bonded or servant women called *wapambe*, a term that means 'the ornamented ones' in Ki-Swahili" (2016, 120–21).

5. The original defines the term *nègre* as "personne appurtenant à la race noire/esclave noire/personne qui vit dans l'assujetissement."

6. Even more invisible than enslaved women of urban households are Black women in rural settings. In fact, rural men are also absent from the photographic record, suggesting that rural Black laborers, both female and male, were not picturesque or exotic enough to be turned in commodifiable images, and/or that European photographers did not have access to them. The exclusion of rural life further demonstrates the point made in chapter 1 that manumitted slaves often

traveled to urban centers, such as Tangier, to pose in the photographic studios set up by Europeans, posing in exchange for economic remuneration.

7. As discussed in this book's Introduction, a Moroccan determined by the majority population to be dark-skinned may be described by the simple neutral Arabic word for the color black (*khal*) or "Sudani" (meaning from the region of West Africa), as well as a number of other words denoting slight differences in complexion and physical appearance. Given the close association between Blackness and slavery in Morocco, the words `abda (female slave) or *khadima* (female worker) were also used to refer to women with dark-skinned phenotypes.

8. The film can also be accessed on the website "What We Learn from Anthropology" (https://dun.unistra.fr/ipm/uoh/anthropologie/en/ressources.html#), and a transcription of the film's text can be read in both English and French.

9. He used the term "Sahara," which is understood in a Moroccan context as referring to the woman as "Black."

10. Deborah Kapchan included a discography in her book *Traveling Spirit Masters* (2007, 312–13). Randy Weston's first recording with Gnawa musicians was done in 1959 and his second in 1990.

11. A Gnawa female diviner is referred to as a *mqaddema* (*mqaddemat*, plural) in Arabic.

12. My translation of the woman's comments from Moroccan Arabic to English is: "They just want me to keep moving these things. What's this? The *Mluk* [spirits]. What's this? The *Jnun* [spirits]. May they [the spirits] come to them [the filmmakers]." I would not translate *jnun* as "demons," as this gives the impression that Gnawa are involved in something sinister.

13. The same scene was also included in the film *Les 7 couleurs de l'Univers* (The 7 colors of the universe) (2005), but it also did not include the complete translation.

14. Similarly, the filmmakers see themselves as decoding an essential, core, authentic Gnawa identity. Throughout the film, as Pâques claims to deconstruct the code of the Gnawa cosmological system, she uses the definite article "the" (*les* in French) before the noun "Gnawa," subtly imposing upon these people a unified identity, suggesting that they form a cohesive unit and share a worldview. As discussed in this book's Introduction, in Moroccan Arabic, the article "the" (*el* in Arabic) is not used by locals before the word Gnawa. Moroccans themselves use the word *tagnawit* to describe "Gnawa-ness," "Gnawa identity," or "Gnawa authenticity." As a cultural mediator, Viviana Pâques contributed to the branding and marketing of Gnawa as a distinct culture.

15. Naji's individual photographs were published in a catalog by Galería Rafael Pérez Hernando in Madrid (2005), but she also used them to create her video work, which was shown in the exhibition *Snap Judgments* held at New York's International Center of Photography in 2006.

16. At the end of a *mqaddema*'s annual *lila*, she performs *kharij lmida*, or "taking out of the table." Everyone sits down, and the *mqaddema* passes out small bowls filled with such ceremonial foods as honey, milk with raisins, clove, and sugar, milk mixed with orange-blossom water, eggs, and *zamita* (cooked flour mixed with spices). Based on my experience, the *mqaddema* also passes out bowls with henna for women to apply to their hands, and the atmosphere is celebratory, as the diviner's annual obligations to the spirits have been met. See Diouri (1994) for more detailed information on Gnawa ceremonial foods.

17. In Arabic, the word *uled* can mean "sons" and "children" in English, but I decided to use the more gender neutral term "children."

3. *FRAJA* PERFORMANCES

1. For the different ideas concerning the Harratin and their origin, see Camps (1970), Dunn (1977), Hell (2002, 73), El Hamel (2013, 156–57), and Meyers (1977). Scholars debate whether

these dark-skinned menial laborers in southern Morocco are an ancient Black population who came to the north from so-called sub-Saharan Africa during Neolithic times or whether they are the descendants of enslaved people who intermarried with Berbers and Arabs. After the decline of the Sa`adian Dynasty, Sultan Moulay Ismail (ruled 1672–1727) sought to reassemble a large army of Black slaves. By this point in Moroccan history, the link between Blackness and slavery had become cemented, so much so that Sultan Moulay Ismail forcibly conscripted Harratin into his army, much to the dismay of Islamic scholars at the time who argued against enslaving fellow Muslims (El Hamel 2013, 163–71). Moulay Ismail argued that the Harratin's dark phenotypes and subservient status betrayed their slave heritage and that they should return to their original role in Moroccan society (Badoual 2004, 345; El Hamel 2002; El Hamel 2013). Although some Muslim clerics spoke out against the sultan's enslavement of Muslims, arguing that it was against the tenets of the Qur'an to enslave Black Muslims simply because of their dark skin, the sultan ignored their protests (El Hamel 2013, 183). The oath of loyalty among enslaved men was meant to ensure their allegiance to the sultan. Black soldiers, therefore, represented a diverse, hybrid community unified by their subaltern status as "others" due to their dark phenotypes.

2. Interview with Abdenbi El Meknassi by the author, Essaouira, June 2016.

3. Having spent more than twenty years getting to know southeastern Morocco on an intimate level, I witnessed Harratin and Ismkhan families leave the region for the cities of Meknes, Fes, Marrakech, and elsewhere. Oral histories indicate that this also happened in the past.

4. In 2007 the annual monthly income for a Moroccan family was US$398.86 for rural families and US$618.81 for urban families. According to Morocco's national statistical agency, Haut Commissariat au Plan, a Moroccan family of five needs a monthly income of US$181 to live above the poverty line. See Hamelin et al. (2016, 54).

5. Possessed spirits are referred to as *jinn, jwad,* "beneficial ones," or as *malk,* meaning "owner" (plural, *mluk*). For a detailed discussion of the multiple meanings of the word *malk* in Moroccan Arabic, see Chlyeh (1998, 38–40).

6. Masquelier (2001, 67–71) writes that the anti-*bori* sentiments of some Muslims have led to a decline in these practices. Meanwhile many *bori* adherents blame the onset of disease or other tragedies in their villages to their failure to set up a boundary between their villages and the bush, which allowed malevolent spirits to enter (2001, 73).

7. See Fuson (2009, 264–65). Kapchan (2007, 37) interprets the word *la`fu* as meaning "blessing from God," but I choose to use the word "healing." Since blessings are the means by which healing occurs, the idea of blessing is implied in the term's usage.

8. I am defining a song as a discrete set of lyrics accompanied by a distinct dance style and musical rhythm.

I collected sixteen individual *Uled Bambara* songs, each of which deploys specific styles of dress, dance, choreography, and song lyrics that associate Gnawa with Blackness and slavery and, in doing so, serve as lamentations of the treatment of their ancestors. The songs are sung in the past tense and address the historical circumstances surrounding the enslavement of people in the Sudan, exposing their suffering as they were forced to migrate across the Sahara.

9. M`allem Mokhtar Gania called this song *Salat `ala Nabi,* meaning "Prayers upon the Prophet." During this performance, musicians do not use metal cymbals but clap their hands to the rhythm of the *guinbri.* While the reason for this is uncertain it may be for the pragmatic reason that clapping allows people to hear the words being sung.

10. The inclusion herein of the concept of *hogra* was influenced by a dissertation workshop held by the American Institution of Maghreb Studies in October 2017. I read and commented on

an excellent chapter of Kristin Hickman's dissertation (2019) on Moroccan Arabic (*darija*) and the concept of *hogra*. I thank her for sharing her chapter's bibliography with me.

11. Gnawa musicians told me the word *bangar* is a Sudani term. It derives from an unknown West African language, and it is likely that its meaning has been lost or its pronunciation changed over time, making it unrecognizable. Further complicating its translation is the fact that words identified as Sudani by Gnawa vary a great deal, not just from place to place or group to group but from person to person. For example, the ethnomusicologist Timothy Fuson wrote that the Gnawa musicians he recorded sang the word *bangara* rather than *bangar* (2009, 330). The term *bangar* may even derive from the word "Wangara," a term historically used to refer to members of the Soninke diaspora who engaged in trade, but the name took on different meanings at different locales during different time periods. As demonstrated by Andreas W. Massing, the use of "Wangara" as an identity term across West Africa seems to have been commonly used to describe people involved in the trans-Saharan trade and the propagation of the Islamic faith (Massing 2000).

12. Jean Bazin (1985) reports that the first use of "Bambara" by a French scholar dates to the 1912 publication of *Haut-Sénégal-Niger* by Maurice Delafosse, revealing a European desire to classify and categorize African groups under convenient ethnic terms. The historical picture is made even more complex by the fact that the arrival of colonialism led these so-called Bambara slaves to join the section of the French army known as the Senegalese infantrymen (*tirailleurs sénégalais*) in order to achieve social mobility. France used Senegalese infantrymen to assist in their military conquest of Morocco. In fact, the Gnawa diviner Zaida Gania recounted to me that her maternal grandfather was part of this Senegalese army, eventually settling in the country where he was posted.

13. Mande refers to a family of ethnic groups in West Africa who speak related languages and includes various groups of people identified as Soninke, Bamana, and Jula.

14. The role of guns in African history helps to further unpack the meanings compressed in the *fraja* dance. In West Africa, for example, before European traders brought guns in large numbers to exchange for slaves in the second half of the seventeenth century (Law 1976, 122), a Moroccan army equipped with muskets invaded and overthrew the largely gunless West African Sahel in 1591, overtaking the Songhai Empire and enslaving many people.

15. One exception is a style of musical performance called Dakka of Marrakech, which includes a very large version of these cymbals.

16. The ethnomusicologist Lois Anderson speculated that the Tunisian *shqashiq* could have entered North Africa during the Ottoman occupation in the sixteenth century. In Turkish, the word *sak* means a "clacking noise, such as wood against wood," and a *sakur* refers to a rattle. Turkish shadow plays performed in North Africa included characters from sub-Saharan Africa and were accompanied by music played with similar cymbals (Anderson 1971, 160).

17. This contrasts with the playing style in Tunisia where they are not fastened together and the playing technique allows them to reverberate; pulling the two plates far apart between each articulation and holding them slightly askew results in a sound louder than the Moroccan *qraqeb* (Jankowsky 2010, 104).

18. According to this logic, the existence of iron cymbals in West Africa means that these instruments, originally made of wood or bone, recrossed the Sahara in the form of iron instruments and made their way back into West Africa to be adopted by Dagbamba blacksmiths and other groups (cited in Erlmann 1986, 14).

19. Interview with Omar Hayat, Essaouira, December 2010.

20. Pâques wrote that the symbolic purpose of a Gnawa spirit-possession ceremony was to reunite the body of the primordial blacksmith that had been fragmented and dispersed at the

beginning of the universe (1991, 80). While Pâques wrote that "the Gnawa" no longer retained a memory of this belief system, she believed it could be reconstructed and inferred through an intense study of their movements and analysis of their ceremonial practices, including the performance of music.

21. Interview Issahaku El Hassan, Tamale (Ghana), August 2017.

22. A similar event happened in the Mzab (Goichon 1927, 46–47) and in the oasis of Tabelbala (Champault 1969, 389), both of which are located in southern Algeria.

23. Interview with Abdelkarim `Asiri, Essaouira, June 2016.

4. SPIRITS IN THE NIGHT

1. The word *jawi* refers to a gum resin (sap) that possesses a sweet, vanilla-like odor when it is burned. It is collected from the *Styrax benzoin* tree that is native to tropical Asia, especially Sumatra in Indonesia. There are three types of *jawi* used in a Gnawa *lila* distinguished by color: white, black, and red. Interestingly, white *jawi* is only referred to as *jawi* while the black and red *jawi* are identified by their color.

2. Unpublished personal memoir of Solange Andrews (née Bartilon) written in English and dating from the 1950s. She was born in Rabat in 1932.

3. Brika refers to the waist beads worn in some areas of West Africa as a sign of beauty by women. Apparently some enslaved women wore them in Morocco.

4. I witnessed the same phenomenon in rural southeastern Morocco where the descendants of enslaved people re-created a slave market at their annual festival and participated in the fictive buying of children. People whose children had died requested that their children be bought by them, to fall under their protection. See C. Becker (2002).

5. Emilio Spadola noted that curing rites contribute to the informal economy in the city of Fes as well and that musicians and diviners are paid similar sums (2014, 140).

6. Kristina Wirtz's discussion of spirit possession in Cuba also demonstrates that even when spirits are characterized as useful, if not properly handled and pleased with their human hosts, they can be potentially destructive (2014, 117).

7. Interview with Hajja Brika, 2009.

8. Interview with Hajja Brika, 2009.

9. Abdelhafid Chlyeh writes that the word *mhalla* (plural *mhallate*) is from Arabic military vocabulary and designates a battalion of soldiers (1998, 40). In *A Dictionary of Modern Written Arabic*, Hans Wehr defines the singular form as a "stopover," a "camp," and a "quarter (of a city)," signaling that the word is also used to refer to particular stages in the *lila* (1980, 200).

10. See Chlyeh (1998) and Kapchan (2007) for a list of spirits.

11. Fuson and Jankowsky acknowledge that in Morocco and Tunisia, respectively, people refer to individual songs as a *nuba*, a word coming from the classical Arabic *nawba*, meaning "turn," since the possessed seek a turn to dance with their spirits (Fuson 2009, 115; Jankowsky 2010, 68).

12. The original French is "les nègres ou plus simplement les metis y sont en nombre élevé."

13. As discussed in this book's Introduction, Bilal is a figure from Islamic history, an enslaved Abyssinian man (i.e., black) who became one of the first followers and a close companion of the Prophet Muhammed, and the religion's first *muezzin* (person who performs the call to prayer).

14. Interview with Abdellah Gania, December 7, 2010.

15. These Gnawa spirits resemble the bush-dwelling, black Hausa *bori* spirits. See Abdalla (1991, 43). Abdalla discussed how after the Fulani *jihad* of 1804, Nigerian Hausa divided *bori* spirits into

beneficial, tame farm-dwelling ones who were understood to be Muslim, and untamed, wild black bush spirits associated with evil and impurity. In other words, Muslims viewed certain spirits as pre-Islamic and classified them as dangerous and wild. Some spirits engaged in acts people classified as non-Islamic, such as drinking alcohol and animal blood and smearing themselves with feces, while Muslim "white spirits" presented themselves as Fulani and wore large-brimmed hats and white clothing associated with Muslims.

16. The Spanish scholar Jodi Aguadé wrote that he recorded an elderly Moroccan man speaking a language people referred to as *gnawiyaa* and "Bambara," but when he played the recording to native speakers in Mali, Niger, and Senegal, none understood what the Moroccan was saying (2002, 407). Aguadé was able to identify some words as deriving from the Hausa language (2002, 410).

17. These spirits of the wilderness consist of three families, including *Ganji Kwarey* (White spirits of the Wild), *Ganji Bi* (Black spirits of the Wild), and *Hausa Ganji* (Hausa Spirits) (Idrissa and Decalo 2012, 26; Stoller 1989, 26–27). As noted by Paul Stoller, who uses the spelling *Genji*, these various families of spirits emerged during periods of Songhai historical contact and crisis, with *Genji Kwari* (his spelling) deriving from first contact with light-skinned Islamized Tuareg, while *Genji Bi* refer to the spirits of the land and represent the earliest populations of Songhai. *Hausa Genji* are held responsible for severe misfortune and chronic illness, and the possessed are dressed as herdsmen and merchants, having entered the Songhai pantheon following Hausa migration into Songhai territory in the late nineteenth century (Stoller 1989, 19, 27).

18. Bertrand Hell noted that the snake spirit, whom he referred to by the name of *Bala Bala Dima*, and whom he designated "The Killer," was a particularly dangerous spirit (2002, 350). A year later, I saw similar feats of possession at a Haitian Vodou ceremony in Mattapan, a suburb of Boston. A woman was possessed by a spirit (*lwa*) named Damballah, described as a snake; she fell to the floor and was covered by a sheet. Members of this Vodou shrine waved a sheet over her body as she was offered a raw egg. The possessed woman later told me that she cracked it open with her mouth and sucked the yolk and egg white out, similar to those possessed by snake spirits during a Gnawa *lila*.

19. The musicological connection between the Gnawa song performed for Lalla ʿAisha and that of the Hamadsha was confirmed by ethnomusicologist Timothy Fuson, who notes that the musical structure of Lalla ʿAisha's song is distinct from other Gnawa songs, retaining traces of its Hamadsha origins (2009, 117). I was told by Gnawa diviners that there were seven ʿAishas who could appear during a ceremony, including ʿAisha Hamdushiya (ʿAisha Qandisha), ʿAisha Sudania, ʿAisha al Baharia, ʿAisha Gnawia, and others.

20. In his book on Hamadsha practices, Victor Crapanzano wrote that "her Sudanese origin is almost universally accepted," and he recounts that some say she was a real woman and the former slave of Sidi ʿAli ben Hamdush, the founder of the Hamadsha brotherhood who lived in Morocco in the late seventeenth and early eighteenth centuries (1973, 1). According to Crapanzano, Sidi Ahmed Dhughi was the servant and follower of Sidi ʿAli ben Hamdush. Both men founded distinct brotherhoods known as Hamadsha, but the followers of Sidi Ahmed tend to be much poorer and have dark complexions. Crapanzano wrote that some Hamadsha believed that Sidi Ahmed Dhughi, the servant of Sidi ʿAli, found ʿAisha while traveling to Mecca by way of the Sudan, and he returned to Morocco with her (Crapanzano 1973, 44). In Niger, a similar female spirit is said to prowl through city streets, attracting men with her slim figure and beautiful eyes, hiding her hooves (and therefore her spirit identity). This spirit manifests with both repulsive animality and alluring human sexuality (Masquelier 2001, 53).

21. People often reported to me that a spirit "struck" or "hit" them (using the Arabic verb *drb*). Deborah Kapchan noted that the same verb was used in her conversations with Gnawa practitioners (2007). Although Gambori did not describe his father as being married to ʿAisha Qandisha, some men describe their relationship with ʿAisha as a sexual one (Crapanzano 1980).

22. Vincent Crapanzano wrote about how the Hamadsha ceremony placated ʿAisha Qandisha. In order to pacify this spirit, members of the brotherhood danced to her rhythm played by a *ghita* (a type of horn), often pulling out knives and performing a trance dance (*hadra*) while slashing their heads and, as a result, curing themselves. Crapanzano interpreted cutting the head as a symbolic castration, allowing a man to pass through feminization and become a man again (1980, 224–27).

5. MARKETING GNAWA AUTHENTICITY

1. I refer to this female leader by the honorific term Hajja, a name that was used locally due to her pilgrimage to Mecca. In this section of the chapter, I refer to Zaida Gania as Zaida and Hajja Latifa Essaguer, as Hajja Latifa. I chose to do this rather than use their last names because the family name Gania is repeated throughout this chapter to refer to various people and because Latifa Essaguer was locally known as Hajja Latifa. It is not meant as a sign of disrespect to refer to them by their first names.

2. The name "Gnawa" is spelled Gnaoua by festival organizers, which conforms to the French spelling. I chose to use the English spelling "Gnawa" throughout this book.

3. As noted by Deborah Kapchan, the word *tagnawit* resulted from adding the Tamazight prefix "*ta*" and the suffix "*t*" to the word *Gnawi*, which in Moroccan Arabic is a noun of identity. The addition of a Tamazight syntactical construction transferred the word *Gnawi* into a noun of attribution. Thus using the phrase *huwa Gnawi* in Moroccan Arabic means "he is Gnawa," whereas ʿand-u tagnawit means "he possesses [the qualities, or attributes of] Gnawa-ness" (Kapchan 2007, 23).

4. The name literally translates to mean "Shrine of Our Master Bilal."

5. Mulay ʿAbdellah ben L-Husin's shrine is at Tamesloht and Hajj Bu Brahim at Mulay Brahim. This was the location of decades of research done by French anthropologist Viviana Pâques. See chapter 2 for more information.

6. The Zawiya of Sidna Bilal featured a room with a *mihrab* built into one wall. This room, which was typically closed, could be used for prayer. The addition of rooms for prayer was also a common feature of Sufi shrines.

7. Moroccan women generally prefer to undergo healing rituals given by other women.

8. Cones of sugar are common low-cost gifts that Moroccans bring to weddings; they are seen as a sign of hospitality. Sugar is broken off the cone and used to make hot tea, a popular daily beverage in Morocco.

6. THE GNAWA *GUINBRI*

1. The word "Guinea" (Guinée in French) is one of the oldest and most widely used European terms to describe West Africa. William Bovill writes that a derivation of the word "Guinea" first appears on European maps in 1320 when the word "Gunuia" was used by a Genoese cartographer and later in 1375 when it appeared in the Catalan Atlas as "Ginyia." The use of the word "Guinea" to refer to the West African coast dates back to 1481 when the Portuguese king referred to himself as the Lord of Guinea after building the trading post of São Jorge de Mina (the contemporary Elmina located in Ghana) (1958, 119, n. 1).

2. Interview with André Azoulay, August 19, 2011.

3. Henry George Farmer (1928) wrote that both the West African and North African lute have an ancient Egyptian ancestry but Charry argues that lutes in West Africa have an indigenous origin (1996, 3).

4. The sound of the much larger *guinbri* differs from Sahelian and Saharan lutes, which are tuned to a much higher pitch than the deep resonant tones of the Gnawa *guinbri* (Fuson 2009, 9).

5. Interview with Adil Amimi, Essaouira, June 27, 2011.

6. Interview with Adil Amimi, Essaouira, June 27, 2011.

7. Although Essaouira has been constructed as a center of Gnawa culture, largely due to the creation of the Gnawa and World Music Festival in 1998, in fact Gnawa musicians exist throughout urban Morocco, including Casablanca, Meknes, Fes, Tetouan, Marrakech, and other cities.

8. The spelling in Morocco is often "Gnaoua," revealing the influence of French, while Anglophones use the spelling "Gnawa." In an article that I wrote for the *Journal of North African Studies* in 2001, I described the annual Ismkhan healing ceremony in great detail, ending the article with a discussion of how Ismkhan see themselves in relation to Gnawa musicians. By the time the article was published, Ismkhan had renamed themselves "Gnaoua of Khamlia" to profit from the popularity of Gnawa music.

9. The most recognizable female musician to play the *guinbri* was Hasna el Becharia from Algeria, but she performed staged concerts rather than hold private spirit-possession ceremonies.

10. Interview with M`allem Abdenbi El Meknassi, May 13, 2016.

11. Interview with Fatima Zohra Meknassi, May 13, 2016.

12. Interview with Asmae Hamzaoui, May 13, 2016.

CONCLUSION

1. Interview with Mohamed Tabal, Morocco, summer 2006.

2. When Damgaard arrived in Essaouira in the 1980s, the painter Boujemaa Lakhdar (1941–89) had been appointed curator of the city's Musée Sidi Mohammed Ben Abdellah, from which position he made important contributions to the development of an art scene in the city (Damgaard 1999, 41–42). Lakhdar has the distinction of being the only Moroccan artist featured in the Paris-based exhibition *Les magiciens de la terre* (1989). This controversial exhibition, which featured self-taught non-Western artists alongside academically trained ones from Europe and the United States, aimed to eliminate the distinction between fine art and folk art, or craft. The exhibition's title suggested that artistic practice was a universal, spiritual phenomenon that connected artists, regardless of their origin or educational background. The exhibition received a great deal of criticism because the contrast between self-taught non-Western and academically trained Western artists was interpreted by some as merely exoticizing the former as "primitive" folk art. Despite Damgaard's retirement and the sale of the gallery to Belgian owners in 2006, his successful art gallery, Galerie d'Art Damgaard, retains his name.

3. Interview with Mohamed Tabal, Morocco, summer 2006.

4. Tabal has achieved more success than most Essaouiran artists and was included in the exhibition *Contemporary Morocco* at the Institut du Monde Arabe (IMA) in 2014, an exhibition that featured works by academically trained Moroccan artists alongside handwoven textiles and works by other self-taught artists. One of the IMA curators was Jean-Hubert Martin, who also curated the 1989 exhibition *Les magiciens de la terre*, an experience that certainly influenced the eclectic mix of artists included in the IMA show, including Tabal.

5. The Organization of African Unity was renamed the African Union in July 2002. For more information about the OAU and AU, see Adejo (2001).

6. A complete transcript of his speech was published in English at the Kingdom of Morocco website: http://www.maroc.ma/en/royal-activities/full-speech-hm-king-28th-african-union-summit.

7. I participated in such a forum on the history of trans-Saharan slavery in 2000, and among the participants were the scholars Mohammed Ennaji, Paul Lovejoy, Martin Klein, Ghislaine Lydon, and Chouki El Hamel. Very few locals attended the conference. Each year the festival organizes an off-site forum. In 2018, the theme was "The Imperative of Equality." For a critique of the 1999 conference on "Trance Practices" held at the Gnawa and World Music Festival, see Lincoln (2000).

BIBLIOGRAPHY

Abdalla, Ismail. 1991. "Neither Friend nor Foe: The Malam Practitioner—Yan Bori Relationship in Hausaland." In *Women's Medicine: The Zar-Bori Cult in Africa and Beyond*, edited by I. M. Lewis, Ahmed Al-Safi, and Sayyid Hurreiz, 37–48. Edinburgh: Edinburgh University Press.

Abu-Lughod, Ibrahim. 1970. "Africa and the Islamic World." In *The African Experience*, vol. 1, edited by John Paden and Edward Soja, 545–67. Evanston, Ill.: Northwestern University Press.

Achy, Lahcen. 2002. "Labor Market and Growth in Morocco." Labor and Demography 0512007, University Library of Munich. https://econwpa.ub.uni-muenchen.de/econ-wp/lab/papers/05 12/0512007.pdf.

Adejo, Armstrong. 2001. "From OAU to AU: New Wine in Old Bottles." *African Journal of International Affairs* 4 (1& 2): 120–41.

Aguadé, Jordi. 2002. "La langue de gnawa." In *Aspects of the Dialects of Arabic Today*, edited by Abderrahim Youssi, 405–11. Rabat: Proceedings of the Fourth Conference of the International Arabic Dialectology Association, Marrakesh.

Aidi, Hisham. 2014. *Rebel Music: Race, Empire, and the New Muslim Youth Culture*. New York: Random House, 2014.

Ait Mous, Fadma. 2013. "The Moroccan Nationalist Movement: From Local to National Networks." *Journal of North African Studies* 18 (5): 737–52.

Alami, Aida. 2014. "'My Name Is Not Negro.'"*Al Jazeera*, April 16. https://www.aljazeera.com/news/middleeast/2014/04/name-not-negro-2014467119127512.html.

Alexander, Isabella. 2019. "Trapped on the Island: The Politics of Race and Belonging in Jazīrat al-Maghrib." *Journal of North African Studies* 24 (5): 786–806.

Al-Ifrani, Muhammad al-Saghir ibn Muhammad. 1889 [1700s]. *Nozhet-Elhadi [Nuzhat al-hadi]: Histoire de la dynastie Saadienne au Maroc (1511–1670)*. Translated and edited by O. Houdas. Paris: Leroux.

Alloula, Malek. 1986. *The Colonial Harem*. Minneapolis: University of Minnesota Press.

Almeida, Cristina Moreno. 2016. "'Race' and 'Blackness' in Moroccan Rap: Voicing Local Experiences of Marginality." In *American Studies Encounters in the Middle East*, edited by Alex Lubin and Marwan M. Kraidy, 81–105. Chapel Hill: University of North Carolina Press.

Alpers, Edward. 2000. "Recollecting Africa: Diasporic Memory in the Indian Ocean World." *African Studies Review* 43 (1): 83–99.

Ames, David W. 1965. "Hausa Drums of Zaria." *Ibadan* 21: 62–79.

Amin, Bahira. 2020. "Anti-Blackness in the Arab World and the Violence that Doesn't Get a Hashtag." *Scene Arabia*, June 10. https://scenearabia.com/Life/Arab-Anti-Blackness-Racism-and -the-Violence-that-Doesn-t-Get-A-Hashtag.

Anderson, Benedict. 1991. *Imagined Communities: Reflections on the Origin and Spread of Nationalism*. London: Verso.

Anderson, Lois Ann. 1971. "The Interrelation of African and Arab Musics: Some Preliminary Considerations." In *Essays on Music and History in Africa*, edited by Klaus Wachsmann, 143–69. Evanston, Ill.: Northwestern University Press.

Andrews, J. B. 1903. *Les Fontaines des Génies (Seba' Aioun): Croyances soudanaises à Alger*. Alger: Typographie Adolphe Jourdan.

Appadurai, Argun, ed. 1986. *The Social Life of Things: Commodities in Cultural Perspective*. Cambridge: Cambridge University Press.

Appiah, Kwame Anthony. 1993. "Art and Secrecy." In *Secrecy: African Art that Conceals and Reveals*, edited by Mary H. Nooter, 14–17. New York: Museum for African Art.

Appiah, Kwame Anthony. 2020. "The Case for Capitalizing the *B* in Black." *The Atlantic*, June 18. https://www.theatlantic.com/ideas/archive/2020/06/time-to-capitalize-blackand-white/61 3159/.

Apter, Andrew. 2004. "Herskovits's Heritage: Rethinking Syncretism in the African Diaspora." In *Syncretism in Religion: A Reader*, edited by A. M. Leopold and J. S. Jensen, 160–84. New York: Routledge.

Arnaud, L. 1940. "Étude anthropologique de la Garde Noire des Sultans du Maroc." *Bulletin de l'Institut d'Hygiène du Maroc* 10: 35–76.

Arnoldi, Mary Jo. 1995. "Wrapping the Head." In *Crowning Achievements*, edited by Mary Jo Arnoldi and Christine Mullen Kreamer, 126–37. Los Angeles: Fowler Museum.

Arnoldi, Mary Jo, Christraud M. Geary, and Kris L. Hardin, eds. 1996. *African Material Culture*. Bloomington: Indiana University Press.

Asiri, Abdulkarim. 1999. `Alam Toqous waalalwan dakhil layla gnawiya. Essaouira: Sefrioui.

Badoual, Rita Aouad. 2004. "'Esclavage' et situation des 'noirs' au Maroc dans la première moitié du XXe siècle." In *Les relations transsahariennes à l'époque contemporaine*, edited by Laurence Marfaing and Steffen Wippel, 337–60. Paris: Karthala.

Badoual, Rita Aouad. 2013. "Slavery and the Situation of Blacks in Morocco in the First Half of the Twentieth Century." In *Revisiting the Colonial Past in Morocco*, edited by Driss Maghraouih, 143–56. New York: Routledge.

Bargery, Rev. G. P., and D. Westerman. 1934. *A Hausa-English Dictionary and English-Hausa Vocabulary Compiled for the Government of Nigeria with Some Notes on the Hausa People and Their Language*. London. Oxford University Press.

Barnes, Ruth, and Joanne B. Eicher, eds. 1992. *Dress and Gender: Making and Meaning in Cultural Contexts*. New York: Berg.

Barthes, Roland. 1981. *Camera Lucida*. New York: Hill and Wang.

Barthes, Roland. 1990. *The Fashion System*. Translated by M. Ward and R. Howard. New York: St. Martin's.

Bauer, Susanne, Anton Escher, and Sebastian Knieper. 2006. "Essaouira: 'The Windy City' as a 'Cultural Product.'" *Erdkunde* 60 (1): 25–39.

Bazin, Jean. 1985. "A chacun son Bambara." In *Au Coeur de l'ethnie: Ethnie, tribalism et étata en Afrique,* edited by Jean-Loup Amselle and Elikia M`Bokolo, 87–127. Paris: Éditions La Découverte.

Becker, Cynthia. 2002. "'We Are Real Slaves, Real Ismkhan': Memories of the Trans-Saharan Slave Trade in the Tafilalet of South-Eastern Morocco." *Journal of North African Studies* 7 (4): 97–121.

Becker, Cynthia. 2006. *Amazigh Arts in Morocco: Women Shaping Berber Identity.* Austin: University of Texas Press.

Becker, Cynthia. 2009. "Matriarchal Nomads and Freedom Fighters: Transnational Amazigh Consciousness and Moroccan, Algerian, and Nigerien Artists." *Critical Interventions* 5 (Fall): 70–101.

Becker, Cynthia. 2011. "Hunters, Sufis, Soldiers, and Minstrels: Trans-Saharan Derivations of the Moroccan Gnawa." *RES: Anthropology and Aesthetics* 59/60 (Spring/Autumn): 124–44.

Becker, Cynthia. 2016. "Visual Culture and the Amazigh Renaissance in North Africa and Its Diaspora." In *Islam and Popular Culture,* edited by Karin van Nieuwkerk and Mark Levine, 100–121. Austin: University of Texas Press.

Becker, Gerd. 2004. "'Transes Saharienne-Transsahariens': Une contribution ciné-ethnographique à propos des cultes d'obsessions des Gnawa du maroc. " In *Les relations transsahariennes à l'époque contemporaine,* edited by Laurence Marfaing and Steffen Wippel, 379–400. Paris: Karthala.

Belmenouar, S. 2007. *Rêves mauresques: De la peinture orientaliste à la photographie coloniale.* Paris: Hors Collection.

Benachir, Bouazza. 2001. *Négritudes du Maroc et du Maghreb: Servitude, cultures à possession et trans-thérapies.* Paris: L'Harmattan.

Benjelloun, Mohamed Othman. 2002. *Projet national et identité au Maroc.* Paris: L'Harmattan.

Bensusan, Samuel Levy. 1904. *Morocco: Painted by A.S. Forrest, described by S. L. Bensusan.* London: Adam and Charles Black.

Bentahar, Ziad. 2010. "The Visibility of African Identity in Moroccan Music." *Wasafiri* 25 (1): 41–48.

Bentahar, Ziad. 2011. "Continental Drift: The Disjunction of North and Sub-Saharan Africa." *Research in African Literatures* 42 (1): 1–13.

Berger, John. 1972. *Ways of Seeing.* London: BBC/Penguin Books.

Berrada, Omar. 2016. *The Africans.* Casablanca: Kulte Editions.

Berzock, Kathleen Bickford, ed. 2019. *Caravans of Gold, Fragments in Time: Art, Culture, and Exchange across Medieval Saharan Africa.* Princeton, N.J.: Princeton University Press.

Berzock, Kathleen Bickford, and Christa Clarke, eds. 2011. *Representing Africa in American Art Museums.* Seattle: University of Washington Press.

Besancenot, Jean. 1990. *Costumes et types du Maroc.* Aix-en-Provence: Édisud.

Besmer, Fremont E. 1983. *Horses, Musicians & Gods: The Hausa Cult of Possession-Trance.* South Hadley, Mass.: Bergin & Garvey Publishers.

Blanchard, Pascal, and Armelle Chatelier. 1993. *Images et colonies: Nature, discours et influence de l'iconographie coloniale liée à la propagande coloniale et à la représentation des Africans et de l'Afrique en France, de 1920 aux Indépendances.* Paris: ACHAC.

Boddy, Janice. 1989. *Wombs and Alien Spirits: Women, Men, and the Zar Cult in Northern Sudan.* Madison: University of Wisconsin Press.

Boddy, Janice. 1994. "Spirit Possession Revisited: Beyond Instrumentality." *Annual Review of Anthropology* 23: 407–34.

Bonsal, Stephen. 1893. *Morocco as It Is, with an Account of Sir Charles Euan Smith's Recent Mission to Fez.* New York: Harper.

Boone, Sylvia. 1986. *Radiance from the Waters: Ideals of Feminine Beauty in Mende Art*. New Haven, Conn.: Yale University Press.

Bouasria, Abdelilah. 2015. *Sufism and Politics in Morocco: Activism and Dissent*. New York: Routledge.

Boum, Aomar. 2012a. "Festivalizing Dissent in Morocco." *Middle East Report* 263: 22–25.

Boum, Aomar. 2012b. "'Sacred Week': Re-experiencing Jewish-Muslim Coexistance in Urban Moroccan Space." In *Sharing the Sacra: The Politics and Pragmatics of Inter-Communal Relations around Holy Places*, edited by Glen Bowman, 139–55. New York: Berghahn.

Bourdieu, Pierre. 1977. *Outlines of a Theory of Practice*. Translated by Richard Nice. Cambridge: Cambridge University Press.

Bovill, Edward William. 1958. *The Golden Trade of the Moors*. London: Oxford University Press.

Bozonnet, Charlotte. 2017. "Maroc: L'empire africain de Mohammed VI." *Le Monde*, January 27. https://www.lemonde.fr/international/article/2017/01/27/maroc-l-empire-africaine-de-moham med-vi_5070071_3210.html.

Bravmann, René. 1977. "Gyinna-Gyinna: Making the Djinn Manifest." *African Arts* 10 (3): 46–52.

Bravmann, René. 1983. *African Islam*. Washington, D.C.: Smithsonian Institution Press.

Bravmann, René. 1995. "Islamic Spirits and African Artistry in Trans-Saharan Perspective." In *Islamic Art and Culture in Sub-Saharan Africa*, edited by Adahl Karin and Berit Sahlstrom, 57–69. Uppsala: Uppsala University.

British and Foreign Anti-slavery Reporter. 1844. "Mr. Richardson's Mission to Morocco." 5 (9): 74–75.

Brunel, René. 1926. *Essai sur la confrérie religieuse des 'Aissaoua au Maroc*. Paris: Paul Geuthner.

Brunel, René. 1955. *Le monachisme errant dans l'Islam: Sidi Heddi et les Heddawa*. Paris: Librarie Larose.

Bry, Auguste. 1874. *Raffet: Sa vie et ses oeuvres*. Paris: Librarie de la Societé de l'Histoire de l'Art Francais.

BTI (Bertelsmann Stiftung's Transformation Index). 2016. "Morocco Country Report." Gütersloh: Bertelsmann Stiftung. https://bti-project.org/content/en/downloads/reports/country_report_2016_MAR.pdf.

Burke, Edmund III. 1976. *Prelude to Protectorate in Morocco: Precolonial Protest and Resistance, 1860–1912*. Chicago: University of Chicago Press.

Callaghan, David. 2002. "Out of the Theatres and into the Streets: Crossing Cultural Borders in the Work of the Living Theatre, 1970–75." *Works and Days* 39/40, vol. 20 (1 and 2): 53–73.

Camps, Gabriel. 1970. "Recherches sur l'origine des cultivateurs noirs." *Revue de l'Occident musulman et de la Méditerranée* 7: 35–45.

Carr, Barry. 1998. "Identity, Class, and Nation: Black Immigrant Workers, Cuban Communism, and the Sugar Insurgency, 1925–1934." *Hispanic American Historical Review* 78 (1): 83 116.

Carter, Donald. 2010. *Navigating the African Diaspora*. Minneapolis: University of Minnesota Press.

Champault, Dominique. 1969. *Une oasis du Sahara nord-occidental Tabelbala*. Paris: Éditions du Centre National de la Recherche Scientifique.

Charry, Eric S. 1996. "Plucked Lutes in West Africa: An Historical Overview." *Galpin Society Journal* 49: 3–37.

Charry, Eric S. 2000. *Mande Music: Traditional and Modern Music of the Maninka and Mandinka of Western Africa*. Chicago: University of Chicago Press.

Cherti, Myriam, and Michael Collyer. 2015. "Immigration and Pensée d'Etat: Moroccan Migration Policy Changes as Transformation of 'Geopolitical Culture.'" *Journal of North African Studies* 20 (4): 590–604.

Chlyeh, Abdelhafid. 1998. *Les Gnawa du Maroc: Itinéraires initiatiques, trance et possession*. Paris: Editions le Fennec, Le Pensée Sauvage.

Chmirou, Youssef, ed. 2013. "Pourquoi nous somme racistes?" *Zamane: L'histoire du Maroc* 36 (Novembre).

Cissé, Youssouf Tata. 1994. *La confrérie des chasseurs malinké et bambara: Mythes, rites et récits initiatiques*. Paris: Éditions Nouvelles du Sud/Association ARSAN.

Claisse, Pierre-Alain. 2003. *Les Gnawa Marocains de tradition loyaliste*. Paris: Editions L'Harmattan.

Clarke, Christa, ed. 2017. *Arts of Global Africa: The Newark Museum Collection*. Seattle: University of Washington Press.

Cole, Catherine M., and Tracy C. Davis. 2013. "Routes of Blackface." *TDR: The Drama Review* 57 (2): 7–12.

Colleyn, Jean-Paul. 1988. *Les Chemins de Nya: Culte de possession au Mali*. Paris: Éditions de l'École des hautes études en sciences sociales.

Colleyn, Jean-Paul. 2001. *The Art of Existence in Mali*. New York: Museum for African Art.

Collier, Patrick. 2012. "Imperial/Modernist Forms in the *Illustrated London News*." *Modernism/Modernity* 19 (3): 487–514.

Comaroff, John L., and Jean Comaroff. 1991. *Of Revelation and Revolution*, vol. 1: *Christianity, Colonialism, and Consciousness in South Africa*. Chicago: University of Chicago Press.

Comaroff, John L., and Jean Comaroff. 2009. *Ethnicity, Inc*. Chicago: University of Chicago Press.

Combs-Schilling, M. E. 1989. *Sacred Performances: Islam, Sexuality, and Sacrifice*. New York: Columbia University Press.

Conquergood, Dwight. 2013. *Cultural Struggles: Performance, Ethnography, Praxis*. Edited by E. Patrick Johnson. Ann Arbor: University of Michigan Press.

Conrad, David. 1983. "Maurice Delafosse and the Pre-Sunjata *trône du Mande*." *Bulletin of the School of Oriental and African Studies* 46 (2): 335–37.

Conrad, David. 1985. "Islam in the Oral Traditions of Mali: Bilali and Surakata." *Journal of African History* 26 (1): 33–49.

Cory, Stehen. 2013. *Reviving the Islamic Caliphate in Early Modern Morocco*. New York: Routledge.

Cotte, Narcisse. 1860. *Le Maroc contemporain*. Paris: Charpentier, Librarie-Éditeur.

Cowie, Elizabeth. 2007. "Specters of the Real: Documentary Time and Art." *differences* 18 (1): 87–127.

Crapanzano, Vincent. 1973. *The Hamadsha: A Study in Moroccan Ethnopsychiatry*. Berkeley: University of California Press.

Crapanzano, Vincent. 1980. *Tuhami, Portrait of a Moroccan*. Chicago: University of Chicago Press.

Cyffer, Norbert, and John Hutchinson. 1990. *Dictionary of Kanuri Language*. Providence, R.I.: Foris Publications.

Dale, Kathryn. 2011. "A Celebration of Empire: Nostalgic Representations of l'Inde française in Chocolat Suchard's Colonial Collecting Cards of the 1930s." In *France's Lost Empires: Fragmentation, Nostalgia and La Fracture Coloniale*, edited by Kate Marsh and Nicola Frith, 31–42. New York: Rowman & Littlefield.

Damgaard, Frédéric. 1997. "The Birth of a Gnawi Painter." In *The Gnawa and Mohamed Tabal*, edited by Abdelkader Mana, 75–81. Casablanca: LAK International.

Damgaard, Frédéric. 1999. *Essaouira: Histoire & creations*. Salé: Imprimerie Beni Snassen.

Daoud, Kamel. 2016. "Être noir en Algérie." *Jeune Afrique*, May 17. http://www.jeuneafrique.com/mag/323695/societe/etre-noir-algerie-kamel-daoud/.

Dermenghem, Émile. 1954. *Le Culte des saints dans l'Islam maghrébin*. Paris: Gallimard.

Diouri, Abdelhaï. 1994. "Lahlou: Nourriture sacrificielle des Gnaoua du Maroc." In *La Alimen-tación en las culturas Islámicas*, edited by Manuela Marín and David Waines, 169–216. Madrid: Agencia Espanola de Cooperación Internacional.

Doutté, Edmond. 1908. *Magie et religion dans l'Afrique du Nord*. Algiers: A. Jourdan.

Doutté, Edmond. 1921. "Essai dur l'histoire des conferee marocaines." *Hespéris* 1: 141–59.

Doy, Gen. 1998. "More than Meets the Eye: Representations of Black Women in Mid-Nineteenth Century French Photography." *Women's Studies International Forum* 21 (3): 305–19.

Drewal, Henry. 2005. "Senses in Understandings of Art." *African Arts* 38 (2): 1, 4, 6, 88, 96.

Driessen, Henk, and Willy Jansen. 2013. "The Hard Work of Small Talk in Ethnographic Field-work." *Journal of Anthropological Research* 69 (2): 249–63.

Du Bois, W. E. B. 1903. *The Souls of Black Folk*. Chicago: A. C. McClurg.

Dunn, Ross. 1977. *Resistance in the Desert: Moroccan Responses to French Imperialism, 1881–1912*. London: Croom Helm; Madison: University of Wisconsin Press.

Durán, Lucy. 1995. "Birds of Wasulu: Freedom of Expression and Expressions of Freedom in the Popular Music of Southern Mali." *British Journal of Ethnomusicology* 4 (Special Issue: Presented to Peter Cooke): 101–34.

Durán, Lucy. 2003. "Women, Music, and the 'Mystique' of Hunters in Mali." In *The African Dias-pora: A Musical Perspective*, edited by Ingrid Monson, 136–86. New York: Routledge.

Echard, Nicole. 1991. "The Hausa *Bori* Possession Cult in the Ader Region of Niger: Its Origins and Present Day Functions." In *Women's Medicine: The Zar-Bori Cult in Africa and Beyond*, edited by I. M. Lewis, Ahmed Al-Safi, and Sayyid Hurreiz, 64–80. Edinburgh: Edinburgh Uni-versity Press.

Edwards, Elizabeth. 2001. *Raw Histories: Photographs, Anthropology, and Museums*. Oxford: Berg.

Edwards, Elizabeth. 2013. "Looking at Photographs: Between Contemplation, Curiosity and Gaze." In *Distance and Desire: Encounters with the African Archive*, edited by Tamar Garb, 48–69. New York: Steidl.

Eicher, Joanne, ed. 1995. *Dress and Ethnicity: Change across Space and Time*. Oxford: Berg.

Eickelman, Dale F. 1976. *Moroccan Islam: Tradition and Society in a Pilgrimage Center*. Austin: Uni-versity of Texas Press.

El Guabli, Brahim, and Jill Jarvis. 2018. "Violence and Politics of Aesthetics: A Postcolonial Maghreb without Borders." *Journal of North African Studies* 23 (1–2): 1–12.

El Hamel, Chouki. 2002. "'Race,' Slavery and Islam in Maghribi Mediterranean Thought: The Question of the *Haratin* in Morocco." *Journal of North African Studies* 7 (3): 29–52.

El Hamel, Chouki. 2006. "Blacks and Slavery in Morocco." In *Diasporic Africa: A Reader*, edited by Michael Gomez, 177–99. New York: New York University Press.

El Hamel, Chouki. 2008a. "Constructing a Diasporic Identity: Tracing the Origins of the Gnawa Spiritual Group in Morocco." *Journal of African History* 49: 241–60.

El Hamel, Chouki. 2008b. "Surviving Slavery: Sexuality and Female Agency in Late Nineteenth and Early Twentieth-Century Morocco." *Historical Reflections* 34 (1): 73–88.

El Hamel, Chouki. 2013. *Black Morocco: A History of Slavery, Race, and Islam*. New York: Cam-bridge University Press.

El Maarouf, Moulay Driss. 2014. "Nomadicates: Staging Roots and Routes in the Essaouira Gnawa Festival." *Globalizations* 11 (2): 255–71.

El Mansour, Mohammed. 1990. *Morocco in the Reign of Mawlay Sulayman*. Wisbech, UK: Middle East and North African Studies Press.

Ennaji, Mohammed. 1999. *Serving the Master: Slavery and Society in Nineteenth-Century Morocco.* Translated by Seth Graebner. New York: St. Martin's Press.

Enwezor, Okwui, ed. 2006. *Snap Judgements: New Positions in Contemporary African Photography.* New York: International Center of Photography.

Erlmann, Veit. 1986. *Music and the Islamic Reform in the Early Sokoto Empire: Sources, Ideology, Effects.* Stuttgart: Steiner-Verlag-Wiesbaden-GmbH.

Euba, Akin. 1965. "Nigerian Music." *Ibadan* 21: 53–61.

Fanon, Franz. 1967. *Black Skin, White Masks.* Translated by Richard Philcox. New York: Grove Press.

Farmer, Henry George. 1928. "A North African Folk Instrument." *Journal of the Royal Asiatic Society,* 1st quarter: 25–34.

Ferchiou, Sophie. 1991. "The Possession Cults of Tunisia: A Religious System Functioning as a System of Reference and a Social Field for Performing Actions." In *Women's Medicine: The Zar-bori Cult in Africa and Beyond,* edited by I. M. Lewis, Ahmed Al-Safi, and Sayyid Hurreiz, 209–18. Edinburgh: Edinburgh University Press.

Fernandez, J. W. 1968. "Book Review: *L'arbre cosmique dans la pensée populaire et dans la vie quotidienne du Nord-Ouest Africain.*" *American Anthropologist* 70 (4): 796.

Fleetwood, Nicole R. 2011. *Troubling Vision: Performance, Visuality, and Blackness.* Chicago: University of Chicago Press.

Flint, Bert. 2018. *La Culture Afro-Berbère, de tradition néolithique Saharienne en Afrique du nord et dans les Pays du Sahel.* Marrakech: Fondation Jardin Majorelle.

Foucault, Michel. 1995. *Discipline and Punish: The Birth of the Prison.* Translated by Alan Sheridan. New York: Vintage Books.

Francesca, Ersilia. 2012. "Dietary Law." *Encyclopaedia of Islam, THREE.* Brill Online. http://refer enceworks.brillonline.com/entries/encyclopaedia-of-islam-3/dietary-law-COM_26018.

Fuson, Timothy Dale. 2009. "Musicking Moves and Ritual Grooves: Across the Moroccan Gnawa Night." PhD diss., University of California, Berkley.

Gabus, J. 1958. *Au Sahara: Arts et symboles.* Neuchâtel: La Baconniere.

Gabus, J. 1973. "Saharan Berber Cultures." In *Encyclopedia of World Art,* 12:630–40. New York: McGraw-Hill.

Garb, Tamar, ed. 2013. *African Photography from the Walther Collection: Distance and Encounters with the African Archive.* New York: Walther Collection.

Garland, Robert. 2014. *Wandering Greeks: The Ancient Greek Diaspora from the Age of Homer to the Death of Alexander the Great.* Princeton, N.J.: Princeton University Press.

Geary, Christraud. 1998. "Different Visions? Postcards from Africa by European and African Photographers and Sponsors." In *Delivering Views: Distant Cultures in Early Postcards,* edited by C. Geary and Virginia-Lee Webb, 147–78. Washington, D.C.: Smithsonian Institution Press.

Geary, Christraud. 2002. *In and Out of Focus: Images from Central Africa, 1885–1960.* London: Philip Wilson Publishers.

Geary, Christraud. 2008. "The Black Female Body, the Postcard, and the Archive." In *Black Womanhood: Images, Icons, and Ideologies of the African Body,* edited by Barbara Thompson, 143–62. Seattle: University of Washington Press.

Geary, Christraud. 2018. *Postcards from Africa: Photographers of the Colonial Era.* Boston: MFA Publications.

Geary, Christraud, and Virgina-Lee Webb, eds. 1998. *Delivering Views: Distant Cultures in Early Postcards.* Washington, D.C.: Smithsonian Institution Press.

Geertz, Clifford. 1968. *Islam Observed: Religious Development in Morocco and Indonesia*. New Haven, Conn.: Yale University Press.

Gell, Alfred. 1998. *Art and Agency: An Anthropological Theory*. Oxford: Clarendon Press.

Gellner, Ernest. 1966. "Book Review: *L'arbre cosmique dans la pensee populaire et dans la vie quotidienne du Nord Ouest Africain.*" *Journal of African History* 7 (2): 358.

Gilroy, Paul. 1993. *The Black Atlantic: Modernity and Double Consciousness*. London: Verso.

Glissant, Edouard. 1989. *Caribbean Discourse*. Translated by J. Michael Dash. Charlottesville: University of Virginia Press.

Godard, Léon Nicolas. 1860. *Description et histoire du Maroc comprenant la géographie et la statistique de ce pays d'après les renseignements les plus recent et le tableau du régne des souverains qui l'ont gouverné depuis les temps les plus anciens jusqu'à la paix de Tétouan en 1860*. Paris: C. Tanera.

Goichon, Amélie. 1927. *La vie feminine au Mzab: Étude de sociologie musulmane*. Paris: Paul Guenther.

Goldsworthy, Patricia. 2009. "Colonial Negatives: The Prohibition and Commodification of Photography in Sharifian and French Morocco." PhD diss., University of California, Irvine.

Goldsworthy, Patricia. 2010. "Images, Ideologies, and Commodities: The French Colonial Postcard Industry in Morocco." *Early Popular Visual Culture* 8 (2): 147–67.

Goodman, David R. 2009. "The End of Domestic Slavery in Fes, Morocco." PhD diss., Indiana University.

Goodman-Singh, David R. 2002. "The Space of Africanness: Using Gnawa Music in Morocco as Evidence of North African Slavery and Slave Culture." *Journal of Asian and African Studies* 64: 75–99.

Gouja, Zouhir. 1996. "Une tradition musicale de transe afro-maghrebine: Stambali." *Cahier des Arts et Traditions Popularies* 11: 71–99.

Grabski, Joanna. 2006. "Painting Fictions/Painting History: Modernist Pioneers at Senegal's *École des Arts.*" *African Arts* 39 (1): 38–49.

Guernier, Eugène. 1950. *La Berbérie, l'Islam et la France: Le destin de l'Afrique du Nord*. Paris: Éditions de l'Union française.

Hall, Bruce. 2011. *A History of Race in Muslim West Africa, 1600–1960*. Cambridge: Cambridge University Press.

Hall, Stuart. 1990. "Cultural Identity and Diaspora." In *Identity: Community, Culture, Difference*, edited by J. Rutherford, 222–37. London: Lawrence & Wishart.

Hamdun, Said, and Noel King. 1995. *Ibn Battuta in Black Africa*. Princeton, N.J.: Markus Wiener.

Hamelin, Nicolas, Ayantunji Gbadamosi, Sofia Mohaouchane, and Imane Benelkaid. 2016. "Consumer Attitudes towards Debt: Empirical Evidence from Morocco." In *Handbook on Research on Consumerism and Buying Behavior in Developing Nations*, edited by Ayantuni Gbadamosi, 53–76. London: University of East London.

Hammond, Andrew. 2007. *Popular Culture in the Arab World: Art, Politics, and the Media*. Cairo: American University in Cairo Press.

Hammoudi, Abdellah. 1997. *Master and Disciple: The Cultural Foundations of Moroccan Authoritarianism*. Chicago: University of Chicago Press.

Harit, Fouâd. 2014. "Maroc: 'Masmiytich Azzi,' une campagne inédite contre le racism anti-Noirs." *Le Nouvel Afrik.com*, March 19. https://www.afrik.com/maroc-masmiytich-azzi-une-campagne-inedite-contre-le-racisme-anti-noirs.

Harrak, Fatima. 2018. "'Abid al-Bukhari and the Development of the Makhzen System in Seventeenth-Century Morocco." *Comparative Studies of South Asia, Africa, and the Middle East* 38 (2): 280–95.

Hassan, Salah. 2012. "Rethinking Cosmopolitanism: Is 'Afropolitan' the Answer?" *Reflections* 5: 3–32.

Haugerud, Angelique, M. Priscilla Stone, and Peter D. Little, eds. 2000. *Commodities and Globalization: Anthropological Perspectives.* Lanham, Md.: Rowman & Littlefield.

Hay, John Drummond. 1896. *A Memoir of Sir John Drummond Hay.* London: John Murray Albemarle Street.

Hell, Bertrand. 2002. *Le tourbillon des genies: Au Maroc avec les Gnawa.* Paris: Flammarion.

Hickling, Patricia. 2014. "*Les coutumes,* Tourism and a Real Photographer." *Visual Anthropology* 27: 339–61.

Hickman, Kristin Gee. 2019. "Darija Revolution? Language Sensibilities and Modernity in Contemporary Urban Morocco." PhD diss., University of Chicago.

Holden, Stacy. 2011. "Pomp and Circumstance: Royal Symbolism and the 'Id Al-Kabir Sacrifice in Morocco." *Arab Studies Journal* 19 (1): 66–93.

Holt, George Edmund. 1914. *Morocco the Piquant.* London: William Heinemann.

Høst, Georgius. 1784. *Nachrichten von Marokos und Fes: Im Lande selbst gesammlet in de Jahren 1760 bis 1768.* Kopenhagen.

Hunter, F. Robert. 2007. "Promoting Empire: The Hatchette Tourist in French Morocco, 1919–36." *Middle Eastern Studies* 43 (4): 579–91.

Hunwick, John. 2002 "The Same but Different: Africans in Slavery in the Mediterranean Muslim World." In *The African Diaspora in the Mediterranean Lands of Islam,* edited by John Hunwick and Eve Troutt Powell, ix–xxiv. Princeton, N.J.: Markus Wiener.

Hunwick, John. 2004. "The Religious Practices of Black Slaves in the Mediterranean Islamic World." In *Slavery on the Frontiers of Islam,* edited by Paul E. Lovejoy, 149–72. Princeton, N.J.: Markus Wiener.

Hunwick, John, and Eve Troutt Powell, eds. 2002. *The African Diaspora in the Mediterranean Lands of Islam.* Princeton, N.J.: Markus Wiener.

Idrissa, Abdourahmane, and Samuel Decalo. 2012. *Historical Dictionary of Niger.* Toronto: Scarecrow Press.

Igreja, Victor. 2018. "Spirit Possession." In *Wiley-Blackwell's International Encyclopedia of Anthropology,* edited by Hillary Callan, 1–9. Oxford: John Wiley & Sons.

Irbouh, Hamid. 2005. *Art in the Service of Colonialism: French Art Education in Morocco 1912–1956.* New York: I. B. Tauris.

Jackson, James Grey. 1809. *The Empire of Marocco and the District of Suse.* London: W. Bulmer.

Jacobson, Ken. 2007. *Odalisques & Arabesques: Orientalist Photography, 1839–1925.* London: Quaritch.

Jacques-Meunié, D. 1947. "Les Oasis des Lektaoua et des Mehamid: Institutions Traditionnelles des Draoua." *Hespéris* 34 (3–4): 397–429.

James Figarola, Joel, Alexis Alarcón, and José Millet. 2007. *El vodú en Cuba.* Santiago de Cuba: Editorial Oriente.

Jankowsky, Richard. 2006. "Black Spirits, White Saints: Music, Spirit Possession, and Sub-Saharans in Tunisia." *Ethnomusicology* 50 (3): 373–410.

Jankowsky, Richard. 2010. *Stambeli: Music, Trance, and Alterity in Tunisia.* Chicago: University of Chicago Press.

Jeannot, Gustave. 1907. *Étude sociale, politique et économique sur le Maroc.* Dijon: Imprimerie Jacquot et Floret.

Johnson, Donald Clay, and Helen Bradley Foster, eds. 2007. *Dress Sense: Emotional and Sensory Experiences of the Body and Clothes.* Oxford: Berg Press.

Johnson, E. Patrick. 2003. *Appropriating Blackness: Performance and the Politics of Authenticity.* Durham, N.C.: Duke University Press.

Johnson, Paul Christopher. 2014. "Introduction: Spirits and Things in the Making of the Afro-Atlantic World." In *Spirited Things: The Work of "Possession" in Afro-Atlantic Religions,* edited by Paul Christopher Johnson, 1–22. Chicago: University of Chicago Press.

July, Robert W. 1981. "The Artist's Credo: The Political Philosophy of Wole Soyina." *Journal of Modern African Studies* 19 (3): 493–94.

Kapchan, Deborah. 2007. *Traveling Spirit Masters: Moroccan Gnawa and Trance in the Global Marketplace.* Middletown, Conn.: Wesleyan University Press.

Kapchan, Deborah. 2008. "The Promise of Sonic Translation: Performing the Festival Sacred in Morocco." *American Anthropologist* 110 (4): 467–83.

Kapchan, Deborah. 2009. "Possessed by Heritage: Sub-Saharan Tradition on Display in Tangier." *Critical Interventions* 5 (Fall): 102–22.

Kasfir, Sidney. 1984. "One Tribe, One Style? Paradigms in the Historiography of African Art." *History in Africa* 11: 163–93.

Kasfir, Sidney. 2007. *African Art and the Colonial Encounter: Inventing a Global Commodity.* Bloomington: Indiana University Press.

Katchka, Kinsey. 2009. "Beyond the Saharan Divide: North African Artists' Participation in Continental Forums." *Critical Interventions* 5 (Fall): 31–46.

Khiat, Salim. 2006. "La Confrérie noire de Baba Merzoug: La sainteté presume et la fête de l'équilibre." *Insaniyat: Revue algérienne d'anthropologie et de sciences sociales année* 10 (31): 113–34.

Kisaichi, Masatoshi. 2008. "Institutionalized Sufism and Non-Institutionalized Sufism: A Reconsideration of the Groups of Sufi Saints of the Non-*Tariqa* Type as Viewed through the Historical Documents of Medieval Maghreb." *Kyoto Bulletin of Islamic Area Studies* 2 (1): 35–46.

Klein, Martin. 1998. *Slavery and Colonial Rule in French West Africa.* New York: Cambridge University Press.

Kopytoff, Igor. 1986. "The Cultural Biography of Things: Commoditization as Process." In *The Social Life of Things: Commodities in Cultural Perspective,* edited by Arjun Appadurai, 64–91. Cambridge: Cambridge University Press.

Kugle, Scott A. 2007. *Sufis and Saints' Bodies: Mysticism, Corporeality, and Sacred Power in Islam.* Chapel Hill: University of North Carolina Press.

Lakhdar, Omar. 2010. *Mogador: Mémoires d'une ville.* Essaouira: Géographique.

Lambek, Christopher. 2014. "Afterword: Recognizing and Misrecognizing Spirit Possession." In *Spirited Things: The Work of "Possession" in Afro-Atlantic Religions,* edited by Paul Christopher Johnson, 257–76. Chicago: University of Chicago Press.

Lamp, Frederick, ed. 2004. *See the Music, Hear the Dance: Rethinking African Art at the Baltimore Museum of Art.* Munich: Prestel.

Lapassade, Georges. 1990. *La Transe.* Paris: Presses Universitaires de France.

Lapassade, Georges. 1997. *Les Rites de possession.* Paris: Anthropos.

Lapassade, Georges. 1998. *Derdeba: La nuit des Gnaoua.* Marrakech: Traces du Présent.

Law, Robin. 1976. "Horses, Firearms, and Political Power in Pre-Colonial West Africa." *Past & Present* 72: 112–32.

Leared, Arthur. 1879. *Morocco and the Moors: Being an Account of Travels, with a General Description of the Country and Its People.* London: Sampson Low, Marston, Searle & Rivington.

Lecocq, Baz. 2015. "Distance Shores: A Historiographic View on Trans-Saharan Space." *Journal of African History* 56 (1): 23–36.

Lefèvre, Raphaël. 2017. "'No to hoghra!' Morocco's Protests Movement and Its Prospects." *Journal of North African Studies* 22 (1): 1–5.

Legy, Françoise. 1935. *Folklore of Morocco.* London.

Le Tourneau, Roger. 1949. *Fès avant le protectorat: Étude économique et sociale d'une ville de l'Occident musulman.* Casablanca: Sociéte marocaine de librarie et d'Édition.

Lewis, Ioan M. 1971. *Ecstatic Religion: An Anthropological Study of Spirit Possession and Shamanism.* Baltimore, Md.: Penguin Books.

Lincoln, Bruce. 2000. "On Ritual, Change, and Marked Categories." *Journal of the American Academy of Religion* 68 (3): 487–510.

Lindsey, Ursula. 2017. "Studying New Forms of Migration in Morocco." *Al-Fanar Media: Covering Education, Research and Culture,* October 9. https://www.al-fanarmedia.org/2017/10/studying -new-forms-migration-morocco.

Lydon, Ghislaine. 2009. *On Trans-Saharan Trails: Islamic Law, Trade Networks, and Cross-Cultural Exchange in Nineteenth Century West Africa.* New York: Cambridge University Press.

Lydon, Ghislaine. 2015. "Saharan Oceans and Bridges, Barriers and Divides in Africa's Historiographical Landscape." *Journal of African History* 56 (1): 3–22.

Maghnia, Abdelghani. 1996. *Un Génie Ophidien de la forêt.* Rabat: Publications de l'Institut des Études Africaines, Université Mohammed V.

Majdouli, Zineb. 2007. *Trajectories des Musiciens Gnawa: Approach et ethnographique des cérémonies domestiques et des festivals de musiques du monde.* Paris: L'Harmattan.

Makris, G. P. 2000. *Changing Masters: Spirit Possession and Identity Construction among Slave Descendents and Other Subordinates in the Sudan.* Evanston, Ill.: Northwestern University Press.

Mana, Abdelkader, ed. 1997. *The Gnawa and Mohamed Tabal.* Casablanca: LAK International.

Masquelier, Adeline. 2001. *Prayer Has Spoiled Everything: Possession, Power, and Identity in an Islamic Town of Niger.* Durham, N.C.: Duke University Press.

Massing, Andreas. 2000. "The Wangara, an Old Soninke Diaspora in West Africa?" *Cahier d'Études africaines* 158 (40, no. 2): 281–308.

Matory, J. Lorand. 2005. *Black Atlantic Religion: Tradition, Transnationalism, and Matriarchy in the Afro-Brazilian Candomblé.* Princeton, N.J.: Princeton University Press.

Matory, J. Lorand. 2006. "Tradition, Transnationalism and Gender in the Afro-Brazilian Candomblé." In *Cultural Agency in the Americas,* edited by Doris Sommer, 121–45. Durham, N.C.: Duke University Press.

Mazrui, Ali. 2005. "The Re-invention of Africa: Edward Said, V. Y. Mudimbe, and Beyond." *Research in African Literatures* 36 (3): 68–82.

McIntosh, Janet. 2009. *The Edge of Islam: Power, Personhood, and Ethnoreligious Boundaries on the Kenya Coast.* Durham, N.C.: Duke University Press.

McNaughton, Patrick. 1988. *The Mande Blacksmiths: Knowledge, Power, and Art in West Africa.* Bloomington: Indiana University Press.

Meier, Prita. 2013. "At Home in the World: Portrait Photography and Swahili Mercantile Aesthetics." In *A Companion to Modern African Art,* edited by Gitti Salami and Monica Blackmun Visonà, 96–112. Chichester: Wiley-Blackwell.

Meier, Prita. 2016. *Swahili Port Cities: The Architecture of Elsewhere.* Bloomington: Indiana University Press.

Mendelson, Jordan, and David Prochaska, eds. 2010. *Postcards: Ephemeral Histories of Modernity.* University Park: Pennsylvania State University Press.

Menin, Laura. 2015. "The Impasse of Modernity: Personal Agency, Divine Destiny, and the Unpredictability of Intimate Relationships in Morocco." *Journal of the Royal Anthropological Institute* 21 (4): 892–910.

Mercer, Kobena. 2005. "Diaspora Aesthetics and Visual Culture." In *Black Cultural Traffic: Crossroads in Global Performance and Popular Culture*, edited by Kennell Jackson, 141–84. Ann Arbor: University of Michigan Press.

Mercier, L. 1906. "Les Mosquées et la vie religieuse à Rabat." *Archives marocaines* 8: 99–195.

Mernissi, Fatima. 1994. *Dreams of Trespass*. Reading, Mass.: Addison-Wesley.

Merzan, Karim. 2001. "Negotiating National Identity in North Africa." *International Negotiation* 6: 141–73.

Meyers, Allan R. 1977. "Class, Ethnicity, and Slavery: The Origins of the Moroccan 'Abid." *International Journal of African Historical Studies* 10 (3): 427–42.

Meyers, Allan R. 1983. "Slave Soldiers and State Politics in Early `Alawi Morocco, 1668–1727." *International Journal of African Historical Studies* 16 (1): 39–48.

Michaux-Bellaire, Edouard. 1907. "Description de la ville de Fès." *Archives marocaines* 11: 252–330.

Michaux-Bellaire, Edouard. 1910. "Notes et documents: L'esclavage au Maroc." *Revue du Monde Musulman* 11 (7–8): 422–27.

Michaux-Bellaire, Edouard. 1923. *Les confréries religieuses au Maroc: Conférences faite au cours de perfectionnement*. Rabat: Imprimerie Officielle.

Michaux-Bellaire, Edouard, and G. Salmon. 1905. "El Qçar el-Kebir." *Archives marocaines* 2: 188–228.

Miers, Suzanne, and Igor Kopytoff. 1979. *Slavery in Africa: Historical and Anthropological Pespectives*. Madison: University of Wisconsin Press.

Miller, Susan. 2013. *A History of Modern Morocco*. Cambridge: Cambridge University Press.

Mohamed, Mohamed Hassan. 2010. "Africanists and the Africans of the Maghrib: Casualties of Analogy." *Journal of North African Studies* 15 (3): 349–74.

Montana, Ismael. 2004. "Aḥmad ibn al-Qāḍī al-Timbuktāwī on the Bori Ceremonies of Tunis." In *Slavery on the Frontiers of Islam*, edited by Paul E. Lovejoy, 173–98. Princeton, N.J.: Markus Wiener.

Montet, E. 1902. "The Religious Orders of Morocco." *Imperial and Asiatic Quarterly Review* 25 & 26 (January–April): 62–70.

Morton, Christopher. 2012. "Double Alienation: Evans-Pritchard's Zande & Nuer Photographs in Comparative Perspective." In *Photography in Africa: Ethnographic Perspectives*, edited by Richard Vokes, 33–55. Woodbridge, UK: James Currey.

Morton, Christopher, and Darren Newbury, eds. 2015. *The African Photographic Archive: Research and Curatorial Strategies*. London: Bloomsbury.

Mudimbe, V. Y. 1988. *The Invention of Africa: Gnosis, Philosophy, and the Order of Knowledge*. Bloomington: Indiana University Press.

Naji, Lamia. 2005. *couleurs primaires*. Madrid: Galería Rafael Pérez Hernando.

Nora, Pierre. 1996. *Realms of Memory: Rethinking the French Past*. Translated by Arthur Goldhammer. New York: Columbia University Press.

Ottmani, Hamza Ben Driss. 1997. *Une cité sous les alizés: Mogador, des origins à 1939*. Rabat: El Maarif Al Jadida.

Pâques, Viviana. 1964. *L'arbre cosmique dans la pensée populaire et dans la vie quotidienne du nord-ouest africain*. Paris: Travaux et memoires, Institut d'Ethnologie.

Pâques, Viviana. 1976. "Le monde des *gnawa*." *Publications de l'Institut d'études et de recherches interethnique et interculturelles* 7 (1): 169–82.

Pâques, Viviana. 1991. *La Religion des esclaves: Recherches sur la confrérie Marocaine de Gnawa.* Rome: Vitalli Press.

Pascon, Paul. 1984. *La Maison d'Iligh et l'histoire sociale du Tazerwalt.* Rabat: Société Marocaine des Editeurs Réunis.

Patterson, Tiffany Ruby, and Robin D. G. Kelley. 2000. "Unfinished Migrations: Reflections on the African Diaspora and the Making of the Modern World." *African Studies Review* 43 (1): 11–45.

Peffer, John, and Elizabeth Cameron, eds. 2013. *Portraiture and Photography in Africa.* Bloomington: Indiana University Press.

Perani, Judith, and Fred Smith. 1998. *The Visual Arts of Africa.* Upper Saddle River, N.J.: Prentice Hall.

Perdicaris, Ion. 1906. "Morocco: 'The Land of the Extreme West' and the Story of My Captivity." *National Geographic Magazine* 17 (3): 117–57.

Perry, Marc D. 2008. "Global Black Self-Fashionings: Hip Hop as Diasporic Space." *Identities* 15 (6): 635–64.

Pinho, Patricia de Santana. 2010. *Mama Africa: Reinventing Blackness in Bahia.* Durham, N.C.: Duke University Press.

Pipes, Daniel. 1981. *Slave Soldiers and Islam: The Genesis of a Military System.* New Haven, Conn.: Yale University Press.

Porch, Douglas. 2005 [1982]. *The Conquest of Morocco: A History.* New York: Farrar, Straus and Giroux.

Powell, Eve Troutt. 2002. "The Silence of the Slaves." In *The African Diaspora in the Mediterranean Lands of Islam,* edited by John Hunwick and Eve Troutt Powell, xxv–xxxvii. Princeton, N.J.: Markus Wiener.

Prestholdt, Jeremy. 2008. *Domesticating the World: African Consumerism and the Genealogies of Globalization.* Berkeley: University of California Press.

Prussin, Labelle. 1986. *Hatumere: Islamic Design in West Africa.* Berkeley: University of California Press.

Prussin, Labelle. 2005. "David in West Africa: 'No More Forever?'" *Yale University Art Gallery Bulletin,* 89–110.

Rahal, Ahmed. 2000. *La Communauté Noire de Tunis: Thérapie initiatique et rite de possession.* Paris: L'Harmattan.

Rausch, Margaret. 2000. *Bodies, Boundaries, and Spirit Possession: Moroccan Women and the Revision of Tradition.* Bielefeld: Transcript Verlag.

Richardson, James. 1860. *Travels in Morocco,* vol. 1. London: Charles J. Skeet.

Roach, Joseph. 1996. *Cities of the Dead: Circum-Atlantic Performance.* New York: Columbia University Press.

Roberts, Allen F., and Mary Nooter Roberts. 2003. *A Saint in the City: Sufi Arts of Urban Senegal.* Los Angeles: UCLA Fowler Museum of Cultural History.

Rolling, James Haywood, Jr. 2009. "Invisibility and In/di/visuality: The Relevance of Art Education in Curriculum Theorizing." *Power and Education* 1 (1): 94–110.

Rosander, Eva Evers. 1997. "Introduction: The Islamization of 'Tradition' and 'Modernity.'" In *African Islam and Islam in Africa: Encounters between Sufis and Islamists,* edited by Eva Evers Rosander and David Westerlund, 1–27. Athens: Ohio University Press.

Ross, Eric S., John A. Shoup, Driss Maghraoui, and Abdelkrim Marzouk. 2002. *Assessing Tourism in Essaouira.* Ifrane: Al Akhawayn University.

Rouch, Jean. 1960. *La religion et la magie Songhay.* Paris: Presses Universitaires de France.

Sabatier, Camille. 1891. *Touat, Sahara et Soudan: Étude geographique, politique, economique et militaire.* Paris: Sociéte d'Éditions Scientifiques.

Said, Edward. 1979. *Orientalism.* New York: Random House.

Salmon, Georges. 1904. "Notes sur les superstitions populaires dans la region de Tanger." *Archives marocaines* 1: 262–72.

Santo, Diana Espírito, and Nico Tassi, eds. 2013. *Making Spirits: Materiality and Transcendence in Contemporary Religions.* New York: I. B. Tauris.

Saul, Mahir. 2006. "Islam and West African Anthropology." *Africa Today* 53 (1): 3–33.

Schroeter, Daniel. 1988. *Merchants of Essaouira: Urban Society and Imperialism in Southwestern Morocco, 1844–1886.* New York: Cambridge University Press.

Schroeter, David. 1992. "Slave Markets and Slavery in Moroccan Urban Society." In *The Human Commodity: Perspectives on the Trans-Saharan Slave Trade,* edited by Eva Savage, 185–213. London: Frank Cass.

Schuyler, Philip. 1981. "Music and Meaning among the Gnawa Religious Brotherhood of Morocco." *World of Music* 23 (1): 3–10.

Scott, James C. 1990. *Domination and the Arts of Resistance.* New Haven, Conn.: Yale University Press.

Shannon, Jonathan Holt. 2015. *Performing al-Andalus: Music and Nostalgia across the Mediterranean.* Bloomington: Indiana University Press.

Sharp, Joanne P. 2009. *Geographies of Postcolonialism: Spaces of Power and Representation.* Los Angeles: SAGE.

Sheller, Mimi. 2012. *Citizenship from Below: Erotic Agency and Caribbean Freedom.* Durham, N.C.: Duke University Press.

Silverstein, Paul. 2011. "Masquerade Politics: Race, Islam and the Scale of Amazigh Activism in Southeastern Morocco." *Nations and Nationalism* 17 (1): 65–84.

The Sketch: A Journal of Art and Actuality. 1905. "The Harem of the Sultan of Morocco." October 4: 454–55.

Smith, Shawn Michelle. 2013. *At the Edge of Sight.* Durham, N.C.: Duke University Press.

Soyinka, Wole. 1991. "Beyond the Berlin Wall." *Transitions* 51: 6–25.

Spadola. Emilio. 2014. *The Calls of Islam: Sufis, Islamists, and Mass Mediation in Urban Morocco.* Indianapolis: Indiana University Press.

Spillers, Hortense J. 2006. "The Idea of Black Culture." *CR: The New Centennial Review* 6 (3): 7–28.

Steiner, Christopher. 1991. *African Art in Transit.* Cambridge: Cambridge University Press.

Stewart, C. C. 1976. "Southern Saharan Scholarship and the Bilal Al-Sudan." *Journal of African History* 17 (1): 73–93.

Stoller, Paul. 1989. *The Taste of Ethnographic Things: The Senses in Anthropology.* Philadelphia: University of Pennsylvania Press.

Stoller, Paul. 1994. "Embodying Colonial Memories." *American Anthropologist* 96 (3): 634–48.

Stoller, Paul. 1995. *Embodying Colonial Memories: Spirit Possession, Power, and the Hauka in West Africa.* New York: Routledge.

Stoller, Paul. 1997. *Sensuous Scholarship.* Philadelphia: University of Pennsylvania Press.

Strother, Zoe. 2013. "A Photograph Steals the Soul: The History of an Idea." In *Portraiture and Photography in Africa,* edited by John Peffer and Elizabeth Cameron, 177–212. Bloomington: Indiana University Press.

Suhr, Christian. 2015. "The Failed Image and the Possessed: Examples of Invisibility in Visual Anthropology and Islam." *Journal of the Royal Anthropological Institute* 21 (S1): 96–112.

Sum, Maisie. 2011. "Staging the Sacred: Musical Structure and Processes of the Gnawa *Lila* in Morocco." *Ethnomusicology* 55 (1): 77–106.

Sum, Maisie. 2012. "Music of the *Gnawa* of Morocco: Evolving Space and Times." PhD diss., University of British Columbia, Vancouver.

Thompson, Krista. 2006. *An Eye for the Tropics: Photography, Tourism, and Framing the Caribbean Picturesque.* Durham, N.C.: Duke University Press.

Thompson, Krista. 2015. *Shine: The Visual Economy of Light in African Diasporic Aesthetic Practice.* Durham, N.C.: Duke University Press.

Thompson, Robert Farris. 1983. *Flash of the Spirit: African and Afro-American Art & Philosophy.* New York: Random House.

Thomson, Madia. 2011. *The Demise of Slavery in Southwestern Morocco, 1860–2000.* New York: Edwin Mellen Press.

Tilley, Christopher. 2006. "Introduction: Identity, Place, Landscape, and Heritage." *Journal of Material Culture* 11 (1/2): 7–32.

Trabelsi, Salah. 2019. "Racism anti-noire: 'Comment le Maghreb en est-il venu à rejecter son africanité?'" *Le Monde Afrique*, February 24. https://www.lemonde.fr/afrique/article/2019/02/24/racisme-anti-noir-comment-le-maghreb-en-est-il-venu-a-rejeter-son-africanite_5427702_3212.html.

Tremearne, A. J. N. 1914. *The Ban of the Bori: Demons and Demon-Dancing in West and North Africa.* London: Heath, Cranton & Ouseley.

Trimingham, J. S. 1959. *Islam in West Africa.* Oxford: Clarendon Press.

Turner, Victor. 1968. *The Drums of Affliction: A Study of Religious Processes among the Ndembu of Zambia.* Oxford: Clarendon Press.

Tytell, John. 1995. *The Living Theatre: Art, Exile, and Outrage.* New York: Grove Press.

Venture de Paradis, Jean-Michel. 1844. *Grammaire et dictionnaire abrégés de la langue Berbère.* Published posthumously by P. Amédée Joubert. Paris: Imprimerie Royale.

Veyre, Gabriel. 2010 [1905]. *Dans l'intimité du Sultan, au Maroc 1901–1905.* Casablanca: Afrique Orient.

Viddal, Grete. 2013. "Vodú Chic: Cuba's Haitian Heritage, the Folkloric Imaginary, and the State." PhD diss., Harvard University.

Vokes, Richard, ed. 2012. *Photography in Africa: Ethnographic Perspectives.* Woodbridge, UK: James Currey.

Ward, Brian. 1998. *Just My Soul Responding: Rhythm and Blues, Black Consciousness and Race Relations.* London: UCL Press.

Webb, James L. A. 1993. "The Horse and Slave Trade between the Western Sahara and Senegambia." *Journal of African History* 34 (2): 221–46.

Wehr, Hans. 1980. *A Dictionary of Modern Written Arabic.* Edited by J. Milton Cowan. Beirut: Librarie du Liban.

Welte, Frank Maurice. 1990. *Der Gnâwa-Kult: Trancespiele, Geisterbeschwörung und Besessenheit in Marokko.* Frankfurt am Main: Peter Lang.

Westermarck, Edward. 1899. "The Nature of the Arab Ginn, Illustrated by the Present Beliefs of the People of Morocco." *Journal of the Anthropological Institute of Great Britain and Ireland* 3/4: 252–69.

Westermarck, Edward. 1934. "Negro Influence in Morocco." In *Negro Anthology*, edited by Nancy Cunard, 624–27. London: Nancy Cunard.

Westermarck, Edward. 1968 [1926]. *Ritual and Belief in Morocco.* 2 vols. New York: University Books.

Willemont, Jacques, dir. 2005. *Les 7 couleurs de l'Univers: Une leçon d'anthropologie*. DVD. Vanves, France: CERIMES.

Willemont, Jacques, dir. 2012. *Gnawa: Au-delà de la musique*. DVD. Under the scientific direction of Viviana Pâques. Strasbourg: Université de Strasbourg, Espaces.

Williamson, M. J. 1938. "A Trip to Morocco." *Journal of the Royal Army Medical Corps* 71 (3): 202–8.

Willis, Deborah, and Carla Williams. 2002. *The Black Female Body: A Photographic History*. Philadelphia: Temple University Press.

Winegar, Jessica, and Katarzyna Pieprzak. 2009. "Africa North, South, and in Between." *Critical Interventions* 5 (Fall): 3–11.

Wirtz, Kristina. 2014. *Performing Afro-Cuba: Image, Voice, Spectacle in the Making of Race and History*. Chicago: University of Chicago Press.

Witulski, Christopher. 2016. "The Gnawa Lions: Paths towards Learning Ritual Music in Contemporary Morocco." *Journal of North African Studies* 21 (4): 599–622.

Witulski, Christopher. 2018. "Contentious Spectacle: Negotiated Authenticity with Morocco's Gnawa Ritual." *Ethnomusicology* 62 (1): 58–82.

Wright, John. 2002. "Morocco: The Last Great Slave Market?" *Journal of North African Studies* 7 (3): 53–66.

Yonan, Michael. 2011. "Toward a Fusion of Art History and Material Culture Studies." *West 86th: A Journal of Decorative Arts, Design History, and Material Culture* 18 (2): 232–48.

Zartman, William. 1963. *Sahara: Bridge or Barrier?* New York: Carnegie Endowment for International Peace.

Zartman, William. 1965. "The Politics of Boundaries in North and West Africa." *Journal of Modern African Studies* 3 (2): 155–73.

Zeys, Mathilde. 1908. *Une Française au Maroc*. Paris: Librarie Hachette et Cie.

INDEX

Page numbers in italics refer to illustrations.

CYNTHIA J. BECKER is associate professor of African art history in the History of Art and Architecture Department at Boston University. She is the author of *Amazigh Arts in Morocco: Women Shaping Berber Identity.*